THE INDIGNANT EYE

THE INDIGNANT EYE

The Artist as Social Critic in Prints and Drawings from the Fifteenth Century to Picasso

by Ralph E. Shikes

BEACON PRESS : BOSTON

Acknowledgments

THIS PROJECT would never have been undertaken were it not for the encouragement of many artists and scholars who thought it worthwhile and who generously shared their vast knowledge. I am particularly grateful to Ben Shahn, Leonard Baskin, Theodore H. Gusten, Lessing J. Rosenwald, Carl Zigrosser and Dr. Arnold Hauser—none of whom is responsible in any way for errors of conception, commission, or omission, nor for opinions and prejudices.

Obviously, it would have been impossible to prepare a book of this nature without the cooperation of the staffs of museums, large and small, throughout the western world, all specifically credited on the pages where illustrations occur.

I am especially grateful to Elizabeth Roth and David Johnson of the Prints Division, New York Public Library; Janet Byrne of the Metropolitan Museum of Art;

Richard S. Field, then curator of the Alverthorpe Gallery; M. Jean Adhémar and Mlle. Madeleine Barbin of the Cabinet des Estampes, Bibliothèque Nationale, Paris; Lydia De Pauw–De Veen, of the Bibliothèque Royale de Belgique, Brussels; and to many individual staff members of the Museum of Modern Art, New York, the Brooklyn Museum, the Library of Congress, the British Museum, the Department of Drawings of the Louvre, and the Institut Français d'Histoire Sociale.

I would like to thank Jacob Kainen of the Department of Prints, National Collection of Fine Arts, Smithsonian Institution, for reading the manuscript and for many helpful criticisms; Peter de Francia for his suggestions on the contemporary European scene; Harold Mehling for reading and styling many of the chapters; and Edith C. Pratt for general assistance.

The Library of Congress catalogued the first printing of this title as follows:

Shikes, Ralph E
 The indignant eye; the artist as social critic in prints and drawings from the fifteenth century to Picasso, by Ralph E. Shikes. Boston, Beacon Press [1969]
 xxviii, 439 p. illus. 26 cm. 12.50
 "Notes and bibliography": p. 407–430.
 1. Caricature—History. I. Title.
NC1340.S5 769'.922 69–14604
ISBN 0–8070–6671–0 (pbk)

For Ruth, Kathy, and Jennifer

The author wishes to acknowledge a special debt to Paula Hays Harper for assistance in picture research and selection throughout the book and for constant invaluable critical judgments. Her knowledge of art history and her special insights into sixteenth-century graphics were indispensable in the preparation of the book.

Contents

Illustrations

COMPLETE INFORMATION accompanies each illustration as it appears in the text. The dimensions are in inches; the first dimension is the height. Only date and source are cited when the illustration first appeared in a published, mechanically reproduced version. The title style (capitalization, punctuation, translation) of the illustrations is governed mainly by three factors: the artist, the museum holding the work, and established reference sources.

Introduction

ANY ARTISTS—perhaps most—have expressed little or only fleeting concern with the economic, political, or social struggles of their time. Some have been naïvely approving of their societies; others, cynical or indifferent. But certain artists have become spiritually and artistically involved in man's seemingly endless quest for social justice. They have used the most effective weapon at their command—their art—to needle the Establishment, duel with oppressive governments, satirize corrupt or indifferent churches, strip bare the foul futility of war, attack exploitation, uncover the bleak existence of the poor, and in general to make visual comment on human folly in its infinite variations. *Il faut être de son temps,* Daumier believed—and a surprising number of artists were very much of their time.

This book focuses on more than 150 such artists and their work, reproducing prints and drawings from Western Europe, the United States, and Mexico on subjects of social comment and criticism that have been executed over the past five centuries—roughly the span of printmaking. The book should be read or viewed with these considerations in mind:

First, the art; as the lawyers say, *res ipsa loquitur*—the thing speaks for itself. This art is intrinsically interesting; some of it is magnificent. Viewed as a whole, these prints and drawings provide a long-neglected phase of art history, with the emphasis more on content than on form.

Second, this art reflects the artist as a human reacting to his environment. An artist's social views have scarcely been mentioned in recent biographical and critical studies. He may not have had any startling views worth mentioning, but there is often little evidence that their existence or nonexistence was ever considered. Yet, social attitudes can often—though not always—affect an artist's content and style. Camille Pissarro, for example, was a lifelong anarchist; he identified with those whom he regarded as the suffering exploited—workers and peasants. Although he created little protest art on specific issues, when he sketched a peasant in the fields every line reflected his belief in the dignity of labor. Nearly all the Neo-Impressionists, for that matter, drew or painted scenes with factory backgrounds as a protest against the "escapist" art of a society they detested.

Third, while this art reflects many of the unhappy aspects of the social and political history of the past 500 years—man's aptitude for killing or abusing his fellow is hardly uplifting—it also mirrors certain artists' outspoken protests against these failures of society, expressed here sometimes

THE INDIGNANT EYE

with courage, often with wit, and nearly always with artistic validity.

It is no accident that social criticism has been expressed largely in prints and drawings. The print is the ideal medium for communicating messages, since multiple copies can reach comparatively wide audiences. Before the advent of newspapers and magazines—during the Protestant Reformation, for example—prints played an important polemical role. In fact, in the early years of printmaking, as Erwin Panofsky has pointed out, they were the artist's only means of self-expression since painting was usually done "on commission" for church or patron. From the sixteenth through the middle of the nineteenth century, broadsides or "penny sheets"—print combined with text—were a major medium for political expression.

Moreover, the starkness of a black-and-white print is often more appropriate for social message than is the sensuousness of color. The dark mass of a woodblock can accentuate the somberness of a mood, and the sharp, thin line of an etching can sharpen the bite of a message, increasing the sting of an attack. It is no coincidence that the vocabulary of printmaking techniques—the "acid" and "bite" in an etching, the "cut" in a woodblock—is also the language of attack. In addition, the technical nature of the print imposes a discipline upon the artist that often brings added strength to the print. As Ben Shahn has said of the print, "It is to art as the essay is to literature—compact, pointed, intensive."

And why drawings? For the obvious reason that drawings, personal and immediate, are the closest we can get to an artist's spontaneous reaction to a circumstance. Hence, when a drawing deals with a social injustice, it can have a quality of "indignation" that a later, technically more demanding execution may not duplicate or retain.

"Every civilization celebrates the successful: the compromisers and the clever, the manipulators of opportunity within the prescriptions of propriety, the tribal chiefs and their wise men," Professor Charles H. George has written.

The greatness of Europe is in its history of brilliant failure. Radicalism from the fourteenth century to the twentieth has attempted in a unique way to close the gap between ideal and practice, to increase the works of the imagination while demanding honesty of society. It has been a positive, specific, sensual, immediate, and utopian history.

What George has said of European history applies as well to the art in this book. While painters have helped "celebrate the successful," this book is composed of the graphic artists who drew "to increase the works of the imagination while demanding honesty of society." The artists who have tried "to close the gap between ideal and practice" are many and distinguished: Goya and Daumier, obviously, and Picasso. The Master E.S. and perhaps Bosch, and Holbein and Cranach, Bruegel, Callot, Hogarth, Rowlandson, Gillray, Cruikshank, Géricault, Courbet, Seurat, Pissarro, Rou-

ault, Klee, Kollwitz, Barlach, Grosz, Beckmann, are among the many Europeans, and numerous Americans, major and minor. Not everyone included in this book is a Goya or a Daumier, but many minor artists have on occasion produced prints worth recording in this context. The works are serious statements, even when satirical in form, and must be considered within the framework of their times.

The particular kind of protest art we are concerned with here is social or political criticism of specific ways of life, institutions, conditions, or circumstances, *not* of man's general spiritual malaise or discontent with his own psyche, or general statements of man's fate. We are concerned with man in relation to society. Mannerism, abstract expressionism, even pop art, have also represented reactions against society, but in generalized terms, and hence have no place here. To cite two obvious examples: Few if any of the great artists had the compassion and immense human understanding of Rembrandt, but these qualities are always implicit rather than explicit in his art. Nor can Piranesi's "Carceri" be regarded as "protest" except against the loneliness of man or the imprisonment of the spirit. Since the purpose of this collection is to trace the artist's handling of social and occasionally political questions, some prints have been included that are of more historical than artistic importance.

Obviously these artists did not spend all their lives in constant indignation at society. A few did, especially some who lived through the political and social turmoil of nineteenth-century France, as well as a number of Mexican artists who witnessed their country's revolutionary upheavals. While most did not, they felt involved and moved enough at some point to make an artistic comment on some phase of the human tragicomedy. Their social commitment did not always persist, of course; familiarly, perhaps, many artists were radical in their youth, gradually saw their work being accepted by a regime they detested, and increasingly muted their protests. A few of these prints reflect a conservative point of view, usually "indignation" at real or imagined excesses at the Left. However, the vast majority of art directed against the abuses of society has been drawn within a liberal or radical framework.

Unfortunately, "protest art" has become a pejorative phrase in recent years. It has been identified unfairly with art that is crude and often overstated. Obviously, good intentions and lofty ideals are not enough. The indignant artist dealing with a social theme has to keep his artistic cool and not permit his feelings to muddy his expression. Protest art is certainly far more effective when emotion and technical skill are in harmony.

Artists represented here, with the exception of a few, were *engagés*, involved, committed. Some used satire to make their statements. Others recorded society's failures with deep compassion or haunting grief. Still others employed a reportorial directness of attack in which the situation

speaks for itself. This last group poses an intriguing problem: Who is the passive observer or reporter, and who is the active commentator? Too many artist-observers suffer from what Baudelaire said of Monnier—that, like a mirror, he simply reflected what passed before him. We have excluded the passive observers and have included a few reporters only when there was emotional identification with their subjects.

This raises a related question of definition: At what point does a caricature or satirical political cartoon transcend topical comment and become "art"? Probably when its draftsmanship is superior and controlled, the composition inherently striking, the impact of the conception immediate, the message of lasting interest—and perhaps when the artist's reputation is secure in art history books. The passage of time often helps a particular engraving or lithograph to surpass the limitations imposed at its conception. Readers once laughed or winced at Gillray's or Daumier's satirical thrusts; today their artistic relevance is more apparent. Caricature—exaggeration for satirical purposes—has been included only when the satire had significant social or political point. Satire is here in generous quantity. "Indignation" can be expressed in many ways, by no means always solemn. Some prints even have a thumb-at-the-nose quality—a suggestion of the hoot of the slum kid who has just tossed a snowball at the rich man's hat.

Most of the prints and drawings are against an injustice rather than for a re-

form. For instance, it is far easier to portray the specific evils of war than to show an abstract vision of peace. Artists have exposed or attacked the conditions that led to revolutions, but once the revolutions had taken place, very little protest art appeared. In simplest terms, when the villain is portrayed beating the underdog, we are caught up in an emotion of hate and indignation and react sympathetically to the art (assuming the art is worthwhile). But when the underdog is shown in action against the villain, the art usually seems falsely heroic and does not attract our sympathy.

Many themes recur in these pages. The loudest and most persistent cry protests the horror of war. To a Leonardo or a Pollaiuolo, the clash of fighting men served mainly as inspiration in portraying the male figure in magnificent motion. But many others, from Romeyn de Hooghe to Picasso, while equally stimulated by the movement and action of war scenes, leave clearly in the observer's mind a revulsion against the bestial behavior of men at war. In this ecumenical age, it may be surprising that anticlericalism was a major theme for four and a half centuries. What has religion to do with the artist as *social* critic? The answer lies in remembering that church and state were often combined or closely related. At times Church *was* State. Hence, the artist in attacking the established church was striking at an important facet of the social order as well.

Another struggle—that between the haves and the have-nots—continues to this

very day, as does the conflict between freedom and oppression. Poverty, civil corruption, prostitution—the sources of "indignation" are many.

The nature of the reforms sought by artists often shifted. In the sixteenth century, religious reform was the goal. In the eighteenth, Hogarth battled for limited social reforms. In early nineteenth-century France the emphasis was on political reform, while in the latter part of that century the Neo-Impressionists were content with nothing less than a change of the entire system.

Were these artists "effective"? Did their efforts topple tyrants? Obviously not, although they certainly contributed to revolutionary climates (when they had the freedom to do so). Did they succeed—or contribute to success—in limited objectives? At times, yes, indeed. The woodcuts of Cranach, Holbein, and others played an important role in the Protestant Reformation. Hogarth's prints were instrumental in obtaining the passage of legislation that curbed the excessive and debilitating consumption of gin and the mistreatment of animals. In America, Nast's cartoons certainly broke up the corrupt Tweed Ring that was swindling New York City of millions of dollars. However, these were rare triumphs. Who can say when a specific print or speech or incident effected a change, but who can doubt that each contributed to the total result? The "effectiveness" of these prints and drawings lies in their very existence—as testament to man's noble tradition of dissent against tyranny or injustice or igno-

bility. That in itself is effectiveness enough.

Certain artists, especially those making political comment, did play major national roles at critical times: Gillray's caricatures during England's struggle against Napoleon, Daumier's prints in the convulsive days of Louis Napoleon's fall, Nast's contributions to the post-Civil War crisis in America, George Grosz's jagged graphics that captured the frenetic atmosphere of post-World War I Germany.

Some of these artists were warm, sympathetic, and compassionate. Some were fanatics; some were rather repulsive but occasionally on a specific issue showed flashes of inspiration and courage. Obviously, there is not always a correlation between a man's beliefs and his personal behavior.

Here are a final few *caveats* to be borne in mind while reading this book:

• Although these were all graphic artists, many were primarily painters, and some were sculptors. It would be a distortion to think that their art was confined to printmaking.

• It would also be a mistake to regard all as *engagés* during their entire lives. Many became interested in a particular cause only at a particular time. Also, several of the earlier artists are anonymous. It is difficult enough—and a bit of an impertinence—to divine an artist's emotion at the moment of creation. When he is anonymous, it is sheer guesswork.

• Some of these prints are not "indignant." They are here to point up a theme or serve historical purpose.

• Similarly, there is not necessarily a direct relationship between the number of prints presented here by a particular artist and his importance, with the obvious exceptions of Goya and Daumier. A relatively minor artist may have drawn hundreds of socially critical prints or drawings and be represented here by five or six examples, while a major artist may have been attracted to these themes only a few times in his life.

• The treatment is chronological since events and conditions of particular times stimulated most of these graphic works. The significant economic, political, social, or historical events have been indicated, but history has necessarily been condensed in the interests of good bookmaking.

• Recent critical or satirical art from Eastern Europe and the Soviet Union is not included. This would constitute a book in itself. Nor is protest art from Japan or China —another book.

• As for recent art, roughly dating from the end of World War II, only a sampling has been attempted, and that mostly from the United States; the current international scene would form still another book.

Since all judgments are necessarily subjective, it might also be helpful to point out that this book was written and edited from a liberal point of view. However, no attempt has been made—consciously, at least—to strain an interpretation of an artist's work into a social meaning the artist may not have intended. Naturally, some of this art is subject to differing interpretation, but valid historical evidence is presented to reinforce any controversial conclusions. Even so, many critics reject any social interpretation of Bruegel's drawings, or feel that Goya was uninvolved, and believe that, in any case, art with a social purpose should perhaps be swept under the gallery rug.

In an eloquent passage in *The Shape of Content*, Ben Shahn replies to this attitude:

While artists try to make their nonconformity as clear and unmistakable as possible, one of the challenging tasks of criticism seems to be to smooth over such nonconformity, and to make it appear that this or that artist was a very model of propriety. "The coarseness of Goya is hardly noticeable unless we set out to look for it." Or again, "There is no evidence to prove that Goya actively assisted in any scheme of protest against the established order of society." But of course Goya did actively assist; indeed he protested with the most crying, the most effective, the most unforgettable indictment of the horrors of religious and patriotic fanaticism that has ever been created in any medium at all. Beauty? Yes, it is beautiful, but its beauty is inseparable from its power and its content. Who is to say when a weeping face becomes a trenchant line? And who may presume to know that the line might have been trenchant apart from the face? Who can say that this passage of color, that formal arrangement, this kind of brush-stroking could have come into being were it not for the intensity of belief which demanded it?"

Intensity of belief. It varies in degree, but it is probably the most universal characteristic of the artists in this collection.

THE INDIGNANT EYE

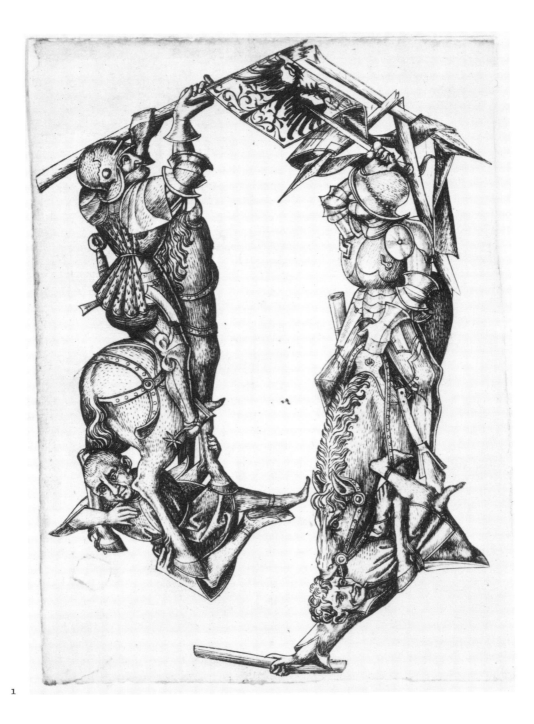

1

1. "The Letter Q." Master E.S. 1467. 14⅜x11⅝. Engraving. Staatliche Graphische Saamlung, Munich.

CHAPTER I
Prologue: The First Stirrings of Protest

I N Munich's Staatliche Graphische Sammlung is the single remaining copy of an intriguing and significant print of the letter Q, part of a "Grotesque Alphabet" in which letters are formed by groupings of human figures and animals. The engraver of this series, made in 1466–67, was a German artist known to us only as Master E.S.

What distinguishes this particular engraving is that it is one of the first sharply barbed social comments in the history of prints. It depicts two heavily armored knights slashing at one another while two unfortunate peasants are trampled beneath their horses. The knights are completely indifferent to the fate of these two literally downtrodden people.

Typical of many other fifteenth-century graphic artists, few facts are known about Master E.S. He was active in South Germany and Switzerland, and probably began his career as a goldsmith. His style was in the Gothic tradition that permeated German art until Dürer: a predilection for the grotesque, and a lack of foreshortening and perspective, with elongated figures and angular fabric folds. In a period dominated by superstition, dogmatic faith, and uninvestigated natural laws, the artist treated his subject symbolically rather than realistically. Master E.S. employed his ele-

gant line with the precision of a goldsmith, and he is credited with inventing cross-hatching.

E.S. executed more than 300 engravings, about a third of which survive in a single impression. Many are devoted to saints and their martyrdoms, and other familiar Biblical scenes. The best known, a large "Madonna of Einsiedeln," was often bought as a souvenir by pilgrims visiting the shrine at Einsiedeln. Some of his work, however, was humorous and occasionally bawdy, including grotesqueries and a few charming scenes of dalliance. He also designed a set of playing cards with men, dogs, birds, and shields representing the four suits, a New Year's card, and a series of ornaments used as models by other carvers and metalworkers—a common practice then.

The purpose of alphabets such as that of the Master E.S. is obscure. Specialists believe they were most likely intended as models or possibly as a diversion from solemn religious subjects. The letters are formed by bizarre, often incongruous, but always delightfully imaginative conglomerations of knights and ladies, grotesque wild men, animals, and birds, intertwined in embrace or combat or amusing juxtaposition.

But why at this particular moment in history did one artist choose to include

sharp social comment in his alphabetical mélange? What impelled him to express open sympathy for the peasant in society's hierarchy? It may simply have been historical accident, but it may also have resulted from the convergence of many forces—social, religious, economic, political, and cultural.

It is worth looking into some of these conditions prevalent at the time of E.S. They inspired a constant theme: "landlord versus peasant," "privileged class versus underprivileged," "class struggle." Call it what you will, it was to stimulate protest art for hundreds of years in a variety of approaches and styles.

Of course satire in the world of art did not commence with Master E.S.'s print. In certain wall paintings and vase decorations, Greeks and Romans occasionally had been audacious enough to burlesque their gods. The Egyptians often ridiculed the more pretentious actions of men by portraying them as animals—or animals as humans—as did the anonymous monks who illuminated medieval manuscripts. In many twelfth-, thirteenth-, and fourteenth-century Gothic cathedrals, there is an amusing contradiction between the noble, soaring lines of these structures and the earthy sculptural detail within, where monkeys are portrayed wearing bishops' miters and monks and nuns engage in sundry unholy actions.

But this was basically irreverence, an occasional furtive expression by unknown artisans. In the fifteenth century, however, came the major turning point in the development of art as a social message. Paper suitable for printing became readily available in Germany. During the 1430's, the technique of making prints from engraved plates was born when goldsmiths began to record their designs by inking the incised metal and pressing paper against it. This technique eventually led to the creation of original engravings in which the design was cut with a tool—the burin—into the surface of a plate, usually copper. The plate was inked so that the lines were filled, and the unworked area was wiped clean. The plate was then run through a press against dampened paper. The pressure transferred the ink to the surface of the paper, and an engraving was born.

Multiple reproductions made a relatively wide audience possible, independent of church or lord. Vital also to the artist was the growth of cities, where a means of distribution was available, and a small middle class emerged with funds to buy inexpensive prints.

Intellectual ferment was also beginning to bubble in the cities. The Renaissance was taking hold with the quest for new ideas. The invention of movable type made it possible to disseminate these ideas.

But what existed for the poor peasants? In the pyramidal structure of fifteenth-century society, the peasant formed the broad base, leading a bleak and weary existence, toiling from dawn to dusk. War, famine, and pestilence were always threats. He was forced to work in his lord's fields and

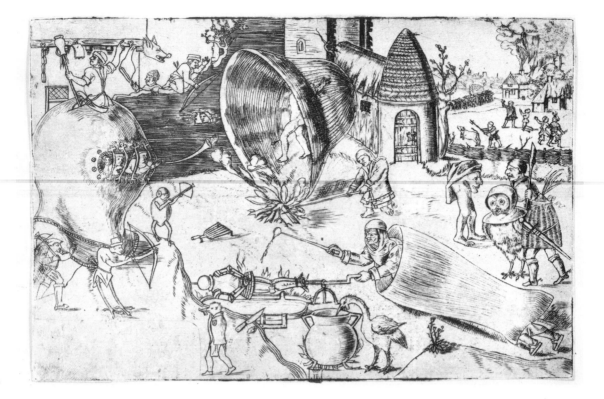

2

to help maintain his lord's manor. If nobles fought, they trampled the peasant's crops or pressed him into unwilling contest. The suffering of the peasant was an almost universal byproduct of knight's warfare. When the "proud, mighty, and lawless" Orsini and Colonna families feuded in Rome in 1484, for example, "The city officials, knowing the suffering of the people whenever the nobles fought each other, went to Sixtus IV with petitions for peace," a chronicler reports. "In the Campagna baron now fought baron. But most of the damage fell on the peasants and on the fields, barns, and threshing places of the Roman citizens."

But the peasant must surely have dreamed of the day when he would turn on his tormentors. In the Bibliothèque Royale in Brussels there is an almost childlike, wistful expression of this dream—an engraving satirizing the chivalric men of arms. In the foreground, a trussed knight in armor is basted as he slowly turns on a spit. Another knight is besieged as he tries unsuccessfully to hide from his attackers. On the left, a figure trumpets judgment day. Bosch-like figures abound in allegorical and occult activities. But in the right background life remains realistic, with a knight about to execute a peasant and another about to kill his cow.

This crude engraving epitomizes the sentiment behind the couplet of the Peasants' Revolt in England that was swiftly adopted by peasants throughout Europe:

> When Adam delved and Eve span,
> Who was then a gentleman?

or, in its Flemish version:

2. "Une satire de la chevalerie et des hommes d'armes." Anonymous. 16th century. 4½x6¾. Engraving. Hollstein, Bosch No. 40. Bibliothèque Royale, Brussels.

Als Adam spode en Eva spon,
Waar was dan den Edelman?

Forces beyond his comprehension complicated the peasant's life. Feudalism was disintegrating and the manorial system was breaking up. The specter of unemployment was added to the peasant's fears and often drove him to the nearest town or city, where the semiskilled or unskilled workingman's existence was bleak. His home was a slum, his food barely life-supporting. When employed, he had little say about the conditions of his work.

Peasant and workingman had no outlet for their grievances and the inevitable followed: explosion, revolt, outbreaks of violence. Revolts throughout western Europe and England in the last half of the fourteenth century were ruthlessly crushed. They failed because they were despairing, sometimes mystical, and often sanguinary outbursts against injustice and misery, rather than planned revolutions with social programs.

Religious observance, ceremony, and feast days provided an emotional outlet for the poor with color and pageantry. But the peasants and city poor paid dearly for the privilege of communion. At every step on the road to salvation, the priest's outstretched hand demanded tithes.

Although the peasant bowed in awe at the majesty of the Church, he was not unaware of its corruption. Appointments and indulgences were sold, and while there were islands of piety, reverence, and high

example, too often the residences of cardinals, bishops, and monks were centers for power struggle, luxury, and licentiousness. Papal prestige was almost irreparably shaken by the degrading Great Schism between 1375 and 1415 when both French and Italian contenders for the Papacy claimed legality and hurled epithets at each other with all the grace of fishwives.

These human failings of the clergy inevitably caught the satirical eye of the artist. One of the earliest to lash out at the worldly indulgences of the unworldly was Hieronymus Bosch (c. 1450–1516), a profound, Jeremiah-like critic of his time, who constantly exploited man's (and clergyman's) sin, fear, and guilt as he probed the inner recesses of his fellowman's mind.

Bosch belonged to the pious, puritanical Brotherhood of Our Lady, spiritual successor to the Brethren of the Common Life, which numbered Erasmus among its members. Alienated by corruption of the Church and repelled by a sinful world, its members sought salvation in a life of simplicity and piety. While faithful to the Pope, the Brethren denounced the abuses and scandalous practices of the clergy.

Just as the details of iconography in Bosch's paintings are fascinating, so is the detail in his graphic work enlightening. In the lower right-hand corner in Bosch's version of "The Besieged Elephant," engraved in Paris by Paul de la Houve, a priest picks the purse of a fallen combatant. In Vienna's Albertina Museum a sheet of his sketches includes a richly garbed

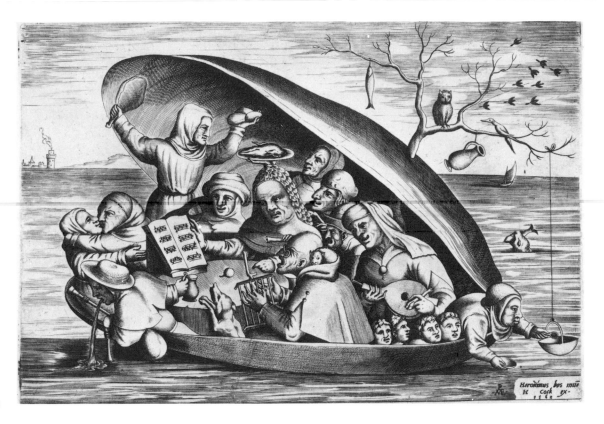

3

bishop among the blind and disabled beggars. Three hundred years later, Goya portrayed the clergy in an equally unflattering manner.

Bosch, like many of his contemporaries, was concerned with man's preoccupation with sin. A wave of post-medieval piety made the sins of the clergy particularly abhorrent and paved the way for the Reformation. To Bosch, the earth was a spiritual desert delivered up to Satan, a Ship of Fools drifting to doom with mankind wallowing in an excess of corrupt pleasures.

Bosch visualized this theme not only in his famous painting, "The Ship of Fools," but in a print that was engraved by Pieter van der Heyden after a lost drawing by Bosch. This engraving, published 46 years after Bosch's death, is listed by Charles de

Tolnay, the Bosch authority, as "Company at Table in a Floating Conch," while the Rijksmuseum in Amsterdam describes it as a satire on "Monks and Nuns," emphasizing its anticlerical tone; and F.W.H. Hollstein, cataloger of Dutch and Flemish prints, describes it as a "satire on the life of monks and nuns." It is doubtful that any of the ladies are nuns, but some of the carousing gentlemen are unmistakably monks, emphasizing that the greatest sinners of all are the sinful clergy. The theme was to intrigue artists for several hundred years. Bosch also expressed a theme only tangential to this book but one which has fascinated the more profound artists from Bruegel to Goya: man's follies and failures. Bosch's drawing is replete with the symbolism of the sixteenth century: man adrift at

3. "The Floating Conch." Hieronymus Bosch. 1562. 7⅞x11⅜. Engraving by Pieter van der Heyden. Foto-Commissie, Rijksmuseum, Amsterdam.

sea, rudderless, with the port in sight. The figure at the lower left represents gluttony, and his neighbors portray lasciviousness. Symbols of vice abound: the mouse peeking out of the monk's hood traditionally represented vanity; street musicians were looked upon as corrupt rogues; the lifeless fish, symbol of Christ, hangs from the barren tree of death; and the owl warns of the foolishness within man. Bosch's iconoclastic comment on the seven deadly ways of high living by clergy and others was probably not meant to be direct criticism of society. But if not an all-out stricture, it was edging close to it; the clergy were certainly part of the higher social order.

The Ship of Fools concept had wide circulation in a runaway bestseller of that name by Sebastian Brant, first published in the Swabian dialect in 1494, then translated into Latin, Dutch, Low German, English, and French. The Basel edition of 1497 with woodcuts by five artists, including Dürer, enabled even the illiterate to comprehend the Ship of Fools concept.

Brant's *Ship of Fools* is not only a moral satire but a graphic reflection of the social conditions of pre-Reformation Europe. His verses illuminate a variety of fools that inhabit this world, from the older woman who marries a young man to the theologian who pursues abstruse subjects while ignoring urgent practical problems. But occasionally the accompanying illustrations include a pointed social comment; his main targets were the rich and their treatment of the poor.

4

5

4. "Of ryches unprofytable." Albrecht Dürer(?). 1494. 4½x3¾. Woodcut. From *Ship of Fools,* 1494 ed. Dick Fund 1930, Metropolitan Museum of Art, New York.

5. "Of the contempt and dispysynge of povertye." Albrecht Dürer(?). 4½x3¼. Woodcut. From *Ship of Fools,* 1504 ed. New York Public Library.

In "Of ryches unprofytable" (from an English translation but printed with copies of the original woodcuts), Brant chides the wealthy man for accumulating riches while the poor starve at his door. The woodcut shows a fanciful use of perspective, but the line is firm, the composition is good, and the poor man has form and dignity.

It is a folly to worship riches, the verse points out,

> But yet no wonder is it sertaynly
> Syth he that is ryche hathe greater
> reuerence
> Than he that hathe sadnesse wysdom and
> scyence

And Brant adds later, of the rich man:

> He shall be callyd to counseyll in the lawe
> Though that his brayne be skarsly worth
> a strawe

Several hundred years later artists were still to portray judges with brains "skarsly worth a strawe."

Below the woodcut "Of the contempt and dispysynge of povertye," Brant comments:

> He that is pore, and wyse, must him
> submyt
> Vnto a rich fole whiche in a trone shall
> syt.

The fifteenth century marked a reduction in the power of the nobles in many countries and a consolidation of royal power with the right to tax and to maintain a standing army. It witnessed the rise of the national state. France for example was

6

practically a united territorial state by 1500. The game of power politics took on new dimensions as ambitious kings expanded their power through large and frequent wars of conquest. It was inevitable that some artists on the sidelines should be moved to make political comment on the rivalries of the high and mighty, even as far back as the fifteenth century. A contemporary political cartoon, which appeared in France in 1499, is neither great art nor "indignant," but an interesting predecessor of political satire surprisingly modern in concept. Lodovico Sforza, regent of Milan, tempted Charles VIII of France into an easy but futile conquest of Naples—futile because his armies could hold this isolated outpost only temporarily. Charles' successor, Louis XII, was

6. "Reverse of the Swiss' Game." Anonymous. 1499. 6¼x8¾. Woodcut. Bibliothèque de Rouen.

9

also lured by an easy conquest of Naples, but first he surmounted the opposition of the Swiss by a series of alliances and then seized Milan before capturing Naples. In the engraving, the King of France, to the right, has just shown his winning hand, while the Swiss opposition realizes his cards are inferior, and the Doge of Venice, Louis' ally, lays down his hand. The Pope is trying to comprehend what is going on. The Infanta Margarita signals the Swiss with a wink, and the Duke of Milan picks up the cards to make a game for himself (his double game only gained him imprisonment by the even wilier Louis XII).

This mild and unemotional political satire was not profound social criticism and the tapestry-like tableau is static, but this fifteenth-century David Low was the forerunner of a tradition that has been carried down to our editorial pages of today. These territorial rivalries which endangered the peace of the world were to draw sharp protests from artists for innumerable generations.

One of the earliest political cartoons was a German woodcut of the 1469–73 period satirizing the greatest power struggle of all —that of the Emperor and the Pope. Reproduced here is a sixteenth-century copy, faithful to the original, but much more beautifully drawn, with solid forms and delicate line and shading. Of the two struggling figures, the Pope seems to be the leader since he has justice on his side. The Emperor, however, has taken the king

of Bohemia away from the Pope's ranks and has the support of the king of Burgundy.

Thus, in the fifteenth century, as the art of printmaking developed, the first whisperings of social and political graphic comment were seen. It was low-key criticism, infrequent, and by no means great art, but these few examples were nonetheless significant portents of the artist's role as social and political critic. Some basic themes emerged: criticism of the pecking order which placed the peasant on the bottom and the rich on top, attacks on the clergy for worldly lapses, and satire of political power struggles.

As the sixteenth century dawned, the artist's function as social critic broadened abruptly. The stage was being set for the struggles of the Reformation, a controversy that provoked many artists, at least in northern Europe, to speak out in their unique manner.

In addition to the wide and deeply felt desire for reform of the Church, other conditions that were to lead to discord—and involvement of the artist—intensified as the century ended: the unleavened misery of peasant and workingman, and especially the root causes of civil, national, and religious war. These were the threads that were being woven into the tapestry of the times, and, because they were the continuing concern of mankind, these were the subjects that certain artists were to turn to time and again for the next 450 years.

7

7. "Fight between the Emperor and the Pope." Anonymous. 1555. 7¾x5⅝. Colored pen drawing. Bibliothèque Nationale, Paris.

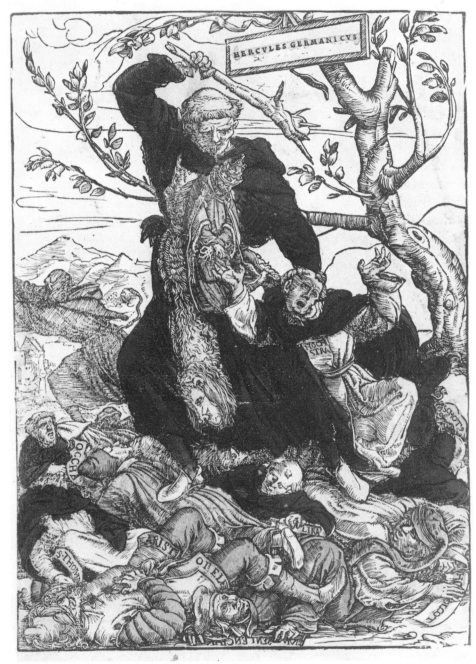

8

8. "Hercules Germanicus." Hans Holbein the Younger. 1520. 14x8¾. Colored woodcut. Department of Manuscripts, Zentralbibliothek, Zurich.

CHAPTER II
The Artist Against the Church Establishment: The Sixteenth Century

IN THE 1520's Hans Holbein the Younger made an impassioned colored woodcut depicting Luther as Hercules slaying his enemies. While the Pope dangles from the hairy chest of the strong man, Luther-Hercules raises his spiked club to kill a desperately struggling Hochstra, the representative in Germany of the Inquisition. At his feet lie the bodies of other theological enemies, including Aristotle and St. Thomas. The legend at the bottom warns Rome and praises Luther as the German son of Alcaeus, the master-killer.

The dark, massive figure of Luther-Hercules is frightening in its unbridled strength. The movement, the forceful pyramidal design, the flow of figure and tree all bespeak an accomplished artist. The one-sided content reflects a deeply involved one. It is blatant propaganda, wildly exaggerated, to the extent that one Holbein authority suspects Holbein of satirizing both sides. However, it is powerful and effective and the artist was obviously very much engagé.

In the sixteenth century, graphic art was used increasingly in social criticism. Many artists, swept up in the struggle of the Protestant Reformation against the established church and the papacy, were in effect attacking an important aspect of society itself, rather than engaging only in a purely religious quarrel. The Catholic Church and the papacy *were* the social order. In several countries Church and State were inseparable; to fight for religious reformation was to challenge the established hierarchy. The Protestant Reformation was not a direct economic or social revolution—although in the long run it contributed to both—but it was at least a struggle to express differing religious beliefs and to reform obvious abuses.

Luther basically attacked the same transgressions excoriated in the fifteenth century, but he succeeded where predecessors such as Wycliffe and Huss had failed. Sixteenth-century Europe was, indeed, a different society. There was now widespread belief that the Church was incapable of purging itself from within of the corruptions that had scandalized its followers for a century. A prosperous and growing middle class, often self-made, resented and questioned the basic concept that salvation was possible only through the medium of the priesthood. The humanist emphasis on literal study of the Bible brought forward the concept of individual salvation. To the middle class, at least, much of the ritual and pageantry seemed medieval and irrelevant. The financial drain caused by the avarice of the church was now unbearable. With the rise of the new national states,

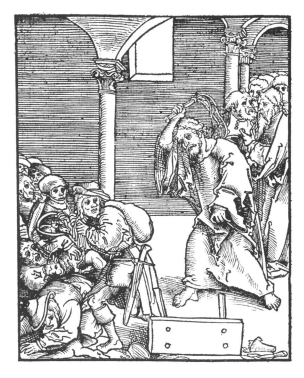

9

territorially unified, it seemed anomalous to pay taxes to a distant Pope and to permit papal interference in national affairs. Moreover, there was an obvious advantage to confiscation of church lands. All these factors were present when Martin Luther nailed his 95 Theses against the sale of indulgences to the door of the Wittenberg church in 1517.

There arose a new element that both Lutheran and papal forces sought to influence—public opinion. With the growth of towns, a compact and influential audience was at hand. Luther used every resource at his command, including the talents of artists, to convey his message to the mass of people who were illiterate. Nearly every major German graphic artist sided with Luther and many lent pen, woodcutter's knife, or burin to his cause.

Luther was quick to see the value of the illustrated pamphlet, with a text to influence the literate and graphic illustrations to convince the untutored. A born pamphleteer, Luther not only wrote many of the texts but often supplied the ideas for the woodcuts and engravings. His genius as a propagandist and the support he received from many of Germany's artists were major factors in his success.

There were no restraints in the Lutheran-papal battle waged with knife and burin. It was basically war propaganda. Most of the prints were as balanced and artistic as newspaper editorial cartoons, but some possessed sharp satirical thrust and power. Others, not unlike some of the eighteenth-

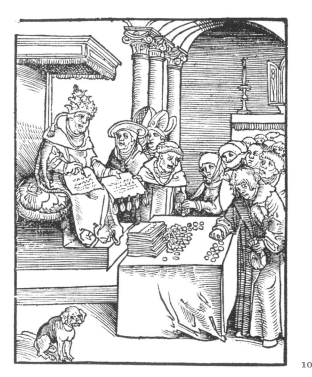

10

9. "Christus." 10. "Antichristus." Lucas Cranach the Elder. 1521. 4½x3⅝. Woodcuts. From *Passional Christi und Antichristi*. British Museum, London.

and nineteenth-century cartoons and caricatures, are included here for their conception and content and not for any great distinction in the execution.

Lucas Cranach the Elder (1472–1553), painter of portraits and exotic nudes, was painter in Wittenberg to the court of Frederick the Wise of Saxony. He was a witness at the marriage of Luther to Katherine von Bora and painted several portraits of him, his wife, and Philipp Melanchthon, Luther's chief lieutenant.

Cranach was also to draw many designs for woodcuts, often crudely executed, for Luther's propaganda pamphlets. He made a series of drawings for "Passional Christi und Antichristi" cut into wood by his son Hans, contrasting the humble and lowly life of Christ and the pompous and prosperous life of his vicar. Christ is shown driving out the moneychangers while the Pope is profiting from the sale of indulgences. Melanchthon's text emphasized this point. The grouping and arrangement of the figures are skillfully handled, but the woodcutting most likely does no justice to the original drawings.

The Church made vain efforts to stem the flow of antipapal propaganda. In 1521 the Edict of Worms tried to censor the press and explicitly forbade the publication of satirical matter. The Diets of Nuremberg (1524) and Augsburg (1530) also confirmed and strengthened the censorship laws. In spite of these efforts, political and religious literature and prints persisted.

This propaganda war lasted for decades.

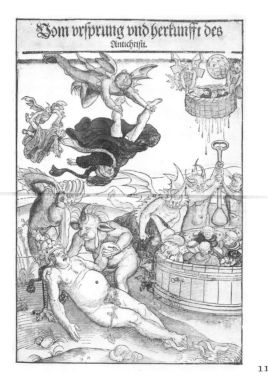

11

In 1545, when Luther was accused in scurrilous verse by his adversaries of being a child of the Furies, he struck back in *Abbildung des Papstum* with characteristic violence. Cranach, aging but spry, gleefully joined in the brutal caricature of the papacy with a series of colored woodcuts on the origins of the Pope. The woodcut was an ideal medium, since text type could be combined with the illustration to print at the same time. Cranach drew the newly born Pope, spawned by a female demon and wearing his triple crown, being nurtured by various agents of the devil. There is a contagious zest to the action-filled propaganda that was probably far more effective than any solemn statement.

Cranach usually made the designs, and his sons Hans and Lucas executed the woodcuts. Lucas Cranach the Younger succeeded his father as head of his workshop

11. "On the Origin and Arrival of the Antichrist." Lucas Cranach the Elder. 1545. 10½x7. Colored woodcut. From *Abbildung des Papstum*. British Museum, London.

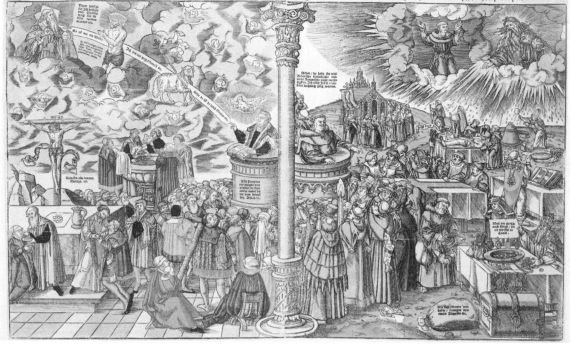

12

and continued to turn out many single-sheet woodcuts, usually colored, supporting Luther and his teachings. Among these is a delightfully simplistic view of "The Differences between Protestant and Catholic Divine Service." On the right we see the Catholic divine service. In the heavens is an angry and vengeful God, with a saint almost on the same level—implying the Lutheran distaste for the Catholic practice of revering human saints as much as a divine God. Other follies attributed to the Church are satirized—the corpulent preacher, with the devil breathing into his ear; a foolish cleric with spectacles and the ears of an ass, probably representing a doctor of theology; and the greedy Pope dispensing indulgences. There exists a general air of raffish disorder and impiety. The Protestant divine service, in contrast, pic-

tures an angel-filled heaven presided over by a loving and gentle God. The congregation is pious and attentive. The sacraments of baptism and eucharist are being performed—the only two sacraments the Lutherans accepted as originating from God and not from the hierarchy of the Church.

High living by church emissaries—especially when flaunted—always infuriated the reformers. A typical lampoon is Matthias Gerung's woodcut, ostensibly an illustration for the Apocalypse. At this gay Bavarian party a cardinal and a bishop are being sick, and a devil holds the papal tiara over a priest while the devil's emissaries take him firmly by the hand. In the landscape soldiers pierce a fallen man and armies clash while money bags hold down the lower left corner. Gerung's lively, swirling tableau is tightly composed; propa-

12. "The Differences between Protestant and Catholic Divine Service." Lucas Cranach the Younger. 1545–50. 23x13¾. Colored woodcut. Stiftung Preufzischer Kulturbesitz, Kupferstichkabinet, Staatliche Museum, West Berlin.

13

ganda does not necessarily have to be bad art.

Stories of licentious and decadent behavior at the papal court grew with each retelling and Luther's followers were not restrained in their versions of the orgies.

This anonymous broadsheet of papal high jinks must surely have titillated reformist viewers when it was published in 1562. The Pope is kissing a nun at the banquet; a cardinal and an abbot are drinking themselves under the table. Monks, preceded by Swiss Guards, are bringing in more platters heaped with food. In front of the house, Luther is being driven away by a Swiss Guard and the verses below sing of the simple life of Luther.

This copper engraving is typical of a publishing phenomenon, the German broadsheet, that flourished in the sixteenth and especially the seventeenth centuries, and

actually continued in one form or another into the twentieth. Early in the sixteenth century Sebastian Brant used the broadsheet to propagate his sermons, and even Dürer was both poet and illustrator for some. Cranach and Luther's *Abbildung des Papstum* described above was later issued as a broadsheet. Although the broadsheet was put to didactic use in the religious controversy of the sixteenth century, it was usually noncontroversial, covering popular humor, prophecies, strange events, and murders. A *Formschneider* (literally, pattern cutter) usually engraved the broadsheets in his own workshop and often acted as publisher, bringing artist and poet together. The broadsheets were distributed by other printsellers and itinerant peddlers who hawked them in the streets and at fairs.

14

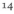

13. "Satire on Church." Matthias Gerung. 8⅛x6⅜. Woodcut. British Museum, London.

14. "The Pope Like a Rich Man at Table." Anonymous. 1562. 10¼x10½. Copper engraving broadsheet. Photo Walter Danz, Grafischen Sammlung der Staatliche Galerie Moritzburg, Halle, Germany.

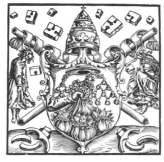

15

This satirical coat of arms is of special interest because it may actually be based upon one of Luther's designs. In a letter Luther refers to a woodcut of a satirical coat of arms of the Pope and says that he drew it, "or rather had it drawn for me." Since this woodcut comes from the Cranach workshop, it may very well be the woodcut referred to by Luther. The crossed keys, symbol of the papacy, are broken and scattered. The keys, instead of unlocking the gates of heaven, are the gallows from which Judas and the Pope hang. On the shield beneath a cardinal's hat, a hand clutches bags of money tied together by bishops' miters.

The anti-Luther prints were relatively mild when compared to the antipapal propaganda. Luther's foes stressed his connection with the devil, as in these two prints. "Luther's Pact with the Devil" is an anonymous woodcut from a 1535 book by Petrus Sylvius attacking Luther. In the anonymous

engraving of "Luther as the Wolf in the Fold," a seemingly pious Luther is shown with the feet and tail of a wolf, while the devil breathes evil into his ear. Around Luther's feet lie dead sheep, representing the Christian souls he has destroyed through his false preaching.

However, the artists who supported Lu-

17

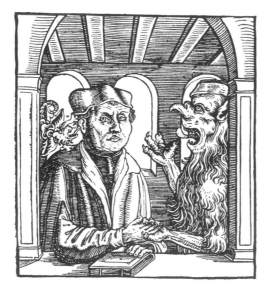

18 16

15. "Papal Coat of Arms." Anonymous. 1550–85. 10¾x12½. Woodcut. Prints Division, Astor, Lenox and Tilden Foundation, New York Public Library.

ther were an illustrious group. In addition to Holbein and Cranach, there were Matthias Grünewald and Albrecht Dürer, to name a few. The greatest genius of sixteenth-century German art, Albrecht Dürer, made no prints on behalf of Luther, but when unfounded rumors of Luther's death reached him in 1521, he wrote in his diary a bitter outburst against the Pope's supporters, an impassioned appeal to Erasmus, and a moving, deeply felt statement of his own position: "O God, if Luther is dead, who shall henceforth so clearly expound to us the Holy Gospels? . . . O Erasme Roderodame, where wilt thou take thy stand? . . . I have heard that thou givest thyself no more than two years in which to accomplish something. Use them well, for the benefit of the Gospels and the true Christian faith, and let thy voice be heard. . . ."

And he wrote: "Whether Luther be yet living or whether his enemies have put him to death, I know not; yet certainly what he has suffered has been for the sake of truth, and because he has reprehended the abuses of unchristian papacy, which strives to fetter Christian liberty with the encumbrances of human ordinances, that we may be robbed of the price of our blood and sweat, and shamefully plundered by idlers, while the sick and needy perish through hunger."

Hans Holbein the Younger shared Dürer's distaste for popery. Although best known for his great portraits, "Henry VIII," "Erasmus," "The Ambassadors," and many others, in his younger years at least Holbein

18

20

19

turned a critical and accusatory eye on the world of his time. When he was only eighteen years old, he made eighty-three pen drawings in the margins of an edition of Erasmus' *In Praise of Folly*. Some of the drawings are gentle in their satire, others ironic. In a typical illustration, he portrays a monk with his hand on a girl's breast. In another, he groups a priest with a soldier, illustrating Erasmus' comment on warlike clergy who "consider it a disgrace to die elsewhere than on the field of battle." Pope Julius II is sketched bearing arms. Erasmus had written: "Only when a pope has shed streams of blood . . . does he believe he is defending the church."

16. "Luther's Pact with the Devil." Anonymous. 1545. 3½x3¼. Woodcut. Prints Division, New York Public Library.

17. "Luther as the Wolf in the Fold." Anonymous. Early 1500's. 5¹⁵⁄₁₆x3¾. Engraving. Prints Division, Astor, Lenox and Tilden Foundation, New York Public Library.

18.–20. Untitled. Hans Holbein the Younger. 1515. 3x1½. Pen drawings. From *In Praise of Folly*. Public Library of the University of Basel.

21

When Holbein was 24, he executed a series of frescoes (since destroyed) at the Basel city hall which sang a paean to justice, hailed the virtues of republican simplicity, and attacked rude despotism.

Erasmus believed the Church could be reformed from within, and the youthful Holbein probably shared this view. As Holbein matured, however, he began to identify with the Reformation and became much more direct and forceful in his attacks on the Church. Two woodcuts and a drawing which reflect these attitudes survive.

A woodcut on the sale of indulgences demonstrates Holbein's genius for compressing a great deal into a small space. In the background the Pope sells indulgences, while at the right, a well-fed canon hearing confession points emphatically to a chest of offerings. A woman is dropping her mite into the box. In the center, three priests are selling indulgences; one of them is rejecting a crippled old man who begs for remission of his sins but is unable to pay. At the far left, true penitents are bowing before God. Not exactly subtle, but Holbein, like all propagandists, wanted even illiterates to get the message. And unlike the art of so many broadsheets of his day, it is beautifully drawn, with an easy, flowing line.

In Holbein's "Christ, the True Light," humble, true believers listen to Christ, while Pope, bishops, and monks turn their backs and blindly follow Aristotle into the abyss.

21. "The Sale of Indulgences." Hans Holbein the Younger. 1520. 3⅛x10½. Woodcut. Ashmolean Museum, Department of Western Art, University of Oxford, Oxford.

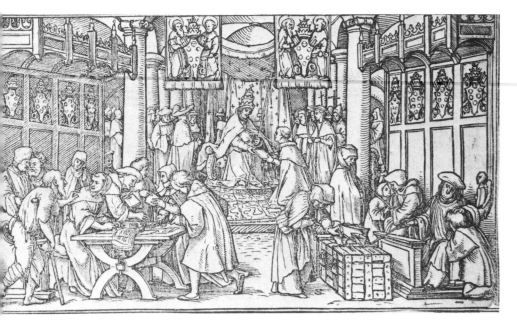

Holbein's penchant for contrasting the worldliness of the papal court with the austere simplicity of Christ's leadership is further represented in a drawing still extant at Erlangen, but in too-poor condition to reproduce. Here, the Pope rides in a litter surrounded by an armed escort; Christ rides an ass, accompanied by his disciples.

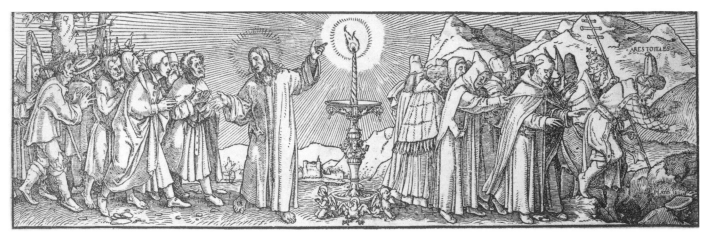

22

22. "Christ the True Light." Hans Holbein the Younger. c. 1520. 3½x10½. Woodcut. British Museum, London.

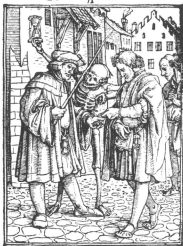

Der Fürſprách.

23

Der Rych man.

24

Die Nunne.

25

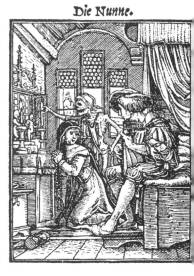

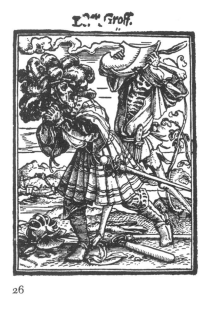

Der Groff.

26

Holbein's feeling about the social and human frailties of his time found further expression in a minor masterpiece, a series of woodcuts illustrating "The Dance of Death." The theme—a familiar medieval caveat—was not new but Holbein played a multitude of original variations on it, with bite and irony and a roguish humor that evokes a smile along with a shudder. Implicit is the warning to the rich and powerful to reform—or else. The strong satirical note obviously is aimed at both church and secular authorities.

Death comes to the mighty as well as to the lowly. Surely preachers have sung this since time remembered, but in Holbein's hands it takes on more social meaning reminiscent of:

> When Adam delved and Eve span,
> Who was then the gentleman?

In these various woodcuts, Death snatches away the advocate who ignores the pleas of the poor; Death robs the rich man, not of his life, but of his bags of gold, dearer than life; Death seizes the nun as she prays in her cell while her lover sits on her bed; Death is a peasant as he attacks the haughty count; Death provides a release from the wearying, burdensome

23. "The Advocate." 24. "The Rich Man." 25. "The Nun." 26. "The Count." Hans Holbein the Younger. 1538. 2⅝x1¹⁵⁄₁₆. Woodcut. From "The Dance of Death." Rosenwald Collection, National Gallery of Art, Washington (except 25: Prints Division, Astor, Lenox and Tilden Foundation, New York Public Library.)

22

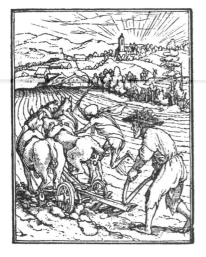

27

life of Everyman. In the woodcut here, Death aids the bent and exhausted Ploughman by whipping his emaciated nags toward the golden horizon of eternal sleep. One can almost hear the strife of the Peasants' War in the background.

The forty-one woodcuts of "The Dance of Death" are a triumph of composition. Each measures about two by two and one-half inches, yet the figures, landscape, and details hold together remarkably when viewed through a magnifier. Each has tight unity and dramatic impact.

Holbein had a rational, inquiring mind. Before he would agree to embrace Lutheranism, he demanded a more logical explanation of the Lord's Supper. Also, for Holbein (and for many other painters) the reformist religion he favored frowned upon

church decoration and religious painting—the main source of his livelihood. England beckoned. He had spent two years there after Erasmus had introduced him to Thomas More, but had then returned to Basel. Now the more relaxed, less somber atmosphere of England, the promise of worldly success, perhaps the lure of the fleshpot—all combined to bring Holbein back to London. He was successful there, eventually becoming court painter to Henry VIII, but apparently at the price of his reputation. In 1535, Erasmus wrote to a friend that "Holbein resided in Antwerp a month ago, and would have stayed longer if he had found fools there. . . . In England he betrayed those to whom he had been recommended."

Luther's revolt had an impact on art that was felt in many of the countries in northern Europe. In the Low Countries and especially in the Netherlands—the commercial crossroads of Europe—the independent and thriving bourgeois were exposed to all the latest intellectual and cultural crosscurrents. Lutheranism, Anabaptism, and then Calvinism secured strong footholds in the northern provinces and had many followers in the southern areas.

The Spanish Hapsburgs through marriage had acquired control of the Low Countries and had traditionally derived a considerable part of their revenue from Flanders and the Netherlands. Charles V had governed the Netherlands with reasonable tact and discretion. But when Philip II ascended the Hapsburg throne in

27. "Everyman." Hans Holbein the Younger. 1538. 2⅝x2. Woodcut. From "The Dance of Death."

1555, he adopted measures which seemed deliberately self-defeating. He increased taxes, bringing both the wealthy burghers and the privileged nobility into open resistance. He tried to establish a centralized government, uniting the independent provinces in opposition to his autocratic authority. His employment of Spanish and German mercenaries created a nationalist spirit of resistance. Charles V had sought to crush heresy in sporadic attempts that cost thousands of lives. Philip not only reissued and strengthened his father's edicts —among other ghastly decrees, informers were given half the property of their victims—but he also embarked on a determined campaign to stamp out all dissent and resistance. When opposition flared into open revolt in 1567, he dispatched the Duke of Alva with Spanish troops and other mercenaries to put down the rebellion with savagery and fury appalling even for that era.

In such a political world Pieter Bruegel the Elder (c.1525/30–69) lived, only a generation and a half from the still medieval times of Hieronymus Bosch.

To Bruegel the world was much like that of Sebastian Brant's in *The Ship of Fools*— it was very much a topsy-turvy place, and he endeavored to set it straight. Essentially a moralist, Bruegel attacked the excesses and intolerances of the Church, and chastised man for his sins and follies. A caustic and resigned observer of the deplorable human condition, Bruegel only occasionally attempted to reform the body politic.

As Arnold Hauser has pointed out, Bruegel's humor shares with Rabelais, Shakespeare, and Cervantes "the same kind of development, the fruits of bitter experience and ultimate reconciliation with the course of the world." But sometimes his comment was sharp and irreconcilable.

Bruegel was a many-sided genius who established a variety of precedents in art. While Italian artists and their northern imitators were concerned with nude gods, classical scenes, and conventional religious themes, Bruegel gained his inspiration from the contemporary life around him. He illustrated biblical events with lively folk scenes sketched from everyday Netherlands life. He preserved peasant and village scenes on pad and canvas and sketched "drolleries"—blind beggars, cripples, drunkards, grotesques—with realism and rare compassion. He was one of the first artists to record the rhythm of the changing seasons and the awesome majesty of mountains. And unlike most artists of his time, whose output was nearly always at the command of patron or church, Bruegel seems often to have painted for himself or his friends.

Relatively little is known about Bruegel's life. He was born in or near Breda, in the border area of Belgium and Holland. He probably studied under Pieter Coecke van Aelst, a leading Flemish artist-decorator. In 1551 he was admitted to the painters' guild in Antwerp and shortly after took a grand tour of Italy that had only moderate influence on the style and content of his art.

Bruegel became associated with the print-maker and publisher Hieronymus Cock at his shop in Antwerp, "Aux Quatre Vents," and this relationship lasted throughout Bruegel's life. With one exception, Bruegel made no engravings directly. The designs he drew were transferred to the plates by engravers—first Cock himself, then Pieter van der Heyden and Philippe Galle. In fourteen years, Bruegel designed more than eighty drawings for engraving.

In 1563 he moved to courtly and aristocratic Brussels, where he painted his greatest works. Shortly after his arrival he married the young daughter of his early teacher, Pieter Coecke. They had two children, Pieter Bruegel the Younger ("Hell" Bruegel) and Jan Bruegel the Elder ("Velvet" Bruegel), neither of whom attained the eminence of their father.

The bare, recorded facts of his life tell us very little, but his drawings, prints, and paintings, despite obscurities, tell us much more. Unlike Bosch, to whom he is so often compared, Bruegel was seldom mystical and never plunged so deeply into a demoniacal world that he lost touch with the real world around him. As one critic put it, "Man and God are the subject of Bosch; Man and Behavior, of Bruegel." Their surface similarity lies in Bruegel's use of the Bosch-like device of creating in many of his drawings a twilight world of demons and monsters, of tormented semihuman figures, grotesque and distorted, and of egg and tree symbols.

The diableries and weird symbols in Bruegel's paintings and in some of his engravings had a purpose, of course. The vicious monsters stood for the sins of mankind, and the orderlessness of his graphic world was his device for condemning man's weaknesses and the abuses of society. It would be exaggeration to profess that Bruegel's phantasmagoria always represented disguised social comment, a device stemming directly from medieval imagery, but it may often have served this purpose.

Many art historians believe that Bruegel was apolitical, that many of his prints were homilies and not social comments. They point to the popularity of his paintings at the Hapsburg court. But Goya's devastating portraits were popular at an almost equally blind and fanatical Spanish court two centuries later. If Bruegel's meanings are not always obvious, he may have been understandably cautious in a day when the censor hovered and the gallows loomed for dissenters. In fact, after 1565, when censorship tightened, Bruegel stayed close to safe subjects, such as landscapes. After all, many of his paintings would hardly have been accepted at the court of Hapsburg except in terms of the court jester. His biographer, Carel van Mander, writing fifty years after Bruegel's death, reported that shortly before Bruegel died he had his wife burn the inscriptions he had written for some of his graphic work because they were too biting and could have been dangerous.

There are obviously many levels of meaning in several of Bruegel's paintings, and it cannot be demonstrated with certainty

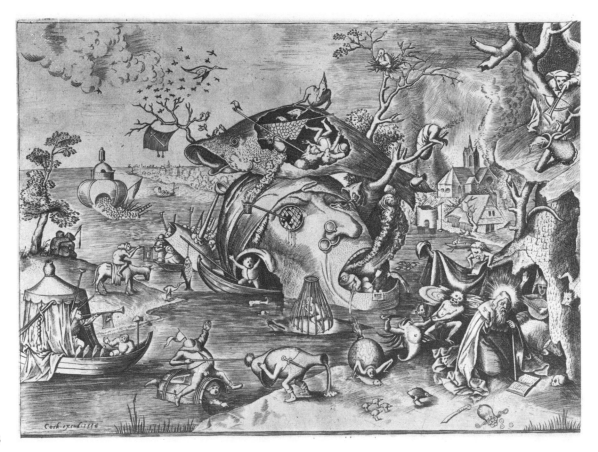

28

that Bruegel was intending forceful protest against the oppressive Spanish rule. Nevertheless, such an interpretation is possible in some instances. It is certainly valid to believe that "The Massacre of the Innocents" is political allegory, and that "Mad Meg," or "Dulle Griet," is an apocalyptic visualization of the brutal violence of persecution and war. "The Triumph of Death" also may have occult political meaning, although the ostensible, nonpolitical purpose is much easier to defend.

Finally, Bruegel's prints, with which we are concerned here, are never "heaven or hell" broadsides—fundamentalist or obvious. They have the subtlety of a deeply reflective artist. At times, the subtlety is so refined it becomes obscurity, and the cabalistic meanings are lost to history. However, many of these so-called obscurities were deliberate. His critical comments were often expressed in proverbs whose meanings escaped the Spaniards (and later generations) but were clear to his fellow Flemish. Bruegel may not have been only cautious; perhaps he was not wholly sympathetic with the rebellious forces. But he certainly broadened the range of social comment and, in some instances, social criticism.

The "Temptation of St. Anthony" is perhaps Bruegel's strongest attack on both Church and papacy. From the tree grow-

28. "Temptation of St. Anthony." Pieter Bruegel the Elder. 1556. 9⅛x12¾. Engraving. Dick Fund, Metropolitan Museum of Art, New York.

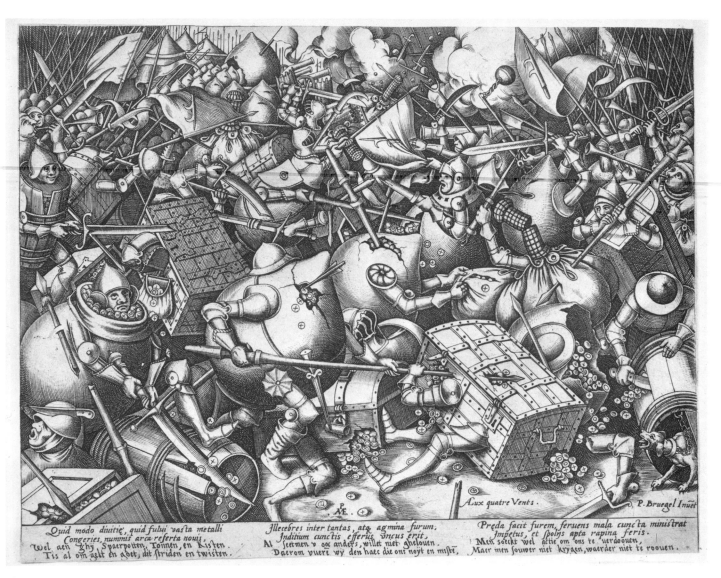

29

ing out of the rotting, decomposed fish hangs what is clearly a papal bull. The half-blind head—the corrupt Church—is hollow, in accordance with the maxim "His head is as hollow as an empty eggshell." In the distance from what appears to be an Oriental ship an enemy army disembarks, probably the Turks who were threatening Western Europe. No wonder St. Anthony turns his back and resists all temptation!

The "Fight of the Money-bags and the Strong-boxes" is the most forthright comment to come from Bruegel's pen. "War and mammon are the same," he is saying. Rarely has this been stated with such savage candor. There is no esoteric, occult meaning in this brutal carnage; wars are made by the rich and are fought for plun-

29. "Fight of the Money-bags and the Strong-boxes." Pieter Bruegel the Elder. 1567. 9⅜x12⅛. Engraving. Dick Fund, Metropolitan Museum of Art, New York.

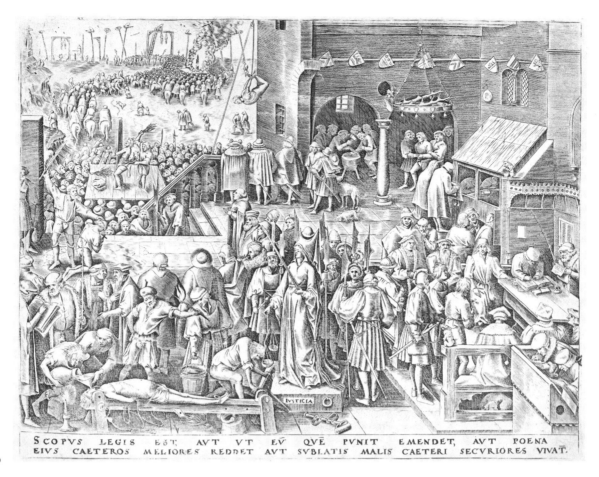

SCOPVS LEGIS EST, AVT VT EV QVE PVNIT EMENDET, AVT POENA EIVS CAETEROS MELIORES REDDET AVT SVBLATIS MALIS CAETERI SECVRIORES VIVAT.

30

der. The Flemish verse, probably added by the publisher, may be roughly translated:

> Have at it, you chests, pots, and fat piggy
> banks!
> All for gold and for goods you are fighting
> in ranks!
> If any say different, they are not speaking
> true—
> That's why we are resisting the way that
> we do . . .
> They're seeking for ways now to drag us
> all under;
> But there'd be no such wars, were there
> nothing to plunder.*

Bruegel's "Justice" lends itself ideally to the art historians' favorite game of "What Did the Artist Really Mean?" Since it is one of a series of seven engravings on the Seven Virtues, it may well be exactly as it seems to be—a representation of the impartial and just punishment of the guilty. As the Latin motto under the engraving says, "The law aims to correct him whom it punishes, or to improve others by his example, or to eliminate the wicked so that the others shall live more securely." *Autres temps, autres moeurs.* Each age is blind to its own inhumanities in the administration of justice, and Bruegel was representing not a panorama of sadism but law triumphant.

28 30. "Justice." Pieter Bruegel the Elder. 1559. 8⅞x11⅝. Engraving. Bibliothèque Royale, Brussels.

* Translation by H. Arthur Klein from P. 145 of his *Graphic Worlds of Peter Bruegel the Elder*, Dover Publications, Inc., New York, 1963. © 1963, Dover Publications, Inc.

Perhaps. But the Latin inscription was added to the original drawing by another hand. As Charles de Tolnay, the Bruegel authority, has pointed out, mercilessness rather than justice characterizes this comment on the human tragedy. And Bruegel's handling of the figure of Justice is significant. She is wearing a double-peaked headdress, which has been identified by historians in other engravings as the sign of the procuress. And while Justice holds the conventional sword and scales, the bed and pillow—symbols of peace and pity—are missing. As de Tolnay has noted, the *omissions* in Bruegel's drawings for the Seven Virtues are often pointed. Many of his prints in the Virtues series are anything but sentimental homilies. In "Faith" most of the congregation seems to be dozing off. In "Temperance" there is considerable intemperance, with all the philosophers talking at once.

De Tolnay states flatly that "The Fall of the Magician" is "a satire on the abuses of the Inquisition." According to the legend, St. James forgave the magician, Hermogenes, for his sins. "It is not our custom to convert anyone against his will," St. James is supposed to have declared in setting the magician free of his captors. In contrast, Bruegel's St. James (patron saint of Spain) has the heretic murdered. "Instead of gentleness and forgiveness, there prevails here the religion of vengeance," de Tolnay comments.

> With an unctuous gesture, St. James conjures the spirits, and gives the command for murder. In the church door behind him stand his younger followers: blind figures, outwardly holy, with a pretense of devotion, who witness the murder of their fellow man with solemn seriousness, as if they were seeing a holy act. The demons, filled with a vital power which absolutely demands bodily activity, are only blind tools of the saint. Where no proper possibility of action is offered to them, they have to mutilate themselves with swords, etc. The central group takes the opportunity to let its innate power impulses rage freely on the command of the saint, against the heretic, who in reality is the martyr and believer (cf. the prayer book in his chair). This scene of the Inquisitional persecution of heretics was hidden by Bruegel, in that he disguised the whole event as a theatrical scene. The serious subject matter is to be looked upon as a juggling trick. There is a placard banner on the wall; tight-rope walkers, puppet-players enliven the stage; at the window at the right he represents the public.

The Duke of Alva's merciless attempt to suppress the rebellion in the Netherlands led to an almost uninterrupted parade of unmitigated horror. Even Alva admitted to Philip II that he had never experienced such a blood bath. Especially in the northern Protestant provinces, fire, pillage, rape, and slaughter of men, women, and children were often the horrendous aftermath, as town after town fell following relentless siege.

Eyewitness accounts and contemporary engravings confirm the inhumanity of the Spanish troops and mercenaries. Of the

29

31

many etchings and engravings that attempted to recapture the vivid events, the most notable are those of Franz Hogenberg, a Flemish engraver who worked in Flanders, Germany, and England as printmaker, book illustrator, and map engraver. A humanist and a friend of Bruegel, Hogenberg made etchings that occasionally pro-

31. "The Fall of the Magician." Pieter Bruegel the Elder. 1564. 8⅝x11½. Drawing. Foto-Commissie, Rijksmuseum, Amsterdam.

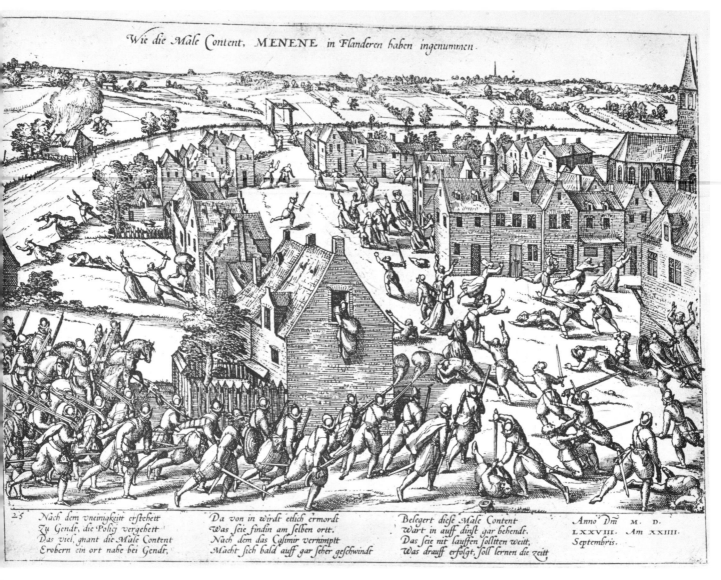

25 Nach dem vneinigkeitt erstehett Da von in wirdt etlich ermordt Belegert dise Male Content Anno Dñi M. D.
 Zu Gendt, die Policy vergehett Was seie findin am selben ortt. Wart in auff dinst gar behendt. LXXVIII. Am XXIIII.
 Das viel, gnant die Male Content Nach dem das Casimir vernimptt Das seie nit lauffen sollten weitt, Septembris.
 Erobern ein ort nahe bei Gendt, Macht sich bald auff gar seher geschwindt Was drauff erfolgt, soll lernen die zeit

32

vided sources for some of Bruegel's paint-
ings. He became a devotee of the Reformed
religion and fled the Netherlands in 1570.
Hogenberg's engravings of the Netherlands
War often have more shock than artistic
appeal. A few of these dramatic prints,
however, capture with fine composition the
sweep and movement of fighting, com-
municate sympathy for the victims, and
move the reader without resorting to repel-
lent detail. The peaceful countryside of
Menene serves to point up the suddenness
of the invasion, when the savage intruders
obviously caught the town by surprise.

32. "Menene." Franz Hogenberg. 8¼x10¾. Engraving. From *Events in the History of the Netherlands, France, Germany, England, 1535–1608.* Whittesley Fund, Metropolitan Museum of Art, New York.

33

33. "The Pope's True Self." Anonymous Dutch broadsheet. 1610. 6½x15¾. Copper engraving. Staatliche Galerie Moritzburg, Halle, Germany.

Although the war dragged on in the northern Dutch provinces for two more generations and an informal truce was finally reached in 1609, the propaganda war continued. Here is a Dutch broadsheet of 1610, utilizing one of the favorite devices of the time—a movable flap of paper. With the flap down, we see the Pope in his usual flowing robe, proclaiming peace. When the flap is lifted, however, the drawing beneath reveals "The Pope's True Self"—a scene of butchery and persecution. Vigorously drawn and strikingly dramatic, this broadsheet is far superior to the routine hack propaganda that flooded the provinces.

As the Dutch Republic prospered, political and social criticism turned away from internal conditions and focused outward on the Catholic rulers Louis XIV of France and James II of England. Although not everyone shared in the prosperity, the artist tended to identify with the wealthy burgher, whom he painted, and became increasingly uninvolved politically. Light satire replaced sharp critical comment. In the seventeenth century the main contribution of Dutch satirical prints was to provide precedents for more pungent English and French protest art.

In France, the Protestant Reformation was so late in coming that it faced a powerful Counter-Reformation. Francis I (1515–47) had consolidated the royal prerogatives and further extended royal control over the Church. With the interests of State and Church identical, censorship was now effective and literary and artistic protest diminished. At one point Francis condemned to death an author, a printer, and an illustrator for passages defaming the king.

Nevertheless, at mid-sixteenth century, Calvinism (rather than Lutheranism) did gain a foothold in France. Calvin's measured French prose and his formidable French logic appealed to many. The Calvinists, or Huguenots, were probably never more than ten percent of the population, but they included some leading nobles, many city burghers, and some country gentry. Because of their prestige, earnestness, and determination, their influence far exceeded their numbers, especially in the south and west. Opposing them were the majority of nobles, headed by the powerful Guise family.

The divisive religious struggle was reflected in a continuous propaganda battle waged by printmakers with as little restraint as the military. Most of the prints were scurrilous, libelous, and stronger in propaganda than in artistic merit. Unlike Germany and the Netherlands, sixteenth-century France had no great printmakers, if we except the mystic Jean Duvet. The Huguenots made charges of pornography against Henry III, while the Catholics represented Protestants as apes. The Huguenots were particularly successful with *medailles satiriques*, profiles of the Pope and the devil arranged so that if you held the medal one way you saw the Pope, and if you turned it around the devil appeared.

33

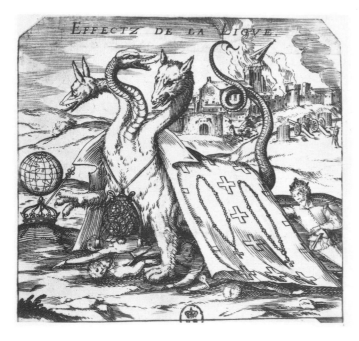

EFFECTZ DE LA LIGVE.

34

The crude drawings of the French print-makers have little significance in this history of graphic protest, but their content does. For the first time printmakers did not resort to symbolical allusion but made direct and violent attacks on king and Pope and other well-known personalities. The critical spirit, passionate and indignant, was liberated as it was not to be again for two centuries. The battle for public opinion had begun, and the great polemical significance of book and print achieved reality.

Popular prints were often peddled in the streets, many like the German broadsheets, combining text and verse. Some have more than historical interest. All the qualities of an effective political cartoon are present in

"Effect of the League," one of a series of three. The three-headed monster—the Guises and Philip II of Spain—under a religious cloak tramples the people while a town burns. In the third of the series, a courageous lion—Henry IV—tears off the cloak of hypocrisy and conquers the beast.

The Wars of Religion abated when the regent, Catherine de' Medici, arranged an uneasy peace, but the truce was shattered when she succumbed to the Guises' pressure and precipitated the St. Bartholomew's Day Massacre in 1572. The Protestant remnants fought on, and the country was torn and drained until Henry of Navarre, the statesmanlike Protestant, succeeded to the throne. For the sake of unity he converted to Catholicism, but in 1598 issued the Edict of Nantes, guaranteeing freedom of conscience and political rights to Protestants. For almost a century toleration prevailed.

Just as Franz Hogenberg made an imperishable record of the Spanish invasion of the Netherlands, Jean Perrissin and his collaborator, Jacques Tortorel, have left a portrait of the French Wars of Religion in their "Tableaux des Guerres, de 1559 à 1570." Neither achieved an artistic triumph —Tortorel even less than Perrissin—but both displayed qualities beyond mere reporting. Both artists had a point of view and occasionally injected emotion into their plates, though some of their renderings are rather flat. "Massacre at Vassy" depicts the slaughter that took place on March 1, 1562, when Vassy, a Huguenot town, was completely wiped out by forces under the Duc de

34. "Effet de la Ligue." Anonymous French. 1594. 6½x4⅞. Etching and burin. Bibliothèque Nationale, Paris.

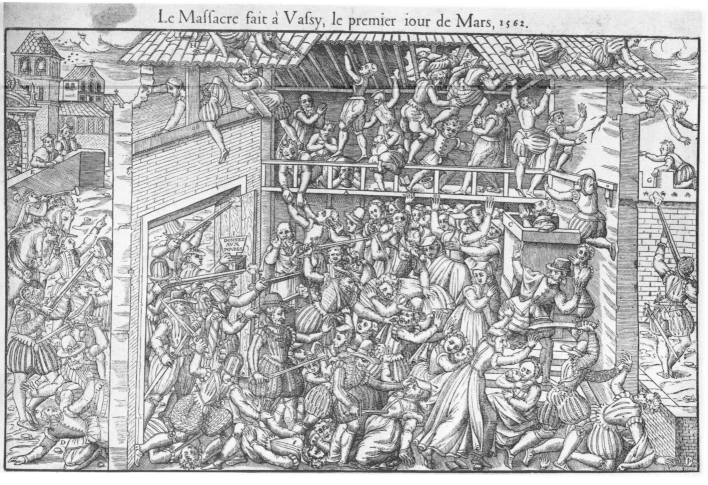

Le Maſſacre fait à Vaſſy, le premier iour de Mars, 1562.

Guise, the dominant figure in the lower left center. Perrissin's apparent detachment is belied by the ironic "Give to the Poor" on the door of the Huguenot chapel and the casual air of the Catholic prelates including the Cardinal de Guise, at the upper left, who are watching the slaughter with the air of spectators at a croquet match.

Little is known of Perrissin except that he was from Lyons where he was elected *maître de métier* of the painters' association. Tortorel fled to Geneva in 1568 as a religious refugee.

The toleration initiated by Henry of Navarre was gradually dissipated during the autocratic regime of the Sun King,

35. "Massacre at Vassy." Jean Perrissin. 1562. Woodcut. From *Les Grandes Scenes Historiques du XVI Siècle.* Bibliothèque Nationale, Paris.

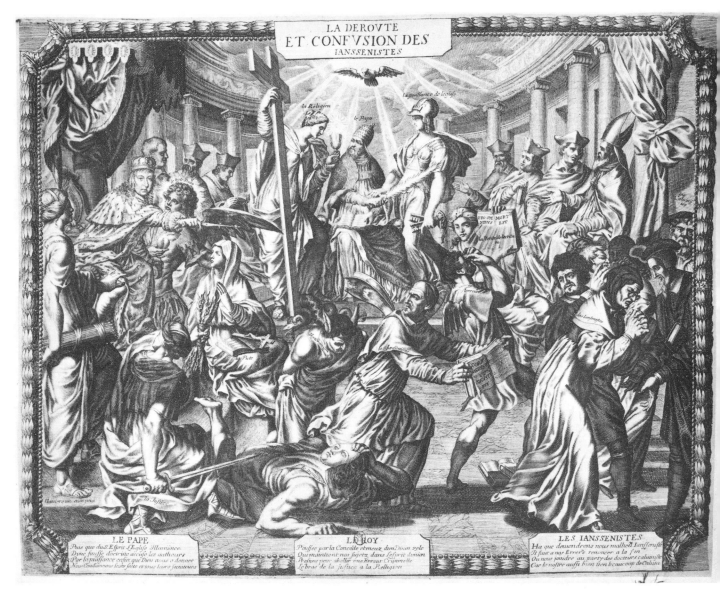

36

Louis XIV, to whom religious dissent smacked of treason. One of the first sects to be prosecuted was the Jansenist, whose austerity and views of salvation conflicted with those of the Jesuits. Here a pro-Jesuit print hails Louis' rejection of the Jansenists while the Pope benignly sanctions the act.

This salute to intolerance is drawn in the grand French manner—theatrical poses staged within swirling draperies and a baroque frame abounding with allegorical figures. Technically masterful, with a painter's quality, it has everything but a focal point. In the artist's eagerness to please all the authorities, he has so overcrowded his scene with dignitaries that the impact is dissipated. It has many of the attributes of art under a dictatorship: the villains routed

36. "La Déroute et la Confusion des Jansenistes." Anonymous French. 1654. 16¾x21½. Engraving. Bibliothèque Nationale, Paris.

by the heroic leader, all posed like a stage setting, and with the moral clear. But if you turn back to the woodcut that opens this chapter, Holbein's "Hercules Germanicus," you will find some of these same attributes. Generalities in art, as in life, can be traps.

The Sun King's ministers gradually introduced a series of measures against the Huguenots, culminating in revocation of the Edict of Nantes in 1685. Many of the Huguenots fled to sympathetic, Protestant Holland, where a flood of caricatures of Louis XIV was let loose. The best of these was by satirist Cornélis Dusart, a pupil of von Ostade, who published a book of 25 mezzotint caricatures of Louis XIV and the minions around him who had played roles in the Revocation. They avoid the grotesqueries of previous caricatures and anticipate by almost 150 years the free-swinging satire of some of Daumier's contemporaries. Dusart strikes a surprisingly modern note in the sceptical realism of his caricatures. Most of them are zestful, as in the "portrait" of the Archbishop of Rheims, with crown of cards, dice, and pipes; but the hooded, torch-bearing Sun King is a sinister figure of the Inquisition.

The spirit unleashed by the Protestant Reformation stimulated the finest examples of graphic art critical of the Church establishment and in some instances of secular authority as well. Artists' criticism of institutions, however, became much more direct when the religious conflicts, joined by other factors, erupted into war.

37

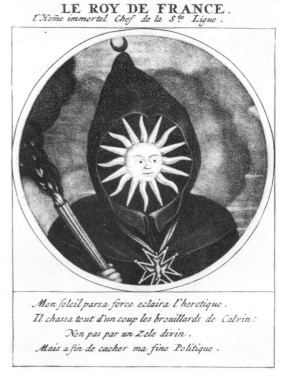

38

37. "Satire on Archbishop of Rheims." 38. "Satire on Louis XIV." Cornélis Dusart. 1691. 5⅝x4¼. Mezzotints. From *Les Héros de la Ligue ou La Procession Monacale Conduitte par Louis XIV pour la Conversion des Protestans de Son Royaume.* Prints Division, New York Public Library.

CHAPTER III
The Artist, the Peasant, and War: The Seventeenth Century

R ELIGIOUS CONFLICTS, territorial rivalries between newly emerging states, economic clashes between peasants and landlords all found resolution in the only way known to man at that time or since—war. War was almost ever-present in the sixteenth and especially in the bloody seventeenth century. Few families during that time failed to witness or suffer from or perhaps profit by war.

It mattered little to a town whether a nearby force was friend or foe. *Any* army, even friendly ones, could mean disaster as they foraged for food from the surrounding communities. Elements in all armies plundered, tortured, raped, burned, and killed. Pillage was the main goal. If there was nothing to confiscate, peasants were often suspected of concealing their wealth and were tortured and killed. The most common mementos left behind were famine and disease.

It was natural that printmakers should record, comment upon, and protest against the observable phenomenon of brutal conflict. By no means did all printmakers record only the miseries of war. Many a printmaker's eye was captured by the brilliance of the costumes and the swaggering pageantry of the warmakers. And many artists viewed sympathetically peasants' violent struggles for bread and justice.

Throughout the fifteenth century, agrarian unrest in Germany had led to a series of sporadic and isolated and easily suppressed peasant outbursts. Luther's successful revolt against the established church, however, fomented rebellious feelings in many

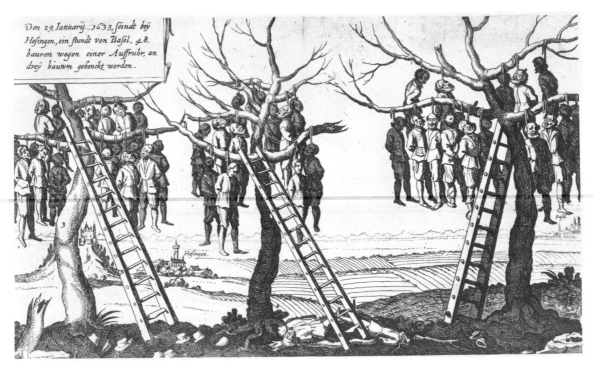

parts of Germany among peasant leaders who found justification for revolt in Luther's advocacy of the Bible as supreme authority. Dreaming of an evangelical Christianity that would bring sound justice to all men, rich peasants and some intellectuals joined forces with the lower economic groups. Within a short time (1524–25) this revolutionary consortium threatened most of central and southern Germany.

When the peasants refused to heed his warnings against violence, Luther, now an established authority himself, called on the princes to slay the "Murderous and Thieving Hordes." The princes needed little prompting. They butchered the rebels and their families—almost 100,000 men, women, and children.

Few artists in the Germany of 1525 could avoid taking a position on the Peasants' War any more than an artist in the Germany of the 1930's could ignore the rise of fascism. But many artists suffered for their principles. Three of Dürer's disciples—Georg Pencz and the brothers Barthel and Hans Sebald Beham—were banished from Nuremberg for sympathizing with the peasants. Matthias Grünewald, master of the great Isenheim altarpiece, was court painter in 1525 to Cardinal Albrecht of Brandenburg, patron of many of Germany's leading artists. When Grünewald sided with the rebels, he was forced to leave his lucrative post to seek a miserable refuge in Saxony. Although Dürer's political position is unknown, he was devoted to Luther and probably sided with him. An apparent antipathy to the peasants seems to be reflected in a rough architectural sketch, "Peasant Monument," on

39. "Peasant Monument." Albrecht Dürer. 1525. 8⅞x2¾. Woodcut. From *Unterweysung Der Messung*, Nuremberg, 1525. New York Public Library.

40. "Peasant Uprising." Anonymous. 1635. 6¾x11¼. Etching. Staatliche Galerie Moritzburg, Halle, Germany.

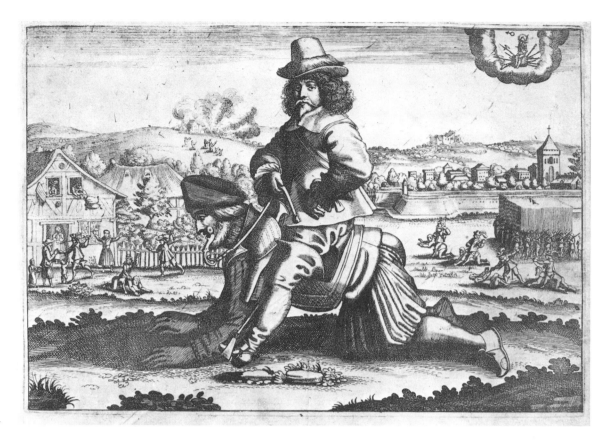

41

top of which a peasant slumps with a knife in his back.

After the Peasants' War failed, the conditions of the peasants remained static. There were occasional uprisings which were often recorded on broadsheets. The grisly aftermath of one uprising in the 1630's in southern Germany was commemorated by an anonymous artist's version of a post-battle commonplace—the mass lynching. The caption reads: "On January 29, 1635, near Hesingen, an hour from Basel, 48 peasants were hanged from three trees because of their part in an uprising."

A particularly bitter and surprisingly revolutionary comment on the peasant's lot was engraved by Peter Aubry (1596–1666?),

a mediocre portrait engraver whose specialty is reflected in the face and bearing of the rider. The full title is "A New Peasant Lament on the unmerciful peasant riders of this age."

The verse which appears below the engraving reads in part:

Dear reader come
See the strange riding
Indulged in by the soldiers
In the world today.
If there is anybody in the whole world
Whom everybody wishes to flay and scalp
It is we, the little peasants!
We are the poorest folk
For our cattle and horses are the soldiers'
 booty.
Whatever the peasant possesses

41. "New Peasant Lament." Peter Aubry. 1642. 13⅞x8. Engraving. Germanisches Nationalmuseum, Nuremberg.

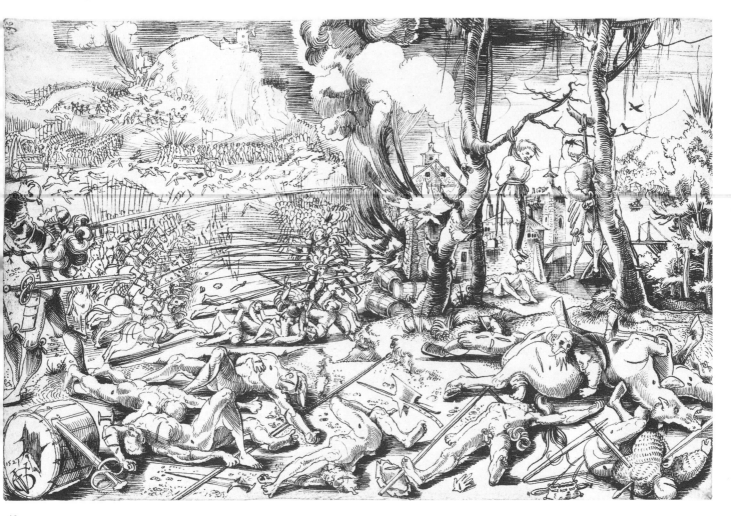

42

Is at once made a prize.
Brother Bailiff is the master of our lives
Houses are burned,
Churches are destroyed. . . .

. . . After the horses are stolen
And nothing is left for the soldiers to take
Then the poor peasant, O overwhelming
 torture
Must wear a bit and serve as horse and
 donkey . . .

The poem ends in a threat by the peasants against the soldiery: "When there is no more war you will be forced to turn to us, and we will remember."

The savage brutality of war was also captured by the Swiss printmaker and goldsmith Urs Graf (1489/90–1529), who had fought at various times as a mercenary. His drawing of a battlefield is quick, nervous, almost convulsive. Yet there is order in the chaos. The soldier on the left calmly pausing for a drink is in ironic counterpoint to the still corpses dangling at the right. In "The Execution," Graf sketches a sight

42. "Battlefield." Urs Graf. 1521. 8¼x12⅜. Pen drawing. Kupferstichkabinett der Oeffentlichen Kunstammlung, Basel.

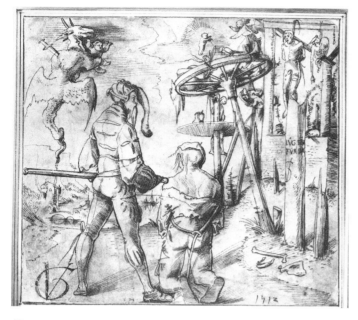

43

well known to those who lived in an age when minor offenses could lead to the executioner's sword. The corpse hanging like butcher's meat and the savage creature bearing off what may be the dead man's soul communicate to the reader the artist's involvement and reaction against such violence.

Graf was constantly in trouble with the authorities. When he fought in Italy as a hired soldier, he probably had his full share of pillage and rape. His print of soldiers in their splendiferous regalia indicates a mind impressed as much by the glory as by the horror of war. Yet, in addition to the drawing and print shown here, Graf painted a canvas of war, with two nude figures ascending to heaven while below rage the fire, pillage, and murder. Graf may have been attracted by the impressive pomp of soldiers in full dress, but obviously he had

moments of revulsion, and these he shares brilliantly with the viewer.

In the entire seventeenth century only seven years were free of wars between European states. The Thirty Years War (1618–48) was the century's greatest calamity. Before it staggered to an end after years of negotiations it had involved most European states, had pitted Catholic against Protestant (although Catholic France joined in the fray against Catholic Spain), had shaken the foundations of the Holy Roman Empire and eclipsed the papacy, had strengthened France, the Netherlands, and Sweden into emerging modern powers, and had left the main battleground, Germany, devastated and divided into still semi-feudal petty states.

The total population of Germany and Bohemia was one third less at the end of the war. This stark statistic only hints at the extent of destruction, disease, and death. Even cannibalism broke out in parts of Germany as the devastating war dragged on.

The antipodal mixture of pageantry and atavistic brutality has been etched deeply and indelibly in copper in the shattering "Miseries of War"—by the genius of an artist, Jacques Callot (1592(?)–1635).

In September of 1633 after a month of bitter siege, French troops under Louis XIII and Cardinal Richelieu entered Nancy, capital of the then independent Duchy of Lorraine. It was their third effort in as many years to annex the province by subduing the plague-stricken city, whose most

43. "The Execution." Urs Graf. 1512. 8½x9¼. Pen drawing. Bildarchiv d. Öst. Nationalbibliothek, Albertina, Vienna.

distinguished resident was Callot, a courtly, ulcer-ridden etcher and engraver.

A contemporaneous story relates that the triumphant Louis XIII asked Callot to etch the siege of Nancy, as he had the sieges of Re, of La Rochelle, and of Breda. Callot refused out of loyalty to his fallen duchy. Instead, he etched the two sets of plates of the "Miseries of War." As J. Lieure, Callot's cataloger and biographer explains, the mercenary troops called in by the Grand Duke treated Lorraine as a conquered country. Their violence horrified and enraged the local citizens. "Callot and his family may have been victims of these depredations by the mercenary troops. In any case, he was outraged and wished to express to us his indignation," Lieure notes. The two "Misères" comprise one of the most overwhelming indictments of war ever drawn, the crowning achievement of a great and prolific etcher.

Born in Nancy, Jacques Callot was the son of the chief ceremonial officer of the ducal court. He grew up amid the pomp and pageantry of the provincial capital and later recorded these scenes with his etcher's needle, endowing them with a grace they perhaps never possessed.

After apprenticeship to a Nancy goldsmith and engraver, Callot went to Rome when still in his teens. There he was apprenticed to the artist-printseller, Philippe Thomassin; he learned and practiced engraving, etching, sketching, and illustrating. Chance took him to Florence, where his genius flowered as a protégé of the Medicis. The ten years he spent in Florence (1611–21) were extraordinarily fruitful. He illustrated numerous books, fulfilled many commissions to commemorate historical events with prints and raised the art of etching to new heights.

Etching, first developed early in the sixteenth century, gives the printmaker far more scope and freedom of line than engraving or woodcutting. In etching, a plate, usually copper, is covered with a resinous ground resistant to acid, usually blackened so that the artist's lines can be seen clearly. The etcher draws through the ground with a needle—a much easier process than cutting into the plate with a burin, as in engraving. The plate is then immersed in an acid bath which eats away the exposed lines. At various intervals the plate is taken out of the bath and a stop-out varnish applied so that great variety in tone and depth of line can be achieved.

Callot's genius created a microcosmic cross section of the wide-ranging contemporary society, which he portrayed with humor, delightful grace, and compassion. He observed realistically, often decorated his prints with fantasy, and occasionally drew grotesqueries. He drew and etched fashionable courtiers, ladies, ragged beggars, gypsies, mercenaries, and dwarfs. He etched the pleasures of the powerful, and misery, violence, and poverty, fantastically detailed fairs, medieval carnivals, and gay landscapes, the passion of religion, and the satirical posturing of the commedia dell'arte.

His series of "Beggars," humane and life-like, advanced Bruegel's tradition and quite probably inspired Rembrandt. Callot's "Gobbi" — hunchbacks and dwarfs — are busy, stylized, little grotesqueries, typical of his fascination with the bizarre. Callot's grace and wit reached their height in his endearing "Balli di Sfessania," a series of pirouetting pairs of commedia dell'arte actors.

The technical brilliance of Callot's etchings is all the more apparent when observed through a magnifying glass. Many of the figures are only half an inch high, yet they are fully realized. In Callot's scheme of things, man was no longer the giant that Michelangelo pictured him to be, but a tiny figure on a puppet stage. More than 1,000 men, women, and children enjoy "The Fair of the Impruneta." By reducing man to microscopic size, Callot made of him a tragic and ironic figure, albeit a graceful one.

Callot returned to Nancy in 1629, where he spent most of his remaining years except for short sojourns in the Netherlands and Paris. In the Netherlands he made sketches for his vast "The Siege of Breda," commissioned by the Infanta Isabella to commemorate the capture of the Dutch Protestant stronghold by Spanish troops. Far in the background in these huge panoramas are several incidental vignettes of war that were to be developed into themes for his masterpiece, "The Miseries of War."

As the late Edwin deT. Bechtel wrote of "The Miseries of War,"

Callot here presents the facts so overwhelmingly that through the centuries he has helped to awaken the public conscience against war. He accomplished this not by being doctrinaire but by etching what he knew to be true.

This truth was not beauty. Callot etched scenes of unmitigated violence—of pillage, murder, and rape, of arson, hanging, and firing squad. The contrast between the brutal subject matter and Callot's graceful, flowing line intensifies the feeling of horror. The delicacy of the drawing, the ballet-like grace of the composition and the figures all belie the violence. The results of this seemingly incongruous combination are overwhelming.

There are actually two sets of "Miseries of War." Often overlooked are the " 'Little' Miseries," only two by four and a half inches, which were etched first. They tell a story with an uncharacteristic bluntness, a far cry from the gentlemanly diffidence usually attributed to Callot. This miniature movie compresses into a few plates the wretched kaleidoscope of war.

The gallant warriors set up camp, ambush travelers, loot and burn a church, ravage the rest of the village; but the swaggering, extravagantly costumed soldiers pay the ultimate penalty themselves when the goaded peasants turn and cut them down with scythes. Nothing's well, nothing ends well in this macabre processional. In the final scene, the maimed and impoverished survivors beg for alms. To what avail do men fight war, Callot seems to be asking.

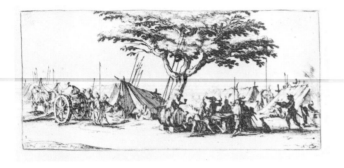

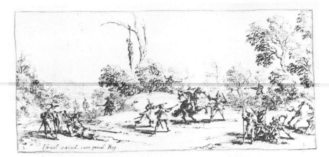

44

45

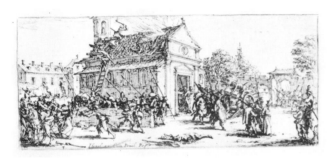

46

47

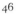

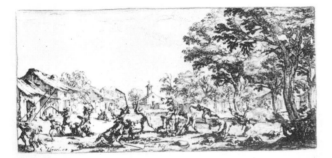

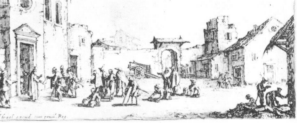

48

49

44. "The Camp." 45. "Attacking Travellers on the Highway." 46. "Pillaging a Monastery." 47. "Ravaging and Burning a Village." 48. "Peasants Take Revenge on Soldiers." 49. "The Hospital." Jacques Callot. 1633. 2¼x4¹¹⁄₁₆. Etchings. From "The 'Little' Miseries of War." Rogers Fund, Metropolitan Museum of Art, New York.

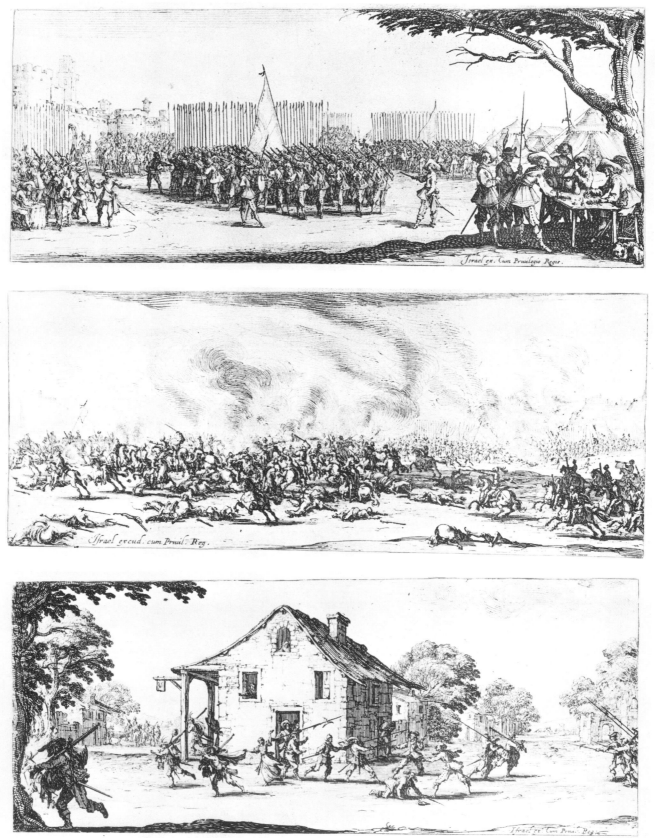

50

51

46

52

50–52. See page 51.

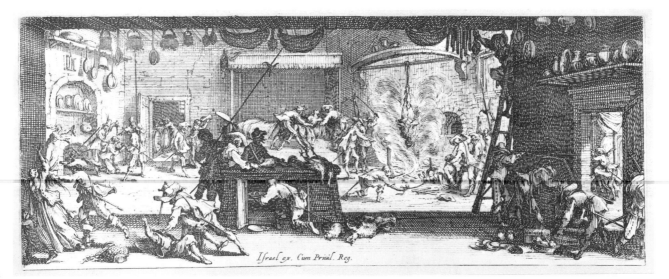

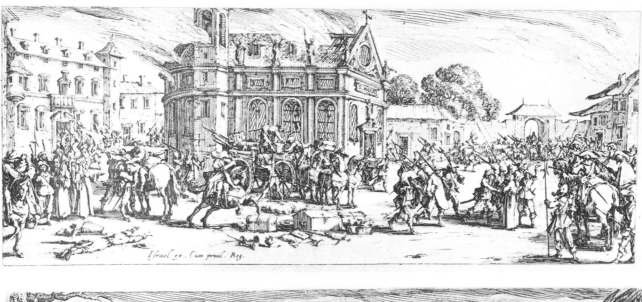

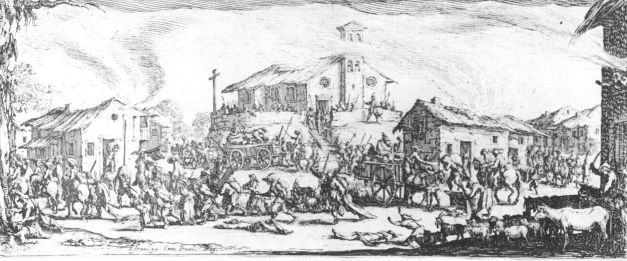

53–55. See page 51.

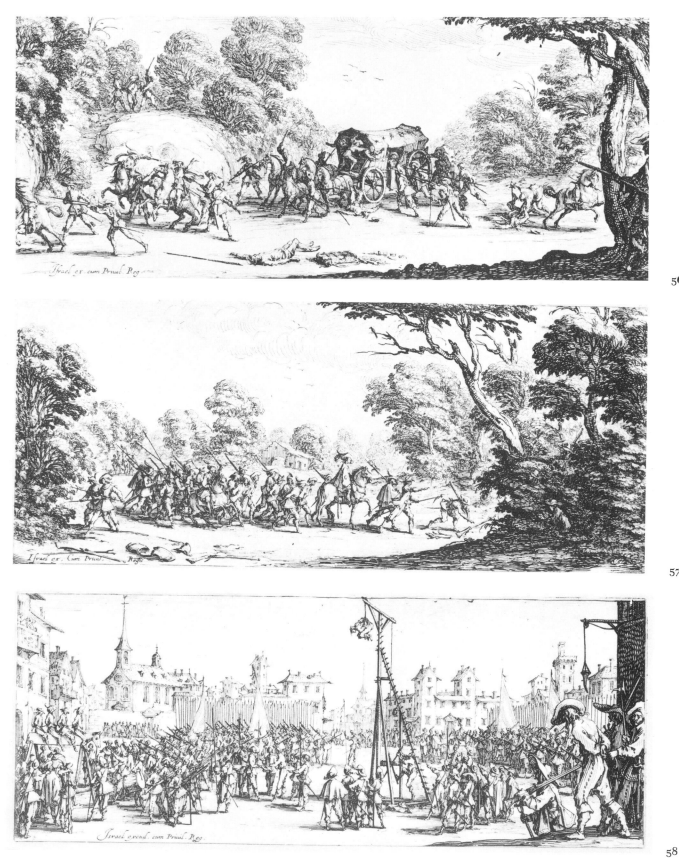

56

57

48

58

56–58. See page 51.

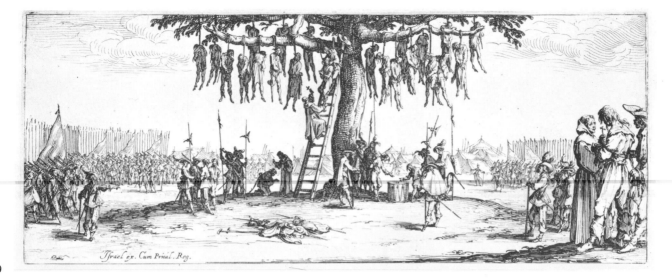

Israel ex. Cum Priuil. Reg.

59

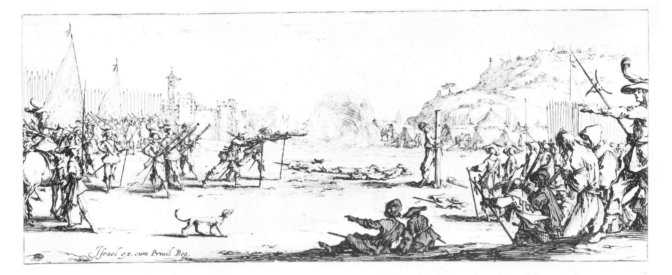

Israel ex. cum Priuil Reg.

60

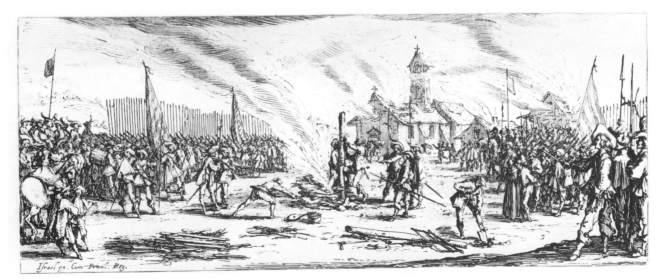

Israel ex. Cum Priuil. Reg.

61

49

59–61. See page 51.

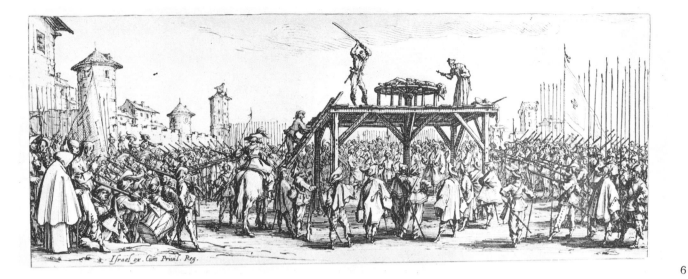

3. Ifrael ex. Cum Prunl. Reg.

6

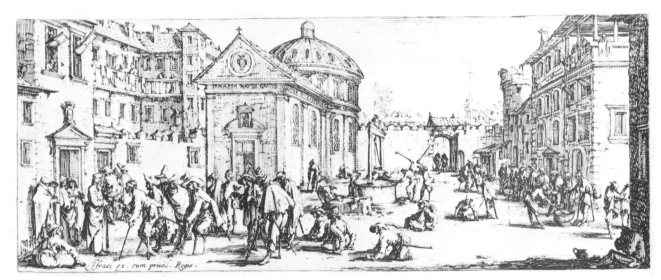

Ifrael ex. cum prunl. Regis.

Ifrael ex cum Prunl. Reg.

50

62–64. See page 51.

65

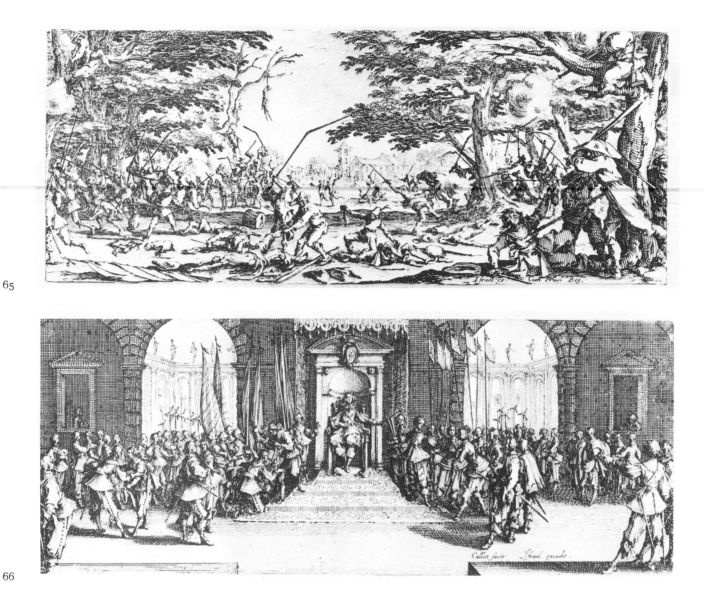

66

50. "Enrolling the Troops." 51. "The Battle." 52. "The Marauders." 53. "Pillage of a Farm." 54. "Devastation of a Monastery." 55. "Burning of a Village." 56. "Holding up a Coach." 57. "Apprehension of the Marauders." 58. "The Strappado." 59. "The Hanging." 60. "The Firing Squad." 61. "Burning at the Stake." 62. "Breaking on the Wheel." 63. "The Hospital." 64. "Victims of War Dying by the Wayside." 65. "The Revenge of the Peasants." 66. "Awarding the Honors of War." Jacques Callot. 1633–35. 2⅞x7⅜. Etchings (except 62, 63, 64, 65, 66: second state etchings, verses eliminated). From "The Miseries and Disasters of War." 50, 51, 52, 54, 55, 56, 57, 60: Bequest of Edwin deT. Bechtel 1957, Metropolitan Museum of Art, New York. 53, 58, 59, 61, 62, 63, 64, 65, 66: Rogers Fund 1922, Metropolitan Museum of Art, New York.

67

The "'Little' Miseries" were not published until after Callot died. He probably meant to replace them with the 18 plates of "The Miseries and Misfortunes of War." These "grand" miseries, though larger, are still only 2⅜ x 7⅜ inches and again display Callot's extraordinary genius for peopling so small an area with dozens of fully realized figures. The theme is the universal destructiveness of war, its innate, inevitable savagery, its counterpoint of murder and retribution, tragedy and death for soldier and civilian alike. The second state has moralizing verses added by the Abbé de Marolles.

The series opens with one recruiting scene and one battle scene. Callot quickly disposes of the conventional military aspects; which side wins seems not to matter. The bored, pent-up troops loot, rape, burn, pillage, and attack the local people. When their outrages become intolerable, even to the military, they are punished by the only justice to which they are subject—military justice. The punishments meted out are pitiless; culprits are hanged, shot, or broken on the wheel. Those who do not meet death

at the hands of their comrades end up in hospitals, become beggars, are set upon by the peasants who now abhor all soldiers.

But Callot adds a seemingly happy ending. In a glittering scene filled with fine clothes, ceremony, pride of rank, and military honors, "recompense" is made as the spoils of war are divided up. It is this last scene, with its terrible irony, which guarantees the perpetuation of the whole hideous round of misery. Those who suffer war's miseries are left dead, crippled, despoiled, while those whom war rewards remain to supervise the next enrolling of troops. Callot's last scene is really the beginning.

Callot is regarded by many critics as detached, diffident, uninvolved emotionally—the objective observer. Most of Callot's etchings reflect that attitude. But the "Miseries" were etched in the twilight of his life. Goya was 50 when he etched the "Caprichos" and revealed a philosophy hitherto unreflected in his painting. It is quite possible that Callot, who turned to religious prints in his last years, may have become more deeply involved during the

67. "Satiric Symbol of War." Jacques Callot. 1634. Etching. Detail from second state of "The Temptation of St. Anthony." Joseph Pulitzer Bequest 1917, Metropolitan Museum of Art, New York.

time he etched the "Miseries." He had seen his own province overrun. He was probably in constant physical pain. A clue to Callot's later feeling about war may be found in the detail from the second state of "The Temptation of St. Anthony." Here the symbol of war is a grotesque monster belching forth the weapons of battle after a charge by a Bosch-like creature. It was etched in 1634, shortly after he etched the "Miseries" and shortly before he died.

As Protestant and Catholic armies fought throughout a devastated Germany, religious propagandists battled with pamphlets and especially broadsheets. For the most

part their popular imagery lacked any artistic distinction or lasting interest. The Thirty Years War, however, stimulated a new kind of polemic—political satire and comment. Tilly, the Catholic military leader, and Gustavus Adolphus, the Protestant standard-bearer, were frequently pilloried, and broadsheets heralded victories. The drawings were often feeble. There were no Dürers or Cranachs or other artists of distinction, although a few had more than ephemeral quality or content.

One of the more interesting is the broadsheet depicting the war god wolf, the beast of war, his mouth full of spoils, devouring

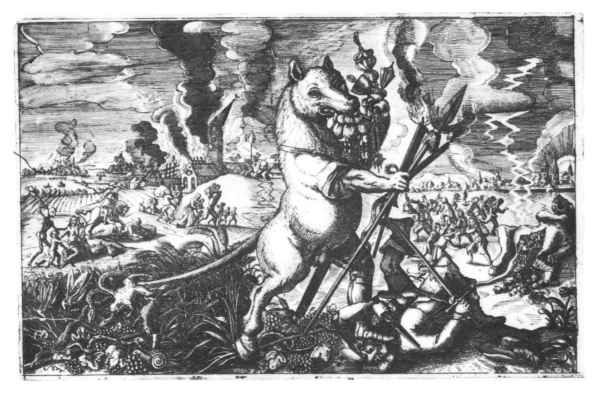

68

68. "Wolf War God." Anonymous. c.1630. 8x10¼. Broadsheet copper engraving. Stadtbibliothek, Ulm, Germany.

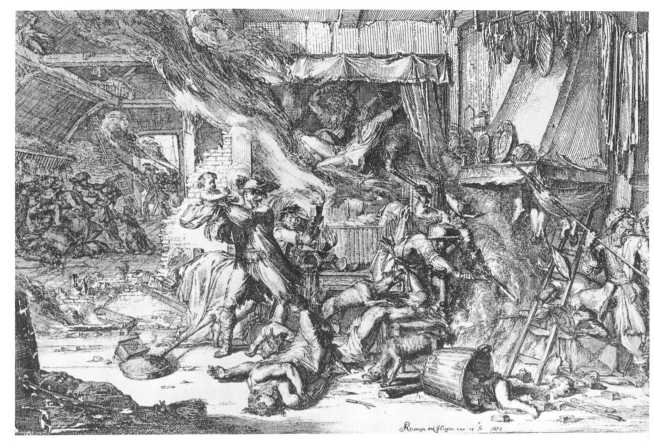

69

jewels and money while his tail destroys the fruits of the earth. The heading reads, "A picture of the merciless, horrible, ruthless, and monstrous Beast who in a few years pitilessly and wretchedly harried, exhausted, and destroyed the greater part of Germany. . . ." On the left in the broadsheet are the results of war—a burning village and general devastation. On the right, the beast has been killed, apparently by prayer and repentance.

Germany was not the only country devastated by war. In 1672, Louis XIV, the Sun King, attacked Holland, which he despised as Calvinistic and republican. History books mention that "many Dutch cities fell to the invaders after siege." How these flat phrases fail to portray the brutality of the

69. Untitled. Romeyn de Hooghe. 1673. 7¾x12. Etching. From *War Scenes and Cruelties of the French in the Netherlands, 1672–73*. Reproduced from *Kulturgeschichtliches Bilderbuch*. Metropolitan Museum of Art, New York.

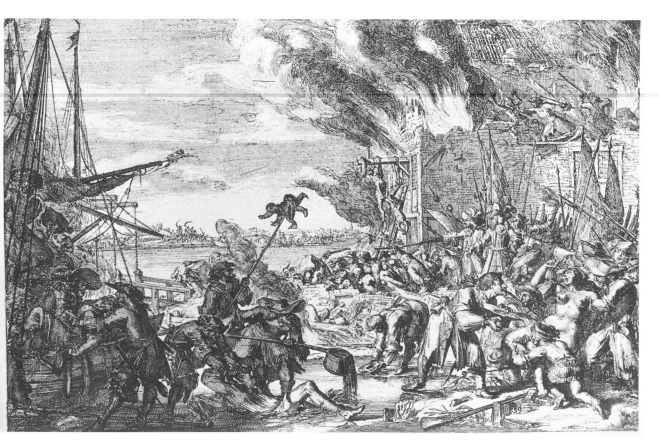

70

sudden attack! Contemporaneous prints and book illustrations convey the human tragedy with a starkness that helped jolt many frightened countries into alliance against France. The passionate, powerful book illustrations and etchings of the French invasion by Romeyn de Hooghe afford a striking contrast to Callot's work. These remarkably vivid tableaus, alive with violence, rape, and murder, lack Callot's subtlety and grace, but capture movement with exciting compositional sweep. De Hooghe's selective eye for the barbarities of the French invasion helped arouse Europe against Louis XIV. The etchings have an element of propaganda, but they are far superior to other propaganda sheets flooding Europe at the time.

70. Untitled. Romeyn de Hooghe. 1673. 8x12. Etching. From *War Scenes and Cruelties of the French in the Netherlands, 1672–73*. Reproduced from *Kulturgeschichtliches Bilderbuch*. Metropolitan Museum of Art, New York.

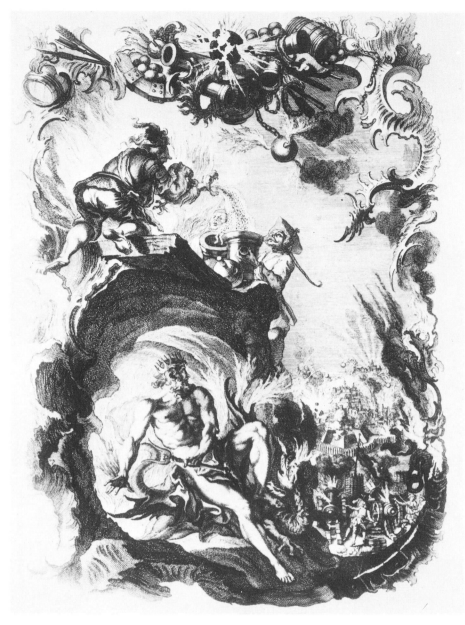

71

An amusing contrast to the stark realism of de Hooghe is the richly embellished rococo of Gottfried Bernhard Goetz's "Horror of War," engraved some fifty years later. The flowing curves and mincing curlicues form a highly decorative border of artillery surrounding mercenaries loading cannon while their cohorts hurl cannonballs on a defenseless town. The line is different but the game remains the same.

71. "Horror of War." Gottfried Bernhard Goetz. c.1750. 13⅜x8½. Engraving. New York Public Library.

CHAPTER IV
Interlude

Art of protest began to diminish after the first quarter of the seventeenth century and eventually disappeared for a century and a half in most European countries as governmental edicts stilled lips and paralyzed pen and burin. The only exceptions were England and a few other isolated areas.

The repressive process was not a sudden phenomenon. Printmaking—and with it free criticism—had originated in the independent cities and developed in an era of dying and ineffectual feudalism. The machinery of government functioned only sporadically, but as the struggle between church and state was resolved in favor of the latter and the two merged in a powerful union, freedom suffered.

The absolute power of Louis XIV was the goal of lesser despots throughout Europe. They envied him his armies, his mistresses, his Versailles, his efficient suppression of opposition. Paralleling the rise of the all-powerful state came the triumph of the Counter-Reformation, with the Church ascendant once more and allied with the state. At the same time, the frequent wars, and especially the Thirty Years War, impoverished the middle class in many parts of Europe. Also, by the end of the Thirty Years War, Protestantism was firmly established in several countries where Church abuses were no longer a concern.

Basic changes had been taking place in both the training and status of artists. In the sixteenth century a distinction arose between "fine" and applied art as painter and sculptor became separate from stone carver, tapissier, goldsmith, and engraver. In the seventeenth century, academies of fine arts, founded with innately conservative approaches to art, were established to train artists. The hierarchy of categories became doctrinally important; large-scale figure paintings with biblical, classical, historical, and mythological subjects became intrinsically more important than portraits, landscapes, or genre scenes. As a result, artists with formal academy training were painting "approved" subjects, far removed from the art of social criticism. Except in Holland and England, the two most democratic countries, most socially critical art of the late seventeenth and eighteenth centuries was done on the level of "popular imagery" by amateur or folk artists. The early sixteenth century had found Dürer making a broadsheet, Cranach illustrating one of Luther's religious tracts, da Vinci designing sewerage systems. The late seventeenth and eighteenth centuries found artists far more grandiose and ambitious.

Quite naturally, the dominant art style partially reflected the prevailing political and social outlook, although it is easy to exaggerate this relationship. Certainly the distortions of Mannerism, which lasted from about 1520 to 1620, represented not only a revolt against the serene classicism of the High Renaissance, but was also a reflection of the disturbances caused by the Reformation. Just as the "uninvolved" artist of our day has turned from realism to abstract expressionism, so did the *dégagé* artist, especially in Italy, find an outlet in the uncertain, transitional style of Mannerism. Later, the confident exuberance of baroque was exploited to glorify Louis XIV and the Church of the Counter Reformation, while the elegant gaiety of rococo was a sort of last gasp of frivolity before the deluge.

By suppressing healthy criticism, by creating an atmosphere in which artists had to conform to exist, by failing to grapple with the conditions crying for redress, the rulers of many of Europe's countries made violent upheavals inevitable. If a Daumier had been allowed to exist in the late seventeenth or early eighteenth century, perhaps there might not have been a French Revolution.

These are generalities; let us examine the individual nations.

The Thirty Years War stimulated bitter satire in prostrated Germany, but this was almost the last outburst of social protest in art for two centuries—in a land where the tradition was then two centuries old. The war left Germany broken into rigid and bureaucratic principalities, with remnants of feudalism still clinging to a body politic in which parliamentarianism had little voice. The restrictive atmosphere was stagnant and not conducive to any art of importance, and with no vocal public opinion, socially critical art in particular declined.

There were also religious reasons for the eclipse of protest art in Germany. As W. A. Coupe has pointed out, even the leveling concept in "The Dance of Death" no longer prevailed in seventeenth-century Germany. Discussing changes in German broadsheets, he writes:

> There is no trace of the social criticism which had often accompanied medieval contemplations of death: all men may be equal before death, but for the seventeenth-century moralist that was no reason to concern himself with the social conditions under which men lived. Any demand for social justice rests on the assumption that material things are important and worthy of our attention, a view to which few writers of the period would subscribe.

No representation of Italian artists has appeared thus far in this book. No Italian artists—and Italy the art center of the world? Although printmaking in Italy had its masters—Mantegna, Pollaiuolo, and Raimondi among others—and engraving and etching flourished, hardly any Italian artists were moved to make visual comment

on those social issues which had stimulated northern artists.

One can make endless conjectures. For all the restless vitality and inspired genius of Italian painting, sculpture, and architecture, the Italian artist was creating in a somewhat closed society, working for patron or church or Pope. Often the patron ruled the city or city-state in which the artist lived, or the city itself employed him. The Pope was not a distant figure; his influence was omnipresent. The very opportunities given the creative artist in Italy were the same that militated against any expression of social criticism in art. The artist was an integral part of the social framework, and his art and livelihood depended on the authority that prevailed. Unlike some of the cities of Germany and the Netherlands, where a flourishing bourgeoisie independently patronized the arts, the Italian city authority was centralized.

Furthermore, there was no Protestant Reformation in Italy to inspire satirical talents. Partisan activity may have produced inferior art, but it did involve the artist in the social conflicts of his time. Conversely, the power and predominating influence of the Catholic Church and the success of the Counter Reformation made certain that art would be uncritical and church-oriented. The issuing of the Index and the revival of the Italian Inquisition in the mid-sixteenth century led to the death of Giordano Bruno and the trial of Galileo. Even when individual cities—Milan or Florence or Venice—

tilted with the papal forces, little if any antipapal satirical art was produced.

The Baroque artist, Pietro da Cortona, expressed the attitude of many devout artists when he wrote in 1652:

> I exhort every artist to restrict himself to the production of sacred works alone, whenever the subject is left to his choice. Whenever he cannot, either by a refusal or by persuasion, gain exemption from profane work, let him execute it diligently and according to the rules of our art, but let him make known, if not by outward signs to men, at least by his inward feeling to God, that only on compulsion does he submit to such vain employ.

Italian Catholic art had always been "other-worldly," mystical, visualizing the mythical, and seeking the ideal, the harmonious. In addition, the traditionalists were strengthened by the edicts of the Council of Trent, which made rigid and specific recommendations for artists to follow. Art was to be once again, as in the Middle Ages, "The Bible of the Illiterate."

There was a glimmer of satirical spirit, though not of protest, in the seventeenth and eighteenth centuries in Italy when the Caracci brothers, the sculptor Bernini, and, later, Pier Leone Ghezzi pioneered in the mild satire of caricature, but this was only comment confined to individuals and types rather than to aspects of society.

Spain is also not represented here, and the reasons are obvious. The Inquisition was revived as early as 1478, with royal

control insuring persecution even more severe than the Pope was capable of. The *auto-da-fé* was for several centuries a common spectacle, even to Goya's day. In such an atmosphere, it would have been unthinkable for an artist—if he did have "subversive" thoughts—to draw critically of society. But as always, when the lid was lifted slightly, the accumulated pressure exploded, even if only temporarily, and Goya's genius burst upon the world.

France emerged from the seventeenth century a near-absolute monarchy, the most powerful state in Europe, centralized, with church and state as one dominant organism. Intolerance was reestablished, with thousands of Huguenots dead or in exile. The pageantry of the Sun King's regime was brilliant, but the glow could not obscure the mounting poverty behind the façade. Only the Calvinist engraver Abraham Bosse was moved to comment on the extravagances of the court of Louis XIV. In the next century, many of France's leading artists, such as Boucher and Fragonard, were an integral part of the royal entourage and were themselves reveling in the frivolity of the court.

It is puzzling that graphic protest should have declined in Holland during the seventeenth and particularly in the eighteenth century. Artists continued their bitter attacks on the French and Spanish who from time to time invaded the Low Countries, but there was no incisive comment on internal conditions within the Low Countries.

Rembrandt's incomparable etchings are concerned with mankind and the failures of the human spirit rather than with the specific failure of Holland's social organization. He suffered from the spiritual mediocrity that enveloped seventeenth-century Amsterdam, but his reactions implicitly embrace the failures of men in all ages.

In Holland, successful burgher replaced church and state or gonfalonier as art patron. Life was relatively free, but it was no millennium. Since the flourishing middle class in Holland provided such a ready market, possibly the artist felt it easier to go along with the way things were. Possibly the general atmosphere of middle-class contentment stultified the critical sense. Ostade, Brouwer, Teniers, and the other genre artists were very mild in their satire. Romeyn de Hooghe attacked the French and English much more than he did his fellow Dutch.

Caricature did continue in the seventeenth and eighteenth centuries but was inconsequential. It served a transcendent purpose, however, providing the initial inspiration for the satirical art that was to flourish in eighteenth-century England.

To this point in history, we have traced socially critical art by subject. In the early stages, certain themes were common to several countries, and the total output of critical art was relatively small. However, freedom of expression grew unevenly in each country—in the seventeenth and eighteenth centuries in England, in the early nine-

teenth in France, in the late nineteenth in Germany, and so on—and the art of social protest also developed at a different pace and in a different manner in each nation. As freedom burst its bonds, socially critical art by known artists swelled in volume. Hence, we will now consider the patterns, trends, and growth of this art nation by nation as the various western countries emerged into the modern world.

Some of the Principal Inhabitants of y.ͤ MOON, as they Were Perfectly Discover'd by a Telescope brought to y.ͤ Greatest Perfection since y.ͤ last Eclipse; Exactly Engraved from the Objects, whereby y.ͤ Curious may Guess at their Religion, Manners, &c.

1725. Price Six Pence

72

72. "Royalty, Episcopacy, and the Law (Some of the Principal Inhabitants of ye Moon)." William Hogarth. 1725. 7¼x7. Etching and engraving. British Museum, London.

The English Artist as Social or Political Critic:
From Hogarth to Cruikshank

WITHIN her borders—though not in her colonies—England had had relative freedom from destructive violence and oppressive stagnation. And a combination of historical forces made it possible for socially critical art to reach its full flowering in eighteenth-century England. As early as 1724 there appeared a remarkably blunt attack on the Establishment by a young English engraver, William Hogarth (1697–1764). This print could not conceivably have been published except in relatively democratic England. "Royalty, Episopacy, and the Law" (technically, "Some of the Principal Inhabitants of ye Moon") is a devastating satire that bares the disillusionment following the collapse of a wild speculative fever that had gripped England. The king's face is a coin; he wears a collar of bubbles and is subordinated to other figures. The bishop has the face of a Jew's harp—possibly an implication that sermons were all noise; he is attached to a pump handle which pumps coins into the episcopal coffer. A blind, faceless judge sits armless and in chains. The figures of fashion at their feet are as faceless as the king and bishop.

The sharp barbs of the Hogarth print went far beyond any previous graphic criticism. Despite moments of stress and violence, the struggle for religious tolerance and constitutional government and the development of parliamentary tradition had evolved in relative peace—a condition conducive to freedom of expression. The religious, military, economic, and political contests which were eventually resolved in the compromise known as the British Way of Life were all reflected in the free-swinging, vigorously polemical—if inartistic—prints of seventeenth-century England. Although English printmaking in that period, lacking a Bruegel, Callot, or Dürer, was without distinction and originality, it did have topical pertinence and a relatively democratic impertinence. Its importance lies in the fact that it existed and even flourished at a time when full expression was disappearing in most other countries.

These early prints were often crude, amateurish, anonymous, emblematical, and not far removed from the symbolism of the Middle Ages and Reformation. English counterparts to the European broadsides and medallions were common.

In the 1640's, with the opening of the Long Parliament, the attack on monopolies, and the outbreak of the Civil War, English prints began to appear more frequently. As always, the attackers had the advantage over the Royalists, just as the

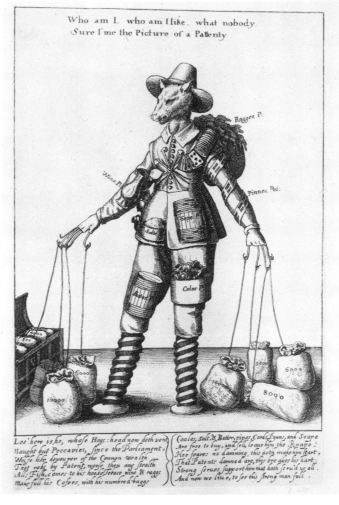

Who am I, who am I like, what nobody
Sure I'me the Picture of a Patenty

Ragges. P.
Wine P.
Pinnes. Pat:

Soape
Salt
Color

5000
6000
10000
1000
3000
6000
8000

Loe' here is he, whose Hogs:head now doth vent
naught but Peccavies, since the Parliament;
Wolfe like, devourer of the Common wealth
That robs by Patent, worse, then any stealth
All: Fish, comes to his hooke, Tobaco wine & ragges
make full his Cofers, with his numbred baggs

Coales, Salt & Butter, piper, Cards, pynns, and Soape
Are free to buy, and sell, leaue him the Roape:
Hee feares no damning, this acty makes him start,
That Patents damned are, this bye gkes his hart;
Strong serues, support him that hath seru'd vs all.
And now we liue, to see this strong man fall.

73

pro-Lutheran prints had effectively denounced the abuses of the Church a century earlier.

A prominent theme in the 1640's, resentment against monopolies, was exploited effectively by Wenceslaus Hollar (1607–77), Czech-born chronicler of English life. In "The Patenty," Hollar uses the ancient folk device of constructing a character out of the objects of his vocation. In this case, the patenty or monopolist, his claws hooked to money bags, is composed of wine, coals, soap, and pins—all the monopolies which were causing the people to suffer from high prices and shortages. Hollar made several thousand delicate etchings, an invaluable record of seventeenth-century England, for which he was paid four pence an hour or six pence a print to produce. In many of his prints he furtively included the bitter symbol of an hourglass.

In sixteenth-century Germany and seventeenth-century France, religion and state were so intertwined that any print on religious themes almost invariably had political overtones. As M. Dorothy George

73. "The Patenty." Wenceslaus Hollar. c.1640. 9½x6¾. Etching. British Museum, London.

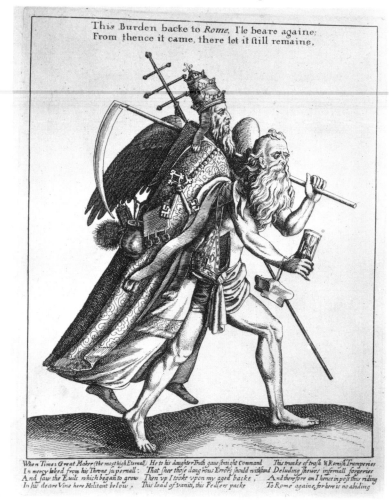

When Times Great Maker (the most high Eternall) He to his daughter Truth gaue straight Command This trunke of trash & Romish Trumperies
In mercy loked from his Throne supernall: That shee those dang'rous Errors should withstand Deluding showes infernall forgeries
And saw the Euils which began to grow Then vp I tooke vpon my aged backe, And therefore am I hence in post thus riding
In his deare Vine here Militant below; This load of vaniti, this Pedlers packe To Rome againe, for here is no abiding

74

pointed out in her classic *English Political Caricature*, "From 1640 to 1710 (roughly speaking) a majority of prints attacked the Anglican Church, or the Presbyterian, or the Independents, or dissent in general, each being associated with Rome." The Pope was the tool used to harass the government or the opposing religion. In "Time and the Pope," Hollar has Time carrying the Pope—"This load of vaniti"—back to Rome.

Archbishop Laud, Cromwell, or whoever occupied the center of the stage soon found himself deluged with insults hurled by the printmakers in a boisterous English tradition that was to reach its pinnacle during

74. "Time and the Pope." Wenceslaus Hollar. 1641. 9x7⅛. Etching. British Museum, London.

the eighteenth century. It reflected a period of remarkable growth, with its attendant stresses and conflicts.

In spite of such disastrous speculations as that of the South Sea Company, England burgeoned in the eighteenth century. Her population doubled, her colonial empire spread throughout the world, her industries prospered. Factories sprouted throughout the land, employing hundreds of thousands of men, women, and children who had previously tilled the soil. It was a vigorous, individualistic age, with fortunes made overnight. It was an age of great refinement, of gracious living, of flourishing and creative literature, music, art, and architecture. And it was also a period of brutality, of dirt, disease, starvation, and hardship, of bare subsistence for most people, who were ill-fed (malnutrition was ubiquitous, and when food prices rose, semistarvation prevailed), ill-clothed (usually one set of clothing was the complete wardrobe, washed annually, if at all), and ill-housed (often many families occupied one room).

From birth to an early death, the average urban or rural laborer ran a losing race against poverty and debt. It is not surprising that those who worked so hard played hard, with the violence of desperation in the little time allotted for relaxation. There was gambling, drinking (the consumption of gin was enormous), cockfighting, bull baiting and, for a really festive occasion, a public hanging. The disorder, the noise, the uncertainty of life drove most people to seek some form of escape.

Some found solace and emotional relief in the fundamentalist preaching of John Wesley. Most found an outlet in sporadic rioting and occasional rebellion. In fact, during the Gordon Riots of 1780, working-class mobs controlled London for several days. But such outbreaks, in London at least, were neither class-conscious nor revolutionary in intent. For the most part they were aimless mob action. In the rural areas, where even worse conditions existed, a few more socially activated outbreaks occurred which were put down by force.

Throughout the century there was a growing awareness of the need to improve municipal conditions. Street paving and lighting were undertaken in London, and sewage disposal and sanitation were improved. Some of the new middle class and religious groups felt stirrings of humanitarianism. Prison reforms were initiated, and some hospitals were founded. At the beginning of the century only one London child out of four survived; by the end of the century the population of England had doubled.

All this feverish growth, change, and exuberant vitality were reflected in the popular prints of the time. The eighteenth century was a golden age of English satirical printmaking. *The British Museum Catalogue of Political and Personal Satires* has 8,082 entries for the period from 1720 to 1800. Let alone the thousands that have disappeared.

Leafing through this tremendous mass, one cannot but be impressed by the pro-

lificness, the zest, and the vigor with which the satirists attacked the leading figures of the day and many of the pet foibles of the upper classes. At a time when censorship prevailed in France and Germany (graphic satire hardly ever existed in Italy and Spain), it is refreshing to behold the vitality of political expression in eighteenth-century England.

There were objectionable features, of course. Only a fraction of the population—the landed aristocracy—actually had the right to vote. Despite attacks on royalty, ministers, and their policies, fundamentals were rarely questioned or basic social problems defined. Most of the political prints were concerned with the intense parliamentary maneuverings. Many of the prints are topical, almost arcane in their references and consequently of limited interest today. Unfortunately, the élan is not matched by quality. Poorly conceived and amateurishly executed, the prints resort to balloons and streamers and verbal devices to compensate for lack of inspiration. The work as a whole is more impressive than the individual prints, with a few exceptions. The vitality is exciting; the artistic inspiration, rare.

The printmakers themselves in the eighteenth and early nineteenth centuries were a mixture of such professionals as William Hogarth, Thomas Rowlandson, James Gillray, the Cruikshanks, the youthful Richard Newton, William Heath, and prolific amateurs including George Townshend, Henry Bunbury, James Sayers, William Dent, and Matthew Darly. The first artist to bring genuine significance and a high satirical level to this vast output was William Hogarth.

It was at the dawn of the century that Hogarth (1697–1764) grew up in London—stinking, brawling, overflowing, noisy, vibrant, aristocratic, democratic, gracious, filthy, intellectual, vulgar London. Hogarth's engravings and etchings bring eighteenth-century London spiritedly to life—the crowded streets, the boisterous taverns, the riotous boxing matches and theaters, the bleak prisons and the aristocratic drawing rooms, the jaded rich and the precarious poor.

Son of a schoolmaster, Hogarth showed an early bent for drawing and at fifteen was apprenticed to a silversmith. He studied drawing at a small academy and later with Sir James Thornhill, the painter and decorator, whose daughter he married. Hogarth engraved many bookplates, show cards, and illustrations, notably for Butler's *Hudibras,* but he made his reputation with "conversation pieces"—small portraits and portrait groups. His real success came when he decided to paint and engrave "modern moral subjects . . . pictures on canvas, similar to representations on the stage." The first of these morality plays was "The Harlot's Progress," first painted, then engraved. The engravings sold very successfully by subscription. His later series, "The Rake's Progress" and "Marriage *à la mode,*" were equally successful, but Hogarth's ambition to be highly regarded as a painter

was constantly frustrated. Even his essay, *The Analysis of Beauty,* was not taken seriously by the art critics of his day. His reputation was based, quite justifiably, on his magnificent satirical prints. Ironically, the very fact that his prints were so popular militated against his paintings being taken seriously. His contemporaries never recognized his great contributions to English painting, notably his superb "Shrimp Girl" and "Captain Coram."

Hogarth was primarily a story teller in the tradition of the medieval moralists. He regarded himself as a painter-engraver, a dramatic writer, with subjects more important than their execution. There are infrequent grace and little subtlety in theme in his drawing. As he saw it, "The passion may be more forcibly expressed by a strong, bold stroke than by the most delicate engraving." He brought to his art an exuberant, baroque gusto in which detail was piled upon detail in the Dürer tradition with sledgehammer effect. There is so much detail, in fact, that many of Hogarth's engravings have to be "read." To make the meanings clear, even to the unlettered, Hogarth often resorted to burlesque and parody.

A self-made man, Hogarth was beset with human contradictions. He was a pugnacious battler against unhealthy social conditions but was sycophantic to the rich, anxious for commissions from the nobility and the wealthy. Indifferent to the graceful line, he was the author of *The Aesthetics of Beauty.* He was witty but moralistic, and

his engravings were often didactic sermons —yet brimming with teeming life. His profound sense of tragedy was matched by his feeling for comedy. He frowned upon low life and debauchery, but he portrayed them with zest. He fought with verve and satire against cruelty and stupidity, yet he mirrored the Englishman's prejudices against foreigners, Catholics, and Jews.

Hogarth was the epitome of middle-class morality. In his view, industry was always rewarded by material success, while laziness and vice led to the gallows. It is interesting that the last letter Hogarth received was from Benjamin Franklin, who admired him. Although he was not at all religious, his middle-class sense of propriety was shocked by the extravagant vice and extremes of corruption prevalent at the time, and he often tried to appeal to the latent puritanism of his fellow Englishmen. In many respects his morality was akin to that of Bosch and Bruegel. Of course, Hogarth's appeal today rests not on his morality plays, but on his superb reportage, his remarkably alive vignettes of high and low London life.

Hogarth's efforts to reform his fellow Londoners had an early beginning. He was only twenty-four when he etched "The South Sea Scheme," a satire on all forms of speculation. The victims can't wait to get on the South Sea merry-go-round that will give them a quick ride but nothing else for their money. At the lower left, Catholic, Jewish, and Protestant men of God are playing pitch-and-toss. In the upper left,

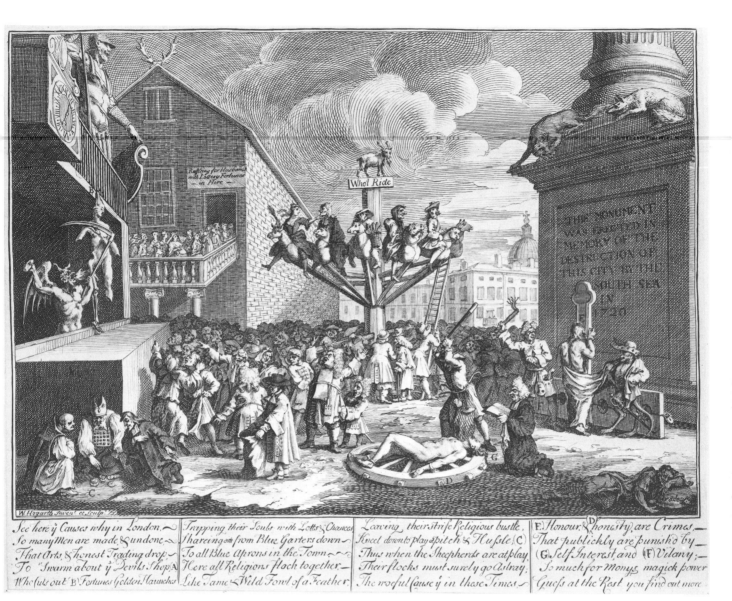

75

husbands are being raffled to eager wives in a building adorned by horns. And "Honour" and "honesty" are being flogged and broken on the wheel. Although the composition is loose, the engraving indicates Hogarth's already fertile imagination.

His most famous subjects were moral in tone and purpose, often done as tableaux,

75. "The South Sea Scheme." William Hogarth. 1721. 8¾x12½. Etching and engraving. Rosenwald Collection, National Gallery of Art, Washington.

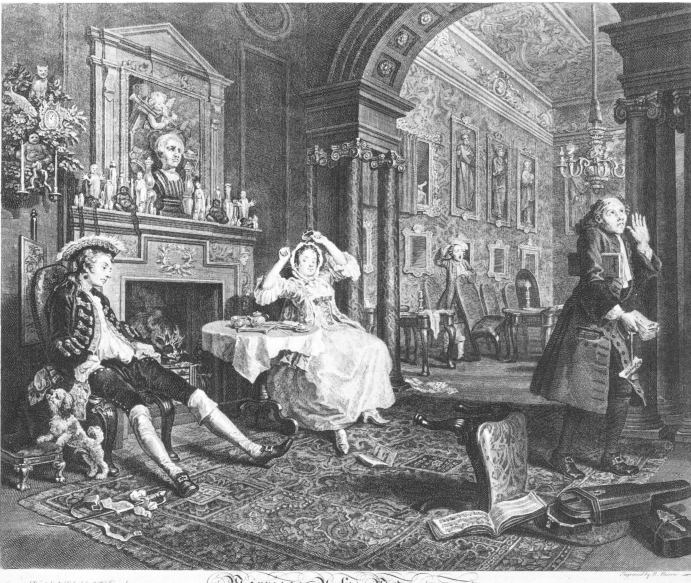

Marriage A-la-Mode, (Plate II)

as a play would unfold. The ethos, as distinct from the artistic merit, of "The Rake's Progress," "A Harlot's Progress," and "Marriage *à la mode*," has often been downgraded, and they have been regarded simply as moralizing picture-stories reflecting

76. "The Unhappy Pair at Home" ("Marriage *à la mode*" Plate No. 2). William Hogarth. 1745. 14x17⅝. Engraving. Rosenwald Collection, National Gallery of Art, Washington.

Hogarth's middle-class bias: the wages of sin, or the penalties for attempting to rise above one's station. This appraisal has some validity, but Hogarth was also condemning a corrupt society and a way of life. "The Unhappy Pair at Home," Plate No. 2 of "Marriage *à la mode*," is a classic picture of the boredom, emptiness, frivolity, and pointlessness of a society life without values.

In one of his series, "Industry and Idleness," he contrasts the life of the industrious apprentice who becomes mayor of London with that of the idle apprentice whose destiny is an evil end with a gang of thieves. It seems—and is—platitudinous. But, as Marjorie Bowen has pointed out, the stuffy atmosphere when the industrious lad is married or when the city banquet is held is "as repulsive as the horrors of the vagabond's garret." Hogarth, then, frequently has to be read on two levels; there are often overtones unnoticed the first few times a Hogarth print is studied.

Hogarth actually had some success as an artist-reformer seeking concrete results. Magdalen Hospital, the oldest home for prostitutes in England, was founded in 1758 as a direct result of "A Harlot's Progress." Hogarth's "Gin Lane" helped back up the pamphleteering efforts of novelist Henry Fielding to curb the disastrous effects of demon gin on the poor. Their joint efforts, with those of Defoe and others, brought about the Tippling Act against the sale of cheap gin.

In "The Four Stages of Cruelty," a boy who maltreats animals eventually—and inexorably—winds up as a murderer. "The prints were engraved," Hogarth wrote, "with the hope of in some degree correcting that barbarous treatment of animals, the very sight of which renders the streets of our Metropolis so distressing to every feeling mind." In the "First Stage," our hero sports the badge of St. Giles' Charity School. Here Hogarth may well be attacking the charity school-apprenticeship system, which was intended to lead abandoned children to a life of virtue but in reality prepared them for the cesspool. Hogarth is always concerned with the consequences of men's actions. In the "First Stage," Tom Nero is savagely maltreating a dog. In the fourth and final plate, "The Reward of Cruelty," surgeons are dissecting the corpse of Nero (hanged at the gallows) with just as much savage glee, while a dog licks Nero's heart.

In several of Hogarth's paintings and engravings he drew attention to the horrendous conditions in prisons—conditions which Fielding attacked in his novels. Hogarth was also an active governor of the Foundling Hospital, the first home in London for abandoned children, and made paintings for the institution.

In a day when politics was synonymous with corruption, when the major difference between the parties was that the outs wanted in, Hogarth distrusted all politicians. His "Election" cycle, one of his few efforts at political satire, was executed after

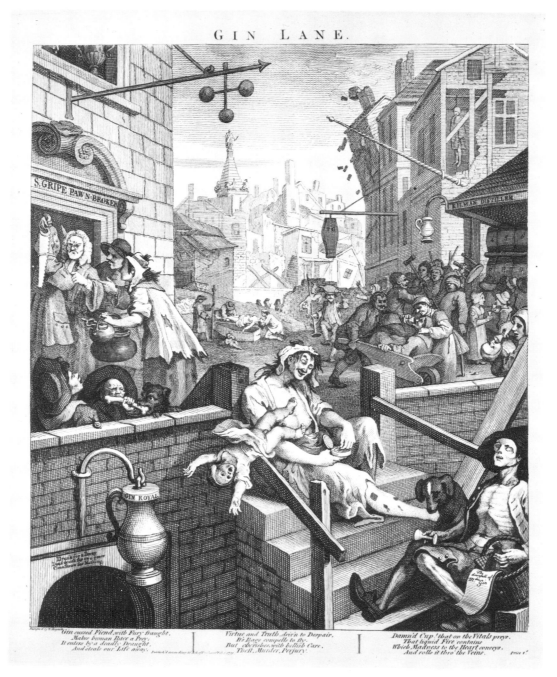

77

77. "Gin Lane." William Hogarth. 1750. 14¾₁₆x12. Etching and engraving. Department of Prints and Drawings, Brooklyn Museum, Bequest of Samuel E. Haslett.

78. "First Stage of Cruelty." William Hogarth. 1750. 14x11¾. Etching and engraving. Department of Prints and Drawings, Brooklyn Museum, Bequest of Samuel E. Haslett.

79. "The Reward of Cruelty." William Hogarth. 1750. 14x11¾. Etching and engraving. Rosenwald Collection, National Gallery of Art, Washington.

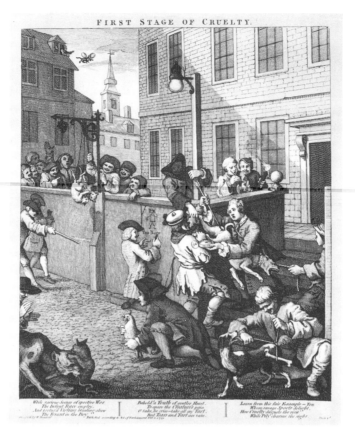

FIRST STAGE OF CRUELTY.

With various Scene of sportive Woe / The Infant Race employ. / And tortur'd Victims bleeding shew / The Tyrant in the Boy. | Behold! a Youth of gentler Heart, / To spare the Creature's pain, / O take, he cries—take all my Tart, / But Tears and Tart are vain. | Learn from this fair Example—You / Whom savage Sports delight, / How Cruelty disgusts the view / While Pity charms the sight.

78

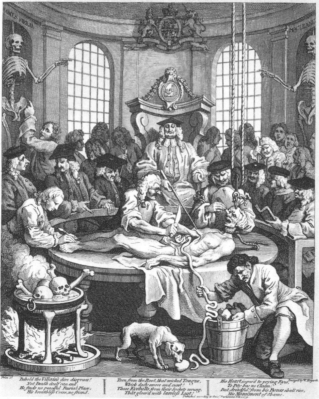

THE REWARD OF CRUELTY.

Behold the Villain's dire disgrace! / Not Death itself can end. / He finds no peaceful Burial-Place, / His breathless Corse, no friend. | Torn from the Root, that wicked Tongue, / Which daily swore and curst! / Those Eyeballs from their Sockets wrung, / That glow'd with lawless Lust! | His Heart expos'd to prying Eyes, / To Pity has no Claim; / But, dreadful! from his Bones shall rise, / His Monument of Shame.

79

73

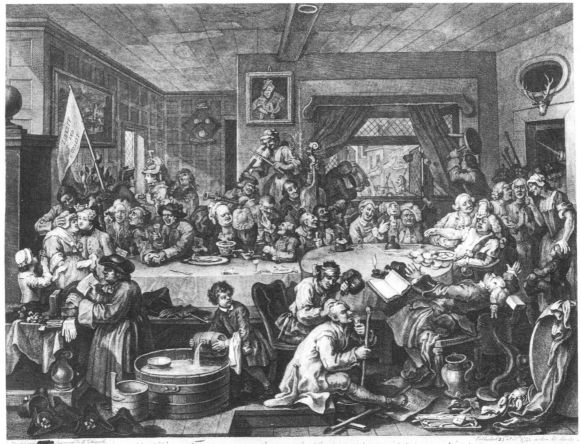

80

the particularly seamy election of 1754. It includes two scenes represented here. In "An Election Entertainment," the candidate's lavish party for his constituents hints at the prize at stake. Among many other fascinating details, note that Hogarth is parodying "The Last Supper" with thirteen at the table and the candidate at the left having his ring lifted as he receives a Judas kiss. In "The Polling," the feeble-minded and the dying are let out of work-house, jail, or hospital for a fee, to vote. In the background Britannia's coach has veered off the road as the coachmen become absorbed in their cards.

Hogarth's targets were a potpourri of

80. "An Election Entertainment." William Hogarth. 1754. 15⅞x21¹⁵⁄₁₆. Etching and engraving. Department of Prints and Drawings, Brooklyn Museum, Bequest of Samuel E. Haslett.

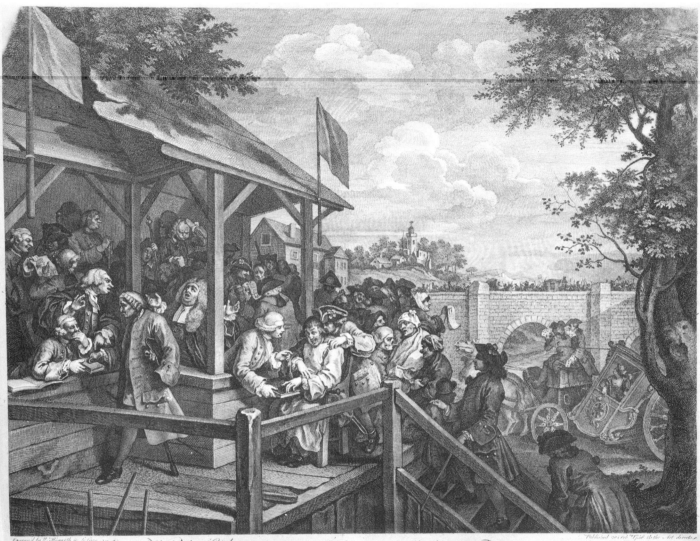

human frailty: idlers, gamblers, corrupt politicians, indifferent magistrates, unfeeling and ignorant physicians, lazy artists, insincere clergy, rapacious soldiers. All were grist for the mill that ground out his satirical prints by the hundreds, protected

81. "The Polling." William Hogarth. 1754. $15\frac{15}{16}$x$21\frac{3}{8}$. Engraving. Gift of Sarah Lazarus 1891, Metropolitan Museum of Art, New York.

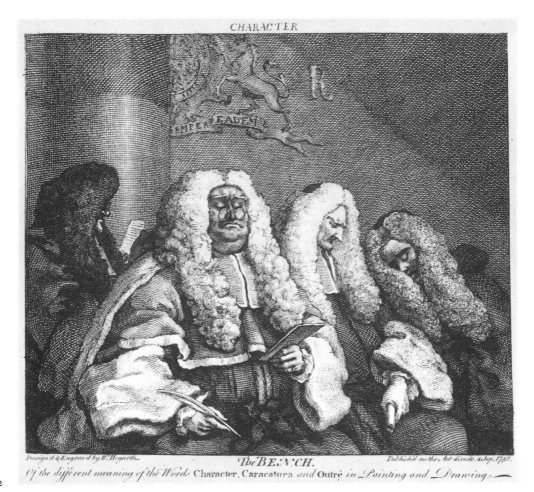

Design'd & Engrav'd by W. Hogarth. The BENCH. Publish'd as the Act directs 4 Sep. 1758.

Of the different meaning of the Words Character, Caracatura and Outré in Painting and Drawing.

82

by the copyright law of 1735 which he was instrumental in getting passed in order to protect his work from pirates. Hogarth prints embodying these themes decorated thousands of middle-class English drawing rooms.

A generation later, the colored prints of Thomas Rowlandson (1756–1827) were also titillating Englishmen (and English women) in London and the provinces, but with a vast difference. No puritan, "Rowly" was a full-blooded, hard-drinking, beef-devouring giant, a towering bon vivant, enamored of the tavern and the gambling table, more a bold and eager participant in than a critic of his brawling eighteenth-century England.

Rowlandson differed from Hogarth in artistic as well as moral approach. Graceful, flowing line distinguished many of Rowlandson's drawings and colored aquatints. He was a fine colorist and landscape artist, with a sure feeling for architectural form. Hogarth brought life to London's swarming streets by massive detail; Rowlandson achieved it by creating a naturalistic atmosphere. Rowlandson's prints are alive with the movement of bustling crowds, flowing with curves so suitable to express his grotesqueries.

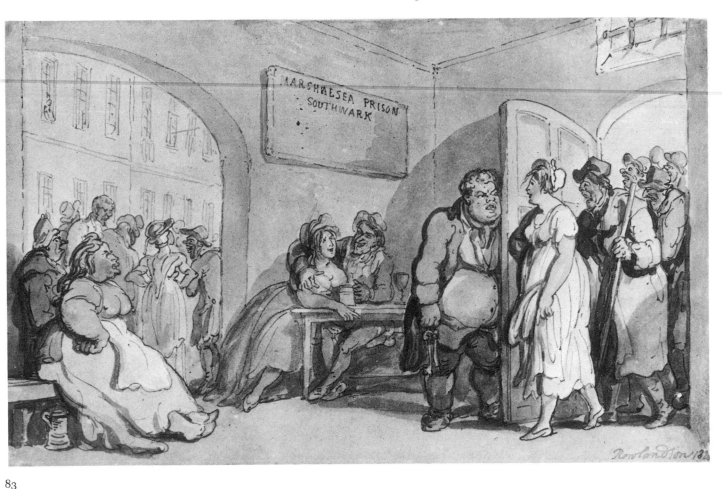

83

Rowlandson moves the viewer to laughter rather than indignation. Hogarth had a keen sense of the comic, but he was basically serious in outlook, with a deep sense of the tragic; Rowlandson never portrayed tragedy, or if he did it had comic overtones. Nevertheless, although Rowlandson was more observer than reformer, some of his works do leave the viewer uneasy, reflective as well as amused. Occasionally there was emotion and seriousness of purpose behind his work.

His drawing, "Marshalsea Prison," is a straightforward representation of the overcrowding, licentiousness, and corruption of prison life in his day. In his depiction of the cruel and villainous face of the jailer, Rowlandson is far from the amused observer.

83. "Marshalsea Prison." Thomas Rowlandson. No date. 5¹¹⁄₁₆x9⁵⁄₁₆. Pen and watercolor. Wiggin Collection, Boston Public Library.

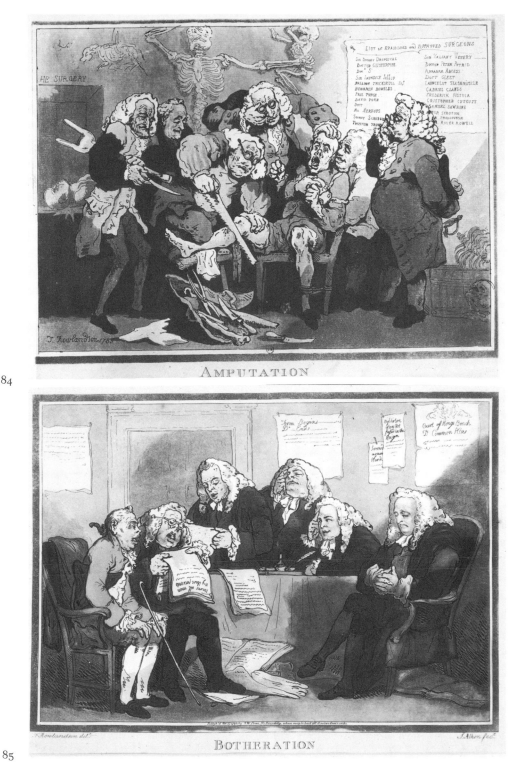

84

85

84. "Amputation." Thomas Rowlandson. 1785. 11x14½. Aquatint. Bibliothèque Nationale, Paris.

85. "Botheration." Thomas Rowlandson. 1793. 9½x13¾. Aquatint. Rosenwald Collection, National Gallery of Art, Washington.

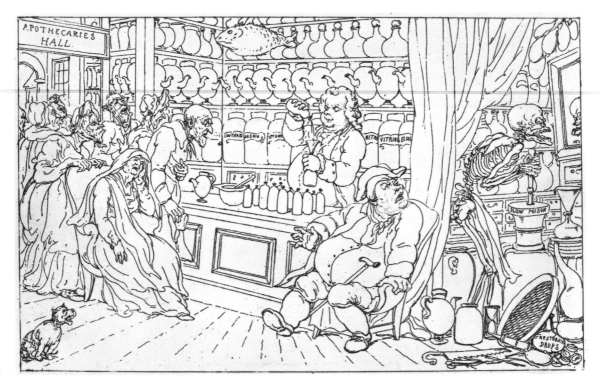

86

Perhaps more typical are Rowlandson's treatments of two of his pet anathemas, dubious doctors and pompous lawyers. In "Amputation" and "Botheration" there is a bite that goes deeper than the surface hilarity. Rowlandson's last major work was a series of drawings for "The English Dance of Death." Characteristically, the ebullient Rowlandson does not concern himself with the traditional theme of death as a leveler; instead he uses the occasion for caricature and humorous observation. Occasionally, however, he lets an indignant note creep in, as in "The Quack Doctor."

His respect for the medical profession of his time was not very high.

While Rowlandson often laughed at man's foibles, James Gillray (1756–1815) snarled at them. Rowlandson occasionally tried political prints; with Gillray it was a lifetime occupation. Much more of a political than a social satirist, Gillray staged savage attacks on the royal family, the leading members of the government, and on the French Revolution and Napoleon. They are among the most devastating of all satirical prints made up to his time. While Hogarth dealt with a broad scene, Gillray,

86. "The Quack Doctor." Thomas Rowlandson. 1815. 4⅞x7¹⁵⁄₁₆. Etching. Henry E. Huntington Library, San Marino, California.

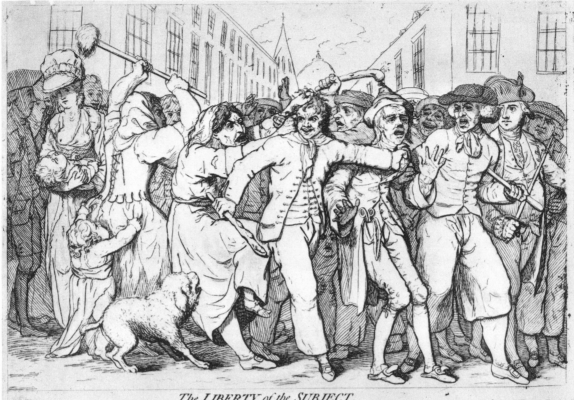

87

The LIBERTY of the SUBJECT.

Publish'd Oct.ʳ 15ᵗʰ 1779 by W.Humphrey N.ᵒ 227 Strand.

like Rowlandson, often achieved his satire by concentrating on facial expression.

Between Hogarth and Gillray there was a host of political and social caricaturists. Their work was mostly infantile, hysterical, vulgar, amateurish, easily forgettable; Gillray's caricatures are masterful, even if nightmarishly ferocious, and quite unforgettable.

Before Gillray's time, most political prints depicted ministers in office as wicked. Gillray tended to satirize with considerable

wit the institutions themselves, though he too eventually became a partisan—against Charles Fox and Burke.

Gillray was born in Chelsea, where he grew up under the strict tutelage of the Moravian church to which his Scottish Calvinist father had been converted. Apprenticed to an engraver, he later studied engraving at the Royal Academy. Although Gillray always had loftier artistic ambitions and did stipple engraving and illustration, his talents as a caricaturist made

87. "The Liberty of the Subject." James Gillray. 1779. 9⅝x13½. Hand-colored etching. British Museum, London.

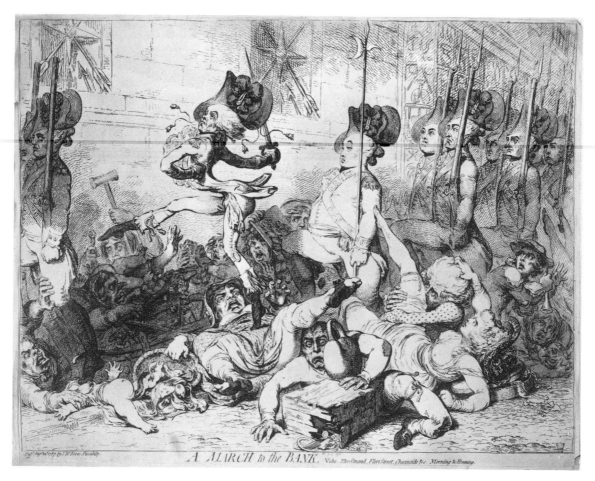

88

A MARCH to the BANK. Vide The Strand, Fleet Street, Cheapside &c. Morning & Evening.

his career as a social and political satirist inevitable. Each of his attacks was swiftly countered as partisans of Pitt and Fox fought it out in their prints. After making prints for various publishers, Gillray made a permanent arrangement with Mrs. Hannah Humphrey to be his exclusive print-seller, and he took permanent lodgings over her shop. He died insane in 1815.

Gillray's print, "The Liberty of the Subject" (1779), attacking the press-gang, displays his early talent for capturing movement and an active crowd. The press-gang rounded up ships' crews for the naval war against the American Revolution, and the print, like the vast majority issued then, was antiministerial and pro-American. In retrospect, these expressions of antigovernment sentiment during wartime were remarkable tributes to the growing resiliency of British democracy.

Eight years later, in "A March to the Bank," Gillray's vigorous feeling for grotesque satire is fully developed in this slapstick of government troops trampling over prostrate citizens. A favorite object of Gill-

88. "A March to the Bank." James Gillray. 1787. 16x20⅛. Hand-colored etching. British Museum, London.

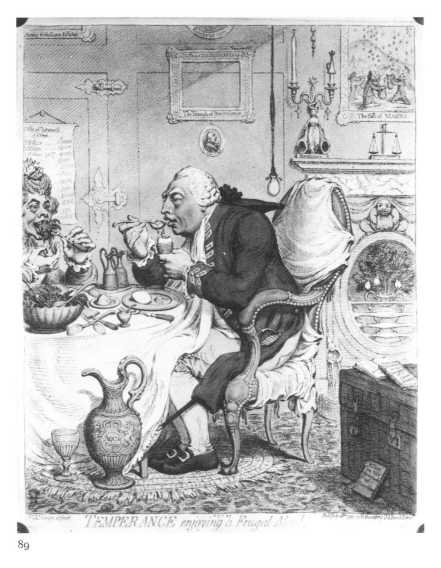

89

ray's darts was the British royalty, which he often portrayed, as Draper Hill has remarked, with "all the manners of a hungry cat in mid-spring." In "Temperance Enjoy-ing a Frugal Meal," the reputedly stingy king and queen dine on boiled eggs and sauerkraut in a fireless room adjoining a strongroom that holds their treasures.

89. "Temperance Enjoying a Frugal Meal." James Gillray. 1792. 13⁹⁄₁₆x11⅛. Hand-colored etching. British Museum, London.

90

FRENCH LIBERTY.

BRITISH SLAVERY.

The excesses of the French Revolution, the war between Britain and France, and especially the rise of Napoleon stimulated Gillray's provincial, anti-Gallic tendencies into a wild outpouring of dozens of anti-French caricatures. His ironic "French Liberty / British Slavery" is timeless. It could have appeared in any daily newspaper in

90. "French Liberty / British Slavery." James Gillray. 1792. 9⅛x13¼. Hand-colored etching. British Museum, London.

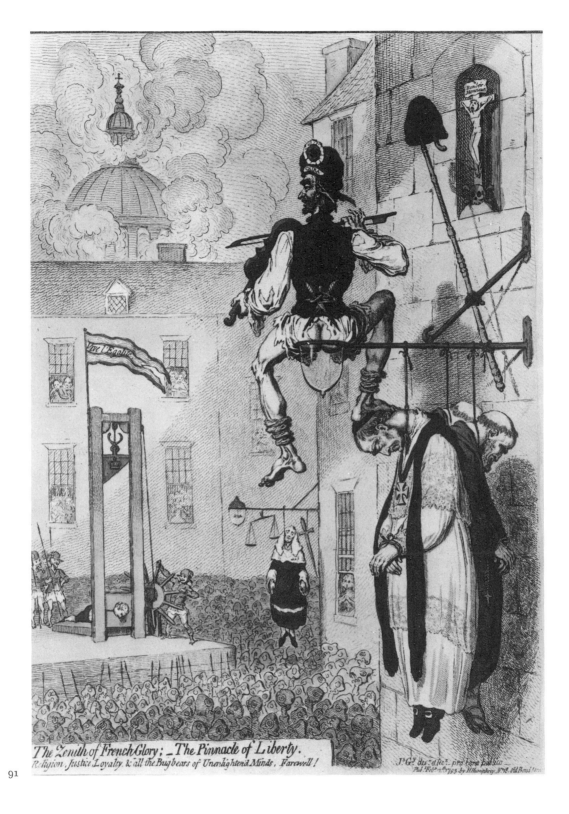

The Zenith of French Glory; _ The Pinnacle of Liberty.
Religion, Justice, Loyalty, & all the Bugbears of Unenlightend Minds, Farewell!

91. "The Zenith of French Glory." James Gillray. 1793. 13½x9⅞. Hand-colored etching. British Museum, London.

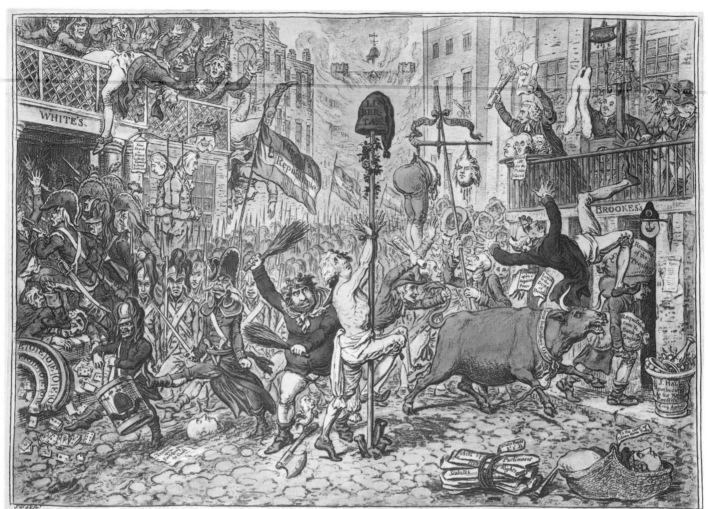

Promis'd Horrors of the French INVASION; — or — Forcible Reasons for negociating a Regicide PEACE. Vide . The Authority of Edmund Burke.

the early years of the Russian Revolution, with "Russian" substituted for "French." The execution of the French king elicited from Gillray his macabre, bitterly humorous "The Zenith of French Glory." Although a superpatriot in his hostility to the French, he also satirized the "scaremongers." Gillray's hilarious "Promis'd Horrors of the French Invasion" satirized both invasion fears and peace overtures. Gillray caricatured the French, as he did all his enemies, with foul faces and misshapen figures. His

92. "Promis'd Horrors of the French Invasion." James Gillray. 1796. 12x16⅞. Aquatint. British Museum, London.

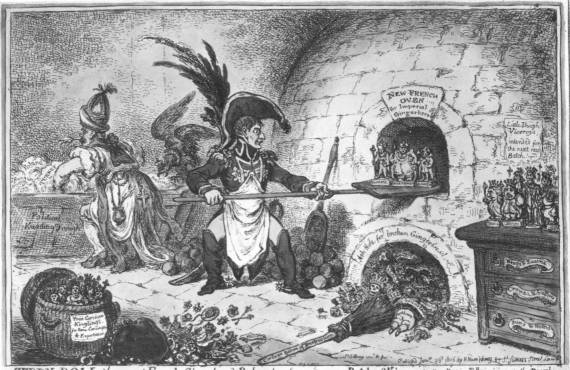

TIDDY-DOLL, the great French Gingerbread-Baker; drawing out a new Batch of Kings. — his Man, Hopping Talley, mixing up the Dough.

93

rancor was passionate. His classic, "Tiddy-Doll, the great French-Gingerbread-Baker; drawing out a new Batch of Kings," which shows Napoleon "baking" new puppet kings, was reprinted throughout Europe and was imitated for generations. Gillray's anti-French gibes were executed with tremendous verve, a keen sense of the ridiculous, and a ferocious excess. In his impatience to strike out, however, he often lacked solid conception and had to resort to long explanatory captions.

Violation by the wealthy of Fast Days instituted by the government to conserve food after the outbreak of war between England and France gave printmakers an opportunity for pungent social comment. The remarkably precocious Richard Newton (1777–98) drew "Fast Day" in 1793 when he was only sixteen. His anticlerical burlesque is typical of his combination of humor, bold design, and bite. His slavery tableau, "Practical Christianity," of black overseers whipping slaves under the beaming approval of an English lady, lacked subtlety but revealed a sensitivity and an awareness that few of his contemporary caricaturists displayed. Newton was arrested during the "sedition" roundup of 1793–94 and was sent to Newgate Prison along with his publisher, William Holland. He died at 21.

93. "Tiddy-Doll." James Gillray. 1806. 9⅜x14½. Hand-colored etching. British Museum, London.

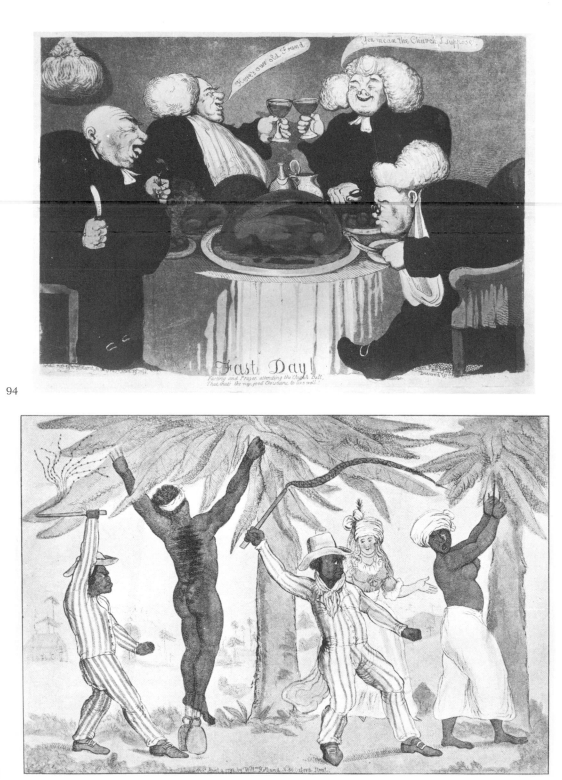

94. "Fast Day." Richard Newton. 1793. 9¼x13⅛. Aquatint. British Museum, London.

95. "Practical Christianity." Richard Newton. 1792. 5⅛x7¾. Engraving. British Museum. London.

When Gillray faltered and his mind weakened, George Cruikshank (1792–1878) emerged as the leading social and political satirist. Occasionally Cruikshank was much more penetrating than his predecessors and dealt with more fundamental issues. The times themselves demanded a more profound approach. In 1815, when the Napoleonic Wars ended, the cracks in the British superstructure were becoming apparent. The new industrial aristocracy—the merchants, bankers, and factory owners—were struggling for more representation in the government, while those on a lower economic level were clamoring for an electoral voice. Only one person in thirty-two voted. There was no secret ballot; hence, tenants had to vote for their landlord. The "rotten borough system" still prevailed, with some large cities unrepresented and some rural areas vastly overrepresented. Agricultural interests thus dominated Parliament, and bishops and lords continued to wield power in the House of Lords.

Children and women still worked long hours at the looms, with children sometimes chained to their machines. In frustration and bitterness, workers sporadically smashed the looms and were sent to jail or to the gallows. When a postwar depression set in, joblessness increased and disorder and rioting spread. The frightened government reacted with repression. In 1816 the Habeas Corpus Act was suspended. After soldiers killed several persons when breaking up a mass meeting in Manchester (the Peterloo Massacre) the panicking government passed the Six Acts of 1819, curbing freedom of speech, press, and assembly.

George Cruikshank's reactions to these events were ambivalent. He fiercely defended civil liberties and fought for reform, yet he savagely attacked Cobbett and the Radical Reformers. Perhaps, like most Englishmen, he was reacting traumatically to what was regarded as the extremism of the French Revolution.

After the Peterloo Massacre, George Cruikshank (or his brother Robert; the attribution is uncertain) etched "Massacre at St. Peter's." It shows fat, complacent yeomen ruthlessly poleaxing the emaciated protesters. "They want to take our Beef & Pudding from us," says the indignant captain of the yeomanry.

When the Six Acts were passed, a classic caricature, "A Free Born Englishman!" was issued in a redrawing of Cruikshank's 1813 version, which in turn was based upon an original conception of 1795. Whenever British liberty was threatened, "A Free Born Englishman!" appeared to defy the oppressors. John Bull is padlocked and shackled, his evicted wife and child starve, and a debtors' prison overflows.

As the dark year of 1819 came to a close, Cruikshank etched another classic satire on the burdens of poor John Bull. A shackled and muzzled John Bull carries on his back rows of tax collectors, soldiers, parasitical courtiers, pensioners, parsons, three bloated bishops, and the crown. "What will become of these Vermin, if the Bull should Rise–?!!!!" asks the caption.

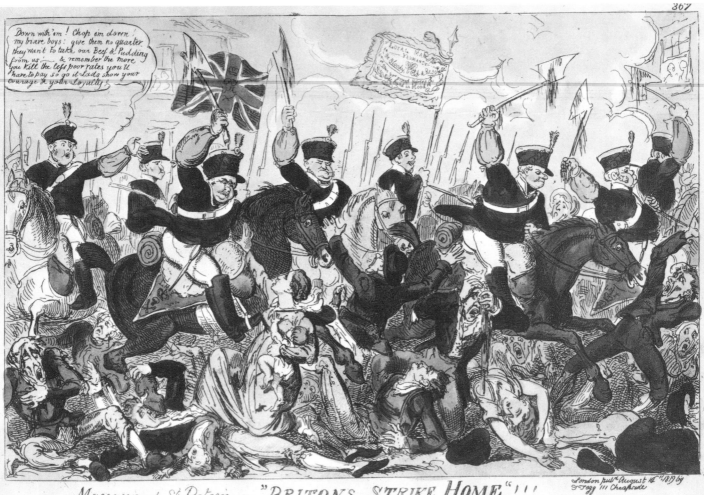

96. "Massacre at St. Peter's." George Cruikshank. 1819. 8¹⁵⁄₁₆x12⅞. Aquatint. British Museum, London.

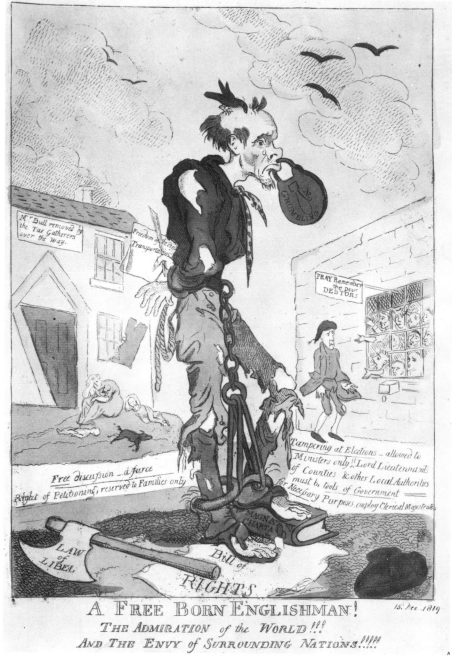

97

97. "A Free Born Englishman!" Anonymous redrawing of Cruikshank's version. 1819. 14x9¼. Colored etching. British Museum, London.

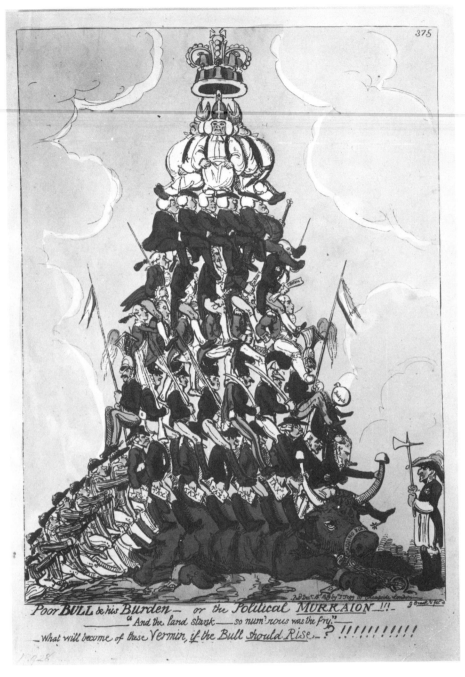

98. "Poor Bull." George Cruikshank. 1819. 12¼x9¼. Colored etching. British Museum, London.

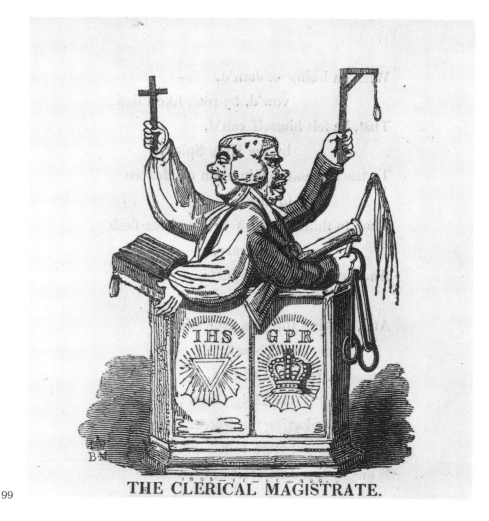

99

THE CLERICAL MAGISTRATE.

Cruikshank teamed up with pamphleteer William Hone for an extremely effective series of propaganda pamphlets. As M. Dorothy George has pointed out, Hone's illustrated pamphlets (together with the invention of stereotyping) led to the use of cuts in newspapers and periodicals, which eventually doomed the separately issued political print. One such woodcut attacked the parsons doubling as magistrates, whose harsh treatment of Reformers stimulated a new wave of anticlericalism.

Cruikshank continued to create satirical prints for a few more years, including a series denouncing the French invasion of Spain in 1823 to restore the absolutism of

99. "The Clerical Magistrate." George Cruikshank. 1819. 4⅛x3¼. Woodcut. British Museum, London.

00

Ferdinand, but then he turned to book illustration, for which he became famous as the illustrator of Dickens, Scott, the brothers Grimm, and numerous others. His detractors charged that he dropped political cartooning because he was bribed.

Cruikshank's talents as illustrator were further evidenced in the series of prints he made much later, in 1847, tracing the ebbing fortunes of a family in which the parents had succumbed to drink. In this striking print, Plate No. 8 of "The Drunkard's Children," the destitute, "gin-mad" daughter leaps to her death. The flash of white skirt against the Piranesi-like wall is an inspired design.

100. "The Drunkard's Children" (Plate No. 8). George Cruikshank. 1848. 9¼x14. Etching. British Museum, London.

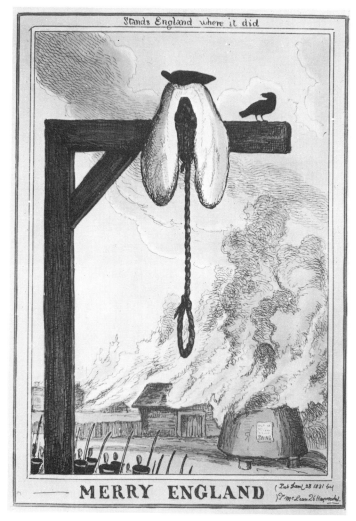

Stands England where it did

MERRY ENGLAND

101

ing conditions and intense agitations in which Radicals backed Whigs for a reform bill to extend the suffrage. The severity with which the rioting was put down is reflected in William Heath's grim "Merry England." Passage of the Reform Bill in 1832 marked a shift in power from agricultural to industrial interests, but the Radicals and workingmen and women gained neither suffrage nor alleviation of dreadful working conditions.

The ascendancy of the industrial, banking, and merchant middle class signaled the decline of the satirical print. But just before it waned, graphic political attack reached its zenith in agitation for the Reform Bill. In addition to an outpouring of individual prints, a host of illustrated penny weeklies appeared during the thirties, along with broadsides and radical penny newspapers.

The most important weekly, *Figaro*, the predecessor of *Punch*, lasted for eight years. It featured a well-drawn wood engraving of political comment, but the small reproduction limited the impact. The short-lived penny weeklies were usually much more radically proletarian than *Figaro*. The most effective radical graphics appeared in a series of prints issued as "The Political Drama," usually by Charles J. Grant. The cartoons were free-swinging attacks on almost every aspect of the social order and went far beyond the political or social comments preceding them. They were vigorous and virile in feeling but primitive and crude in execution.

Throughout the 1820's, the tradition of graphic satire was carried on by William Heath, H.B. (John Doyle), Robert Seymour, Charles Williams, and others. The reactions of the post-Napoleon period eased in the twenties, but as the decade ended, there were widespread riots against work-

94 101. "Merry England." William Heath. 1831. 15x10½. Colored etching. British Museum, London.

The extreme bitterness felt at the lack of support for reform from the king and church hierarchy stimulated, among countless other attacks, an extremely effective caricature that appeared in *The Ballot*, "The Crown—The 'Order'—The Church—and the People!" in which the whole social order is denounced. A new, radical note is struck in this and others, reflective of the depth of feeling for social reform. The text describes the crown as "worth, probably, the subsistence of all the labourers in Kent for a dozen years." The head represents the legislature, "round, rosy with beef and wine"; the upper body is the "order"—the aristocracy; the arms are the Army and Navy; the abdomen is the clergy, "plump, round, swelling in black cloth"; the pockets are the monied interests. The thighs— the farming and manufacturing interests —are shrinking. And the emaciated legs— "bare, shivering, wasted away"—are, of course, the people.

After 1832 the individual colored print began to fade away, and as cartoon replaced caricature, mild comment substituted for uninhibited attack. H.B.'s popular "Political Sketches," representational and nonpartisan, were a far cry from Gillray's vituperative sallies. The founding of *Punch* and *Illustrated London News* marked the demise of unbridled political and social graphic satire. Mildly satirical comment was as far as any editor would go. The Victorian era was at hand, with its emphasis on gentility, decorum, middleclass respectability. Later Victorian efforts

THE CROWN—THE "ORDER"—THE CHURCH—and *The People!*

102

at reform found graphic expression in somewhat sentimentalized reportage rather than agitational prints. The working class, disillusioned in its efforts to achieve universal suffrage and the secret ballot when their Chartism crusade failed, turned to trade union organization rather than political action to gain their aims. Graphic social criticism was never again to reach the height in England begun by Hogarth's first tentative efforts.

102. "The Crown—The 'Order'—The Church—and the People!" Anonymous. 1832. 8¼x5½ (with text). Wood engraving. British Museum, London.

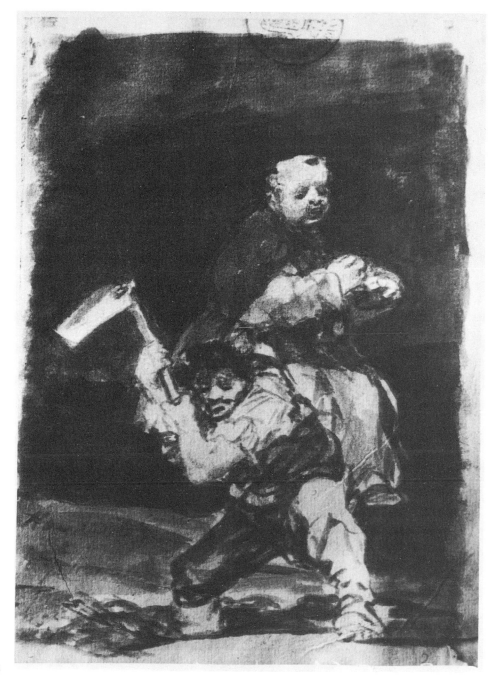

103

103. "You didn't know what you were carrying on your shoulders." Goya. 1818–24. c.8⅛x5½. Sepia and india ink washes. Goya No. 128. Prado No. 361. Museo del Prado, Madrid.

CHAPTER VI

Goya

From the dynamic, lusty, and strident atmosphere of eighteenth-century England it is a leap in time as well as space to the shadows of Spain, where the dark, bitter talent of Francisco Goya was emerging.

The English Marxist critic, F. D. Klingender, has declared that the "radiant essence of Goya's genius [was] his profound optimism, faith in reason, and heroic affirmation of human dignity and freedom." The French non-Marxist art historian, Claude Roger-Marx, has written of Goya: "All the virulent and corrosive qualities implicit in the words etching, needle, biting; all the quality of blackness implicit in the word ink, combined to serve a passionate temperament obsessed with man's and woman's cruelest and darkest powers."

Both men are more or less right, even in the subjectiveness of their interpretations. Sensitive, intelligent though not intellectual, liberal, Goya's reactions to his personal crises and to the recurring crises of his divided and benighted Spain were reflected in his art. As he wavered between hope and despair, as political and personal events buoyed or disheartened him, his faith in humanity and in himself also surged and ebbed. Few artists have had their faith subjected to such strains.

The Spain of Goya's time hardly mirrored the rationality and dignity of man. It was a country of contrasts even starker than those of pre-Revolutionary France. The harsh statistics of late eighteenth-century Spain are depressingly eloquent. Half the land in Spain was owned by the nobility, who made up fifteen percent of the population. Great nobles were immune from imprisonment except by decree of the king, and—shades of the Peasants' Revolt in fourteenth-century England!—they enjoyed a monopoly of hunting and fishing. Over sixty percent of the people were peasants or landless day laborers, barely subsisting in primitive huts with little furniture and few windows. Only one in nine children had any education in a country that boasted three thousand monasteries and convents. In Madrid, a fifth of the population was maintained by charity of the church. The church owned one-sixth of the land; its revenue almost equaled that of the state. The burden of this huge church establishment was graphically portrayed in Goya's powerful drawing of a laborer bearing a monk on his back, with the caption, "You didn't know what you were carrying on your shoulders."

In general, initiative was discouraged; deadening custom ruled, and submission to authority was the dominant characteristic of Spanish society. However, the popula-

tion of Spain doubled during the eighteenth century, reflecting some economic advances and discernible improvement of sanitation and living conditions in the cities. But it was only in the closing years of the century that there was considerable increase in the number of Spaniards employed in manufacturing or industrial crafts.

The clerical forces were all-powerful. Religious observance was required, with confession and communion mandatory at least once a year. In an age when tolerance was spreading throughout most of Europe, the Spanish Inquisition endured in Spain, although it had been partially curbed under Charles III, whose relatively enlightened despotism had vainly attempted to guide Spain toward becoming a modern state. Death penalties became less frequent, but torture was still commonplace; victims could never confront accusers or even know who they were. Goya's sketch of a victim of the Inquisition at the moment of judgment was made just before the dawn of the nineteenth century.

Both church and state instinctively reacted with apprehension to the rationalist philosophy that dominated intellectual circles in Europe. They resisted and suppressed new ideas and seemed determined to prevent Spain from joining the mainstream of European culture. The Inquisition issued new Indices in 1790 and 1805, and in 1792 censors were placed at customs houses to screen the influx of republican propaganda. The democratic spirit of inquiry was curbed but not crushed.

The corrupt reign of the dim-witted Charles IV (1788–1808) was disastrous. His domineering queen, Maria Luisa, promoted her favorite—the incompetent and grasping Manuel Godoy—from guardsman to prime minister when he was only twenty-four. The young prime minister and the royal couple paid little heed to the pleas of a loosely organized reform group of a few lawyers, aristocrats, churchmen, and officials. But it was with this group of enlightened seekers that Goya identified.

Francisco José de Goya y Lucientes was born near Saragossa in 1746, son of a gilder. He studied painting in Madrid, married his teacher's sister, and created conventional decorations for churches in Saragossa and Madrid. He received his first major opportunity through his brother-in-law when he was commissioned in 1776 to paint cartoons for the royal tapestry. For sixteen years he executed these gay, buoyant scenes of everyday life. The emphasis, as in practically all of Goya's work, was on people—society people and middle-class, beggars and servants, and especially his favorite *majos* and *majas*, picturesque, flamboyant avant-garde of the working class, whose style and even dress were often imitated by the more daring of the aristocracy. Some of the cartoons were charming, others witty or exuberant; all were rich in color.

They were well received and Goya rose rapidly. Commissions for portraits fol-

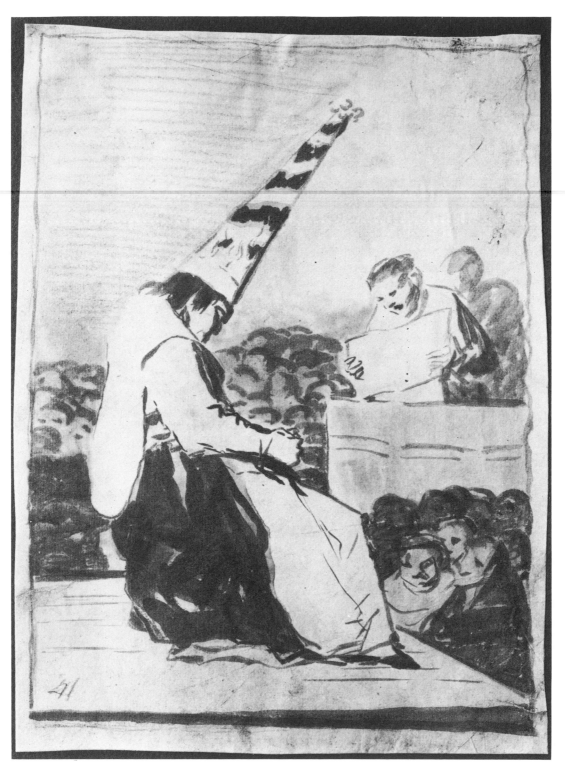

104

104. Drawing for "Caprichos" No. 23. Goya. 1818–24. 8x5³⁄₁₆. Prado No. 105. Museo del Prado, Madrid.

99

lowed. He became deputy director of the Academy of San Fernando in 1785 at 39; *pintor del rey* in 1786, and *pintor de cámera,* or Knight Painter, in 1789.

Goya seemed well on his way to fashionable court triumphs when a combination of events transformed a gifted but conventional court painter into a corrosive social critic, a profound if occasionally wavering seeker of truth. As André Malraux has written, "He discovered his genius the day he dared to give up pleasing others."

In 1792 the ambitious and rising Goya who participated in life so vigorously and fully was dealt a stunning, irremediable blow. A serious illness left him completely deaf. Practically cut off from communication with others, he became withdrawn, introspective, brooding, phantom-ridden. Locked within his silent world, he seems to have faced more honestly and directly the reality of the court society for which he had worked and painted.

From letters by his contemporaries and other written records, we know that Goya was most closely attached to the liberals, the rationalists, the Spanish intellectuals who, influenced by the French Encyclopaedists, were anxious to introduce modern, more democratic concepts into Spanish society and bring about elementary reforms in the political and social structure. As Jean Adhémar has pointed out, a friend and model of Goya's, Lhorente, unsuccessfully advanced a proposal for reform of the Inquisition; another friend, the poet Valdès,

was denounced to the Inquisition for having read forbidden books and becoming contaminated with their ideas; his closest friend, the poet Moratín, who supplied some of Goya's captions, visited France during the Revolution where he absorbed its new ideas. Whatever reservations or disillusionments Spanish intellectual liberals may have had about the French Revolution, they embraced the theories that had engendered it. The French Revolution did mean that old oppressive ways were being swept away, that drastic changes in the social fabric were being woven, and the dream of these men was that perhaps *some* winds of change would blow over Spain. Their bitterness against the corrupt Godoy government was compounded when in 1793 Spain declared war (a brief and futile adventure) against the French revolutionary government.

Goya's personal trial was intensified by the frustration and inevitable failure of his relationship with the Duchess of Alba. No one is certain of the exact nature of their relationship, although generations of novelists have speculated about it—and embroidered it in the telling—and scholars have explored every facet of the objective evidence, which is sparse. After the Duchess' husband died, Goya joined her at her estate at Sanlúcar. Aging, irascible, deaf, but proud and independent, he was obviously fascinated by the beautiful, spoiled, contradictory younger woman who was capable of an occasional generous impulse.

Probably he shared her bed, though he enjoyed no exclusive rights. He painted her with his name on her ring and made a book of sketches of his impressions at Sanlúcar. Some of them, fairly intimate, were later transformed into etchings for his "Caprichos." In one, for example, the Duchess is sketched pulling up her stocking; in the "Caprichos" the female figure in the exact same pose is now a prostitute. He was both fascinated and repelled by the flirtatious, frivolous, feminine world of the Duchess and her attendants, a dichotomy he was to exhibit in his work the rest of his life.

In crisis, Goya turned from painting to etching, as he would do again and again whenever catastrophe turned him inward. Returning from Sanlúcar, he executed the series of etchings combined with aquatint called "Los Caprichos," or caprices, from the Italian word for fantasy, *capriccio*. They were published in 1799, but only twelve days after publication a frightened Goya withdrew them, probably under threat of prosecution by the touchy Inquisition. In a letter written a quarter of a century later, he said that "it was because of ["Los Caprichos"] that I was accused by the '*Santa*'—an abbreviation of the full title of the Inquisition.

Goya had reason for fear. Although, like Bruegel, he disguised many of his political and social references in phantasmagoria, his double meanings were probably clear to his contemporaries. Terse captions some-

times intensify the sarcasm, at other times soften it. He later added a commentary, probably with the help of Moratín. Unfortunately, the commentary often seems to obfuscate rather than clarify the meaning, particularly when a political interpretation of an etching is possible.

A certain amount of guesswork accompanies any interpretation of the political and social satires in many of Goya's etchings. In the face of little or no documentation, Goya specialists frequently differ, often according to their own social and political backgrounds or attitudes.

All the passions that crowded Goya's life in those critical years between 1792 and 1797 emerge in the "Caprichos": the phantoms that haunted his soundless world, his almost misogynic attitude toward women and his revulsion against the social mores which debased them, his anticlericalism, and his contempt for Godoy and the Spanish Court. There is a Ship of Fools quality in the "Caprichos," but Goya is much more biting than Sebastian Brant. Like Bosch and Bruegel he was a moralist, but a very "involved" one. He observed, felt, lived what he drew. "He does not so much pity the victims as feel he is one of them," Malraux has noted. There is compassion here for man's failings, but there is anger at man's meanness, too; sardonic humor as well as a black despair.

In some of his etchings there is a frightening insight into the fears and forebodings hidden in the deepest recesses of the hu-

man mind, almost an obsession with horror and the macabre. He saw the monsters within, as well as man's monstrous actions without. Long before psychoanalysis, Goya peered deeply into his own unconscious and discovered morbidity. And he probed far into his contemporaries' depths: Witches and sorcerers become dominant in the second half of the "Caprichos"—monsters who take over men's souls when Reason sleeps.

Folly, stupidity, greed, superstition were Goya's general targets. Procuresses, prostitutes, marriages for money, hypocritical coquetry, the frivolity of women, the snobbery and vanity of the upper classes, the venality of lawyers and especially the parasitic behavior of monks and priests—all are denounced, upbraided, or satirized. As Goya expressed it when he announced publication of the "Caprichos," "The artist has selected from the extravagances and follies common to all society and from the prejudices and frauds sanctioned by custom, ignorance, or interest. . . ."

At times the tone is shrill, but most of the work is executed with an exuberant zest. Goya flays with such enthusiasm that even the most ghastly creatures of his imagination have life, movement, and vitality. In these, as in many of his prints, he creates a darkened stage with two or three actors highlighted by the footlights. Aquatint is used superbly for shadowy background to heighten the drama. Here, at one sweep, Goya gained a unique position in the ranks of the world's great etchers.

Aquatint is an etching process that enables the artist to obtain a gradation of tones. A fine film of powdered resin is sprinkled on a copper plate, which is heated to make the resin adhere. The acid attacks the plate through the porous ground, creating tiny pits. By stopping out areas with varnish during etching, the artist can create lightly or deeply etched areas which, when inked and printed, will produce a variety of tones.

The eighty plates of the "Caprichos" are divided roughly into two sections, the first mainly exploring the hypocritical mores and vices of private and social life in a society with debased values. This section also contains a dozen more directly political themes, possibly intended to confuse the censor along with the viewer.

Of the first thirty-six plates, thirteen concern prostitutes, sometimes sympathetically as when they meet their inevitable fates, but usually with contempt. This disproportion seems obsessive, and perhaps it was. The series was started after the onset of deafness which some Goya students believe was the sequel to a venereal disease. If true, his bitterness is understandable, and his hatred of Spanish society would have been intensified by his own misfortune. Critical social and political attitudes sometimes have some basis in personal tragedy; in Goya's case, many factors combined to mold his thinking.

His cynical attitude toward courtship and marriage in this first section may also have derived in part from the frustrations

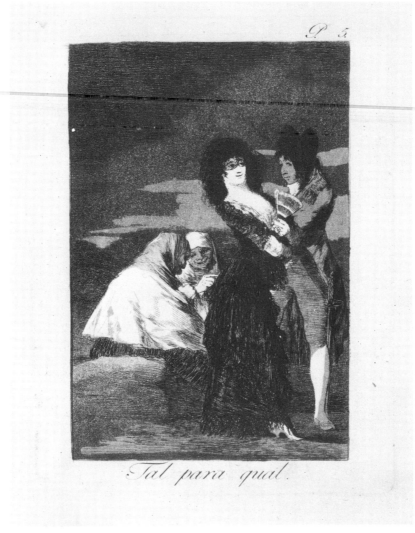

105

and torment of his relationship with the Duchess of Alba. She appears twice in the series, quite uncomplimentarily. In a plate which he deleted in publishing the "Caprichos," a two-faced duchess embraces the artist as her other face looks back to a second lover with whom she secretly holds hands. Its title: "Dream of Lying and Inconstancy."

In "Birds of a feather flock together," we see a favorite target of Goya's ire—the old procuress in the background, often shown telling a rosary as her wrinkled, malicious face gloats over a sale. She appears again in

105. "Birds of a feather flock together (Tal para qual)." Goya. 1799. 7⅞x5¹³⁄₁₆. Etching, aquatint, and drypoint. Plate No. 5 from "Los Caprichos." Hispanic Society of America, New York.

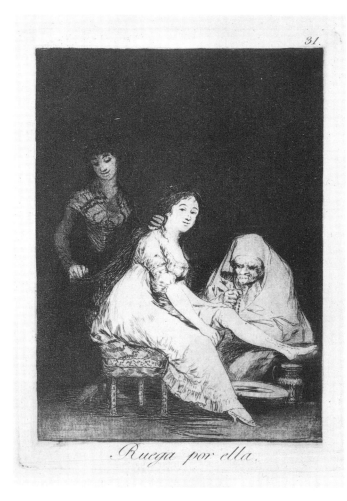

Ruega por ella.

106

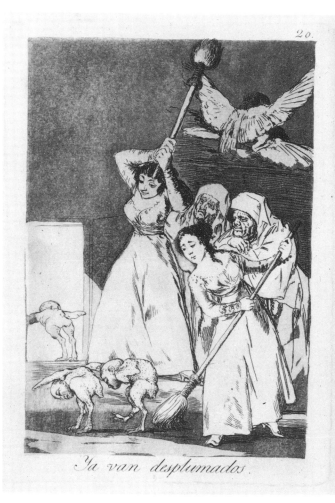

Ya van desplumados.

107

"She prays for her"—praying, as Goya added in his commentary, "that God may give her luck, keep her from harm, money-lenders, and cops."

The prostitutes, having plucked their male victims of their feathers, are throwing them out. Then the prostitutes are them-selves plucked by cat-faced judges. "Give and take," is Goya's wry comment. He is sympathetic when a prostitute is con-demned by the Inquisition. He lashes out at the hated institution with an etching of the *auto-da-fé* that has become a classic, the drawing for which appears on page 99.

106. "She prays for her (Ruega por ella)." Goya. 1799. 8¹⁄₁₆x5¹³⁄₁₆. Etching, burnished aquatint, drypoint, and burin. Plate No. 31 from "Los Caprichos." Hispanic Society of America, New York.

107. "They are going off, plucked (Ya van desplumados)." Goya. 1799. 8⁷⁄₁₆x5¹³⁄₁₆. Etching, burnished aquatint, and drypoint. Plate No. 20 from "Los Caprichos." Hispanic Society of America, New York.

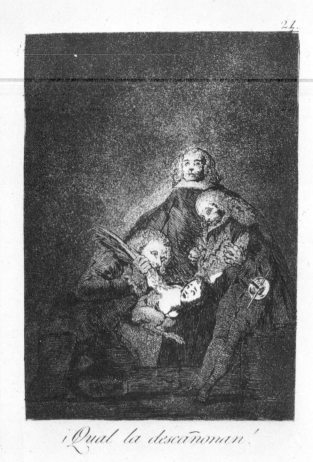

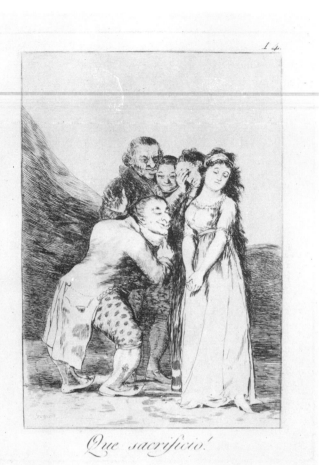

¡Qual la descañonan!

Que sacrificio!

108

109

Marriage was the biggest masquerade of all, in Goya's lexicon. "What a sacrifice! The bride's relatives can't bear to look at the ugly old monster she is marrying—but he is rich and will support the whole family." In another, the bride's snobbish relatives expound the virtues of her ances-

try—"But who is she? He will find this out later."

Between the two sections of the "Caprichos" is a sequence of six plates whose "hero" is probably Godoy appearing in the form of an ass. He is shown applauding "not knowing what," displaying a fake ge-

108. "How they pluck her! (Qual la descañonan!)." Goya. 1799. 8⁷⁄₁₆x5¹¹⁄₁₆. Etching and burnished aquatint. Plate No. 21 from "Los Caprichos." Hispanic Society of America, New York.

109. "What a sacrifice! (Que sacrificio!)." Goya. 1799. 7⁷⁄₈x5¹³⁄₁₆. Etching, burnished aquatint, and drypoint. Plate No. 14 from "Los Caprichos." Hispanic Society of America, New York.

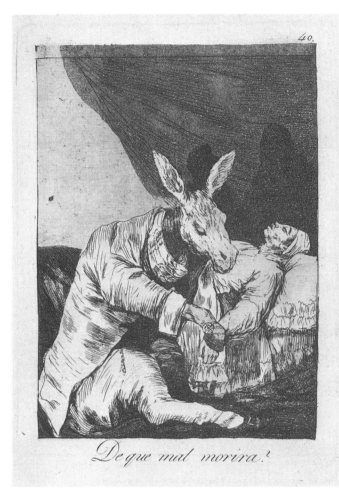

De que mal morira?

110

Tu que no puedes.

111

nealogy, quack "doctoring" a dying man—
either King Charles IV or Spain herself,
and having his portrait painted—in the
shape of a lion! In the final sequence, two
asses (Godoy and king?) ride on the groan-
ing backs of two citizens. Of course this
sequence may simply be satirizing human

vanity, but a political interpretation is not
improbable.

The second half of the "Caprichos" is in-
troduced by a haunting masterpiece that
has intrigued, challenged, disturbed, and
tantalized viewers for generations—"The
dream of reason produces monsters." As

110. "What will he die of? (De que mal morira?)." Goya. 1799. 8⁷⁄₁₆x5¹³⁄₁₆. Etching and burnished aquatint. Plate No. 40 from "Los Caprichos." Hispanic Society of America, New York.

111. "They cannot help it (Tu que no puedes)." Goya. 1799. 8⁷⁄₁₆x5¹³⁄₁₆. Etching and burnished aquatint. Plate No. 42 from "Los Caprichos." Hispanic Society of America, New York.

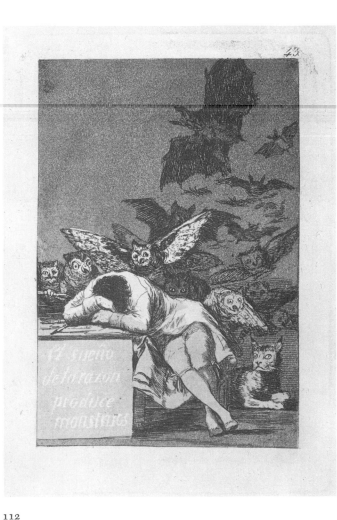

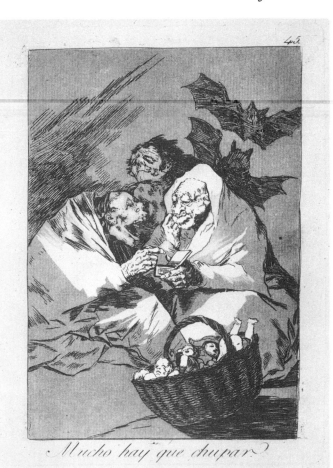

112

113

Goya sleeps, bats and owls defile the night and an unblinking, malevolent cat exudes hostility.

This print has had as many interpretations as there are books on Goya. Its philosophical content is self-evident. "Fantasy abandoned by reason produces monsters; united with reason, she is the mother of the arts and source of their marvels," reads Goya's legend. And Goya saw superstition dominating the Spain of his time.

But, as with so many of the demon-haunted "Caprichos" that follow, do they have social-satirical meaning as well? Is

112. "The dream of reason produces monsters (El sueño de la razon produce monstruos)." Goya. 1799. 8⁷⁄₁₆x5¹³⁄₁₆. Etching and aquatint. Plate No. 43 from "Los Caprichos." Hispanic Society of America, New York.

113. "There is a lot to suck (Mucho hay que chupar)." Goya. 1799. 8¹⁄₁₆x5¹³⁄₁₆. Etching, burnished aquatint, and burin. Plate No. 45 from "Los Caprichos." Hispanic Society of America, New York.

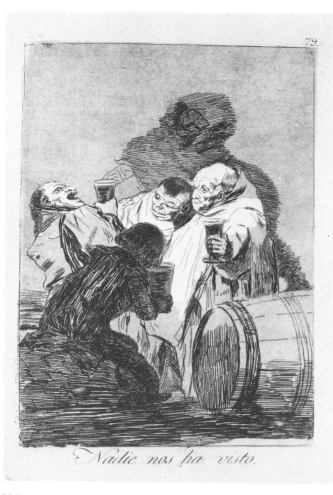

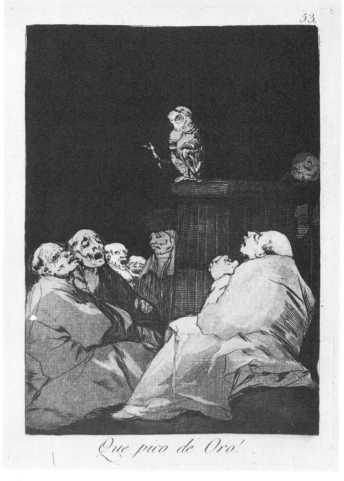

Nadie nos ha visto.

Que pico de Oro!

114

115

there a hidden contemporary reference—beyond the fact that in an age of reason and of enlightenment, Spain had been passed by, still slumbering in a miasma of superstition?

The balance of the "Caprichos" is dominated by monsters, nightmare images, demons, witches, and sorcerers—though there are intervals of reality, as in a dream. "The sort of thing that goes on in the squalid catacombs of the human mind," wrote Aldous Huxley. Again, the witches and monsters could be fantasy expressions of

the fears that haunted the stricken and depressed Goya, or they could be "coded" attacks on the superstitions that plagued man in general and the Spanish people in particular, or maybe they are symbolic figures representing more specific social conditions that offended Goya's sense of reason. Perhaps, they are the products of all three of these sources.

While bats hover, the witches suck the little children dry. Witches were "known" to prey on infants and drain the life from them. But Goya's commentary is pointed: "It

114. "No one has seen us (Nadie nos ha visto)." Goya. 1799. 8⁷⁄₁₆x5¹³⁄₁₆. Etching, burnished aquatint, and burin. Plate No. 79 from "Los Caprichos." Hispanic Society of America, New York.

115. "What a golden beak! (Que pico de oro!)." Goya. 1799. 8⁷⁄₁₆x5¹³⁄₁₆. Etching, burnished aquatint, and burin. Plate No. 53 from "Los Caprichos." Hispanic Society of America, New York.

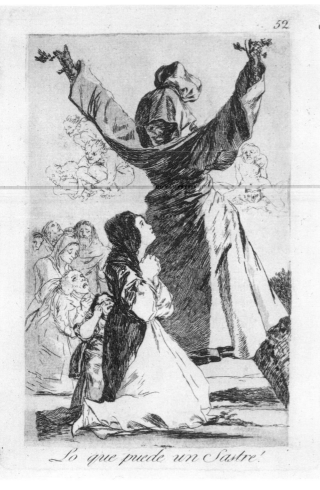

Lo que puede un Sastre!

116

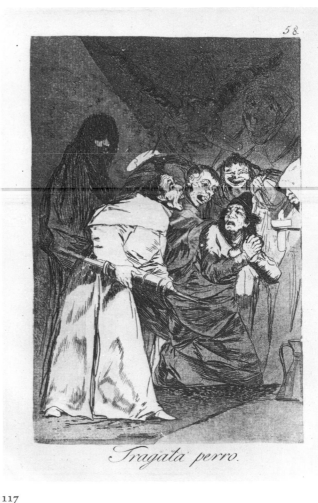

Tragala perro.

117

looks as if man is born into this world and lives just to have the marrow sucked out of him." So whom do the witches really represent? Court hangers-on? Monks? Nobility? In the "Caprichos," Goya impales them all.

Goya's barbs are perhaps sharpest when directed at the clergy. He has them guzzling scalding soup early in the series and wine near the end. (In the preparatory drawing for the soup scene he wrote, "These were the men who were devouring us.") In between, he condemns them for being fools as well as gluttons, and upbraids the super-

stitious for blindly worshiping the cloth. "This is an academic session," he says of the monks absorbing the wisdom of a golden-beaked parrot. He is equally contemptuous of the young woman and the old people kneeling before a monk's cowl spread over the trunk and branches of a tree. And in "Eat that, you dog!" he attacks his two most prevalent abhorrences —religious fanaticism and ignorant superstition.

The "Caprichos" appear to act as a purgative, to free Goya from his personal depres-

116. "Fine feathers make fine birds (Lo que puede un sastre)." Goya. 1799. $8\frac{7}{16}$x$5\frac{13}{16}$. Etching, burnished aquatint, and drypoint. Plate No. 52 from "Los Caprichos." Hispanic Society of America, New York.

117. "Eat that you dog! (Tragala, perro!)." Goya. 1799. $8\frac{1}{4}$x$5\frac{13}{16}$. Etching, burnished aquatint, and drypoint. Plate No. 58 from "Los Caprichos." Hispanic Society of America, New York.

sion. In 1799, Goya was appointed principal painter to the king. Despite his anticlericalism, he painted the frescoes of the cupola of San Antonio de la Florida. He also produced numerous portraits, painted his two *Majas*—naked and clothed—the extraordinary *Charles IV and His Family*, and many others. He made many friends in spite of his intransigence and quick temper and achieved considerable material success, with an imposing, richly furnished home, a carriage, and all the trappings of a man of means. At the same time, he jotted down in his sketchbook what he observed while walking about Madrid—beggars, cripples, everyday scenes.

In 1808, at the age of 62, Goya was faced with another deep crisis and again turned to etching. French troops had entered the country, ostensibly to share with Spain the partitioning of Portugal. Napoleon used the occasion to impose his brother Joseph on the Spanish throne. Although the ignoble Ferdinand VII, who had succeeded his father, bartered his crown and accommodated the usurper—as did most of the aristocracy, higher clergy, and bureaucracy—the people of Madrid revolted on May 2, 1808. The uprising spread, and for six years the country was the scene of barbarous cruelty and inhumanity as the Spanish people fought unrelenting guerrilla warfare against the leading army of Europe. Guerrilla onslaughts led to massive retaliation, often bloody massacres, which led in turn to ferocious counter-atrocities. Scenes reminiscent of the Thirty Years War, of the

Spanish invasion of the Netherlands, and of the French rape of the Palatine were reenacted in all their bestiality. Hunger stalked the land.

Motivations in this harsh cacophony of slaughter were indeed mixed. From the beginning, many elements sought to combine the struggle against the invaders with the struggle to free Spain from its medieval fetters. These "liberals" (this was the first use of the appellation in the political sense) actually succeeded at one point in proclaiming a constitution which called for universal suffrage and education and vested most powers in a democratically elected *cortès* which promptly abolished the Inquisition and the remnants of feudalism and established a graduated income tax.

At the same time, the Church, fearful of French anticlericalism, whipped the peasants into a frenzy of fanaticism, transforming the struggle for independence into a holy war against the anti-Christ and diverting efforts for social emancipation into a drive to restore the absolutism of Ferdinand.

The conservatives, or *serviles,* determined to restore Ferdinand's power and their own prewar privileges, also had the backing of Wellington and the British armies, whose victories eventually guaranteed the monarch's return in 1814—to the cheers of Madrid mobs crying "Long live our chains!"

The uprising placed Goya in a dilemma of conflicting loyalties which he never fully

resolved. Many of his friends who dreamed of reform saw in the French the means of bringing Spain into the nineteenth century. Actually, a constitution and subsequent decrees proclaimed by Joseph swept away many of the archaic institutions that were suffocating the Spanish people; nevertheless, he was attempting to govern by force, which aroused the lasting enmity of many who would otherwise have supported him.

Goya's sympathies with the struggle against the French were paramount, even though he spent much of the war on the fringes of Joseph's court. At the outbreak he was in Madrid, where he witnessed the uprising and the dreadful retaliation which precipitated the war and which he later immortalized in his paintings, "The Second of May" and "The Third of May." In 1809, he was in his birthplace near Saragossa at the time of the French siege of that city and observed guerrilla warfare at first hand. ("Yo lo ví"—This I saw—and "This also," he wrote under Plates 44 and 45.) He was again in Madrid during the famine of 1811–12, when twenty thousand Madrileños died of starvation. The dream of French-led reform became a nightmare of violence and cruelty.

Goya etched the nightmare in a series, "Los Desastres de la Guerra," the most powerful and unforgettable indictment of war in the history of art. "La Guerra" can be translated as "The War" or simply as "War." Goya probably meant *the* war, as he was concerned not with war in the abstract but with the specific war he observed. In depicting the hideous terrors, he indicts man himself—the dark, bestial side of man that emerges when he wages war without quarter.

The impact of the war was shattering on a sensitive observer, and the "Disasters" is a heartbreaking lament for the suffering man is capable of inflicting on his fellow-men. There is no glory here, no pomp and circumstance, no troops marching; just stolid, almost immobile French mamelukes committing acts of bestiality on Spanish civilians, who in contrast are in vigorous motion as they die or wreak vengeance.

Women, children, and old men play their parts. The war is fought out against a starkly bare landscape frequently consisting of only a few figures against the sky. Many of the most violent scenes, especially those of attempted rape, take place under sinister arches, even more foreboding than the arches in Piranesi's prisons. Goya seems as preoccupied here with rape as he was with prostitution in his "Caprichos."

A fierce light burned in this irascible, ill-tempered, sensual old man—a love for the people of Spain, a hatred for those who exploited them, and a disgust when they yielded to superstition or unreasoning mob action.

There are eighty-two plates in the "Disasters." Plates 2 to 47 show scenes of guerrilla warfare; plates 48 to 64 depict the famine of 1811–12; the final 18 plates are symbolic fantasies with political overtones. Three of the plates are known to have been etched in 1810. The first two groups were

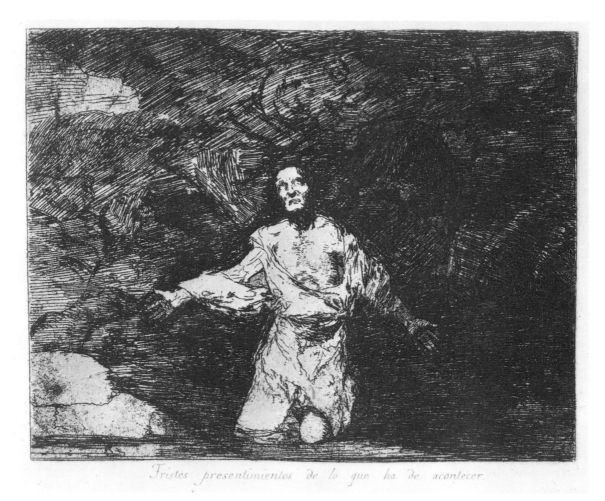

Tristes presentimientos de lo que ha de acontecer.

118

for the most part executed, or at least sketched, when the impressions were fresh. The final group was probably etched after 1820, when a liberal government prevailed, but the series was not published until 1863.

The opening plate, "Sad presentiments of what must come to pass," is grimly prophetic. The next plate shows lightly armed peasants, torn and bleeding, hurling themselves at a wall of fixed bayonets and rifles held by French soldiers. And the brutal war begins.

It is a savage struggle, an incredible ka-leidoscope of death, in brilliant etching and aquatint of black and white, of light and darkness, and often in shadow. "Yo lo ví!— I saw it," says Goya, and he makes the viewer see it too—see it, feel it, live it; one weeps with him, cries out with him in anger, shouts with him for vengeance, until just as an unbearable crescendo is reached, and one cries "Stop!" Goya shifts to starving Madrid, where the agony is as real but slightly more endurable.

The uniformed French soldiers, armed with rifles, bayonets, and swords are impas-

118. "Sad presentiments of what must come to pass." Goya. Between 1810–20. 6⅞x8⅝. Etching, burin, drypoint, and burnisher. Plate No. 1 from "Los Desastres de la Guerra," 1863. Hispanic Society of America, New York.

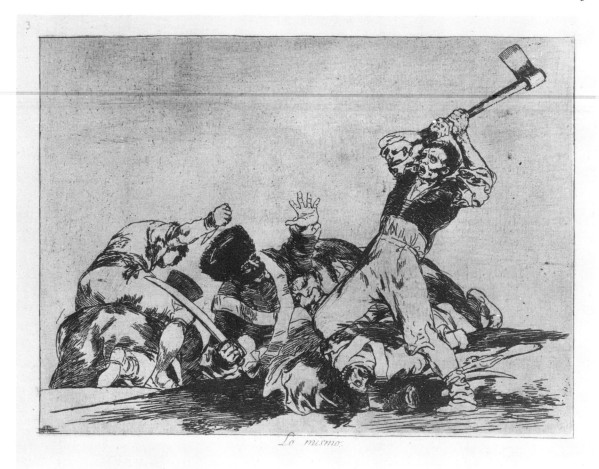

Lo mismo.

119

sive as they mow down the peasants, hack them to pieces, hang them, rape their women, despoil the dead, garrote, execute hostages as "examples," set fire to villages, kill priests, and bombard a town.

There is extraordinary action in every plate. By focusing on just a few figures (there is only one "battle scene" in the series) Goya plunges the viewer into the heat of each fracas. You are "there" alongside the embattled peasants. You feel Goya's identification with them as they struggle for their lives.

Women fight heroically in the opening

119. "The same." Goya. Between 1810–20. 6⁵⁄₁₆x8⁵⁄₈. Etching, lavis, drypoint, burin, and burnisher. Plate No. 3 from "Los Desastres de la Guerra," 1863. Hispanic Society of America, New York.

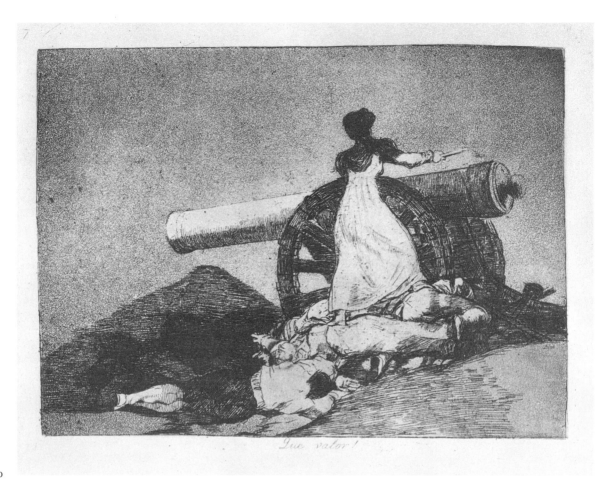

Que valor!

scenes. One clutches her child as she thrusts a pike into a French soldier; another hurls a huge rock. A mother stabs a soldier as he tries to rape her daughter in a sequence of three unforgettable scenes where they are struggling to resist. "What courage!" Goya exclaims as the Maid of Saragossa, celebrated in Byron's verse, fires the cannon and saves the day after all the gunners have been killed.

Peasants, led by a priest, hang other civilians—perhaps traitors, or perhaps French residents—then face firing squads in a scene reminiscent of the war's beginning in Madrid. In plate after plate, the dead lie on deserted battlefields ("The same elsewhere") and are dumped into ditches.

Goya overlooked few aspects of guerrilla or civil war. In two plates, mobs drag a body through the streets. He discriminates: "Mob" is his contemptuous caption for the first—perhaps the victims were innocent; but, "He deserved it," Goya says of the second. The next plate is a scene familiar the world over in this age of indiscriminate bombing of civilians. Beams, furniture, and

120. "What courage!" Goya. Between 1810–20. 6⅛x8¼. Etching, aquatint, drypoint, burin, and burnisher. Plate No. 7 from "Los Desastres de la Guerra," 1863. Hispanic Society of America, New York.

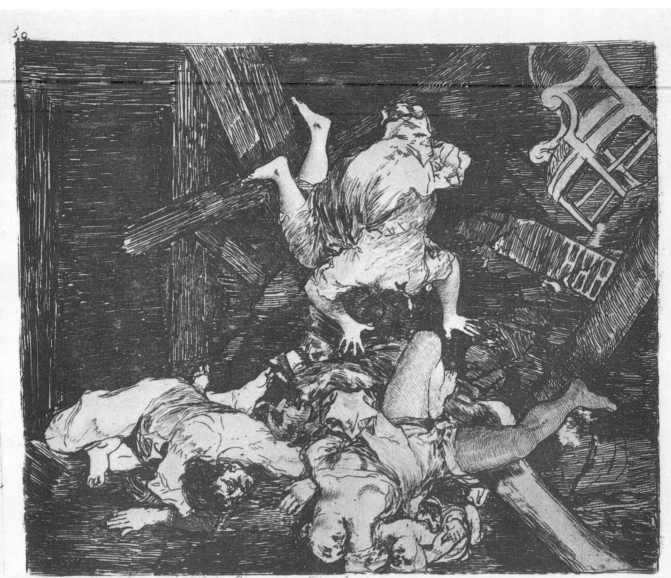

Estragos de la guerra

121. "Ravages of war." Goya. Between 1810–20. 5½x6¹¹⁄₁₆. Etching, drypoint, burin, and burnisher. Plate No. 30 from "Los Desastres de la Guerra," 1863. Hispanic Society of America, New York.

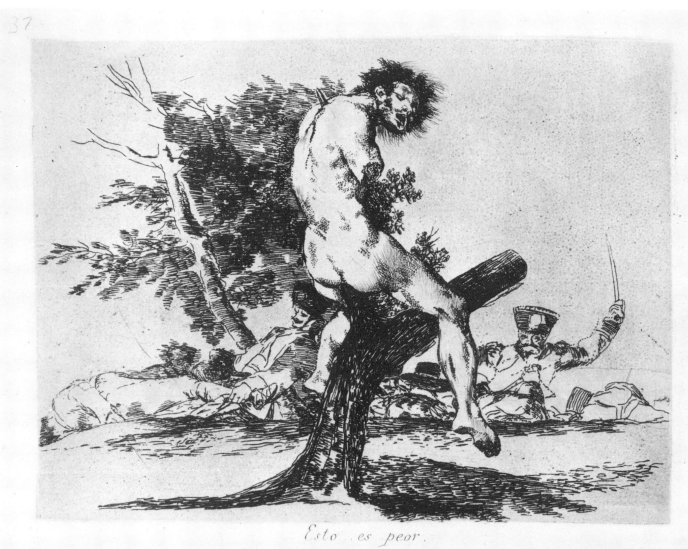

Esto es peor.

122

bodies of men, women, and children are flung helter-skelter after an artillery shell has crashed into their home.

For what? "Barbarism," cries Goya as he then etches a sequence unparalleled in its savagery. The French hang, garrote and quarter their victims, carve them up, and in one nightmarish plate embellish trees with torsos and severed limbs. No wonder the peasants flee. In five plates filled with

122. "This is worse." Goya. Between 1810–20. 6⅛x8¹⁄₁₆. Etching, lavis, and drypoint. Plate No. 37 from "Los Desastres de la Guerra," 1863. Hispanic Society of America, New York.

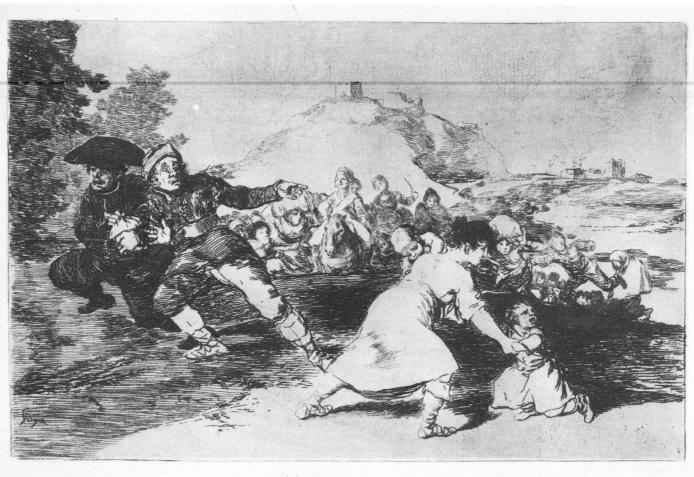

Yo lo vi.

123

panic, horror, and occasional dignity, men, women, children, monks, nuns, and even pigs, flee the flaming villages.

In the final plate of this first section, a despairing priest collapses by the communion rail as French soldiers carry off the church's sacred vessels.

Goya shifts from the interior of the despoiled church to the streets of starving Madrid, to scene after scene of famine, de-

123. "This I saw." Goya. Between 1810–20. 6⅛x9¼. Etching. Plate No. 44 from "Los Desastres de la Guerra," 1863. Hispanic Society of America, New York.

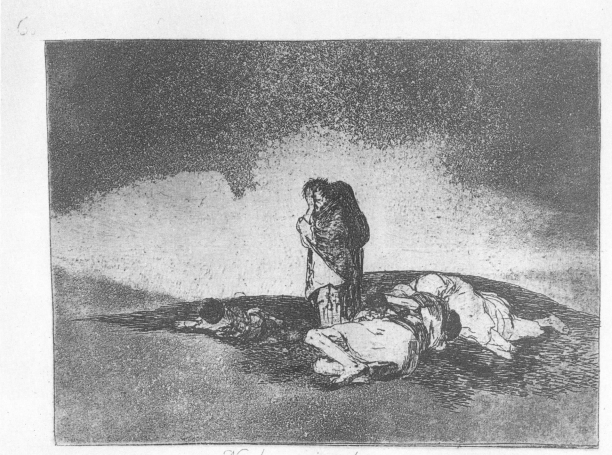

No hay quien los socorra.

124

spair, death. There is no action here—only an unrelieved, somber dirge, deliberately repetitious, as the starving Madrileños collapse in the streets, carry off their dead, beg for food, and starve. "Nobody could help them," Goya says as the grieving survivor stands silhouetted against the sky, the corpses of his family at his feet. In the next plate, one of his bitterest indictments of the social order, he shows that they could have been helped. "As if they were of another race" he comments as a sleek, well-dressed pair observe a starving family while a policeman keeps them safely apart.

124. "Nobody could help them." Goya. Between 1810–20. 5⅞x8¹/₁₆. Etching, burnished aquatint, burin, and burnisher. Plate No. 60 from "Los Desastres de la Guerra," 1863. Hispanic Society of America, New York.

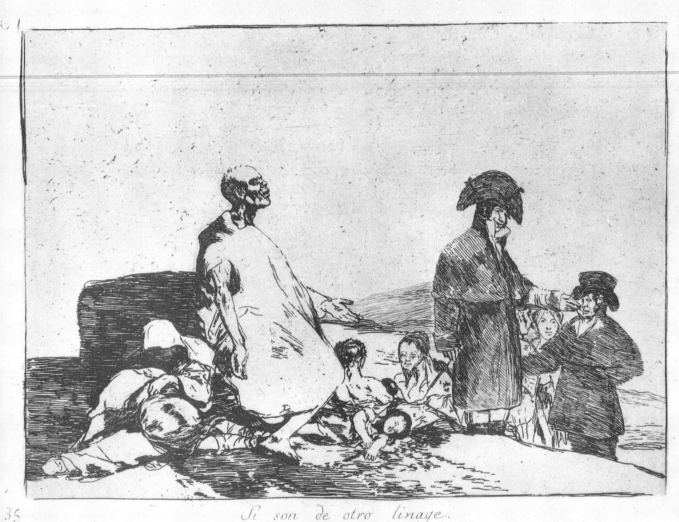

35 *Si son de otro linage.*

125

125. "As if they were of another race?" Goya. 6⅛x8⅟₁₆. Etching, lavis, drypoint, burin, and burnisher. Plate No. 61 from "Los Desastres de la Guerra," 1863. Hispanic Society of America, New York.

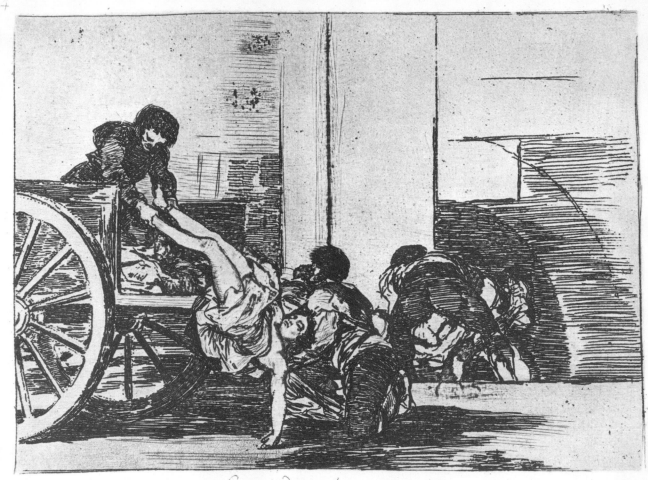

Carretadas al cementerio.

126

In the final plate of this grouping, men are handing bodies down from the carrion cart for burial in a common grave. Goya sketches them as they are removing the lifeless but still lovely shape of a girl. At 66 he still had an eye for the shapely limb, and the saddest deaths seemed to him to be those of the young and beautiful.

The war's end and the restoration of Ferdinand led to a violent reaction that shattered the power of Spain's liberals. The prewar privileges of the aristocracy and

126. "Cartloads for the cemetery." Goya. Between 1810–20. 6⅛x8¹⁄₁₆. Etching, aquatint, drypoint, burin, and burnisher. Plate No. 64 from "Los Desastres de la Guerra," 1863. Hispanic Society of America, New York.

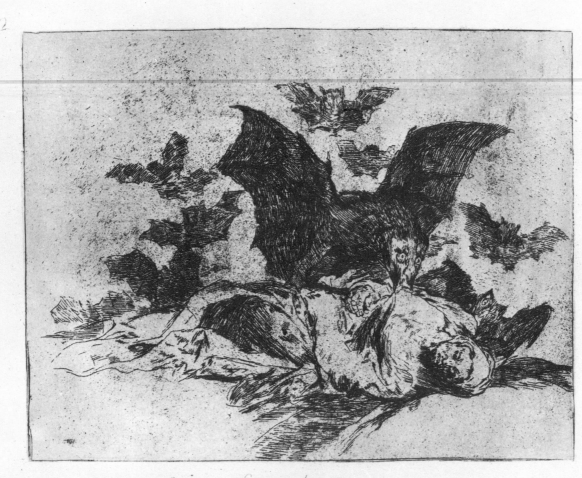

Las resultas.

127

church were restored along with the Inquisition. Strict censorship was reestablished, and liberals of every hue were persecuted and imprisoned.

This disheartening triumph of reaction is reflected in the final sequence of the "Disasters," probably etched between 1816 and 1820. The documentary realism of the previous plates is now replaced by symbolism and allegory. The sequence opens with three plates attacking the return of a fanatical clericalism. Vampires suck on the

127. "The consequences." Goya. Between 1810–20. 6⅞x8⅝. Etching. Plate No. 72 from "Los Desastres de la Guerra," 1863. Hispanic Society of America, New York.

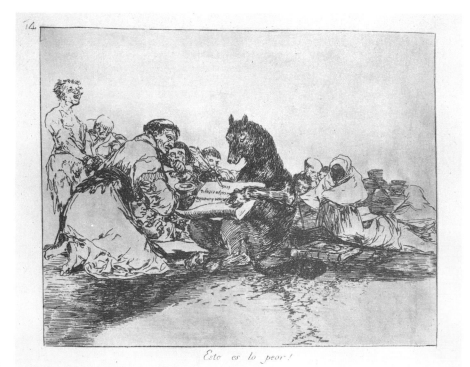

74

Esto es lo peor!

128

75

Farándula de charlatanes.

129

128. "That is still worse." Goya. Between 1810–20. 7 1/16x8 5/8. Etching and burnisher. Plate No. 74 from "Los Desastres de la Guerra," 1863. Hispanic Society of America, New York.

129. "The trickery of charlatans." Goya. Between 1810–20. 6 7/8x8 5/8. Etching, aquatint or lavis, drypoint, and burin. Plate No. 75 from "Los Desastres de la Guerra," 1863. Hispanic Society of America, New York.

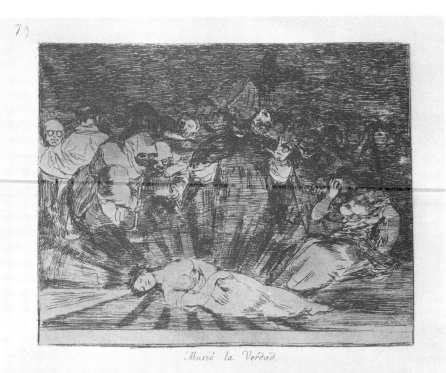

Murió la Verdad.

130

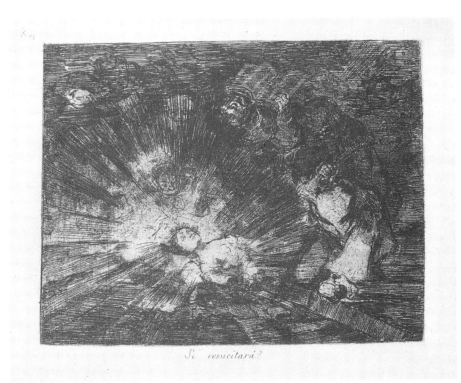

Si resucitará?

131

130. "Truth is dead." Goya. 6⅞x8⅝. Etching and burnisher. Plate No. 79 from "Los Desastres de la Guerra," 1863. Hispanic Society of America, New York.

131. "If she should rise again?" Goya. Between 1810–20. 6⅞x8⅝. Etching and burnisher. Plate No. 80 from "Los Desastres de la Guerra," 1863. Hispanic Society of America, New York.

prostrate body of the man of Spain. "Wretched humanity, the guilt is yours," writes a fierce wolf as fettered people grovel before him. A cleric with the claws and beak of a parrot holds forth to a congregation of asses, wolves, and almost ape-like Spaniards.

"Truth is dead," is Goya's penultimate conclusion. Beautiful Truth lies dead, clerics shovel dirt, a bishop presides over the burial, officials look on, and Spanish women grieve. Typically, Truth is bare-bosomed, almost voluptuous. However, the following plate is optimistic as the priests retreat and Truth's light flowers again. Goya speculates on what would happen "If she should rise again?"

His final note is one of optimism. Truth, now a plump and matronly figure with none of her previous sexual overtones, has indeed risen and is embracing a bearded peasant, hoe in hand, surrounded by the fruits of his toil. Enrique Lafuente Ferrari's summation of Goya is the most judicious: "A pessimist where human nature is concerned, but an optimist in his belief in Progress through Reason."

During Ferdinand's oppressive reign, Goya periodically withdrew from the court to his own world, painting his friends, covering the walls of his country house (La Quinta del Sordo) with macabre and nightmarish "black paintings." He etched the "Tauromaquia," dazzling impressions of the drama of the bullring, published in 1816.

In 1819 Goya had another severe illness,

and it was approximately in that period that he etched the "Disparates," or "Proverbs." Like the "Caprichos," they were created in a mood of deep pessimism and are made up of tortured, nightmarish visions. He was twenty years older now and sunk even deeper into psychological depths of retreat; the acute hallucinatory qualities are much more obscure, the topical references much more elusive, and the mood more somber. Many are Bosch-like attacks on human folly and stupidity; some are sardonic comments on women; others are enigmatic fantasies from the recesses of his mind.

Goya's pessimism was alleviated somewhat in 1820 when the liberals successfully revolted, curbed the absolutism of King Ferdinand, and proclaimed the Constitution of 1812. For three years, Spain was to emerge from the darkness.

During the closing years of Ferdinand's oppression and the early years of the liberals' liberation, Goya composed a remarkable cycle of drawings, now housed in the Prado. Captioned in his handwriting and carefully numbered, their arrangement was obviously meant to be meaningful, but the significance is elusive today. Like the "Disasters" and the "Proverbs," they were not published during his lifetime. Again, Man is his theme—suffering, superstitious, courageous Man. Backgrounds are minimal. In two moving sequences of Inquisition and prison scenes, he creates with a few masterful strokes in India or sepia ink and wash, an imperishable record of the fate that awaited

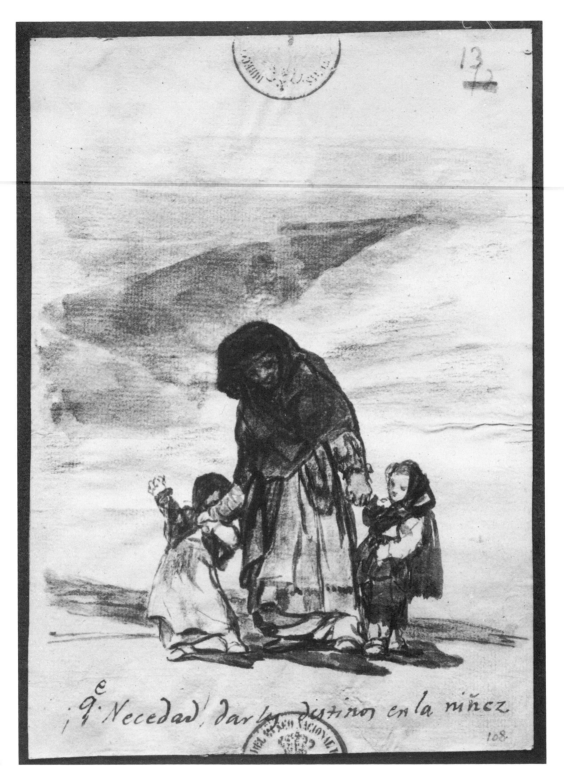

132

¡Qᵉ Necedad! dar los destinos en la niñez

132. "What a stupidity to assign them destinies in childhood." Goya. 1818–24. 8¹/₁₆x5⅝. Sepia and india ink washes. Goya No. 13. Prado No. 15. Musco del Prado, Madrid.

125

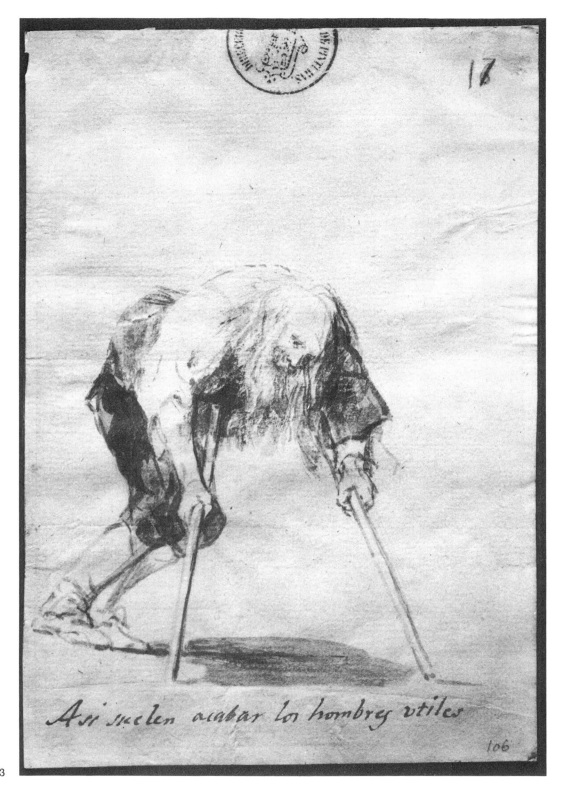

133

133 "So are useful men likely to end." Goya. 1818–24. 8⅛x5⅝. Sepia ink wash. Goya No. 17. Prado No. 46. Museo del Prado, Madrid.

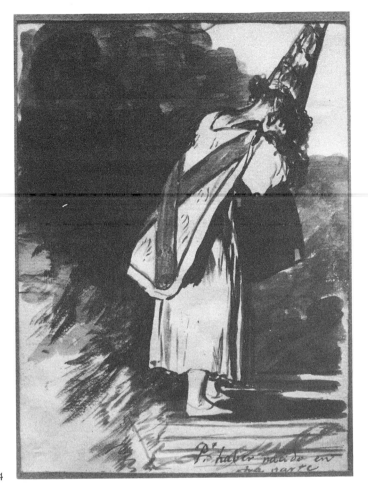

134

seekers after truth in the Spain of his day. Many of the themes have been touched upon before: religious intolerance and persecution, dream images reminiscent of the "Caprichos," beggary, idleness, debauchery, and lechery. As a dramatic counterpoint, however, he interjects three drawings—executed with the utmost tenderness and delicacy—of maternal love, of paternal love, and of a pair of lovers.

Goya's disgust with the rigid social order is expressed in a drawing of a woman with two children, one richly dressed and ill-behaved, the other poorly attired and man-

nerly. "What a stupidity to assign them destinies in childhood," Goya exclaims. In another bitter comment on Ferdinand's Spain, he portrays a dignified, elderly man in tatters but determinedly propping himself up with crutches. "So are useful men likely to end," reads the caption.

Of a half-dozen sketches of victims of the Inquisition, the most haunting is that of a woman standing, scorning fetters, as the flames rise. Wearing the traditional cone-shaped *coroza* and the *sanbenito* on which the "crime" is inscribed—"For having been born in other parts"—she epitomizes the in-

134. "For having been born in other parts." Goya. 1818–24. c.8⅛x5½. Sepia ink wash. Goya No. 85. Prado No. 309. Museo del Prado, Madrid.

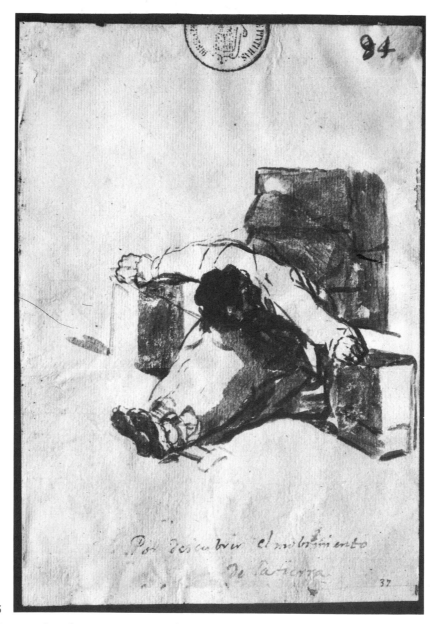

Por descubrir el movimiento
de la tierra

135

tegrity of human freedom. Goya must have drawn this work from memory, for no executions were ordered by the Inquisition after 1808. However, a prison sentence was even more unbearable for some victims. In a notable sequence, he condemns both the inhuman prison practices and the tyranny which imprisoned those who struggled for his twin ideals of Truth and Liberty. "For discovering the motion of the earth" shows Galileo, imprisoned by the Inquisition, forced into submission and debasement—a monumental, haunting figure. "You should not have written for idiots" shows the writer imprisoned, and "For being a liberal?" a woman, or Liberty herself, is

135. "For discovering the motion of the earth." Goya. 1818–24. 8⅛x5⁹⁄₁₆. Sepia and india ink washes. Goya No. 94. Prado No. 333. Museo del Prado, Madrid.

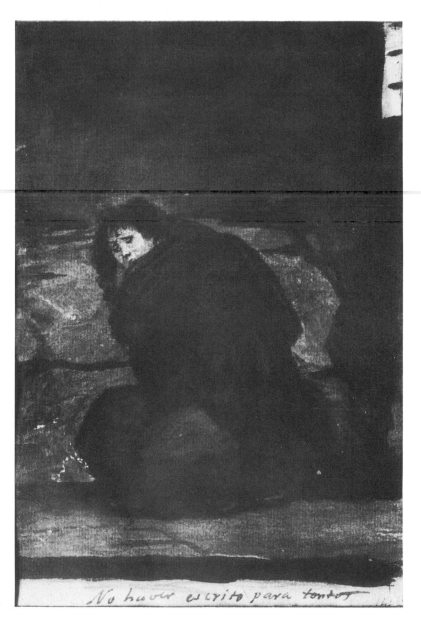

136

136. "You should not have written for idiots." Goya. 1818–24. 8⅛x5⁹⁄₁₆. India and sepia ink washes. Goya No. 96. Prado No. 343. Museo del Prado, Madrid.

chained. The barbarous treatment of prisoners is emphasized; they are often shown chained hand and foot, almost garroted, unable to sit. Always these tragic, abandoned figures are drawn against a background in which light and darkness interplay symbolically.

In the "Caprichos" the only women prisoners are prostitutes; here in several scenes he depicts women in irons, tortured, facing death with dignity and with human spirit unbroken.

In one of his greatest drawings, a delicately featured woman, hands behind her back, is forced to a kneeling position by a monstrous chain. The chain dominates the

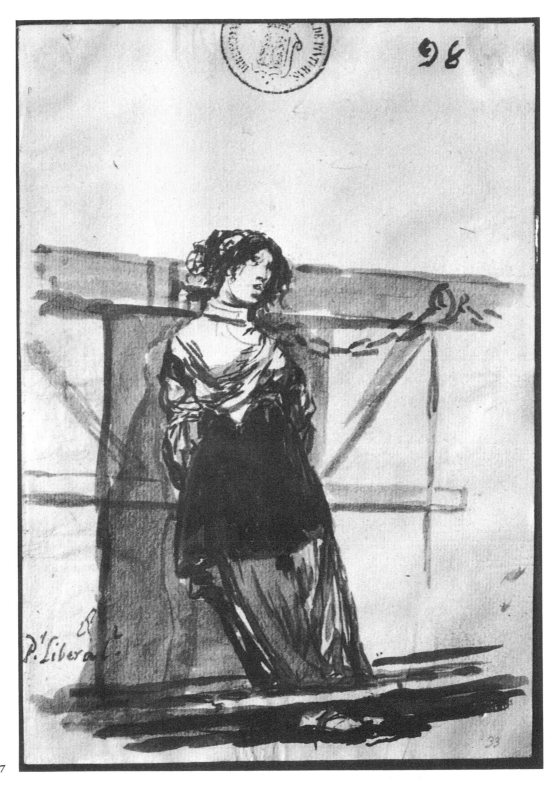

137

137. "For being a liberal?" Goya. 1818–24. 8⅛x5⁹⁄₁₆. India and sepia ink washes. Goya No. 98. Prado No. 335. Museo del Prado, Madrid.

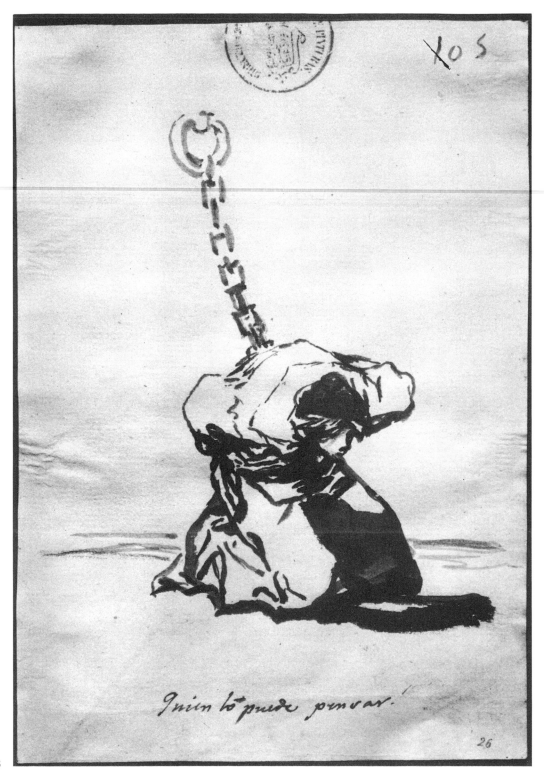

138

138. "Who can think of it!" Goya. 1818–24. 8⅛x5⁹⁄₁₆. Sepia wash with india ink touches. Goya No. 105. Prado No. 353. Museo del Prado, Madrid.

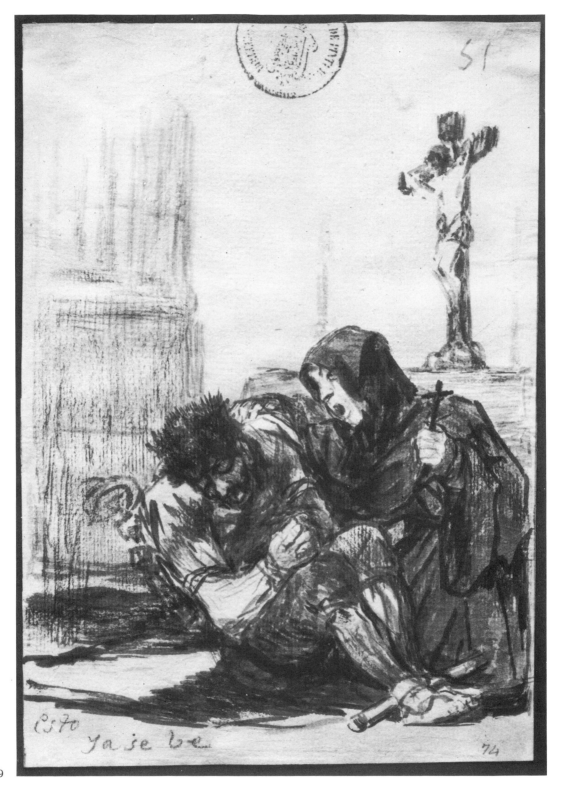

139

139. "One can see it at once." Goya. 1818–24. c.8⅛x5½. India ink wash. Goya No. 51. Prado No. 300. Museo del Prado, Madrid.

scene—the enemy, implacable, unforgettable. "Who can think of it!" indeed.

Goya was probably in his seventies when he made these drawings; he had seen oppressive reaction assert itself time and again, yet his faith in man's struggle for liberty remained undiminished. The prison sequence ends with a paean to Liberty.

His anticlericalism is introduced directly in one of his prison scenes. A pallid monk clutching a crucifix tries to proselytize a chained but strongly masculine prisoner who turns away. The Christ on the cross on the wall is obviously identified with the prisoner.

Some of Goya's sketches of religious figures are occasionally sympathetic, especially in a sequence on the defrocking of nuns and monks, but his relentless anticlericalism—extending over a quarter-century—is overtly associated with the fanaticism and amorality of the religious orders. He probably drew the laborer with a parasitic monk on his back reproduced on page 96 after the secularization law was passed.

But the liberal victory was short-lived. In 1823 the French army crossed the Pyrenees and eventually restored Ferdinand's absolute powers, which he exercised with vindictiveness and stupidity.

Goya, seventy-eight and ailing, applied for six months' leave to visit France "for reasons of health." We have a very felicitous contemporary description by Moratín of his arrival in Bordeaux: "Goya has arrived, deaf, old, awkward, and weak, not knowing a word of French, but happy as a lark and eager to see the world."

He didn't see the world, but he did see Paris, returned to Bordeaux, made lithographs (including the great "Bulls of Bordeaux") and painted. He died there in 1828.

CHAPTER VII
The French Revolution and the Restoration: Prologue to the Nineteenth Century

THE DEATH PLACE of Goya—France—was just beginning to feel the rumblings of a political and economic struggle between conservative and relatively liberal forces that was to shake the country for a century, a conflict that was to be mirrored in some of the greatest protest art of France and the world. The French Revolution had shattered the nation's very foundation. Under the Restoration, France settled into a modified form of the pre-Revolutionary pattern, but the forces set in motion by the events of 1789 were again regaining momentum. The Revolution and the Restoration thus provided a prelude to the full-scale political and artistic drama to follow.

Throughout most of the eighteenth century in France, there were sputterings of mildly satirical art, mostly of historical or antiquarian rather than of artistic significance. John Law's financial system, the nobility, and the Jesuits were occasional targets, but the caricatures were mere pinpricks. Cartoons satirizing hypnotism, the dubious practices of medicine, and fashion were frequently of little aesthetic merit. One of the first caricatures of physicians was Watteau's drawing of a Dr. Misaubin surrounded by the caskets and bones of his victims. There was no outlet for work sharply critical of an obviously vulnerable society. The court and the aristocracy provided practically the only audiences that painters and engravers had, and the government restrained political satirists by banning prints or imprisoning their authors.

The Revolution unleashed a flood of prints, but for the most part these anonymous works were undistinguished. A few of those hostile to the Revolution's excesses are of interest. Better executed than most was "Exercise of the Rights of Man," abounding in Gillray-like exaggeration of

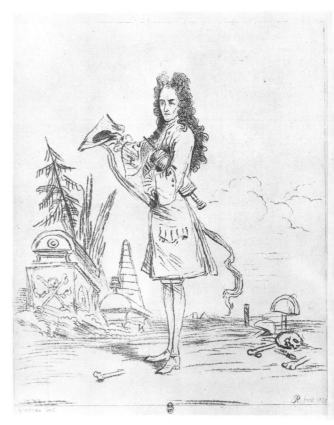

140

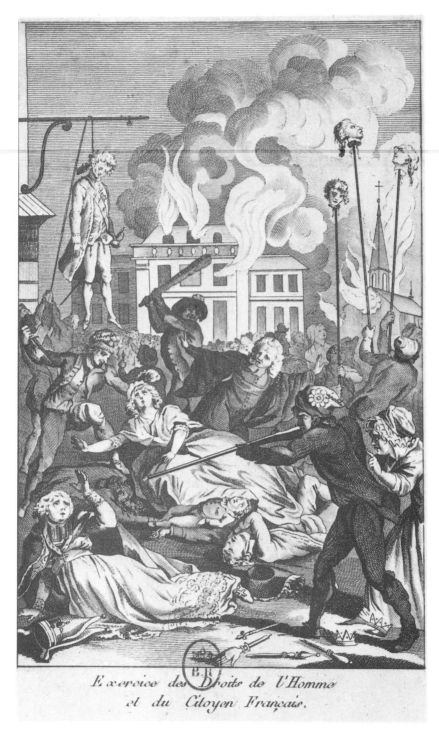

Exercice des Droits de l'Homme et du Citoyen Français.

141

140. "Dr. Misaubin." A. Ponden. 1739. 9½x7¾. Etching. After Antoine Watteau's 1720 drawing. Bibliothèque Nationale, Paris.

141. "Exercise of the Rights of Man." Anonymous. 1792. 13½x15. Engraving. Bibliothèque Nationale, Paris.

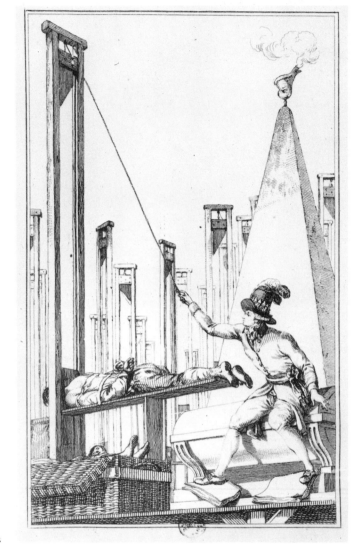

142

horrors but well composed. The outstanding critical print was "Robespierre guillotining the executioner (after having guillotined every Frenchman)," a striking work fittingly surrealistic in its vertical design. Each guillotine is reserved for a special category of victims—priests, nobles, generals, women. The funeral pyramid is labeled, "Here Lies All France."

Advocates of the Revolution ground out hundreds of cartoons and caricatures, helping to prepare the way for the drastic

142. "Robespierre guillotining the executioner." Anonymous. 1794. 5½x3⅛. Engraving. Bibliothèque Nationale, Paris.

143. "Funeral of the Clergy." Anonymous. 1789. 6⅝x9⅜. Etching and wash. Bibliothèque Nationale, Paris.

144. "Pitt's Plot." Jacques-Louis David. 1794. 12½x19⅞. Hand-colored etching. Bibliothèque Nationale, Paris.

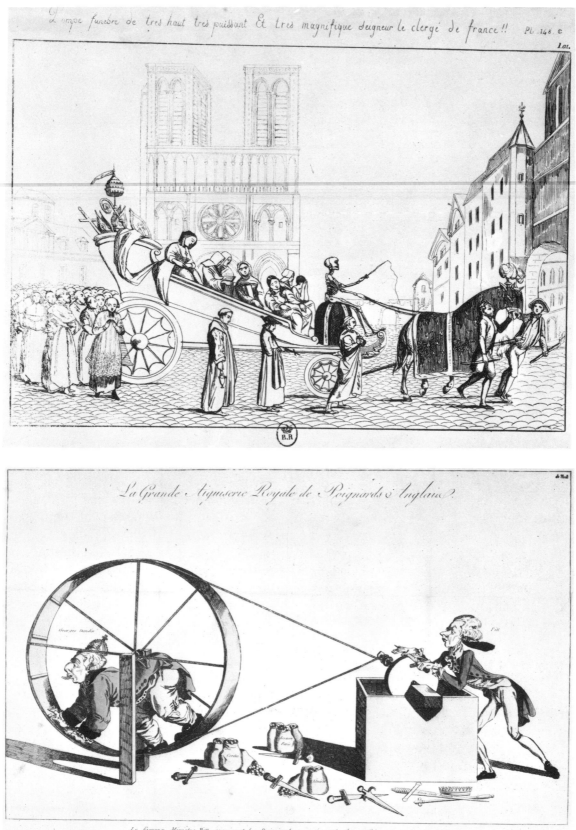

Pompe funebre de tres haut tres puissant Et tres magnifique seigneur le clergé de france!!

Pl. 148. C.

Lat.

B.R

143

La Grande Aiguiserie Royale de Poignards Anglais.

Le fameux Ministre Pitt aiguisant les Poignards avec lesquels il veut faire assassiner les défenseurs de la liberté des Peuples, le gros Georges Dandin tournant la roue et haletant de fatigue.

144

137

events of the Revolution in 1793. Somewhat superior was the "Funeral of the Clergy," with the kind of caption Daumier and his cohorts were to compose with such glee: *Pompe funèbre de très haut, très puissant, et très magnifique Seigneur, le clergé de France.*

In hindsight, critical art might have played a constructive role in molding the course of the Revolution, but the authorities gradually intervened, especially after 1792. They discouraged any art that tended to "mislead, belittle, or insult the common people" and encouraged art favorable to the principles of the Revolution and exposing its enemies. Jacques-Louis David lent his considerable abilities to a series di-

rected against the English critics of the Revolution. In "Pitt's Plot," David has Prime Minister Pitt sharpening his daggers to assassinate the "defenders of the liberty of the people." A breathless, puffing George the Third turns the wheel. An amusing, uncluttered conception, but since it is by the Revolution's foremost painter, it is apparent that mediocrity was the rule. In attacking their enemies, the pro-Revolutionary printmakers tried to out-Gillray Gillray in coarseness but lacked his saving touch of inspiration.

Unfortunately, didactic art lauding the virtues of a society or expounding its principles has innate weaknesses and can never have the vivacity or interest of critical art.

145. "All Men Are Equal." Anonymous. Colored etching. Bibliothèque Nationale, Paris.

Perhaps typical of government-sponsored art was the print "All Men Are Equal," extolling the Decree of May 15, which guaranteed equality. Reason demonstrates that white and black are equal, while the devils of injustice and aristocracy flee across the waters. Laudable as its intent may be, it has the static and stiff quality usually found in prints hailing civic virtue or high principle. In too many of these prints, Reason is presented as a classic figure in flowing robes, lifeless and heavy-handed.

The Napoleonic era was the satirist's heyday. Caricatures of Napoleon were forbidden within France's borders, but from nearly every corner of Europe, engravers and etchers poured out a mounting volume of anti-Napoleonic caricatures. One book reproduces almost a thousand and lists another eight hundred. The English satirists, Gillray, Rowlandson, and Cruikshank, as we have seen, were outstanding. None could compare in conception and draftsmanship with Gillray's "The French-Consular-Triumverate Settling the New Constitution," in which Napoleon swiftly drafts a new constitution, tailor-made for his powers, while the other consuls bite their pens. For the most part, the caricatures of Napoleon had much more polemical than artistic value. They served the purpose, however, of maintaining and extending the tradition of political cartooning.

After a generation of revolution and a war that culminated in crushing defeat, the majority of Frenchmen in 1815 were ready to settle for order and tranquillity under

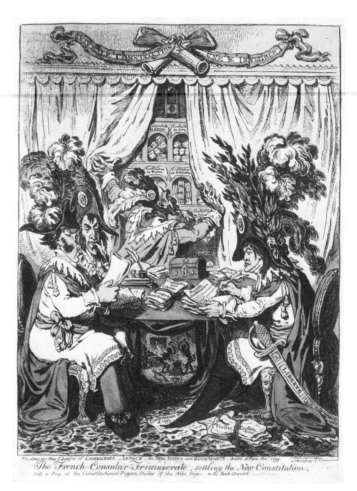

The French-Consular-Triumverate, settling the New Constitution,
with a Peep at the Constitutional-Pigeon-Holes of the Abbe Sieyes in the Back Ground

146

the restored Bourbon King Louis XVIII. But this understandable yearning was doomed to frustration, for inherent in the structure of 1815 France were numerous elements making conflict inevitable.

The nobility had returned, allied with church and crown to hold back the "people." With most of their wealth gone and their lands confiscated, the nobles looked

146. "The French-Consular-Triumverate." James Gillray. 1800. 13x9½. Colored etching. British Museum, London.

139

longingly at their former possessions and position. The church, its power clipped, looked beyond the Alps to the Pope for support.

The chief benefactors of the Revolution had been the bourgeoisie. Some of them had bought the confiscated estates and formed a new, conservative, landed gentry. Others were successful in the professions or in manufacturing. Indifferent or hostile to the church, the middle class aspired to political control. While the government was representative in form, its substance was quite different. Suffrage was confined to about 100,000 males over thirty who had each paid at least 300 francs in taxes. Skilled and unskilled workers, small shop-keepers, and peasants still made up the vast majority of French citizenry. The peasants alone comprised 75 percent of the population. In many parts of France, agriculture was still at an almost medieval level, with poverty the rule. The peasantry was hard-working, mostly illiterate, conservative, and indifferent to the larger issues fought in the halls of the Chambre. Industry, much less advanced than in England, was concentrated in the overcrowded larger cities. Women and children worked long hours, strikes were forbidden, and all industrial workers had to carry *livrets*, or workbooks, in which the employer was supposed to enter a record of his employee's conduct, making police control of the disgruntled easy.

Thus, the stage was set for a series of conflicts that were to convulse France through-out the nineteenth century: the struggle for supremacy by the bourgeoisie against nobility and church; the efforts of the petty and urban bourgeoisie and workers to extend suffrage and make France a republic; the drive by workers for economic and social reform, to regain the heritage of the Revolution and to transform France into an economic as well as a political democracy.

For five years a moderate cabinet governed the country, but in 1820 the Rightists gained power. Press censorship was re-established and all engravings had to be approved prior to publication. A few small outbreaks in 1822 were quickly suppressed, and in 1823, as we have seen, the French government sent its army into Spain to restore the absolutism of Ferdinand and the church and to crush the liberal government.

French liberals were bitterly opposed to this foray. Théodore Géricault, in a sketch preparatory to a huge painting, seized upon the occasion to contrast this forcible restoration of reaction with the action of Napoleonic troops in Spain fifteen years earlier, when they opened the gates of Inquisition prisons. Although unfinished, the drawing, "Liberation of Victims of the Inquisition," captures the excitement, bewilderment and joy as the prisoners are reunited with their families.

Tall, elegant, gentle, sport-loving, sensitive, Théodore Géricault (1791–1824) played a pivotal role in the development of nineteenth-century French art, providing a

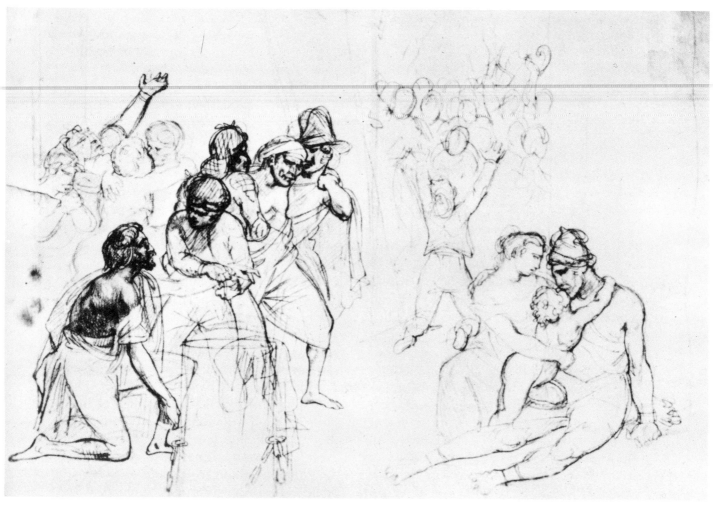

147

transition between the traditional classicism and romanticism, naturalism, and realism. Delacroix, his friend, drew inspiration from him, as did Courbet almost two generations later. Géricault set a bold precedent for militant liberalism in art with meaningful social content. He established a tradition that was to endure throughout the century. He accomplished all this in a brief life span of thirty-two years.

Géricault was born in Rouen of moderately wealthy parents. In his late teens he studied art in Paris and exhibited his "Officer of the Imperial Guard" at the Salon of

147. "Liberation of Victims of the Inquisition." Théodore Géricault. 1823. 16⅜x22⅝. Pencil and red chalk. Pierre Dubaut Collection, Paris.

1812 when only twenty-one. His paintings at that time were influenced mostly by Rubens' dynamic movement and Gros' heroic themes. Studies in Italy, particularly of the works of Michelangelo, helped complete Géricault's artistic growth. On his return to Paris, he was involved in an artistic and political circle opposed to the Restoration and became an active liberal.

In 1818, Géricault found a theme worthy of his artistic and political demands. After a ship, the *Medusa,* was wrecked off Africa, forty-nine survivors were put on a raft and towed by rescuers. But the hawser broke and for twelve days the hapless victims drifted on the high seas. Only fifteen survived. The tragic event became not only a human but a political *cause célèbre* when it was learned that the ship's incompetent captain, an old *émigré,* had been appointed out of favoritism by the Bourbon Restoration government. The symbolism of a shipwrecked France, drifting aimlessly, its people despairing, as well as the inherent drama of the raft scene, appealed to all Géricault's senses. He worked intensely for sixteen months to prepare the immense canvas, which covered forty square yards. His romantic-naturalist handling of the agony on the raft is reflected in the sketch reproduced here. The political reaction to "Raft of the Medusa" was immense. It failed to make the impact Géricault expected, although its artistic influence grew as the years went by. As Géricault's biographer, Klaus Berger, has written, "The neoclassicists discussed its composition and the structure of its space, the romantics the physical intensity of the scene, and the realists the reportorial vividness of the events portrayed."

Disappointed at the immediate reaction to the "Medusa," Géricault went to England to accompany his painting on a traveling exhibit. It was a huge financial success, attracting large crowds everywhere. Géricault's stay in England was artistically fruitful as well. His drawings and paintings of horses reached their height in the almost impressionistic "Epsom Derby" and in magnificent studies of workhorses.

In London, Géricault's acute observation and human sympathies prompted a series of drawings and lithographs of life among London's poor. His identification with the oppressed and the sick was consistent; he was one of the first artists to portray poverty with some involvement. Despite the embarrassingly sentimental title (lifted from Gillray out of a quotation by Burke), "Pity the Sorrows of a Poor Old Man," Géricault's lithograph of a beggar fainting from hunger outside a bakery is indicative of his mastery of the chiaroscuro potential and the tonal qualities of lithography.

Lithography, invented at the close of the eighteenth century by Alois Senefelder, is based on the principle that water and grease do not combine. The artist draws on a lithographic stone with a greasy crayon. After the stone is wetted, greasy ink ap-

148. Sketch for "Raft of the Medusa." Théodore Géricault. 1818. 16⅛x23. Pen and ink. Gemeente Musea van Amsterdam.

149. "Pity the Sorrows of a Poor Old Man." Théodore Géricault. 1821. 12⅜x14⅝. Lithograph. Bibliothèque Nationale, Paris.

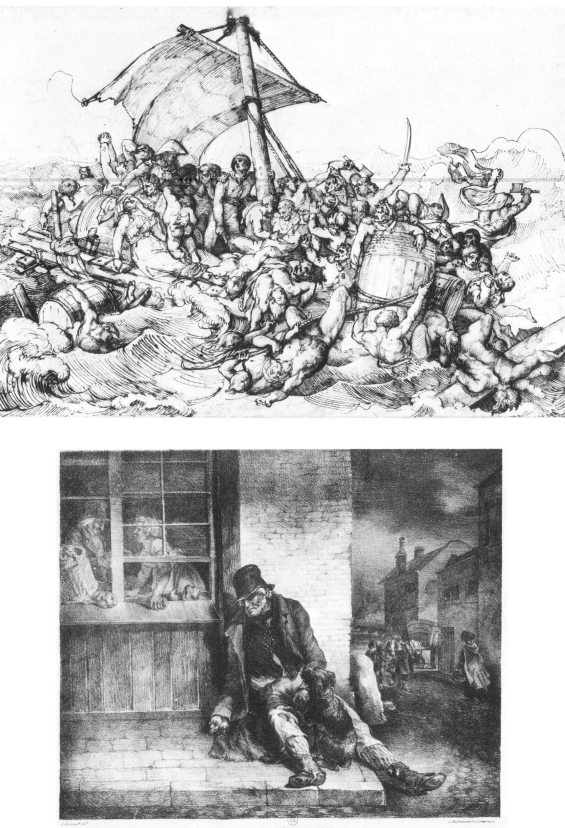

148

149

"Pity the sorrows of a poor old Man!"
"Whose trembling limbs have borne him to your door."

143

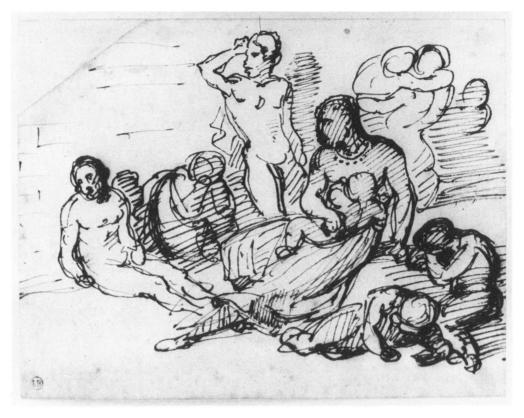

150

plied to the stone adheres only to the areas touched by the crayon. In certain cases, a large number of prints may be pulled. Hence, once again, the times seemed to have created the medium. Lithography came just in time to play a key role in the democratic revolution.

Back in Paris in 1822 and 1823, Géricault made sketches for two huge unexecuted frescoes. One was the Inquisition liberation scene mentioned above, and the other, "The Slave Trade." The latter, par-

ticularly, reflects Géricault's desire to fuse art with reality. Slavery was one of the outstanding issues of the day, and it is not surprising that it stirred Géricault's passion. He had made many portrait studies of blacks, all of them with dignity and individuality instead of the conventional exoticism. Although the *Medusa* survivors did include three blacks, it is significant that Géricault should assign the key role in the painting to a black.

Géricault's humanity was also reflected

144 150. Sketch for "The Slave Trade." Théodore Géricault. 1823. 4⅛x5¼. Pen. Photo Aubert, Musée Bonnat, Bayonne.

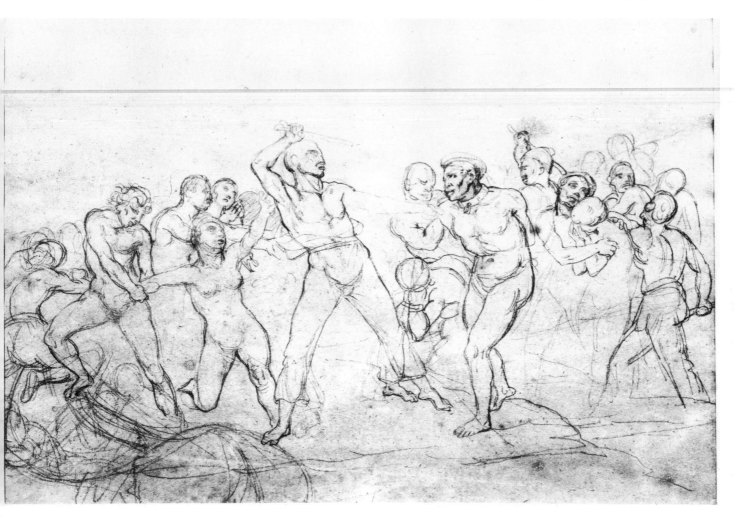

51

in his sympathy for the Greek struggle for independence, which he attempted to portray, and in a remarkable group of perceptive, sympathetic portraits of insane men and women.

Melancholic, alienated, and enigmatic after his return from England, Géricault plunged into feverish speculation and intense high living with spurts of great creativity. He died in 1824 at thirty-two from a spinal injury exacerbated by a series of accidents while riding his beloved horse.

151. Sketch for "The Slave Trade." Théodore Géricault. 1823. 12x17. Pencil and red chalk. Photo Giraudon, École des Beaux-Arts, Paris.

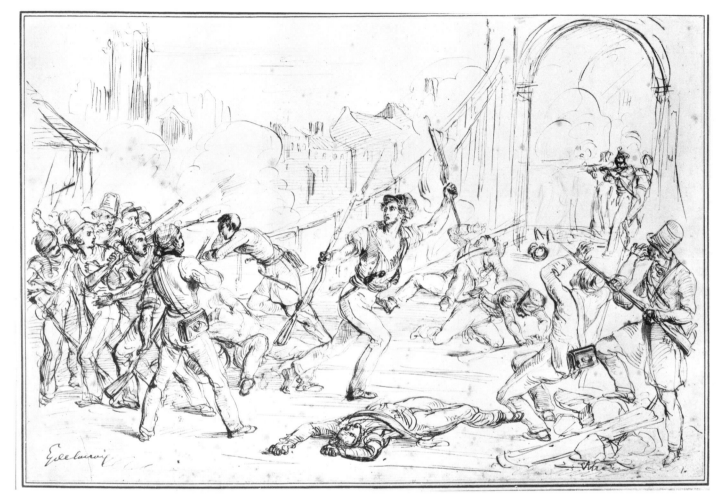

152

In 1824, Charles X, a Rightist under cler-
ical influence, succeeded to the throne upon
his brother's death. The charming and ele-
gant Charles X never grasped the need for
any constitutional limitations upon his pow-
ers. In restoring the powers of the church

and issuing decrees which gave the church
control of education and provided the death
penalty for sacrilege, he succeeded only in
strengthening the forces of anticlericalism.
His policies were so reactionary that even
the very limited electorate returned majori-

152. "Fight on the Barricades." Eugène Delacroix. 1830. 13¼x19¾. Pen drawing. Grenville L. Winthrop Bequest,
Fogg Art Museum, Harvard University, Cambridge.

ties against him, which he continued to ignore. Finally, on July 26, 1830, he issued four drastic, ultra-Royalist decrees.

Barricades went up all over Paris. Students, workers, and national guardsmen, who had been disbanded, joined with the Republican bourgeoisie and attacked the small government force. Four days later, Charles abdicated and fled into exile, and the restored Bourbon monarchy came to an end.

Géricault's disciple and friend, Eugène Delacroix, captured the spirit of the July Revolution in his masterpiece, "Liberty Leading the People," one of those rare moments when the right artist was at the right place at the right moment. So rare, in fact, that it was one of the few times that Delacroix related his work to the contemporary scene.

Alexandre Dumas reports that when revolution was imminent, in that late July of 1830, he found Delacroix fearful when he met him near the Pont d'Arcole where men were sharpening their daggers. But two days later, Delacroix was excited and eager. His enthusiasm caught the passion of the "Fight on the Barricades," shown here, with young Arcole rallying the insurgents. Delacroix's enthusiasm continued until he completed the painting, stemming in part from this sketch.

The painting was denounced by the *Journal des Artistes* because only "urchins and workmen" and "rabble" were depicted. Why, the journal asked, did he not portray the noblemen and doctors and lawyers who actually took over from Charles X?

The question raised by the *Journal des Artistes* symbolized the struggle that was to agitate France throughout the rest of the century. Were the benefits of the Revolution to be restricted to men of property, or were they to be shared by "workmen" and "rabble"? Many French artists were to lend their talents and devote their passions to a more democratic extension of these benefits.

CHAPTER VIII
Daumier and His Contemporaries: France, 1830–71

THE July Revolution of 1830 was a triumph for the upper bourgeoisie, but a bitter disappointment to the republicans. They wanted no part of a king, even a "citizen king" such as Louis-Philippe, whose truncated powers were bestowed by the Chambre, not by God. Nor were they mollified when Louis-Philippe walked the streets of Paris, umbrella in hand, like any middle-class Parisian.

To the liberty-loving, reform-seeking republican artist of the day, Louis-Philippe was the symbol of dashed hopes, of mediocrity and materialism triumphant, of a detested monarchical form of government. In one of his few genuine inspirations, Charles Philipon—caricaturist, publisher, and relentless gadfly—hit upon the resemblance between Louis-Philippe's jowled physiognomy and a plump pear, slang in French for simpleton or dope. Many of his fellow artists, like gleeful delinquents, returned to the theme again and again.

The reasons that so disillusioned the artists and their fellow republicans lay in the structure of the government and the composition of French society after the July Revolution.

Theoretically a constitutional monarchy, the government was in fact an oligarchy of landowners, with suffrage restricted to a small minority. Understandably, the un-reconciled republicans pressed relentlessly for a broadened electorate. At times they were joined by the social reformers whose goals extended beyond a truly representative form of government to a drastic overhauling of the entire social structure. While the vast majority of Frenchmen were peasants, a rapidly growing working class was becoming increasingly restless and militant in protest against long hours (many worked more than twelve hours a day), poor housing, and the unsanitary conditions of their slums in the textile cities and towns. They too were disappointed in the July Revolution from which they had hoped for an improvement in their marginal existence and a relief from the haunting specter of unemployment.

The accession of Louis-Philippe opened the Age of Get-Rich-Quick. His advisers, confidants, and supporters wanted freedom to build their fortunes unhampered by governmental restriction or by pressures from worker or peasant movements. Cautious, prudent men of affairs were now in power, seeking only to maintain the political and economic status quo; socially, their goal was "*vivre noblement.*" It was an age similar to that of England in the reign of Victoria and of the United States in the 1870's and 1880's, but more primitive, more ruthless.

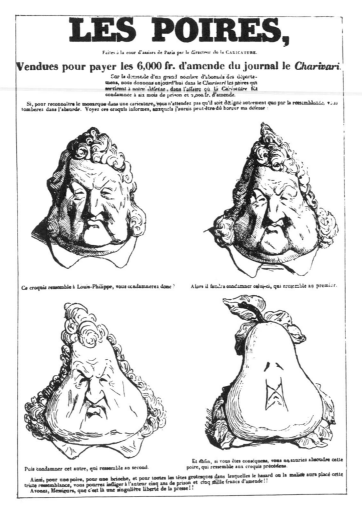

Arrayed against these entrepreneurs were republicans seeking a democratic society, moderate social reformers, radicals, urban workers, and Romantic writers and artists who were repelled by the materialism of the age and indignant at the obvious injustices—but vague in their aims and methods of achieving change. And, as always, university students and frustrated youth rebelled against the prosaic, the material, and the oppressive atmosphere.

The inactivity of Louis-Philippe and his ministers in the face of critical needs, and their desire for "order" when conditions be-

153. "The Pears." Charles Philipon. 1832. 12½x9½. Woodcut. From *Le Charivari*, Jan. 17, 1834. Prints Division, Astor, Lenox and Tilden Foundation, New York Public Library.

neath the surface were so chaotic, made turmoil inevitable. Imprisonments, beatings, and repressions only exacerbated the situation.

In 1831, textile workers in Lyons revolted, and barricades arose in Paris when two workers' newspapers were suppressed. Both uprisings were crushed, but resistance continued and the voices of dissent grew more strident.

Artists with a polemical bent had both weapon and means at hand. The weapon was the relatively new technique of lithography and the means were two newspapers edited and published by a remarkable caricaturist, Charles Philipon, who was to wage editorial war for thirty years against French governments with bludgeon, sword, and lance, or, when balked by outraged censorship, with needle and stiletto.

Philipon launched *La Caricature* as a completely political weekly in 1830; two years later he added *Le Charivari,* which had more literary pretensions and was somewhat broader editorially, containing notes on fashions and Parisian life. From the outset Philipon planned a graphic as well as written onslaught on the governmental establishment. Political cartooning had become, in the phrase of Champfleury, art critic and chronicler of caricature, *"le cri des citoyens."* And Philipon had an extraordinary range of talents from which to draw. Balzac wrote polemics at *La Caricature* under a nom de plume, and leading satirical artists pilloried political leaders; among them were Daumier, Grandville,

Raffet, Traviès, Vernet, Gavarni, Forest, and Alexandre Decamps.

La Caricature, read Philipon's announcement, was edited "by young people, addressed to young people." Young his artists were—all in their twenties or early thirties; they had the courage, the enthusiasm and exuberance, the ferocity of youth. At the same time they had the tendency of youth to oversimplify and exaggerate maliciously; they often portrayed Louis-Philippe and his advisers in such odious and grotesque ways that it seems miraculous that *La Caricature* survived as long as it did.

Philipon's artists were bullterriers, barking belligerently and snapping at the heels of a furious government, dodging the kicks of the outraged victim, often sinking their teeth into ankles or calves, biting painfully but never reaching throat or vital artery. The retaliatory blows were mainly financial, in the form of fines. To avoid a constantly threatening bankruptcy, Philipon then launched *L'Association Mensuelle,* a monthly series of lithographs sold by subscription.

The artists varied greatly in their political philosophies; they were united by a love of liberty and a detestation of the government and its allies. They portrayed Liberty being branded, and Louis-Philippe was shown firing at the charter and stabbing the constitution. Their blasts were often both ingenious and ingenuous, always courageous and frequently vicious. Except for much of Daumier's work, most were of only passing interest, usually too

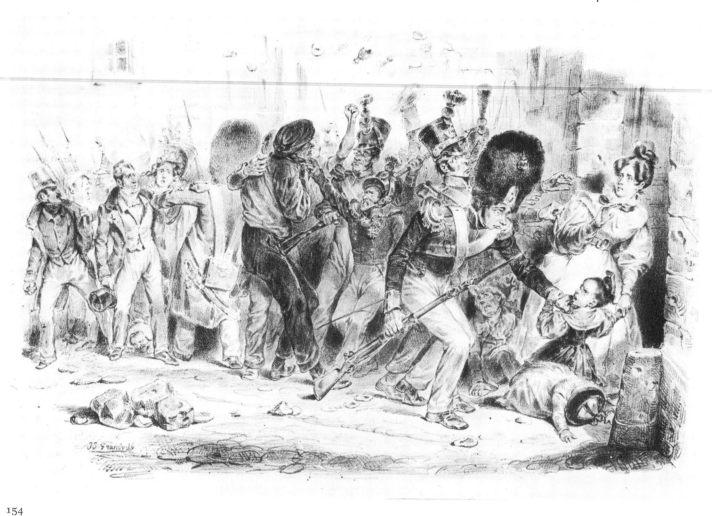

154

tightly or too loosely drawn or composed, blurring their impact. A few are worth noting.

Typical was Grandville's "La Grippe," an oblique protest against the quick suppression of the 1831 workers' revolt in Paris. The accompanying note explains that a contagious malady—la grippe, which means

"dislike" as well as flu—swept through Paris. Louis-Philippe's soldiers seem nonplused to find that la grippe seized everyone—workmen, women, and children. An interesting, action-filled scene, obviously not a hastily drawn political cartoon and yet diffuse and circuitous, "La Grippe" suffers from a prevailing weakness—a lack of

154. "La Grippe." Grandville (Jean Ignace Isidore Gérard). 1831. 9x13½. Lithograph. From *La Caricature*, July 7, 1831. Dick Fund 1941, Metropolitan Museum of Art, New York.

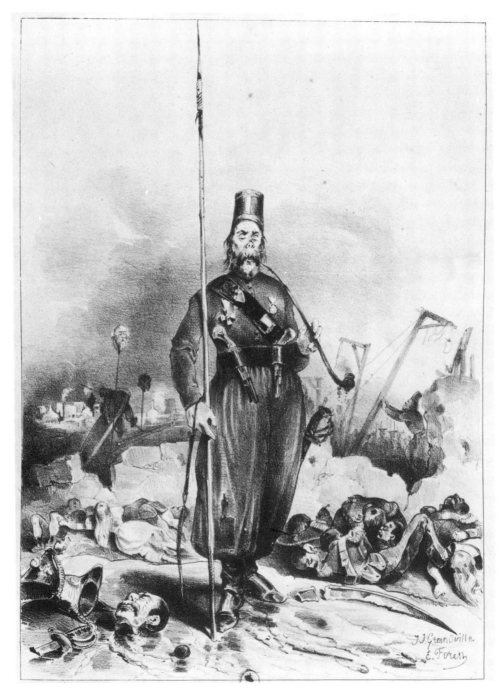

155

155. "Order Reigns in Warsaw." Grandville (Jean Ignace Isidore Gérard). 1831. 14¼x11¾. Lithograph. From *La Caricature*, April, 1831. Bibliothèque Nationale, Paris.

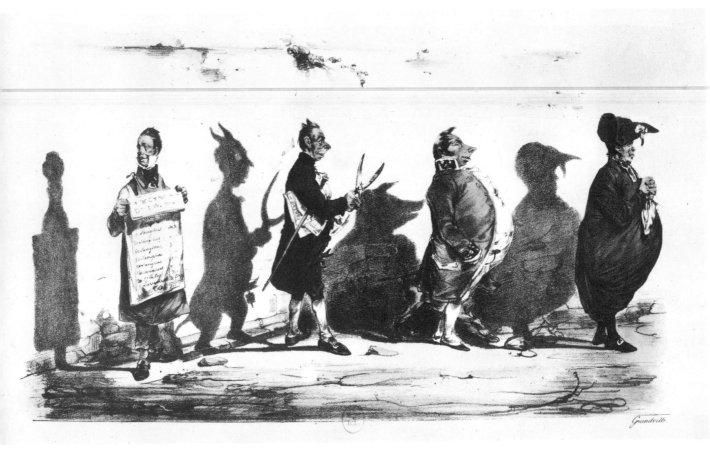

156

coherence in the composition. A year later another unsuccessful revolt drew Grandville's sympathetic attention, this time more effectively. After the Russians had violently suppressed an insurrection in Warsaw, he drew a cossack standing in a corpse-strewn, bloody battlefield, smoking his pipe. He called it "Order Reigns in Warsaw."

Grandville was sometimes reminiscent of Gillray in his grimness, his crowded detail, and his bizarre illustrations. Per-

haps more representative was Grandville's "Shadows," in which the silhouetted shadows of Louis-Philippe's ministers transformed them into pigs, devils, and similar figures. Grandville often resorted to laborious devices in his satires, imparting human character to walking sticks, animals, and birds.

Grandville (Jean Ignace Isidore Gérard, 1803–47)—melancholy and introspective, projecting the subconscious into much of

156. "Shadows." Grandville (Jean Ignace Isidore Gérard). 1830. 14x20¼. Colored lithograph. From *La Caricature*, Nov. 18, 1830. Bibliothèque Nationale, Paris.

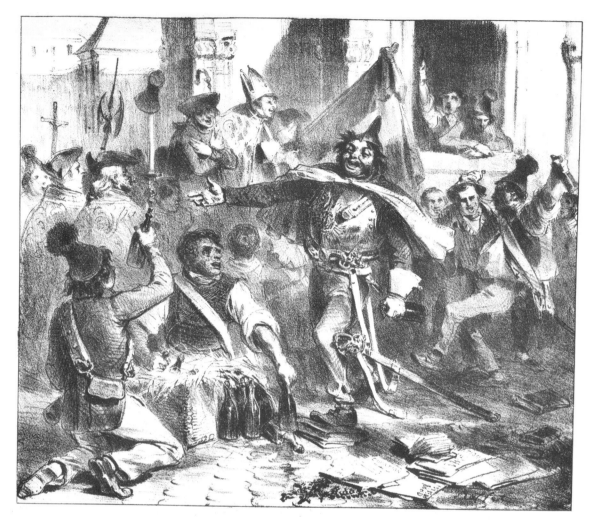

his work—has been credited as a forerunner of surrealism, yet missed becoming a major artist. Perhaps, as Baudelaire suggested, his failing lay in his being too literary, too preoccupied with ideas to be successful in his artistic projection. In much of his political comment humans were given animal heads —bears, crocodiles, cows—according to the qualities he assigned to characters. This was a favorite contrivance, and his animals

are regarded as the models for Tenniel's illustrations for *Alice in Wonderland*.

Grandville's political satires in *Metamorphoses of the Day*, published in 1829, and in *La Caricature* and *Le Charivari*, made him the David Low of the early 1830's. In more than 3,000 illustrations for books and magazines, he struggled to pursue his dreams on paper. Artistically, he was a contradiction. His drawing was often

157. "Archbishop's Palace, 29 July." Auguste Raffet. 1830. 7x7¾. Lithograph. From *La Caricature*, Dec. 23, 1830. Metropolitan Museum of Art, New York.

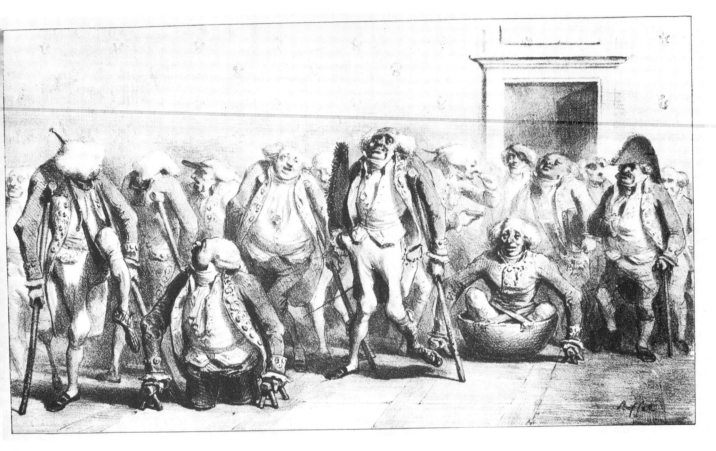

too precise, dry, pedantic, too detailed; yet his images were often hallucinatory, requiring the free exuberance he lacked.

Anticlericalism was an additional attitude that bound Philipon's young artists in common cause. Although the July Revolution ended the special privileges of the church and launched the barest beginnings of free secular education, republican liberals remained fearful of a resurgence of church power. In December of 1830, "Archbishop's Palace, 29 July," by Auguste Raffet, appeared in *La Caricature* as a grim re-

minder to the church of the anticlerical phase of the July upheaval. It proved prophetic; two months later a mob sacked the archbishop's palace.

Raffet (1804–60) was a frequent, popular, and capable contributor to *La Caricature*. Sometimes he was amusingly trivial, as when the crowd that broke into the archbishop's palace found a woman's corset in his closet. Occasionally he was bitterly pungent, as in "Les Incurables," a parade of crippled aristocrats. His comment: "Only they have understood the Revolution."

158. "Les Incurables." Auguste Raffet. 1831. 7⅞x10⅞. Lithograph. From *La Caricature*, March 31, 1831. Metropolitan Museum of Art, New York.

Raffet's political caricatures did not achieve lasting distinction. His fame derived mainly from his lithographs of army life, in which his handling of massed troops was brilliant and his portrayal of the common soldier was accomplished with feeling and meaningful detail. His "Nocturnal Review," "They groan but they always follow," and others kept the Napoleonic legend alive by vividly recapturing military scenes of the Napoleonic era, many of them suffused with a mysterious haze giving the feeling that the massed, ghost-like figures must have existed exactly that way. Raffet completed more than 2,000 lithographs and woodcuts.

Philipon's artists differed not only in artistic competence and style, but in personality and motivation. Charles Traviès (1804–59) and the genial Henry Monnier (1799–1877) are representative of those not quite achieving first rank. Traviès contributed frequently to *La Caricature,* with extreme attacks lacking subtlety, only a few bearing the stamp of verity and artistic wholeness. His drawing was uneven, sometimes weak and meager, perhaps reflecting his own physical infirmity and suffering, and at other times was strong and forceful. A series of portraits of government leaders in *Le Charivari* was excellent satire, but Daumier's series on the same theme far surpassed his. His misanthropy found expression in his famous, or notorious, character, Mayeux—a cynical, libidinous, hunchback, repellent but fascinating, and artistically complete. Traviès drew him in dozens of guises, from butcher to judge. Mayeux represented the social outcast, the scoffer, the epitome of vices secretly coveted by so many Parisians and lurking behind the façade of bourgeois respectability. (Grandville and others also drew Mayeux occasionally; the figure appeared in 160 lithographs in various magazines, to the amusement and consternation of Parisians.) Traviès also sketched tramps and beggars with sympathy and lifelike reality.

Henry Monnier, actor and playwright as well as artist, a gregarious, good-humored chronicler of middle-class mores, occasionally departed from his role as detached observer. Typically, his "Victime de

159. "Mayeux." Charles Traviès. 1833. 12x9. Lithograph. From *Le Charivari,* April 21, 1833. Metropolitan Museum of Art, New York.

60

put him onto paper. It was left to Daumier to draw Joseph Prudhomme in a way that made him memorable.

In young Honoré Daumier (1808–79), Philipon had an emerging giant, one powerful enough to hurl thunderbolts at Louis-Philippe and his entourage in an attempt to dethrone the established order.

Son of an idealistic glazier—a poet manqué—and a down-to-earth mother, Daumier absorbed the traits of both as he grew up in the narrow streets of Paris, always remembering the homely details of Parisian life. After brief service as bailiff's errand boy and bookstore clerk, he was apprenticed to a maker of lithographic portraits. In the relatively new art of lithography which was spreading rapidly in Paris, Daumier found his métier. When he began to draw for *La Caricature* in 1831, the 22-year-old Daumier discovered the ideal outlet for his maturing talent and philosophy and formed a working relationship with Philipon which was to endure, with brief interruptions, almost until his publisher's death in 1862.

In a sense, the relationship was also to enslave him. In forty years, he would produce 4,000 lithographs—an average of two a week! It provided a meager living, keeping him constantly on the verge of poverty, but undoubtedly giving him an immense inner satisfaction at boldly striking out against those who clouded his ideal of a truly democratic France. When censorship made this work impossible, he satirized the manners and morals, the dreams and do-

l'ancien système," fat and prosperous, represents an attack on the newly rich who reaped financial benefits from the Revolution. His "Parisian Sketches," "Bureaucracy," and "Grisettes," are pleasantly observed, mildly satirical, understated reflections of middle-class life. His notable achievement was the creation of "Monsieur Joseph Prudhomme," a French Pickwick—bumbling, banal, and the epitome of self-satisfied middle-class Paris. Monnier's portrayal of Monsieur Prudhomme on the stage was apparently more effective than his visual representation. As Baudelaire pointed out, however, Monnier studied his prototype so well he "traced" him when he

160. "Une victime de l'ancien système." Henry Monnier. 1831. 7½x7½. Colored lithograph. From *La Caricature,* Nov. 4, 1830. Metropolitan Museum of Art, New York.

mesticities, of the French bourgeoisie—of which he himself was so much a part. Undoubtedly there were moments, many moments, when Daumier longed to escape from the drudgery of lithography to the freedom of the palette—a goal he achieved only a few times. However, he built, lithographic stone by stone, an enduring commentary on mid-nineteenth-century France and a monument to the spirit of democracy.

As Oliver Larkin has expressed in *Daumier: Man of His Time*, the splendid biography to which all students of Daumier will be indebted, "nearly forty years of drawings were to prove his obstinate belief in a republic, in economic, social and political equality, the right of all Frenchmen to determine who should best represent them, and full freedom of written and spoken opinion." Certainly a lexicon of integrity, but this modest man who observed so much and spoke so little would probably have blushed at such an attribution.

There is a striking contemporaneity but also a timeless appropriateness to much of Daumier's work, especially his more serious political drawings. His perceptive commentaries on such basic problems as disarmament and the arms race, war and peace, the stupendous costs of a military budget, and the middle-class fear of radicals, are as pertinent today as a century ago. Many of his lighter satires of the Parisian bourgeoisie are also surprisingly modern; human frailty and foibles, as he portrayed them, are eternal.

He was remarkably consistent in pursuit of rational, democratic, humane goals, and for four decades rarely wavered in his faith in the ultimate triumph of democracy. The Romantics shared his sympathies for the oppressed but proved unreliable allies when confronted with harsh political reality. Republicans fought valiantly enough for full suffrage but crumbled before governmental opposition to economic equality or drastic social reform. Daumier had little faith in socialism or in the radical movements, but he respected them and strongly defended their right of advocacy when French McCarthyites were in power and thirsting for radical blood.

Daumier was essentially a moralist who lacked the humanistic breadth of a Rembrandt or a Goya and possessed little of Rembrandt's spiritual depth or Goya's almost frighteningly profound insight. But he had a commitment that Rembrandt never fully embraced and a consistent compassion lacking in Goya. He had affection for and no illusions about the average, struggling Parisian; he had an abiding faith in his fellow man's ability to create a democratic society if given the opportunity, and he despised the politicians, the priests, and all the obscurantist forces who placed obstacles in the path of the Frenchman groping for a measure of freedom and happiness. If this seems a somewhat simplistic philosophy, it must be remembered that the issues were sharp and clear, the exploitation and the corruption obvious.

Paul Valéry, with a poet's extravagance and a kernel of truth, has likened Dante,

Cervantes, and Balzac to Daumier—"this swift, exuberant draughtsman who finds ghosts, demons and the damned, monsters of cupidity and pride, of egotism and folly, in the gutters and on the pavements of the Paris of his time." Valéry also saw in Daumier a kinship to Michelangelo and Rembrandt—not in technique, of course, but in "the need, the instinct, the desire to use the image of Man to some deep purpose, to give it a meaning beyond the endurance of any real human being."

That Daumier had his limitations is obvious to anyone who leafs through his tremendous oeuvre. His field of ridicule or attack was confined almost wholly to what he personally lived, felt, or observed—the French middle class. "The voice of the bourgeoisie was in the air," remarked Henry James, who as a sensitive child in Paris was frightened by the "abnormal blackness" of Daumier's drawings, and by "their grotesque, magnifying movement." Other elements of French society hardly ever appear in Daumier's work; there are few aristocrats and workers and fewer peasants. When he turned from political to social satire under the stress of censorship, he sometimes wandered into rather narrow byways. Women were almost always ridiculed—especially when the Bluestockings sought to emancipate themselves—or appeared simply as accessories. The artist was uncomfortable with change and its advocates; hence he also ridiculed the new railways and the new highways.

Despite his youth, Daumier quickly became the brightest of Philipon's artists. His drawings and their content were uneven and inconsistent at the beginning, but the genius was apparent. The unevenness—which would continue for years—was obviously the result of his tremendous output. In *La Caricature's* five years of polemics, he made ninety drawings, from 1833 to 1840 he averaged fifty to ninety for *Le Charivari*, plus those for *L'Association Mensuelle* and miscellaneous others. In 1832, he spent six months in jail—not too uncomfortably—for a mediocre and somewhat tasteless cartoon of Louis-Philippe as Gargantua, gorging riches and excreting them to his followers.

Daumier chose topical subjects, as his colleagues did, but he often penetrated to the principles involved, imbuing many of his political cartoons with universal and lasting thematic significance. Instead of cluttering the lithographs with too many figures or too much detail, he concentrated on one or a few, making the drawing vigorous and the impact incomparably more forceful and satisfying. He was able to create an atmosphere of verity that gave an impression of detail.

Daumier always drew from his remarkable memory. He could neither afford the cost of models nor the time, making his drawings usually generalized, not particularized. In an astonishingly short time Daumier was to mature and create with bold, firm strokes many classics of political art as agitation in Paris grew.

The universality of much of Daumier's

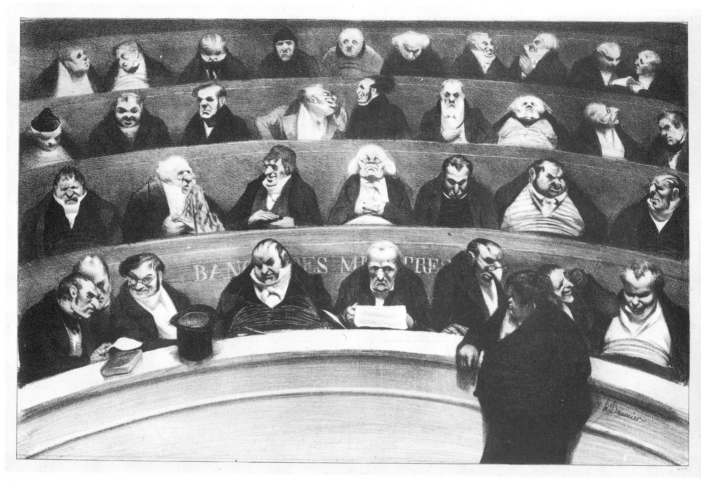

161

work is reflected in his famous "The Legislative Paunch," where curve of bench and curve of gluttonous belly harmonize in this classic portrait of greedy, self-satisfied, self-aggrandizing legislatures. Both Grandville and Traviès made satirical lithographs of the Assembly, but with less effect. Many of the legislators portrayed here were first modeled in clay by Daumier in preparation for a precociously brilliant series of caricatures which ran in *La Caricature* and *Le Charivari*. The sculptural quality and solid monumentality in these and other figures obviously derived from these preliminary conceptions.

"First bleed, then purge," shows Louis-Philippe bleeding an expiring patient, the French nation. When Louis-Philippe suspended the parliament in December 1833, Daumier portrayed him as a clown ringing down the curtain on the legislative show— "The farce is over." Daumier also went a

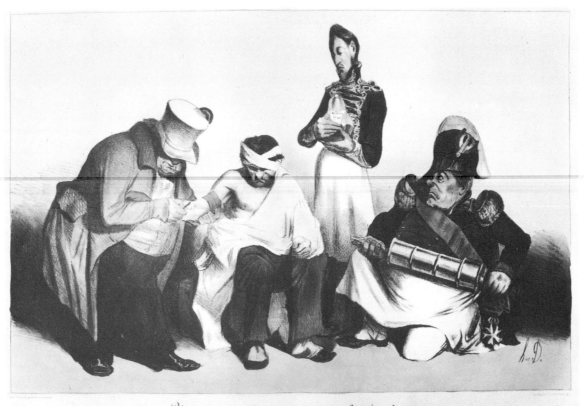

Primo saignare, deinde purgare, postea clysterium donare.

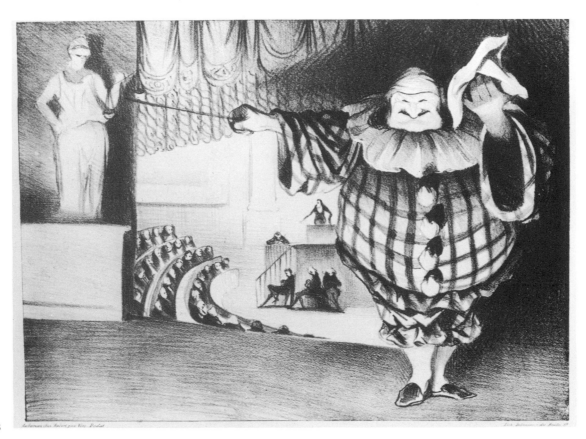

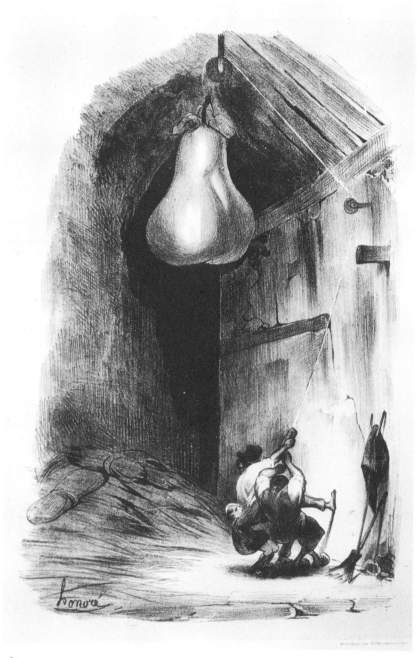

164

164. "Ah! His! Ah! His!" Honoré Daumier. 1832. 10¾x7⅛. Lithograph. Delteil 47. Dick Fund 1941, Metropolitan Museum of Art, New York.

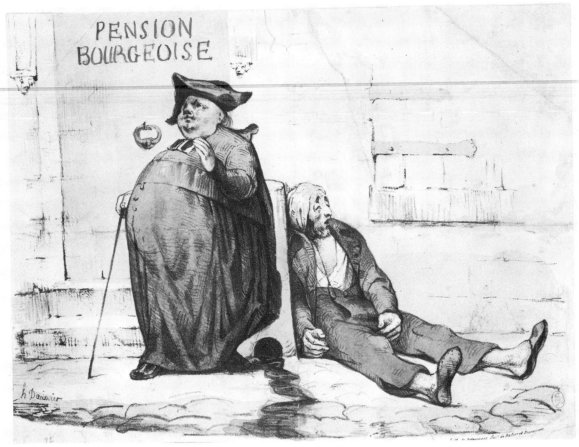

165

significant step beyond his fellow artists in portraying Louis-Philippe as a pear. He drew workers hoisting this burdensome pear, implying that they not only raised him to power but could drop him as well.

Anticlericalism was one of the dominant notes of the July Revolution. A few state schools were opened, marking the first tentative steps toward secular education, and there was even a period when priests were hesitant to wear clerical garb in the streets of Paris. But as Louis-Philippe leaned increasingly to the right for support, church forces regained some of their power over education. Daumier drew a fat priest passing a starving man, piously proclaiming, "Blessed are they that hunger and thirst."

165. "Blessed are they that hunger and thirst." Honoré Daumier. 1830. 7¹/₁₆x9⁷/₁₆. Lithograph. Delteil 20. British Museum, London.

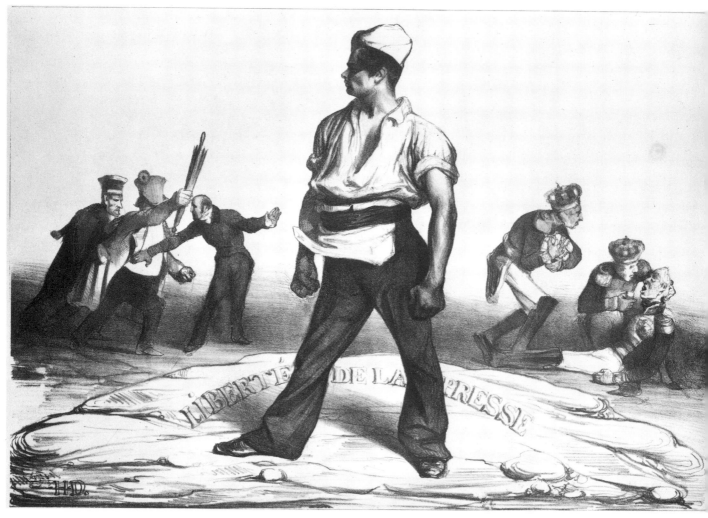

166

By 1834, passions had mounted. In a foreboding lithograph, "Don't meddle with the press" (March 1834), a towering figure of a pressman stands firmly and defiantly, fists clenched, threatened by Louis-Philippe on the left while Charles X, whose proposed press restrictions helped cause his overthrow, swoons on the right. Louis-Philippe did not accept the suggestion.

That same year the government passed a law restricting the right of association. In the textile city of Lyons fighting broke out, and an uprising led by the Société des Droits de l'Homme took place in eastern

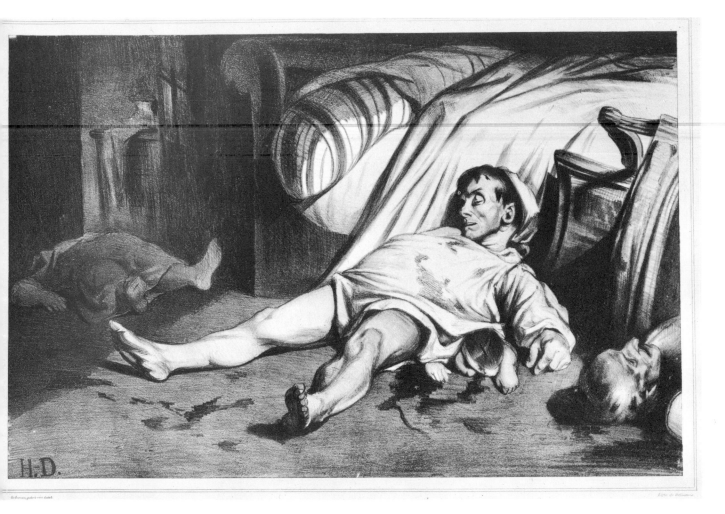

Paris. It was quickly and bloodily suppressed by Thiers, Minister of the Interior, who was to be Daumier's antagonist for decades. When the police were fired upon from a house in the Rue Transnonain, they slaughtered all the occupants in reprisal—men, women, and children. This violent act of police brutality drew from Daumier's crayon perhaps his greatest lithographic expression, Goya-like in its violent eloquence—"Rue Transnonain, April 15, 1834." Baudelaire commented on this masterpiece of lithographic art, "In this cold attic all is silence and death. It is not precisely caricature—it is history, both trivial and terrible."

Some of the leaders of the insurrection

167. "Rue Transnonain, April 15, 1834." Honoré Daumier. 1834. 11¾x17½. Lithograph. Delteil 135. Rogers Fund 1920, Metropolitan Museum of Art, New York.

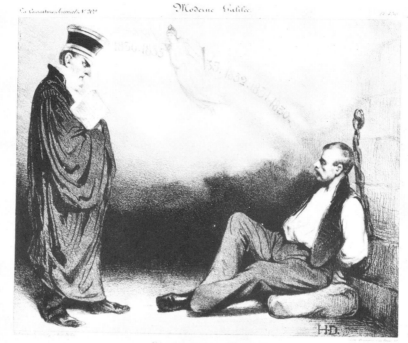

168

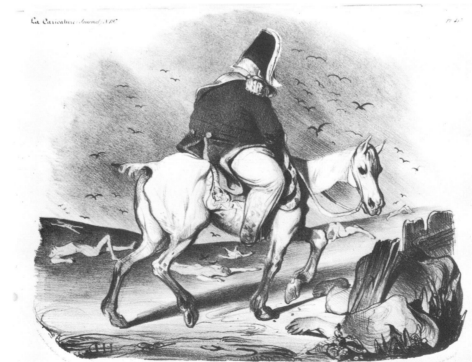

169

168. "A Modern Galileo—It goes on all the same." Honoré Daumier. 1834. 9x10¾. Lithograph. Delteil 93. Dick Fund 1941, Metropolitan Museum of Art, New York.

169. "Louis Philippe rides among his eager subjects." Honoré Daumier. 1834. 10x12. Lithograph. Delteil 82. Dick Fund 1941, Metropolitan Museum of Art, New York.

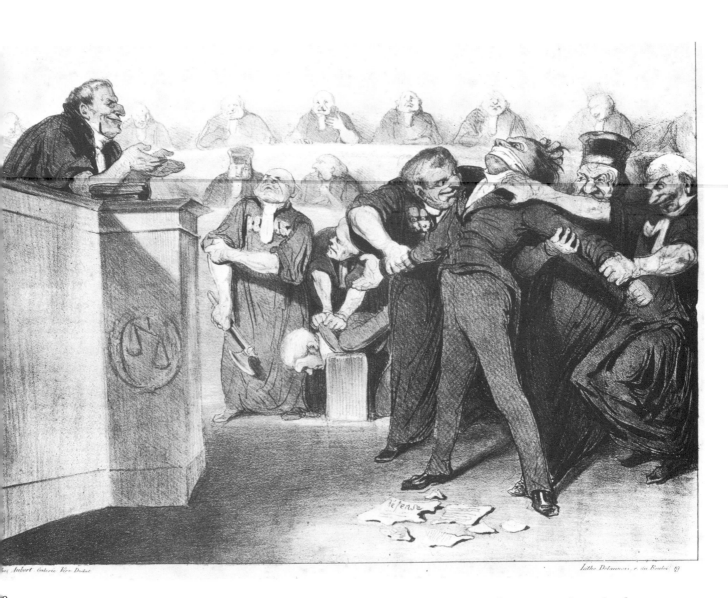

were imprisoned, and in the months preceding the trial, Daumier and Philipon kept up their relentless attack. In one lithograph, "It goes on all the same," says a republican prisoner, defying the chief prosecutor and referring to Liberty and the republican cause; unlike the great astronomer, this "modern" Galileo refused to recant. A few weeks later, Daumier portrayed Louis-Philippe traveling on horseback among his "eager subjects"—corpses scattered on the scene.

Daumier's sketches of the trial of the rebels were devastating. "You have the floor, explain yourself," a judge smirks to a gagged defendant. But as the verdict at this trial was apparent before testimony, so was an end to this period of free-swing-

170. "You have the floor, explain yourself." Honoré Daumier. 1835. 11¹¹⁄₁₆x8¹⁄₁₆. Lithograph. Delteil 116. Bequest of William P. Babcock, Museum of Fine Arts, Boston.

ing political satire. In 1835 the government took advantage of an attempted assassination to introduce laws placing strict controls on the press. Among other expressions, insults to the king were to be regarded as threats to public security.

Daumier's spectacular career as a strictly political commentator was thus suspended. The republican cause was routed and Philipon had to acknowledge defeat; *La Caricature* closed.

For a dozen years Daumier shifted his emphasis in *Le Charivari* from political attack to social satire. "The live and starving corpse, the plump and well-filled corpse, the ridiculous troubles of the home, every little stupidity, every little pride, every enthusiasm, every despair of the bourgeoisie —it is all there," wrote Baudelaire. "By no one as by Daumier has the bourgeoisie been known and loved (after the fashion of artists)." There is much affection, humor, and gentle satire in the more than 1,000 lithographs he created in this period. He made his middle-class Parisian both ridiculous and human; few foibles or vices escaped his eye. But there is scorn and contempt, too, for the shoddier aspects of French middle-class society. Often there is irony, making his Parisians pathetic victims of forces beyond their control.

Daumier's kaleidoscope of bourgeois customs and activities varied from the trivial to the significant, from the ridiculous halfway to the sublime, although the ideas were sometimes perfunctory—as if Daumier made his sketch only because of the tyranny

of demand or because Philipon's inexorable caption was waiting. The lithographs of bourgeois boredom at home, of George Sand's Bluestockings fighting the feminist battle while neglecting husband and children, or of knock-kneed, skinny non-heroes acting out the great ancient legends, trying so unsuccessfully to bridge the gaps between bourgeois dreams and sad reality, were great caricatures but are not within the scope of this book.

In two series drawn during this period, the satirical edge is sharp, the social satire pointed, the emotion within Daumier much closer to the surface. There is no geniality in his series of 100 portraits of Robert Macaire, the confidence man who in his own way was so very much "of his time." Fast-talking swindler, Robert Macaire epitomizes the opportunistic, unscrupulous *sauve-qui-peut*, get-rich-quick atmosphere of the bourgeois king's reign, when securities, utilities, and government contracts were manipulated for the enrichment of a few.

From the fall of 1836 to 1838, Daumier regaled his Parisians with the adventures of Macaire and his scavenger-like shill, Bertrand, as they gulled the naïve and hapless public and worked their way from rags to riches. His readers relished this series, as the streets of Paris were crawling with Macaires. "The public, *mon cher,* is stupid," Macaire confides to an equally well-dressed Bertrand, and Macaire, talented chameleon, proceeds to carry on his swindles in such varied roles as silvermine peddler,

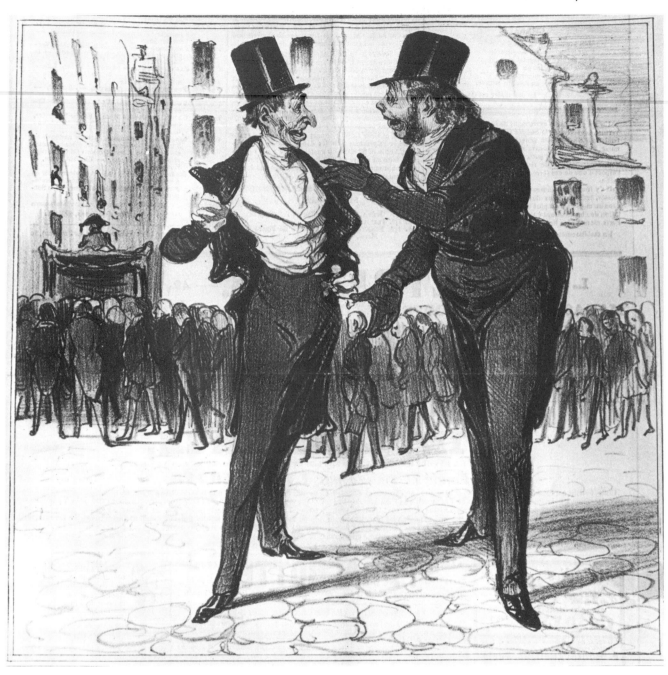

171

171. "The public, *mon cher*, is stupid." Honoré Daumier. 1837. 8⅝x8⅞. Lithograph. Delteil 425. Rogers Fund, Metropolitan Museum of Art, New York.

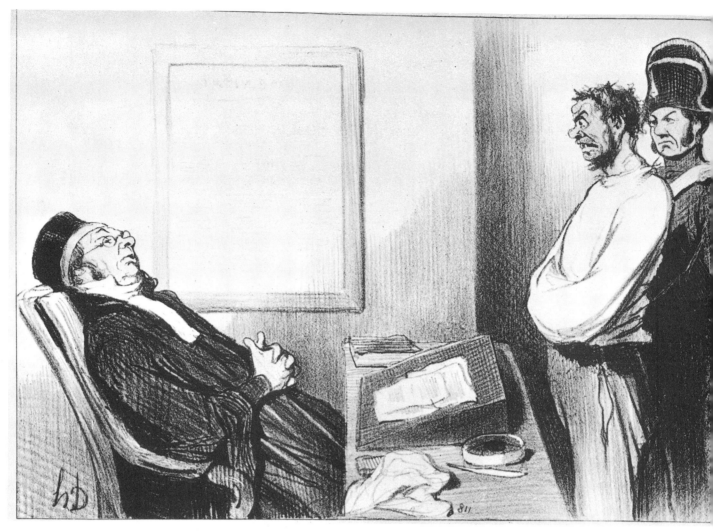

172

journalist, notary, lawyer, physician, businessman, beggar ("distinguished," of course), landlord, dentist, pharmacist— charlatan in all, expert in hypocrisy, knavery, and fraud. Perhaps Macaire's (and Daumier's) contempt for the public morals of the time is best summed up in the cartoon in which Macaire is describing to Bertrand his plan for a bank, one that will sink the Bank of France, bankers, and depositors alike. "But what about the police?"

Bertrand asks. "How stupid you are," is Macaire's scornful reply. "Does one arrest a millionaire?"

Daumier's early unfavorable impression of the law courts, formed during his work for a bailiff and his term in jail and sharpened by his keen sense of the justice the courts dispensed so little of, found expression in "Les Gens de Justice," a series of 39 lithographs created between 1845 and 1848. That work pinioned the humbug, chicanery,

172. "Hunger is no excuse for robbery." Honoré Daumier. 1845. 10½x7½. Lithograph. Delteil 1351. Dick Fund 1941, Metropolitan Museum of Art, New York.

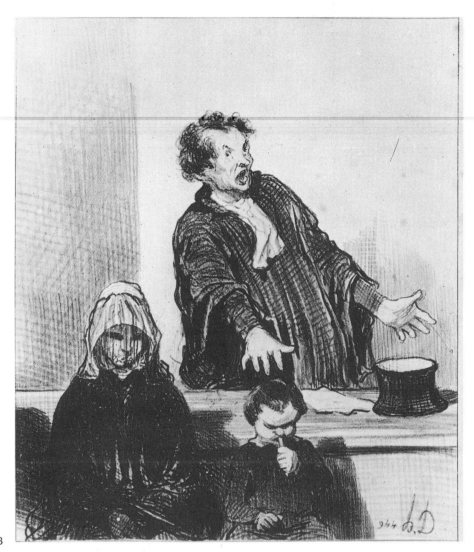

173

double-dealing, and amorality of the legal profession, the roguery of its advocates, and the corruption of its judges. No captions were needed in many; eloquence lay in the hypocritical smirk, the callous shrug, the self-satisfied bonhomie. In others, the captions spoke literally. "Hunger is no excuse for robbery—I am hungry all the time," the portly judge tells the prisoner. (This judge is awake; most of Daumier's justices sleep on the bench.) "He defends orphans and widows—when he is not attacking or-

173. "He defends orphans and widows." Honoré Daumier. 1846. 9x7½. Lithograph. Delteil 1358. Dick Fund 1941, Metropolitan Museum of Art, New York.

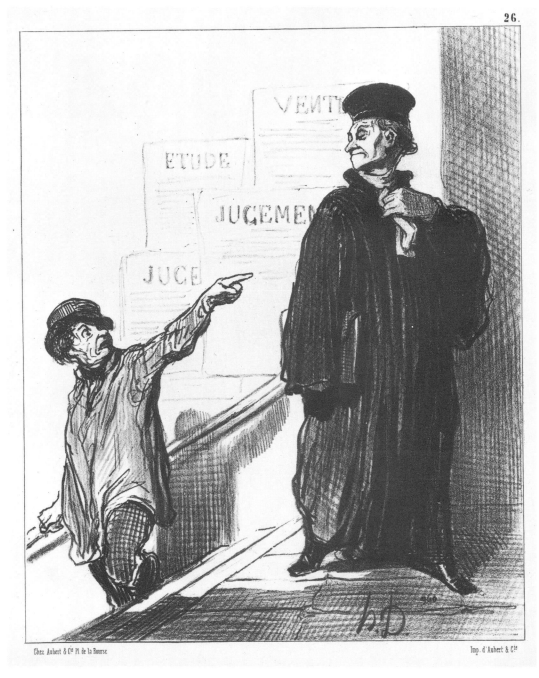

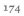

174. "A Dissatisfied Client." Honoré Daumier. 1846. 9¹⁄₁₆x7½. Lithograph. Delteil 1362. Rosenwald Collection, National Gallery of Art, Washington.

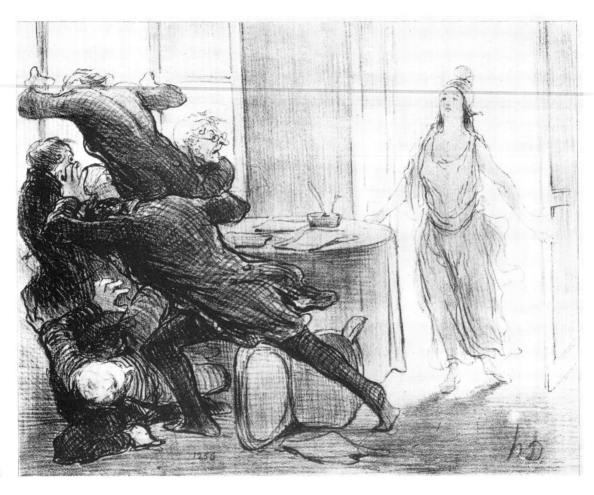

175

phans and widows." The always self-satis-
fied lawyer is impervious to the indignation
of the little-satisfied client whose case has
been grandly lost.

In 1847, a financial and agricultural crisis
increased the demands for reform. In Feb-
ruary of 1848, the façade crumbled when
barricades, manned by middle-class repub-
licans, workers, and students, went up over
much of Paris, and Louis-Philippe abdi-
cated in favor of his grandson. But now the
republicans were determined against an-
other monarchy. Triumphant crowds pro-
claimed the Second Republic, and it seemed
as if a new dawn were breaking. Daumier
hailed the new era with "The Final Coun-

175. "The Final Council of the Ex-Ministers." Honoré Daumier. 1848. 8¼x10¼. Lithograph. Delteil 1746. Rogers
Fund 1922, Metropolitan Museum of Art, New York.

cil of the Ex-Ministers," with Louis-Phi-lippe's ministers retreating in confusion before the goddess of the Republic.

The working day was reduced to ten hours in Paris and eleven in the provinces, national workshops were created to absorb the unemployed in Paris, and universal male suffrage was decreed.

But the situation resembled 1830, for there still existed opposing forces—those who felt the new reforms were sufficient, and those more radical groups who believed that the revolution was incomplete without more fundamental social and economic reforms. Universal suffrage proved a mirage; the vast majority of new voters consisted of illiterate peasants who, disturbed by talk of goings-on in radical Paris, voted conservatives into power in the new Assembly. When the Assembly dissolved the workshops and offered young men a choice between conscription or unemployment, barricades again went up in the working-class quarters. After three days of intense fighting, troops under General Cavaignac suppressed the insurrection. Thousands were imprisoned or deported, the work day was increased to twelve hours again, and a new reservoir of bitterness was created.

Events seemed to move too swiftly for Daumier to absorb, for he made only a few lithographs before the uprising; but these were bold, incisive, and pertinent. Especially noteworthy was a series of seven "Alarmists and Alarmed," in which Daumier satirized the middle class for their

fear of the "Reds." The bourgeois dives under the mattress when it is only the postman knocking at the door. A couple quake in fright at the sight of "armed men," who are only children playing soldiers. An extra candle is lit in a neighbor's window, and the frightened burgher thinks the neighbor's house has been set afire.

In the presidential election of 1851, peasants and conservatives—and even many workers—placed their faith in the magic name of Napoleon and elected Louis Napoleon, nephew of the emperor, by a huge majority. For four years Daumier took up his political crayon again, attacking the reactionary coalition of monarchists, clerics, and Bonapartists that dominated the Assembly.

Along with sketches of divorcees hoisting a drunken toast to the emancipation of women and satires on socialist women, Daumier kept up a running comment on the Assembly's machinations. He executed three series on the leading figures of the Assembly and their political maneuvers, but on the whole, each was distinguished more for its courage, political consistency, and shrewd insight than for care in draftsmanship.

Daumier spoke up sharply on specific events and often with powerful graphic effect. He renewed attacks on his old adversary, the prosecutor Thiers, dressing him in jester's clothes, leveling the charge of "Patricide" at a Thiers clubbing the press. He brought Robert Macaire and Bertrand back and placed them "on guard"—protect-

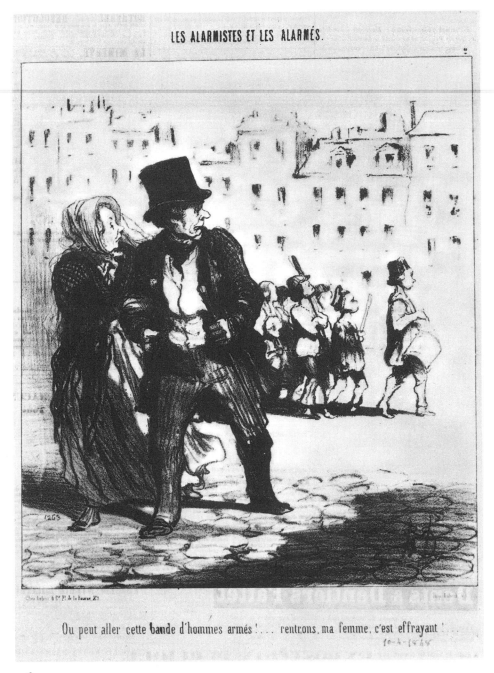

176

176. "This Band of Armed Men." Honoré Daumier. 1848. 9⅞x8¼. Lithograph. Delteil 1762. The Benjamin A. and Julia M. Trustman Collection, Brandeis University Library, Waltham, Massachusetts.

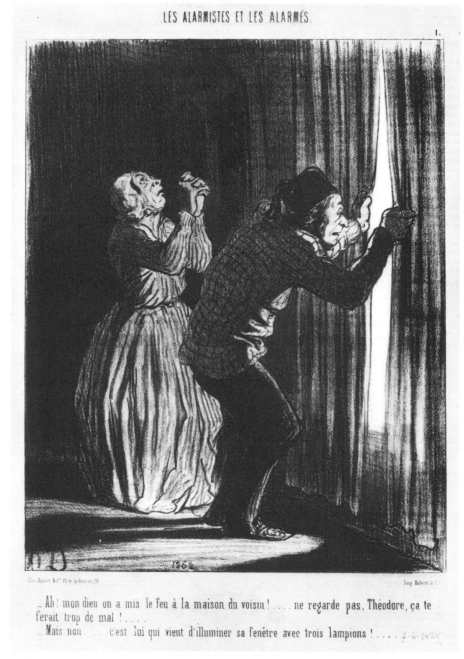

177

177. "They're Burning a Neighbor's House!" Honoré Daumier. 1848. 9⅞x7⅞. Lithograph. Delteil 1761. The
Benjamin A. and Julia M. Trustman Collection, Brandeis University Library, Waltham, Massachusetts.

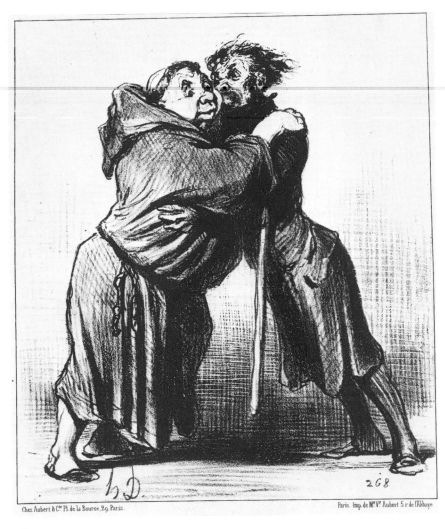

Chez Aubert & C.^ie Pl. de la Bourse, 29 Paris.

Paris. Imp. de M.^me V.^e Aubert 5 r de l'Abbaye

178

ing the Bourse. He excoriated the clerics and their leaders, the Comtes de Falloux and de Montalembert, and fought a hard if losing battle against their renewed control of public education. When Daumier's friend, Michelet, the liberal historian, was ousted from his classroom, the artist drew a repulsive priest lecturing to an empty classroom. A month later, in April of 1851, "Alliance of Bonapartists and Capuchins," became a bitter comment on this uneasy and distrustful but effective coalition.

178. "Alliance of Bonapartists and Capuchins." Honoré Daumier. 1851. 9⅞x8¼. Lithograph. Delteil 2093. The Benjamin A. and Julia M. Trustman Collection, Brandeis University Library, Waltham, Massachusetts.

To sharpen his attacks on the shoddy conspiracy that was unfolding before him, Daumier, after sculpting a model in clay, created Ratapoil, a baleful mountebank who typified the impending new order. Daumier is often presented as genial and compassionate with no hatred for the victims he satirized, but the Ratapoil series dispels this myth, for the sinister character epitomizes the miserable hanger-on of every dictatorial putsch in history—swaggering, insolent, sycophantic, hypocritical, and ready to perform the dirty work. Daumier's series of twenty-four lithographs on history's hired thug bristles with contempt and displays acute political insight as Ratapoil leads his drunken stooges in cheers for the emperor, swindles the peasants, beats up republicans, and organizes fake demonstrations of support for Louis Napoleon.

The Ratapoils won. In December of 1851, Louis Napoleon seized power, and a frightened electorate—especially the conservative peasants—confirmed the coup d'etat by ballot. The Empire replaced the Second Republic. Leading oppositionists were imprisoned or exiled, and early in 1852 a system of "warnings," which if unheeded would lead to prison, was sufficient to cow both publisher and journalist.

Once again Daumier's dream of a republic was shattered and he was again forced to turn from direct political commentary to a blander social observation. With few exceptions, his lithographs for *Le Charivari* in the 1850's were confined to gently satirical or humorous portraits of the passing scene. The inconveniences caused by the Baron Haussmann's ruthless transformation of Paris into a city of radiating boulevards, the fashions of the time, audiences in the art galleries (which he detested) and in the theater (which he loved)—for these and other equally innocuous subjects Daumier turned out print after print, often cursorily but with a mastery of three-dimensional craftsmanship. One of his happiest creations was a series depicting the Dickensian Joseph Prudhomme, based on Monnier's stage creation and lithograph. Prudhomme was the symbol of bourgeois complacency, a social-climbing seeker of respectability at all costs—ridiculous but hardly ever vicious.

In contrast to Daumier's middle-class Prudhomme was Gavarni's very lower class Thomas Vireloque. Gavarni (Guillaume-Sulpice Chevalier, 1804–66), was born the same year as Traviès and Raffet. Balzac persuaded Gavarni to make an occasional drawing for *La Caricature*, which he did without much political acuity, but with elegant, graceful line. He mostly concerned himself with the world of fashion, which he depicted exquisitely, of the drawing room, and of coquetry. In *Le Charivari* and elsewhere, he was (as Gautier called him) historian of the Carnival of Paris, under the July Monarchy. His "Deceits of Women" and his "Lorettes," roughly equivalent to nineteenth-century call girls, were eagerly followed in *Le Charivari*.

Although Gavarni participated in the superficial world which he satirized, he was not in sympathy with it. A trip to London in

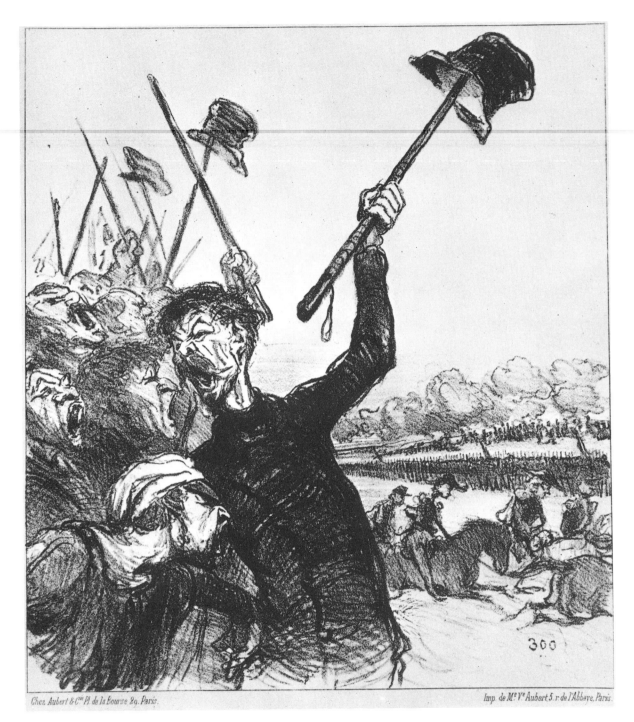

179

179. "Ratapoil and his General Staff." Honoré Daumier. 1851. 10x8¾. Lithograph. Delteil 2123. Dick Fund 1941, Metropolitan Museum of Art, New York.

1847 is credited with horrifying him at the condition of the working class. At any rate, from then on he began to include in his numerous drawings more and more scenes of the Parisian poor, culminating in the creation of Thomas Vireloque. Vireloque was in the tradition stemming from Callot's sympathetically etched beggars, but Vireloque is always portrayed in a context to stir the conscience of Parisians. And as he grew older, Gavarni's chic, beribboned mignonnes became old harlots and beggars.

Gavarni's drawings, watercolors, and lithographs doubled in quantity those of Daumier; he drew a "Masques et Visages" every day of 1853! His drawings had what Daumier's often lacked—charm, grace, wit —but he never achieved the power of modeling or drawing that seemed to come so effortlessly to his colleague. Moreover, as Baudelaire pointed out, removing the captions from Daumier leaves a work of art standing by itself; with Gavarni, the text is usually essential.

The acerbic, pointed social comment that characterized some of Gavarni's later work is reflected here in three lithographs. His smug bourgeois, hands firmly in pockets, pontificates: "He is hungry. I'm hungry also, but I take the trouble to go to dinner."

Rarely until that time had an artist bothered to portray two battered old jailbirds with an empathy that captures their resigned skepticism in "The bourgeois! . . . what a bunch of beasts." And in Gavarni's wit, an ironic old prostitute says, "Charity

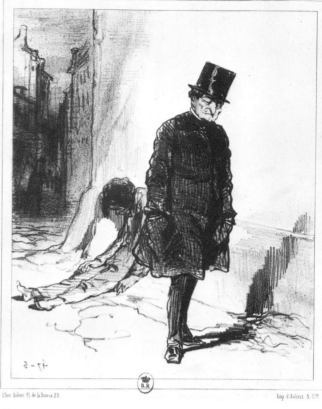

180

please Sir, may God keep your sons from our daughters."

The cause of Italian liberation in 1849 had a deep emotional appeal to Daumier and his liberal friends at mid-nineteenth century, and they were elated when revolts in many parts of Italy seemed momentarily successful against the occupying Austrian armies. They were aroused and bitter when Louis Napoleon sent an expeditionary force to Rome, ostensibly to help the Italians fight Austrian domination, but actually to restore Rome and its environs to the Pope after it had been seized by a revolutionary movement.

Auguste Raffet, Daumier's erstwhile colleague on *La Caricature*, was particularly

180. "Hunger? Laziness!" Gavarni (Guillaume-Sulpice Chevalier). 1846–7. 7¾x6⅞. Lithograph. From *Baliverneries Parisiennes*. Bibliothèque Nationale, Paris.

181. "Les Bourgeois." Gavarni (Guillaume-Sulpice Chevalier). 1853. 8⅝x7¼. Lithograph. From *Les Petits Mordent*. Bibliothèque Nationale, Paris.

182. "Charity please, Sir." Gavarni (Guillaume-Sulpice Chevalier). 1851–53. 8⅜x7¼. Lithograph. From *Les Lorettes Vieillies*. Bibliothèque Nationale, Paris.

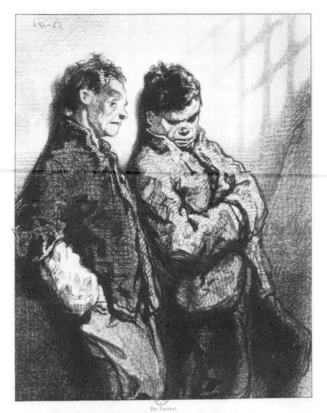

181

Par Gavarni

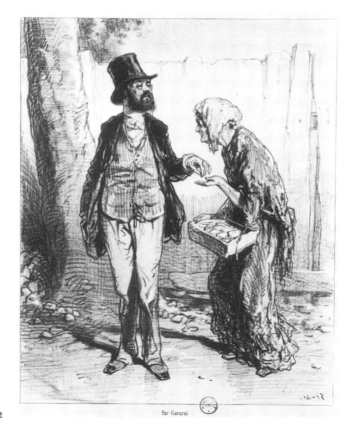

182

Par Gavarni

181

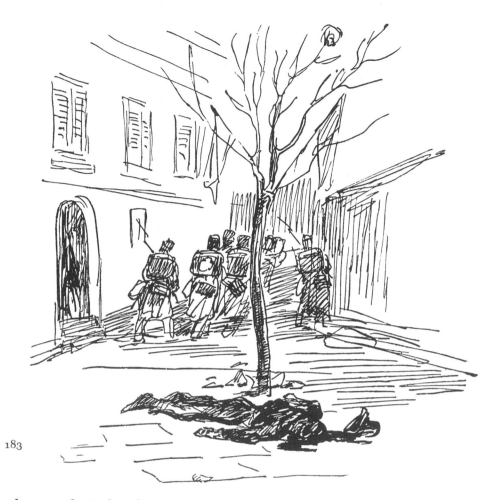

183

sympathetic to the Italians' struggle for independence. His diary and sketchbook provide eyewitness accounts of the uprising in Livorno, at that time in the Duchy of Tuscany. He worked with drive and passion, capturing an ever-shifting scene with his loose, nervous, impressionistic drawing.

There is a crushing finality to the single dead civilian on a Livorno street. The stark tree, the tense soldiers glancing apprehensively at the shuttered windows as they reconnoiter up the street, create an unforgettable scene, as much a part of 1949 as of 1849.

Daumier returned to the theme of Italian independence many times over the following decade. "The King of Naples," in August 1851, depicted the king surveying his quiet streets—his subjects now obedient corpses after their revolt was put down. A few years later Daumier returned to the Naples scene with a series of savage and acid comments on the brutality of the government. In one, the king tells his guards that he will be lenient to his victim: "Don't beat him for more than three-quarters of an hour."

In 1860, Daumier and *Le Charivari*

183. "Street Scene in Livorno." Auguste Raffet. 1849. Pen drawing. From *Notes et Croquis*, 1878. Prints Division, New York Public Library.

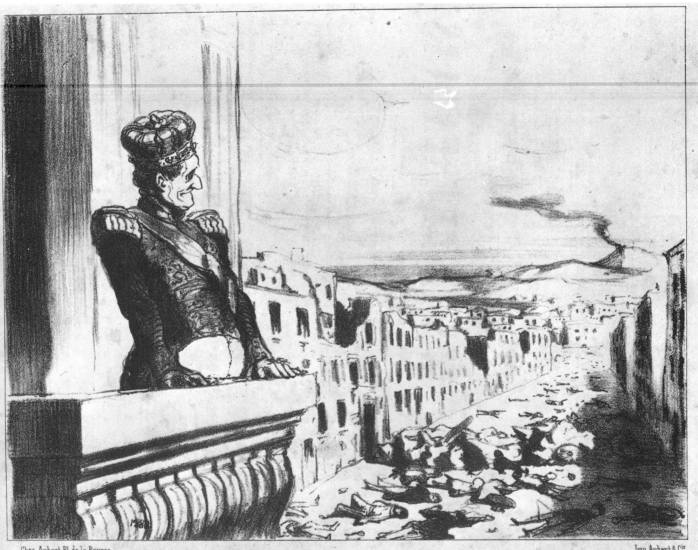

Chez Aubert, Pl. de la Bourse.

Imp. Aubert & Cⁱᵉ

184

parted, possibly because of boredom, but probably because Daumier was not chic enough for an Empire audience. Daumier's financial problems grew intense, but he de-

voted much time to his paintings, which were beginning to earn him some recognition. At Barbizon and Valmondois this artist's artist saw much more of his friends—

184. "The King of Naples." Honoré Daumier. 1851. 8¹/₁₆x10⅝. Lithograph. Delteil 2142. The Benjamin A. and Julia M. Trustman Collection, Brandeis University Library, Waltham, Massachusetts.

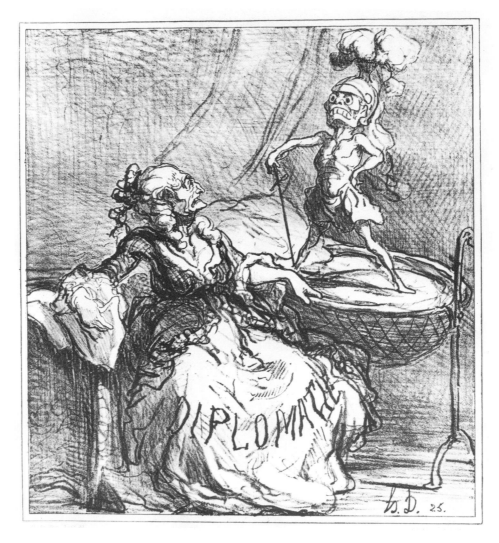

185

Millet, Rousseau, Corot, Daubigny—who were devoted to the quiet, contemplative, kindly man. Four years later Daumier began to draw for *Le Charivari* again and then, when censorship lifted slightly in 1866, his light, topical sketches of the passing scene appeared to harden into more forthright political comment and into more direct artistic statements as well. The simplicity of his paintings began to be reflected in his drawings. And for the first time, he dealt with abstractions and employed symbolism.

Many of his sharpest lithographs were attacks on the ultra-Catholics for their attempts to forbid the sale of works by liberal writers and for their hostility to the Italian people's efforts to free themselves from both Austrian and papal yokes. The artist observed with prescient trepidation the emergence of a powerful Prussian state on France's flanks and the dangers to peace

185. "Diplomacy." Honoré Daumier. 1866. 9¼x8⅜. Lithograph. Delteil 3505. Rogers Fund 1922, Metropolitan Museum of Art, New York.

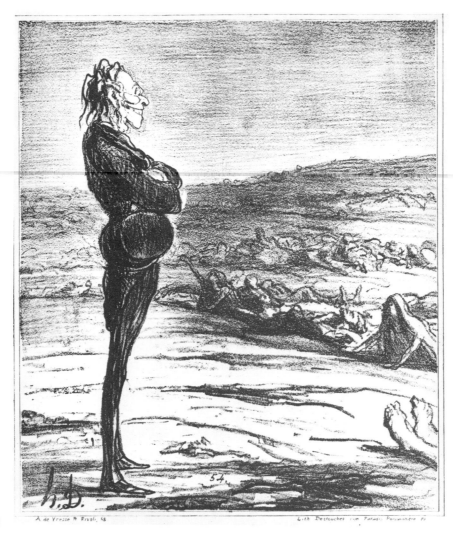

186

which this expanding power represented. Daumier, the man of peace, was haunted by the burdensome arms race and the specter of a disastrous war. His political insight warned him of an exploding holocaust. For four years his lithographic crayon slashed out with Jeremiah-like warnings, brilliant in conception and crackling in execution.

As he aged, this dedicated and committed humanitarian still lived fiercely by his dictum, "*Il faut être de son temps.*" And

there is a passion and a depth to his handling of these larger issues that make his Parisian sketches, delightful as they are, seem trivial. Always, Daumier's greatest and most timeless lithographs are those that were concerned with profound issues or events.

Examples are numerous. "Diplomacy" is frequently pictured as an old hag in a giddy dress. The inventor of the needle gun smirks with satisfaction as he gazes

186. "The Dream of the Inventor of the Needle-gun." Honoré Daumier. 1866. 8x9¼. Lithograph. Delteil 3535. Dick Fund 1941, Metropolitan Museum of Art, New York.

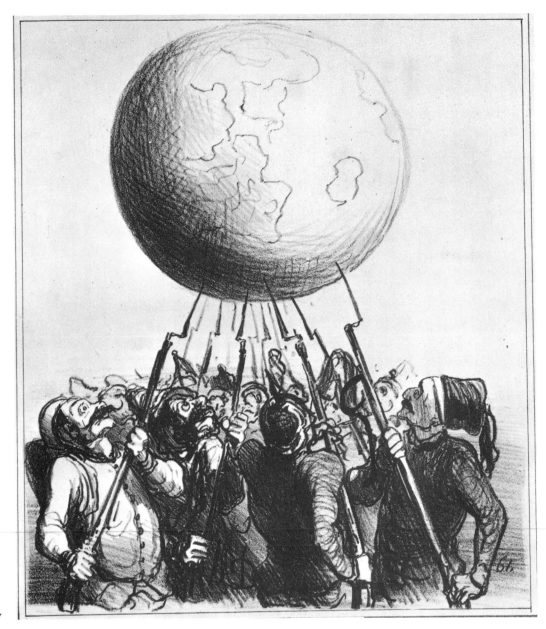

187

upon the corpse-strewn battlefield. Time and again the theme of "European Equilibrium" is returned to, with the earth supported by bayonets, or peace balanced precariously on an earth that is a smoking bomb. Galileo reappears, astonished at the condition of the world as he picks his way gingerly through bristling bayonets. Death drives a locomotive, and the future is portrayed as a blind wrestler. Hercules staggers under the weight of the military budget, Peace sleeps on the barrel of a can-

187. "European Equilibrium." Honoré Daumier. 1866. 11x9⅛. Lithograph. Delteil 3540. W. G. R. Allen Estate, Museum of Fine Arts, Boston.

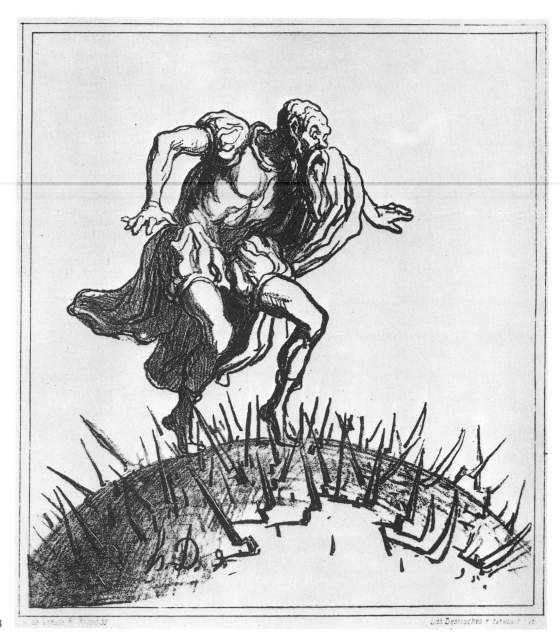

188

non, and in a timeless bit of irony entitled "After You!" each warring side insists with hypocritical politeness that the other go first into the Bureau of Disarmament.

Meanwhile, Daumier persisted in his attacks on the extreme right-wing forces in the Catholic Church and lashed John Bull for repressing the Irish. He expressed sympathy for the Italians when Napoleon's intervention prevented Garibaldi from joining Rome to the rest of Italy and unifying that nation.

188. "Galileo surprised at the surface of the earth." Honoré Daumier. 1867. 8½x10. Lithograph. Delteil 3556. Dick Fund 1941, Metropolitan Museum of Art, New York.

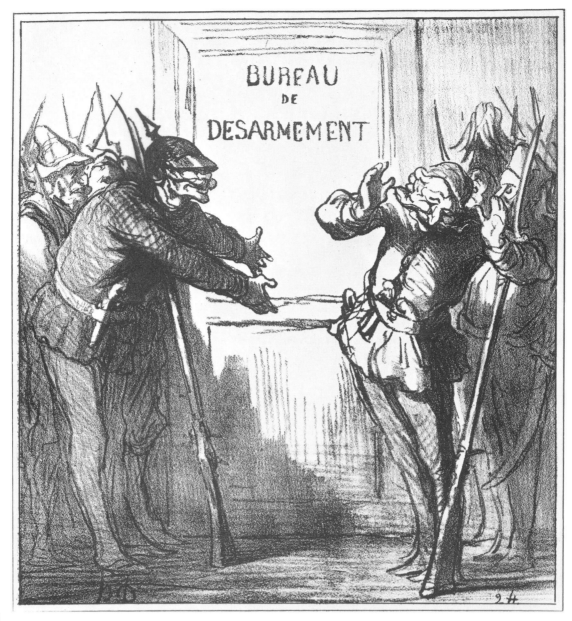

189

Daumier also took up the defense of the constitution when the parliament was authorized to draw up a new document, and with fervor reminiscent of Goya he struck out at the legislative leaders. Napoleon succeeded in having the new constitution approved through confusing phraseology in a plebiscite, but time was running out for the Empire.

When the Spanish crown was offered to a German prince, the French government saw its interests threatened and sought to

189. "After You!" Honoré Daumier. 1868. 10x9¼. Lithograph. Delteil 3640. Bequest of William P. Babcock, Museum of Fine Arts, Boston.

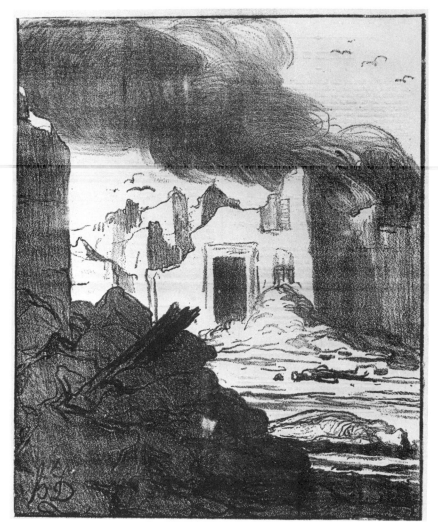

190

prevent such an accession. Although the German prince finally declined the honor, ultra-Imperialists in the French cabinet pushed Napoleon into demanding of King William I of Prussia that he never permit a kinsman to accept the Spanish crown. Bismarck publicized this French blunder in such a way that the French were maneuvered into declaring war in July of 1870.

It was a disaster for Napoleon. Within six weeks he surrendered at Sedan and two days later the Empire was declared dissolved and a Government of National Defense was established in Paris. For four and a half months Prussian troops besieged Paris while radical republicans and conservatives fought—verbally at this point—for power.

As Paris starved and artillery boomed, Daumier bitterly recalled Napoleon's grandiose claim of ten years earlier, "The Empire means peace!" Shortly after the new

190. "The Empire means peace!" Honoré Daumier. 1870. 9x7½. Lithograph. Delteil 3814. Dick Fund 1941, Metropolitan Museum of Art, New York.

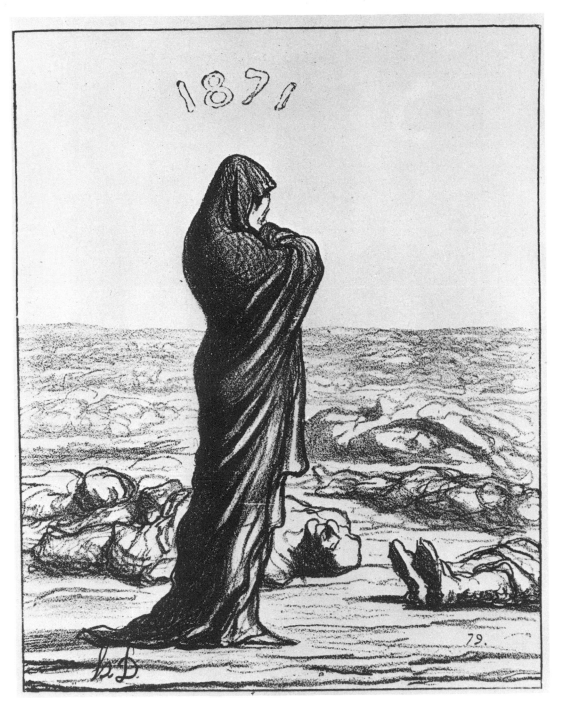

191

191. "Horrified by the heritage." Honoré Daumier. 1871. 9 1/16 x 7 1/16. Lithograph. Delteil 3838. Dick Fund 1941, Metropolitan Museum of Art, New York.

190

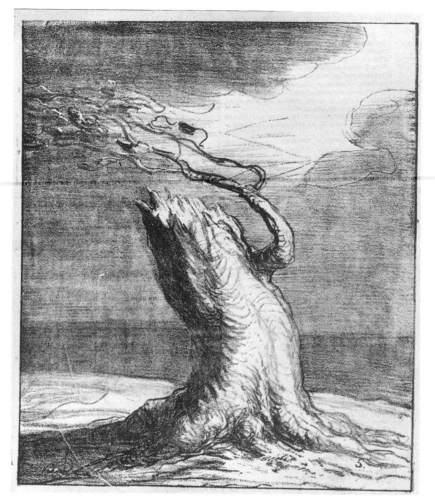

192

year *Le Charivari* published the unforgettable "Horrified by the heritage." The Second Empire had left a heritage of corpses to the embattled new Republic. The shrouded woman, surveying the heritage in silent grief, is 1871 or France herself.

Paris surrendered at the end of January, and a few days later Daumier drew a shattered oak, bent by the wind: "Poor France! The trunk is blasted, but the roots still hold." The clouds were parted in Daumier's drawing; he seemed to hold a glimmer of hope. But in March he prophetically drew

Peace as a grinning, gay-hatted skeleton piping on a desolate landscape. A week later, still distrustful of clericalism in "One invasion replaces another," he showed priests marching into Paris as the Prussians marched out.

After the surrender, a government eager for peace moved to Versailles from a hostile Paris.

The gulf between Paris and the provinces had always been wide; now it seemed unbridgeable. The Parisians were determined to carry on the war; the government

192. "Poor France! The trunk is blasted." Honoré Daumier. 1871. 9$\frac{1}{16}$x7$\frac{1}{2}$. Lithograph. Delteil 3843. The Benjamin A. and Julia M. Trustman Collection, Brandeis University Library, Waltham, Massachusetts.

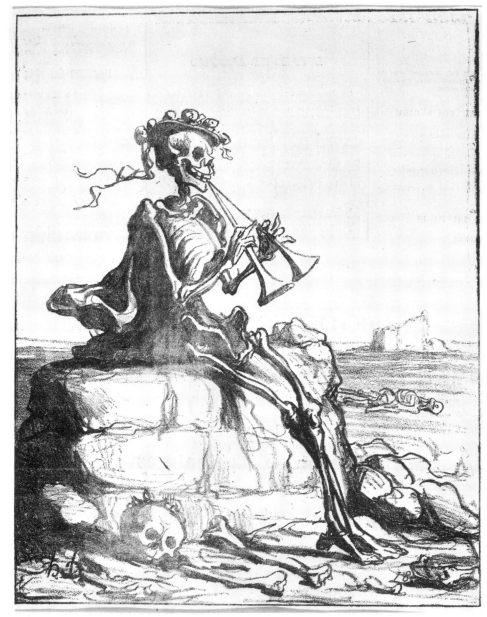

193

wanted only peace. The government was dominated by monarchists and conservatives; Paris was both republican and, in varying degrees, radical. When property owners and landlords in the Versailles government ordered back rents—suspended during the war—to be paid immediately and terminated the pay of the national guard, the pride of Paris, the lower middle class and the guard joined Parisian workers in opposition. On March 26, elections were held in Paris for a Commune, or municipal

193. "Peace, an Idyl." Honoré Daumier. 1871. 9¼x7¼. Lithograph. Delteil 3854. Rogers Fund 1922, Metropolitan Museum of Art, New York.

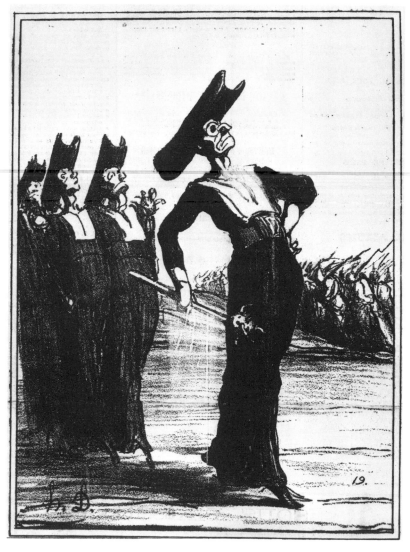

194

council, which in spite of its name included only one Marxist. It was a mixture of republicans, moderates, radicals, and socialists. A week later the second siege of Paris began and again civil war bled France.

Daumier's sympathies were with the Commune, although he must have been dismayed at the violence. When the government threatened to attack the Commune, he pleaded that there be no more graves, and during the subsequent siege of the Commune he pictured Versailles as a singularly loathsome hag. He made no other comments on the Commune and none on the slaughter that followed its collapse, when government troops killed and executed at least 20,000 Parisians. The middle class was securely entrenched, but at the price of a hate that would smolder in the laboring class for generations to follow.

194. "One invasion replaces another." Honoré Daumier. 1871. 9½x6¹⁵⁄₁₆. Lithograph. Delteil 3856. The Benjamin A. and Julia M. Trustman Collection, Brandeis University Library, Waltham, Massachusetts.

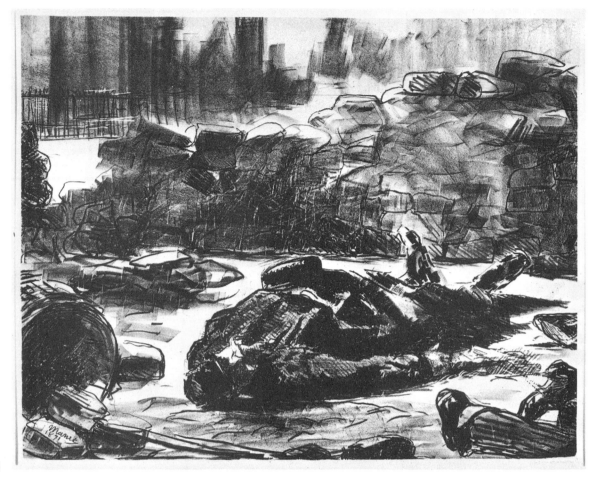

195

Two other great French artists have left works that provide a stark and fleeting glimpse of the tragedy of the Commune and its aftermath. Édouard Manet (1832–83) had served on the general staff of the national guard during the first Prussian siege of Paris but afterward left the city to join his well-to-do family. Manet was generally sympathetic to the republican cause although not active in its behalf. Distressed by the news that civil war was raging in Paris, he returned. The horror of the street fighting, the mercilessness of the reprisals, and the savage nature of the repression which followed, are symbolized in the silent corpses of "Guerre Civile" and the implacable slaughter of "La Barricade," Manet's great lithographs.

195. "Civil War." Édouard Manet. 1871. 15½x19¾. Lithograph. New York Public Library.

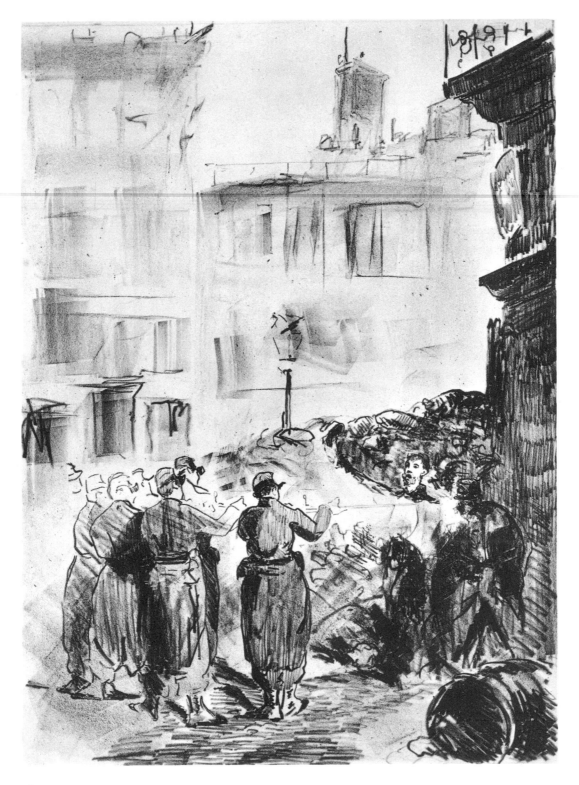

196

196. "The Barricade." Édouard Manet. 1871. 18¼x13. Lithograph. Library of Congress, Washington.

During the life of the Commune, Manet, together with Daumier, Corot, Millet, Courbet, and others, was elected to a grandiosely conceived Commission of Artists, established to preserve Paris' art treasures and encourage exhibitions. There is no evidence that either Daumier or Manet or the others consented to their election, but Courbet, who received the most votes, participated enthusiastically and conscientiously in trying to protect works of art during the fighting.

Gustave Courbet (1819–77) had displayed no special interest in political affairs until 1848, when he witnessed the government troops' ruthless slaughter of Parisian radicals, which he likened to the St. Bartholomew's Day Massacre. Becoming a friend of Proudhon, within a few years he proclaimed himself "not only a socialist, but also a democrat and a republican, in short a partisan of the entire revolution." Emotional, dramatic, antiintellectual, Courbet had no profound political philosophy; his bombastically proclaimed "socialism" reflected a democratic, pacifistic, humanitarian, and anticlerical viewpoint.

He rejected classicism and romanticism and gradually evolved a vigorous realism in his painting of everyday scenes, including those of peasant life, and a strong naturalism in his still lifes and landscapes. His artistic statement of political concern was expressed indirectly, by breaking with traditional techniques and subjects. Only occasionally did he make a more direct statement, as in "The Stonebreakers," a portrait of two men, poverty-stricken but monumental, eternally doomed to crushing rock, which Proudhon called the first socialist painting; or as in "Return from the Conference," a crudely propagandistic depiction of drunken priests which an indignant Catholic purchased in order to burn.

Courbet had been elected to the governing body of the Commune and had participated in its sessions, but in the closing days, democratic to the core, he vigorously opposed formation of the dictatorial Committee of Public Safety. He did play a role —though a questionable one—in the destruction of the Vendôme column, the hated symbol of Bonapartism, and for this as well as for his participation in the Commune he was later arrested. After spending three months in prison awaiting trial, he was sentenced to an additional six months and a heavy fine, but illness shortened his term.

Courbet kept a "Notebook of Sainte Pélagie" (the same prison where Daumier spent a more comfortable incarceration), in which he included sketches of the Commune, of the repression by the Versailles troops, and of the prison itself. One drawing showed his fellow Communard prisoners—men, women, and children—huddled together on the floor of a cell. In another moving sketch, men, women, and children are indiscriminately being marched off by Versailles troops—usually to prison, exile, or death.

Two years after his release, a court held Courbet personally responsible for the de-

197. "Les Fédérés." 198. "Cortège." 199. "L'execution." Gustave Courbet. 1871. 6½x10¼. Drawings. From "Notebook of Sainte Pélagie." Cabinet des Dessins, Musée du Louvre, Paris.

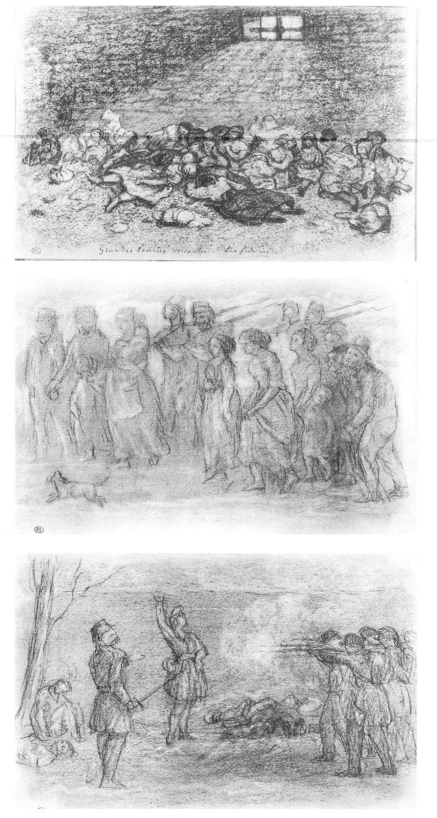

197

198

199

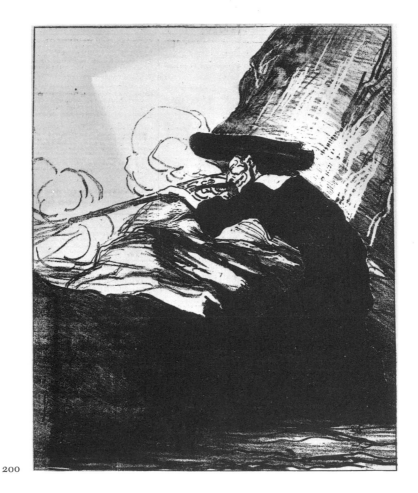

200

struction of the Vendôme column, although its destruction had been ordered before he was elected to the Commune (and there is evidence that he simply wanted to remove and preserve it) and ordered him to pay the huge costs of rebuilding it. He fled to Switzerland, where he died in 1877.

As for Daumier, still fearful for his beloved Republic and wary of monarchists and clerics who could subvert it, he continued to attack both of these enemies. He sketched his priest symbol, Basile, praying before a donkey, portrayed "Christian Charity" in Spain as a priest firing a rifle, and drew Basile and Ratapoil leaning on their canes, arm in arm—"These two ugly debris."

Daumier worried over contention in his republic. "If the workers fight among themselves, how shall the home be built?" he asked. In a by-election held in July of 1872, republicans won 100 of 118 open seats. Although monarchists still held a majority in the Assembly, their bickering made it impossible for them to agree on a ruler, and the provisional government clung to the republican form of government. On September 24, 1872, Daumier had the satisfaction of placing Monarchy in a casket. It was his last political cartoon and a fitting climax to

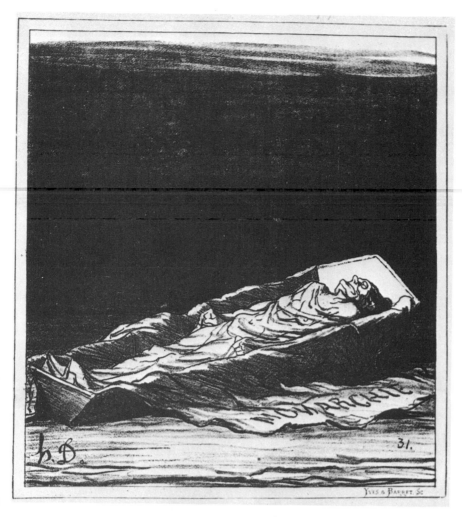

201

a lifelong struggle for representative government.

His eyesight began to fail and his lithographs appeared only sporadically. A small government pension and occasional sale of his work maintained him in modest retirement. In April of 1878 his friends arranged for an exhibition of his paintings, watercolors, drawings, sculpture, and a few lithographs at the Durand-Ruel Gallery. It was neither a financial nor popular success, but the critics hailed a major talent. Ten months later, on February 11, 1879, he died.

Daumier did not live to see the fulfillment of the Revolution's (and his) ideals of Liberty, Equality, Fraternity. These were impossible standards in an essentially conservative society dominated in the towns by men of considerable property and little vision and in the country by peasant proprietors with even more limited horizons. But for forty years he fought, with all the superb artistic means at his command, to transform these ideals into reality. Rarely have artistry and moral integrity been fused with such purpose.

201. "And during that time . . ." Honoré Daumier. 1872. 9¼x8⅜. Lithograph. Delteil 3937. Rogers Fund 1922, Metropolitan Museum of Art, New York.

CHAPTER IX
France and Belgium After the Commune:
From Pissarro to Rouault

THE AFTERMATH of the Commune in France found the forces of the Left bitter, defeated, scattered, their leaders dead or in exile. Even decades later their spirit was unreconciled when Maximilien Luce drew a moving evocation of '71, "Scène de Guerre Civile," with four Communards lying dead in a deserted, sunlit street and a lone dead policeman or bystander in the gutter. The Right was triumphant, and the vast bulk of Frenchmen longed again for peace and order. Conservative monarchists dominated the Assembly, and restoration of a monarch was barely averted. It was not until 1879 that the republicans won a clear majority in both chambers. A liberal democratic regime was established, and the Third Republic was secure.

"Liberté, Egalité, Fraternité" was inscribed on public buildings once again, and the *Marseillaise* became the national anthem and July 14 a national holiday. Within a few years laws were passed guaranteeing freedom of press and assembly, and amnesty was granted to the Communards. Rallying behind Gambetta's cry, *"Le cléricalisme, voilà l'ennemi!"* republicans of every shade—and they ranged from extremely conservative to far left—joined forces in the century-old struggle with the church.

Despite some legislative victories against the church, the anticlerics continued to be agitated by the issues, as mirrored in Jules Henault's turn of the century pastoral punning, "The Dirty Crows." ("Crow" in French is also slang for "priest.") Free, compulsory, secular primary education was authorized (in theory at least), a move that loosened clerical control of the lower schools, and the Jesuits and other unauthorized congregations were ordered dissolved. The right of divorce was reinstated, and secular secondary education for women was established. In 1884, in another significant act, the government granted legal recognition to the labor *syndicats*.

Although these measures helped to nurture political democracy, the French nation remained divided by conflicting political and economic philosophies, as it had been in 1830, 1845, and 1870. The Rousseauist concept of political equality—the belief that power in a democracy stems from the people—was still ranged against the conviction of the church, the army, the higher bureaucracy, the aristocrats, and the wealthier bourgeoisie that authority must come from above and that special privilege was justifiable.

In the economic sphere, the struggle was to continue for years. Thus, issues that had wracked France throughout the nineteenth

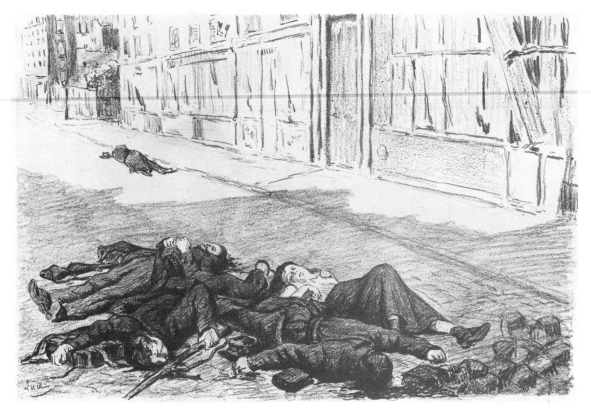

202

century persisted unresolved as the twentieth century approached.

The radical groups advocated numerous sweeping programs in addition to fundamental political reform. These ranged from the establishment of a graduated personal income tax to governmental regulation of hours and conditions of labor and the nationalization of utilities, mines, and transportation. The industrial proletariat still worked long hours at low pay, lived and worked under unsanitary conditions with tuberculosis and syphilis rampant, and enjoyed little protection from unemployment.

To the urban factory worker, the bourgeoisie by contrast appeared to be living in decadent luxury and degenerate dissipation. France was far behind England and Germany in provisions for social welfare. France was more absorbed in developing colonies in Africa and Asia than with the conditions that were degrading her urban industrial workers and their families. Not until the first decade of the twentieth cen-

202. "Civil War Scene." Maximilien Luce. 1910. 11½x17⅛. Lithograph. Bibliothèque Nationale, Paris.

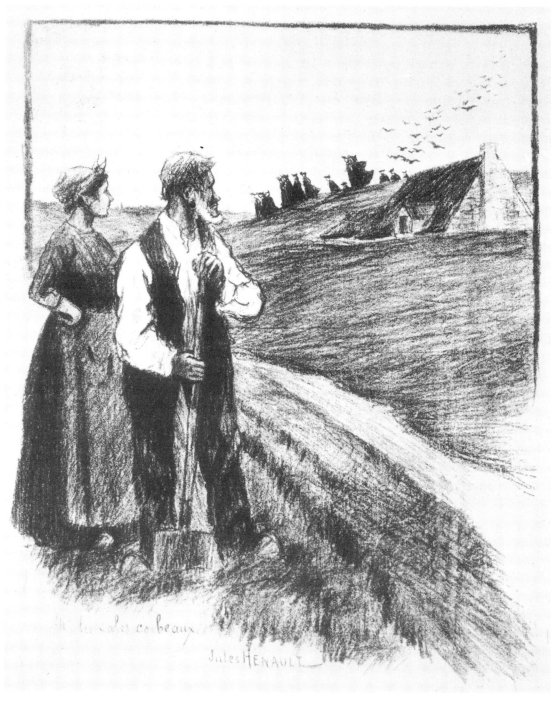

203

203. "The Dirty Crows." Jules Henault. 1904. 18½x14. Lithograph. From *Les Temps Nouveaux,* 1904. Institut Français d'Histoire Sociale, Paris.

tury, when the socialists elected more than one hundred deputies, did workers win the protection of a pension system and a degree of accident insurance and the ten-hour day.

The French working-class movement was long on agitation, short on accomplishment. France's industrial development was slow; most factories were small. In this predominantly agricultural land, the urban proletariat was a minority, with peasant and petite bourgeoisie comprising the bulk of the population. The latter—shopkeepers, teachers, lower-level bureaucrats—usually backed reform measures and often voted socialist, but generally showed little interest in a drastic reshaping of society. Finally, the radical movement was splintered. There were three groups of Marxists who sought complete overhaul of the French social structure, at first through direct assault, later through parliamentary political action. There were the anarchists, antiauthoritarian in the Proudhon tradition, who relied on direct action—including bombing in the 1890's—as the most effective way to achieve revolution. There were the syndicalists, who believed that the workers could and should rely exclusively on their own bargaining power. And finally, there were the gradual socialists—the "possibilists"—under Juarès and Millerand, who eventually gathered most of the groups into the support of a minimum political program under the leadership of a united Socialist Party that achieved political effectiveness on the eve of World War I.

Where were France's great artists during this turmoil? Most of the Impressionists—Renoir, Degas, Monet, Cézanne, Gauguin—were too absorbed in their painting and the struggle for recognition to have more than sporadic or passing interest in the political and economic struggle and were by and large conservative in outlook.

Typical was Renoir's attitude when, in 1882, the dealer Durand-Ruel tried to arrange another joint exhibition of the Impressionists, including, of course, Camille Pissarro, a founder of Impressionism but also regarded as a "dangerous socialist." Renoir, hopeful of recognition by the scorned art establishment, recoiled, declaring that the public didn't like "political" painters. Moreover, he said, he did not want to be regarded as a "revolutionary" at his age (he was all of forty-one).

It was certainly one of the most difficult times artists have ever faced. Gone was the church as patron; rich sponsors, purchasing only conventional academy art, disdained the innovators; and there was no coterie of aficionados eager to be the first collectors of "new movements."

These difficulties both hardened and divided the artists' attitudes toward society; some aligned themselves more strongly with the philosophy of the conservatives and the wealthy, while others identified with the struggling lower classes whose poverty they often shared.

One entire group, the Neo-Impressionists, was allied not only by their common efforts to practice Seurat's theories of Divi-

sionism, but, in varying degree, by a common faith in anarchism as a solution to France's ills. With the artist's instinctive resistance to fetters, it was inevitable that many should be drawn to socialist anarchism with its stress on individual freedom, rather than to Guesde's Marxist communism with its inherent discipline. Rarely have so many artists been bound—even if only for a brief period—by political conviction as well as artistic theory: Camille Pissarro (1831–1903) and his son, Lucien (1863–1944); Georges Seurat (1859–1891); Paul Signac (1863–1935); Maximilien Luce (1858–1941); Henri-Edmond Cross (1856–1910); Charles Angrand (1854–1926); the Belgian Théo Van Rysselberghe (1862–1926), and others.

Many of the Neo-Impressionists were diehard anarchists, with a compassionate feeling for the poor and an idealistic attachment to a socialist society organized along community lines. Reacting against the oppressive life of the city worker which they observed at first hand, they tended to idealize the peasant way of life. Most were friends of Jean Grave, the anarchist editor and leader. Although they contributed both money and drawings to his magazines, they felt strongly that their art should be devoid of obvious symbols and free of bald social message. Rather, they believed they could attack debased bourgeois values most effectively by breaking with traditional "escape" subjects and portraying peasant and worker with dignity. By a straightforward depiction of homeless or working people, often against factory backgrounds, they criticized the social order by implication.

Finally, they believed—perhaps mystically—that the purity of their anarchist principles would be expressed in their art (and even in the landscapes for which most of them are best known today) in some transcendental way. Signac wrote: "The anarchist painter is not he who does anarchistic paintings, but he who without caring for money, without desire for recompense, struggles with all his individuality against bourgeois and official convention . . . basing his work on the eternal principles of beauty which are as simple as those of morality." Signac's rhetoric was more high-flown than practical; few could afford to paint "without desire for recompense." Camille Pissarro defined the philosophy less sententiously when he wrote to his son Lucien: "I firmly believe that something of our ideas, born as they are of the anarchist philosophy, passes into our works which are thus antipathetic to the current trend." It should be remembered, however, that the Neo-Impressionistic anarchists were referring primarily to painting and not to the graphic arts, a much more pliable medium for social comment than painting.

By their understatement, the Neo-Impressionist anarchists were not so much protesting against as speaking up for the dignity of the workingman and especially the peasant. The peasant had traditionally been depicted as a picturesque or quaint object, or regarded as a genre subject to amuse the middle class.

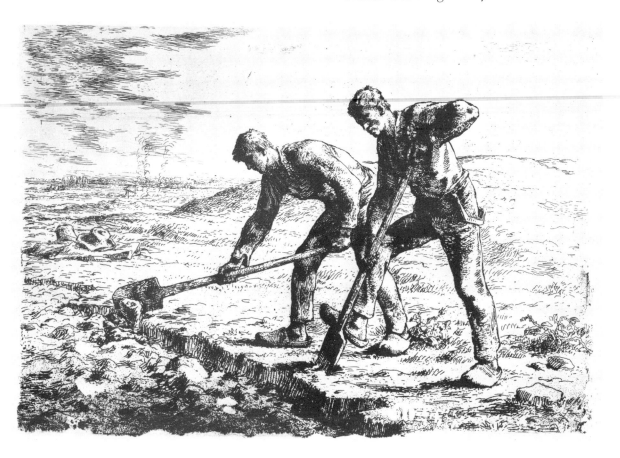

204

Bruegel painted the peasant at work in the fields and made many sketches of peasants, and Callot etched them. But neither identified spiritually with the peasant, as Millet and Van Gogh were to do. Also, in the seventeenth century the Le Nain brothers had painted poverty with a sober, matter-of-fact sincerity. And all of Rembrandt's etchings, including those of peasants, have a pervasive humanity.

It was Jean François Millet (1814–75), however, who captured the biblical simplicity of the peasants' life, the rhythm of their seasonal toils, the strain of their labors. Because of his painting "Angelus" and his many twilight scenes, Millet has too often been regarded as a sentimentalist and a creator of popular images, while the realism of his graphic work has been overlooked.

"The Diggers" is typical of his etchings. He relies on the curvature of the body, the

204. "The Diggers." Jean François Millet. No date. 9⅜x13¼. Etching. New York Public Library.

play of muscles, the modeling of the figures, to express the sense of back-breaking toil. But Millet's pictures and etchings were not meant to be indictments; he had no political "message" in mind. In fact, in 1887, a dozen years after his death, two letters were published which he wrote during the Commune attacking the Commune and Courbet. Camille Pissarro, fervent social anarchist that he was, was outraged. "Because of his painting, 'The Man With the Hoe,'" he wrote his son Lucien, "the socialists thought Millet was on their side, assuming that this artist, who had undergone so much suffering, this peasant of genius who had expressed the sadness of peasant life, would necessarily have to be in agreement with their ideas. Not at all! . . . He was just a bit too biblical. Another one of those blind men, leaders or followers, who unconscious of the march of modern ideas defend the idea without knowing it, despite themselves!" It was ironic that Millet was extolled by some, condemned by others, for being so "biblical." Actually, he was a lifelong agnostic.

Vincent Van Gogh (1853–90) was another artist of this period who painted and drew the peasant with dignity and feeling, but without specific social purpose. Unlike Millet, Van Gogh gradually evolved a critical, socialist-oriented philosophy, if an amorphous one. In the early eighties he chided Daumier and Gavarni for looking on society "with malice" and extolled Millet because he "chose subjects which are as true as Gavarni's or Daumier's but have

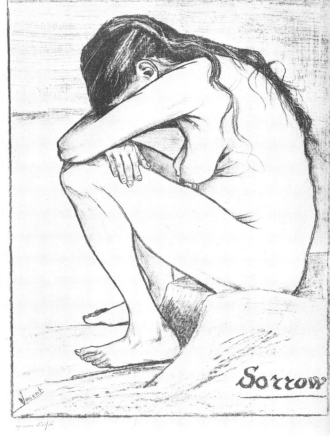

205

something noble and a more serious sentiment. . . . An artist needn't be a clergyman or a church worker, but he must certainly have a warm heart for his fellow man." Although he never affiliated with the anarchists of Neo-Impressionism or any other group, he became convinced, in the later eighties, that the century "will end in a colossal revolution."

Wherever Van Gogh lived during his twenties—Holland, England, or Belgium—he identified with the poor and the exploited. Unfortunately his sketches of Belgian coal miners are gone and we have little direct expression of his deeply felt an-

205. "Sorrow." Vincent Van Gogh. 1882. 15⅜x11¾. Lithograph. Museum of Modern Art, New York.

ger at a society he saw crumbling. A rare exception is his "Sorrow," a poignant lithograph of a despairing and starving prostitute to whom he gave shelter and employment as a model.

We do have visual expression of his feelings for the peasants. Whereas Millet usually made his subjects almost faceless, Van Gogh not only painted masterful portraits, but sketched the peasants in the fields with an almost passionate beauty, as in his "La Paysanne Creusant le Sol." Perhaps the strength and limitation of Van Gogh's philosophy are best exemplified in "The Potato Eaters." He wrote his brother Theo:

206

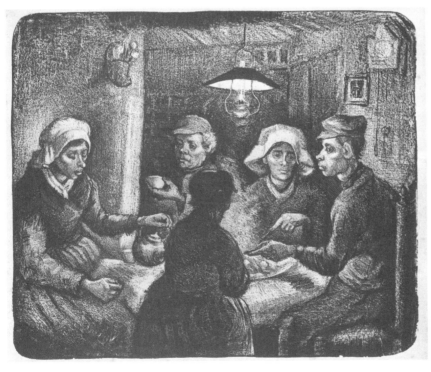

207

206. "La Paysanne Creusant le Sol." Vincent Van Gogh. No date. 20⅞x17⅜. Black chalk drawing. Nasjonalgalleriet, Oslo.

207. "The Potato Eaters." Vincent Van Gogh. 1885. 10⅛x12½. Lithograph. Rosenwald Collection, National Gallery of Art, Washington.

"I have tried to emphasize that these people, eating their potatoes in the lamplight, have dug the earth with the very hands they put in the dish, and so it speaks of *manual labor,* and how they have honestly earned their food."

There is no direct record of Georges Seurat's participation in the anarchist movement, but as the contemporary critic, Félix Fénéon, concluded: "His literary and artistic friends and those who supported his work in the press belonged to anarchist circles, and if his opinions differed radically from theirs, the fact would have been recorded." Seurat, son of petit bourgeois parents, did not contribute to the anarchist magazines as the others did, but through most of his tragically brief career his work reflected a deeply felt empathy for his peasant and laborer subjects.

Robert L. Herbert has expressed this point in his book, *Seurat's Drawings,*

Peasants are not, in his eyes, mere pretexts for formal study, nor are they the quaint rustics of Salon genre. They are simple people of immense dignity, always at work. His city folk are not chosen indiscriminately; they are the humble urban dwellers: market porters, nurses, bootblacks, street vendors, vagabonds. And beyond the humanitarian ideal they express is a tacit expression of social criticism: in the wake of Millet and Daumier, Seurat is saying that the little people of the world are more important than the nymphs and Venuses preferred still by the bourgeoisie, who would like to ignore the lower echelons of society on which they build their well-

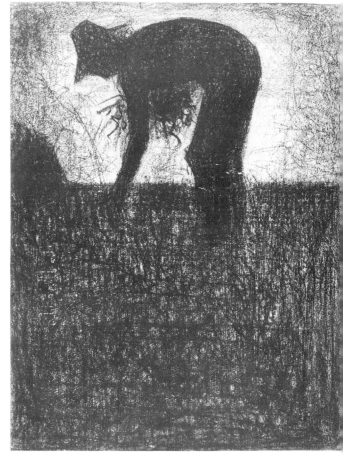

208

being. . . . Seurat's choice of the forlorn manufacturing district north of Paris is consistent with his humanitarian concern. He does not draw landscape in the spirit of escape from the ugliness of the city, he draws the ugliness itself. Landscape rose to preeminence in the nineteenth century in opposition to the changing cities of the industrial revolution. The bourgeoisie could escape into healthy, untainted nature and forget the disfiguring scars and social misery that hung like a pall of smoke over their consciences. To remind them of it was a radical act.

208. "Peasant Gathering Plants." Georges Seurat. 1881–82. 32x24. Drawing. British Museum, London.

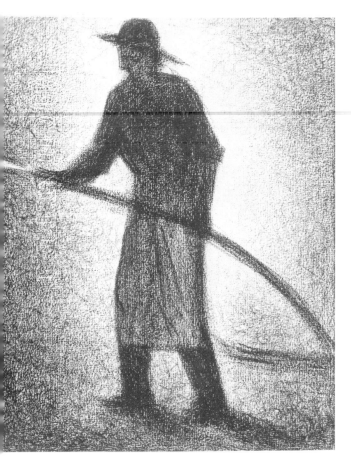

209

Just as Seurat converted Camille Pissarro temporarily from Impressionism to Divisionism, so it is likely that the older Pissarro played a role in the development of Seurat's political attitudes. This dean of the Impressionists, a lifelong radical who was attracted by and contributed to the social theories of the more active Neo-Impressionists, insisted that Seurat and Signac be permitted to exhibit in the final (1886) Exhibition of the Impressionists, even though it meant the withdrawal of Monet, Renoir, and Sisley.

Unlike Daumier and Courbet, the socialist anarchists—Pissarro, Signac, Luce, and others—were not interested in political reform. Doubting the relevancy of such issues as republicanism versus monarchy, or constitutional reform and progress through parliamentary procedures, they sought the overturning of a social order which had abused them. A socialistic, communal society was their dream, with artists liberated from privation and restraints. In 1891 Pissarro wrote his son Lucien that "artists could work with absolute freedom once rid of the terrible constraints of Messrs. capitalist collector-speculators and dealers."

Camille Pissarro was the most deeply involved in the philosophy and theory of anarchism and socialism; hence his views are worth exploring in detail, even though their specific expression through art was limited. Born in Saint Thomas in the Virgin Islands, son of a Frenchman of Spanish-Jewish descent and a Creole mother, he arrived in Paris in 1855, where he was influenced by

Frequenting the industrial suburbs of Paris, Seurat was the first major artist to treat the factory—and the new industrialization with its overtones of man versus machine—as a proper subject of art. Since it was not in Seurat's subtle temperament or technique to make an open preachment, we must regard such drawings as "Peasant Gathering Plants" and "Street Cleaner with Hose" as reflective of his general philosophy.

209. "Street Cleaner with Hose." Georges Seurat. 1882–3. 12⅛x9¾. Conte crayon drawing. Photo Courtesy Wildenstein. Mr. and Mrs. Paul Mellon Collection, Upperville, Pennsylvania.

Corot and subsequently by Courbet. In the 1860's he became friendly with Monet, Renoir, Sisley, Manet, and Degas, and later with Cézanne and Gauguin. Pissarro's qualities—warmth and kindliness, steadfastness and lack of pettiness, generosity and lively intellect—often made him the connective between these divergent personalities. Pissarro was the most radical of the group, possibly because his constant privation and omnipresent poverty convinced him that the wealthy bourgeois would never accept innovation, in art or elsewhere.

Throughout this period and during much of his life, Pissarro lived in villages not far from Paris, painting landscapes and scenes of peasant life. His communion with nature was intimate, tender, profound—in effect, a declaration of faith. He was closer to the soil than the other Impressionists, perhaps because he came from the West Indies where he observed labor's condition as tantamount to slavery. He painted and sketched peasants sympathetically, with dignity, suggesting the rhythm of poetry as they toiled. Whereas Millet tended to be romantic in some of his portrayals of peasants, Pissarro was always essentially humanistic. Soul-searing poverty haunted Pissarro perennially, but he never allowed it to distract him from tireless application to his work. His output was tremendous, partly because of single-minded devotion, partly because his wife, in the fashion of artists' wives, staved off most creditors and somehow fed their numerous children.

The critics had no praise for Pissarro and the other Impressionists, and his paintings sold for less than 200 francs, if they sold at all. In 1873, an auction brought reasonably higher prices for some of his work for the first time; thus, when the Independents held their first exhibition the following year, Pissarro was urged to withhold and seek recognition at the Salon. Characteristically loyal to his friends and to the principle of freedom of expression, he refused. The Independents' exhibition was a commercial failure, as were their subsequent shows.

Constant financial worries, want, and deprivation plagued Pissarro throughout most of his life. "I am at my wits' end," he wrote Monet in 1884. The desperateness of his condition is illustrated by the fact that his conversion to Seurat's Divisionism, which occurred just as he was regaining some acceptance, so intensified his financial plight that his wife threatened to drown herself with their two youngest children.

However, the 1890's were an exciting decade for Pissarro. He returned to Impressionism and abandoned Divisionism which had enriched his palette and made his color relationships lighter and more subtle. His landscapes and village scenes gained in harmony and luminosity. Durand-Ruel, his dealer, had success with an Impressionist show in the United States and by the end of the decade had built up a sizable audience for Pissarro's works.

Until his death in 1903, the white-bearded patriarch of Impressionism and

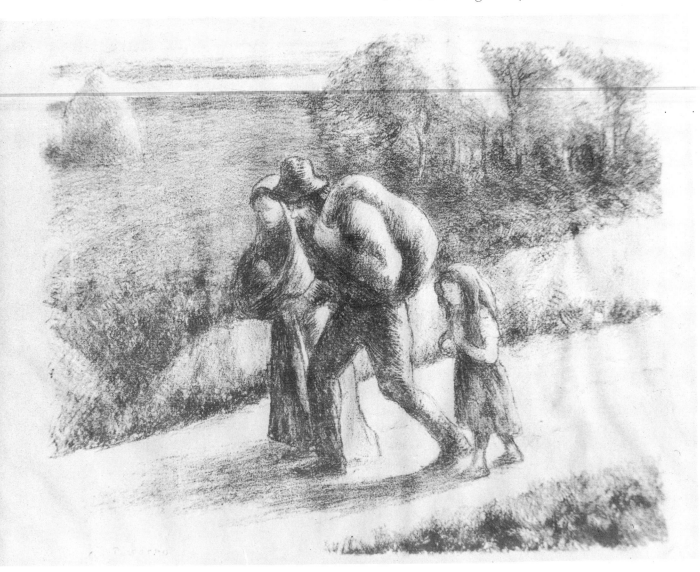

210

210. "Les Sans-Gîtes." Camille Pissarro. 1896. 9¾x12. Lithograph. Delteil 154. Galerie St. Michel, Paris.

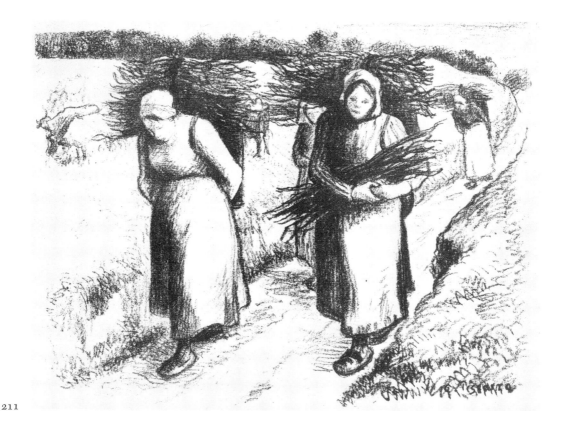

211

anarchism clung to his politico-economic views through travail and belated, moderate financial success. Although widely read in socialist theory and contemptuous of capitalism and of the possibility of reforming it by parliamentary means, Pissarro was essentially humanistic and simplistically idealistic in his views. He was, nevertheless, capable of bitterness. When Gauguin, whom he had befriended and encouraged, turned to symbolism, Pissarro wrote:

> The frightened bourgeoisie, surprised by the immense clamor of the disinherited masses, by the tremendous demands of the lower classes, feels that it is necessary to bring the people back to the superstitious beliefs. Hence the bristling of religious symbolists, religious socialists, idealistic art, occultism, Buddhism, etc., etc. . . . May this movement be only a death rattle, the last. The Impressionists have a true function; they stand for a healthy art based on sensation, and that is an honest stand.

While Pissarro dreamed of a utopia without governmental restraints, many of his fellow anarchists took direct action. In the inexorable chain which culminated in the suppression of anarchism, pitched battles with the police led to trials and convictions, which in turn stimulated anarchists into

211. "Les Porteuses de Bois." Camille Pissarro. 1896. 9x11¾. Lithograph. Delteil 153. From *Les Temps Nouveaux*. Kupferstichkabinet, Berlin.

bombing the homes of judges; thus, more beatings and more trials.

In April 1892, Pissarro wrote Lucien:

> Pouget and Grave [anarchist editors] have been arrested in the general sweep that was made of all the comrades in the name of the laws which even the bourgeois newspapers are beginning to regard as ill advised. The Republic, of course, defends its capitalists—that is understandable. It is easy to see that a real revolution is about to break out—it threatens on every side. Ideas don't stop!

Pissarro had obviously been carried away; a "real revolution" was remote, to say the least. A month later he admitted to Lucien: "You are right, the bulk of the poor do not understand the anarchists." Just two years later assassination of the president of France led to a roundup of anarchist leaders and artists, including Maximilien Luce, and to the legislation that suppressed the movement. Pissarro, in Belgium at the time, found it discreet to remain there until passions had subsided.

Although it was now a legal offense to advocate anarchy, the laws were not enforced to the letter and the anarchist press was permitted to continue. Pissarro, who gave money to Jean Grave at great personal sacrifice, contributed a lithograph, "Les Sans-Gîtes," to Grave's paper, *Les Temps Nouveaux*, when it ran a series on the homeless. Characteristically, another lithograph for *Les Temps Nouveaux*, "Les Porteuses de Bois," is also not overt propaganda, but symbolic.

Pissarro created many beautiful and ob-

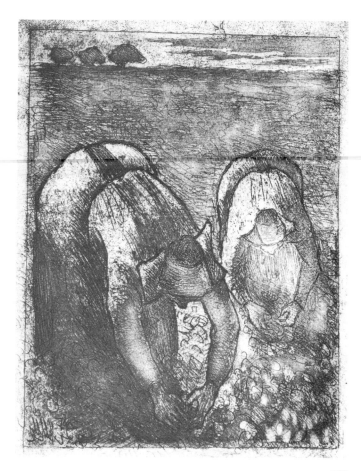

212

viously deeply felt etchings and drawings of peasants at work, such as "Peasants in a Field of Beans." As pointed out by Eugenia W. Herbert in her brilliant pioneering book on the French and Belgian radical artists of the 1890's, *The Artist and Social Reform:* "Simply by portraying workers and social outcasts, the painters were bringing truth before the public; truth about the existing order was by definition criticism of it." Unlike Millet and Van Gogh, Pissarro attributed to his etchings and sketches of peasant life a deep social import, as a conscious expression of his social philosophy.

212. "Peasants in a Field of Beans." Camille Pissarro. 1891. 6¾x5¼. Etching. Delteil 103. Bibliothèque Nationale, Paris.

Pissarro departed from this broad approach only once, for an unpublished album of twenty-eight drawings, "Les Turpitudes Sociales." The propaganda is simplistic, the drawing swift and sure. In "Le Pendu," a millionaire hangs from a lamp post. The caption: "A millionaire is too heavy . . . he crushes the poor." In a sketch of the poor at the barricades, Pissarro's caption denounces the rich as robbers and executioners.

France's unresolved conflict between church and state came to a thundering climax in "l'Affaire Dreyfus." The republican, radical, and anticlerical forces confronted the military, royalists, clerics, conservatives, and anti-Semites in a *fin de siècle* titanic struggle that eventually resulted in a strengthening of the democratic trend and a curbing of both military and church.

Pissarro—and almost all the radical artists—lined up with the Dreyfusards, but unfortunately there was no Daumier among them. "It is becoming clear now that what we are threatened with is a clerical dictatorship, a union of the generals with the sprayers of holy water," Pissarro wrote Lucien. "Will this succeed? I think not."

A month later, during Zola's trial for publishing *J'accuse!*, Pissarro's optimism had deserted him: "Poor France!" he wrote. "Who could have imagined this nation, after so many revolutions, enslaved by the clergy like Spain! The slope is slippery." The very next day, he told Signac that Degas and Renoir would no longer recognize him since the anti-Semitic incidents.

"What can there be in the minds of such intelligent men that leads them to become so silly?"

But nine months later Pissarro affirmed his faith that justice would prevail. "I believe and hope that in the end free men will have the upper hand," he declared. When he died, in 1903, he still retained this belief.

Paul Signac, a contemporary of Pissarro's son Lucien, shared many qualities with the older man: generosity, open-mindedness, and constant political or artistic activity. Even more than Pissarro, he was unsparing of friends and energy for the causes he believed just, despite the price he paid for his commitment. "If there is one fear he never had, it was that of being too radical," John Rewald has commented.

In 1898, Signac, then 35, visited Pissarro and found him shaken by the loss of a son but passionate about the Zola trial and, as always, working hard. "When one compares the old age of this artist—all activity and work—with the dreary and senile decay of the old *rentiers* and pensioned-off, what a reward art holds for us!" he noted in his diary. But Signac, too, stayed young all his life; dynamic, eternally active, and, like Pissarro, receptive to youth. "At my age you've got to love young people," he observed almost 30 years later, and thus "escape becoming a bad-tempered old man."

Signac was heir to Seurat's theories. His book, *De Delacroix au Néo-Impressionisme*, which he issued in 1899, was a lucid

213

Un millionaire c'est trop lourd, ça trouble l'harmonie des intérêts, ça rompt l'équilibre des droits, ça écrase les gouvernés." (révolte)

213. "The Hanged Man." Camille Pissarro. 1890. 13x18. Drawing. From "Les Turpitudes Sociales." Bibliothèque Nationale Suisse, Berne.

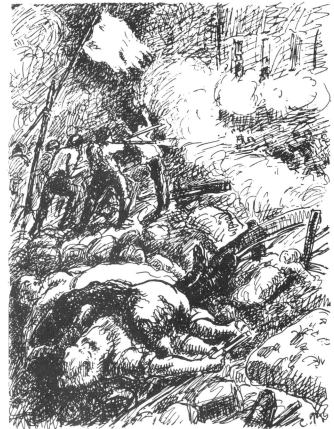

214

exposition of the scientific theories of Neo-Impressionism, but his chromatic innovations went further. He became much more lyrical than Seurat, particularly when he discovered the world of ports and harbors, masts and sails. His color became brilliant, the light vibrant, tremulous.

Signac was also a disciple of Jean Grave and corresponded with him for years, occasionally giving him drawings for reproduction in his anarchist papers. But Signac was emphatic that art should not have an openly propagandist social message. To Signac as others, Neo-Impressionism, by challenging prevailing artistic concepts and by its innovations in subject matter—the industrial suburbs, people at work, the poor, the toiling peasant, the decadent pleasures of the bourgeoisie—was by its nature an attack on bourgeois values. Such content, he felt, dealt "a solid blow of the pick to the social edifice, which, worm-eaten, is cracking and falling away." In one of his few graphic works which may probably be interpreted as a direct piece of social symbolism, the stonebreaker is delivering "a solid blow of the pick" on the capitalist state.

Signac maintained his friendship with

214. "The Poor at the Barricades." Camille Pissarro. 13x18. Drawing. From "Les Turpitudes Sociales." Bibliothèque Nationale Suisse, Berne.

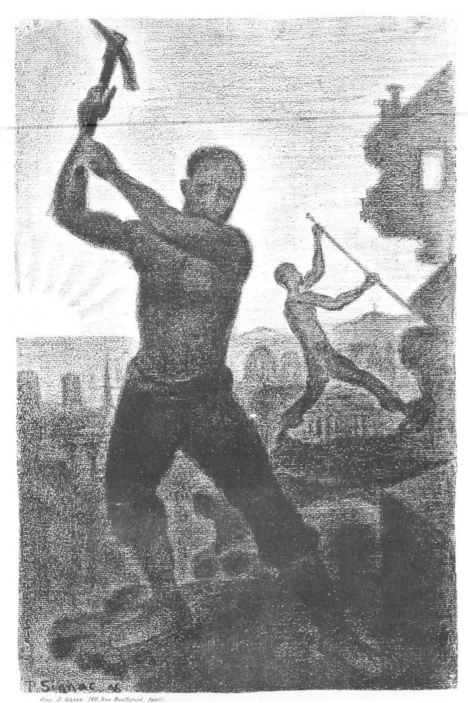

215. "Les Démolisseurs." Paul Signac. 1896. 22¼x18. Lithograph. Museum of Modern Art, New York.

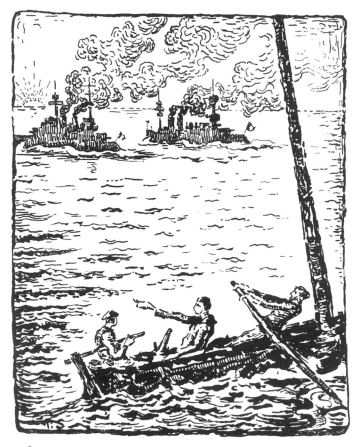

216

Cofounder with Signac of the Neo-Impressionist school was Maximilien Luce, the most "proletarian" of the anarchist artists. Luce, who exhibited with the Independents in 1888, shared his friend Pissarro's love of landscape, but with Seurat and Signac developed the "cityscape." Factories, smokestacks, and sometimes flaming furnaces formed the backgrounds for his painting of that period. Less intellectual than the others, Luce was much more openly propagandist in his work for the anarchist press. He contributed more than one hundred drawings to Émile Pouget's *Père Peinard*, a slangy, unsophisticated weekly, its propaganda crude but effective, week after week making graphic assault on the government, the new colonialism, the constitution, and the decadent bourgeoisie. Luce also made frequent contributions to *Les Temps Nouveaux*, including the mordant "Sa Majesté la Famine," and he often appeared in the socialist *Le Chambard*. In "La Vache a Lait" he combined his satirical bent with his love of a pastoral scene.

Luce helped organize lotteries for Grave's benefit and was among the anarchists imprisoned in 1894. He was acquitted and returned to the fray, continuing his drawing for the radical magazines for another quarter century. Only during the last year of his life did his paintings gain recognition, but, like Pissarro, he lived long enough to enjoy at least a little homage. Like Pissarro too he had warmth, kindness, simplicity, and a feeling for humanity that were reflected in his work.

Grave long after he moved his pictorial locale from the industrial suburbs to harbors and other marine scenes.

A drawing for Grave's *Les Temps Nouveaux* combined Signac's love of harbor scenes with sardonic social comment. An oarsman points out that the two new battleships are worth 400 million loaves of bread. In 1916, during World War I, he reproached Grave for approving of the war: "You taught me that war is always evil, atrocious."

216. "The Two New Battleships." Paul Signac. 1907. Drawing. From *Les Temps Nouveaux*. Collection of Institut Français d'Histoire Sociale, Paris.

217. "Sa Majesté la Famine." Maximilien Luce. 1898. 11¾x8¾. Lithograph. Institut Français d'Histoire Sociale, Paris.

218. "La Vache a Lait." Maximilien Luce. 1894. 12⅞x12¾. Lithograph. From *Le Chambard*. Bibliothèque Nationale, Paris.

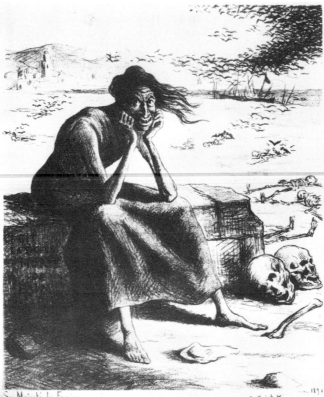

Sa Majesté la Famine

217

218

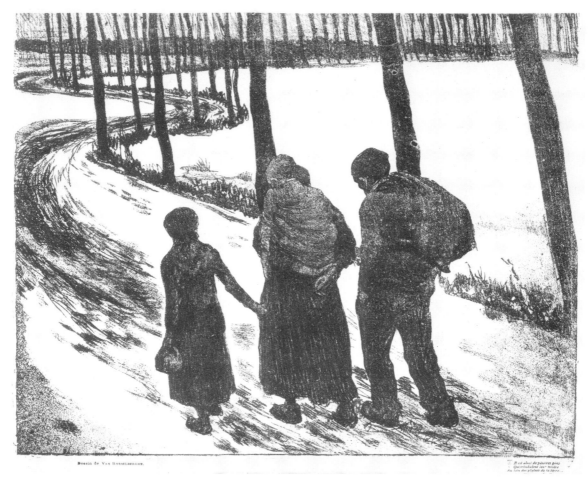

Dessin de Van Rysselberghe.

Il est ainsi de pauvres gens
Qui trimballent leur misère
Au loin dès qu'éclate du la terre

219

To Théo Van Rysselberghe, Seurat's "La Grande Jatte" was a revelation, and the young Belgian soon became both an artistic and political ally of the Neo-Impressionists. He specialized in applying the technique to the human figure and portraits—not with profundity but with considerable charm and skill. Van Rysselberghe exhibited with Les XX, Brussels' counterpart to the Independents. He too became a friend of Grave and gave him several lithographs, of which "Les Errants" was for the "homeless" series in *Les Temps Nouveaux*. The symbolically endless row of trees deepens the poignancy of the four sculptured figures and makes for a strong design.

One of the most brilliant draftsmen of Les XX was the satirical Félicien Rops (1833–98) whose satanic drawings and prints were later to become very much in vogue in Paris. His ventures into political satire were incisive and memorable, especially his "Order Reigns in Warsaw," a lithograph drawn when the Poles were again ruthlessly slaughtered by the Russians after an abortive revolt.

219. "The Wanderers." Théo Van Rysselberghe. 1897. Reproduced from *Les Temps Nouveaux*, Oct. 21, 1905. Institut Français d'Histoire Sociale, Paris.

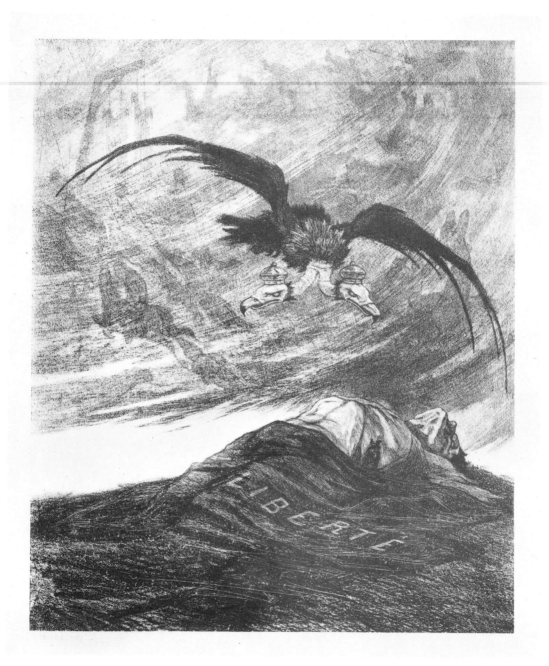

220

220. "Order Reigns in Warsaw." Félicien Rops. 14¼x11¾. Lithograph. Bibliothèque Royale, Brussels.

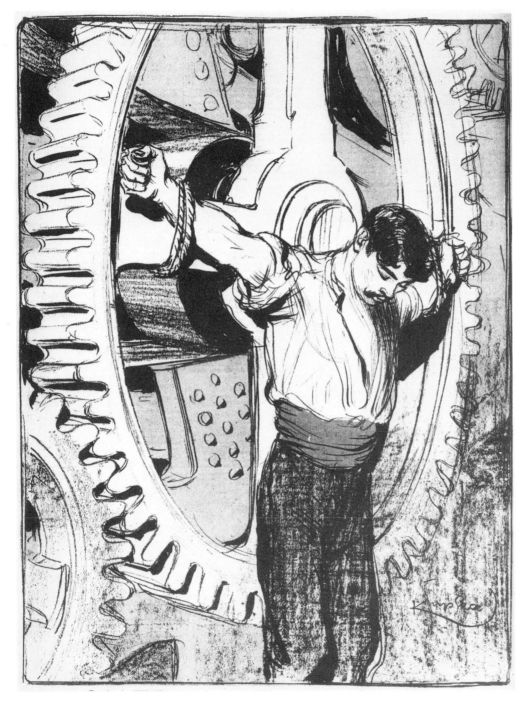

221

221. "The Cog." Franz Kupka. 1905. From *Les Temps Nouveaux.*

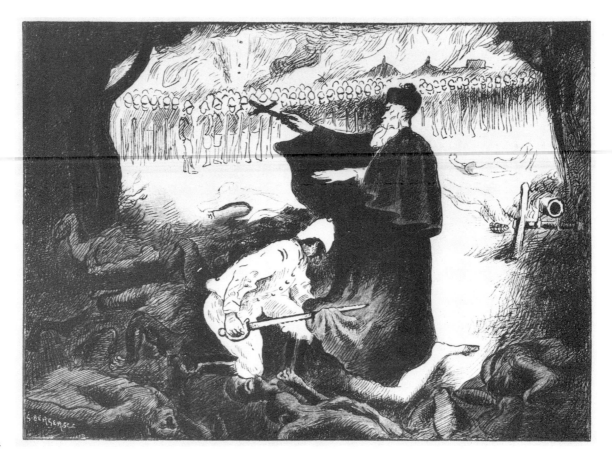

222

A number of artists who worked primarily in graphics also contributed to the anarchist and socialist press, with much greater frequency and variety and with infinitely less concern over whether message intruded on their art.

Early in the twentieth century *Les Temps Nouveaux* shifted political gears, declared its independence from any ideological ties, and proclaimed, "We have no special class to defend—we desire the emancipation of the whole human race." Graphic protest art played a major role in the paper's efforts to achieve this lofty goal. In addition to work by Pissarro, Luce, and Signac, a number of artists contributed, including Kees van Dongen, who was later to become the acidulous but popular painter of fashionable women during the postwar period, and Franz Kupka (1871–1957), who was to pioneer in abstract art. Kupka's worker chained to the cog was obvious in its symbolism, but his sure draftsmanship is equally apparent. In a special *Les Temps Nouveaux* album on "Patriotisme-Colonisation," Henri-Edmond Cross (1856–1910) contributed a satire on the alliance of church and military in colonial oppression.

222. "Satire on Church and Military." Henri-Edmond Cross. 1903. 7¼x5¼. Drawing (Engraved by Bergerac). From the album "Patriotisme-Colonisation" published by *Les Temps Nouveaux*. Institut Français d'Histoire Sociale.

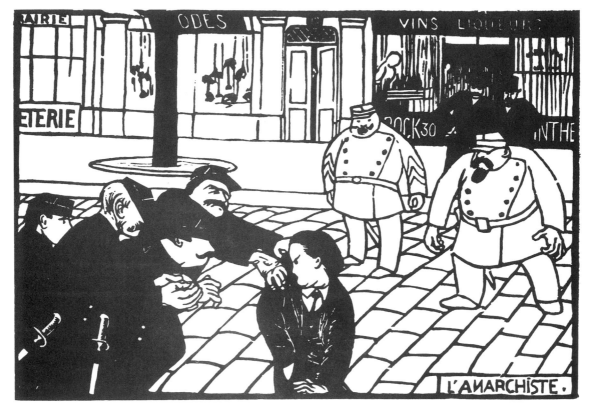

223

Félix Vallotton (1865–1925) literally carved a niche for himself with an unusual group of woodcuts which clearly reflect the influence of Japanese prints circulating in Paris during the 1880's and 1890's. The studied pattern of black and white achieved a decorative effect, ideal for his ironic statements. Some of them recapture scenes of the nineties only too painfully familiar to the radical Left: in "L'Anarchiste," one feels the terror of the lone anarchist as a cordon of police swoop down upon him;

"La Manifestation" rekindles the passions of the demonstration; "La Charge," the frightening moment when the police attack the demonstrators; and "Patriot's Speech," against right-wing forces who were glorifying superpatriotism for their own political purposes.

Vallotton contributed to *Les Temps Nouveaux*, joined other artists in an album in defense of Dreyfus, and did a series of drawings for a collection, "Inquest on the Paris Commune." In 1902 he illustrated an

223. "The Anarchist." Félix Vallotton. 1892. 6½x9¾. Woodcut. Cabinet des Estampes, Musée d'Art et d'Histoire, Geneva.

224. "La Manifestation." Félix Vallotton. 1893. 8x12. Woodcut. Kunstmuseum, Basel.

225. "The Charge." Félix Vallotton. 1893. 7½x10. Woodcut. Larry Aldrich Fund, Museum of Modern Art, New York.

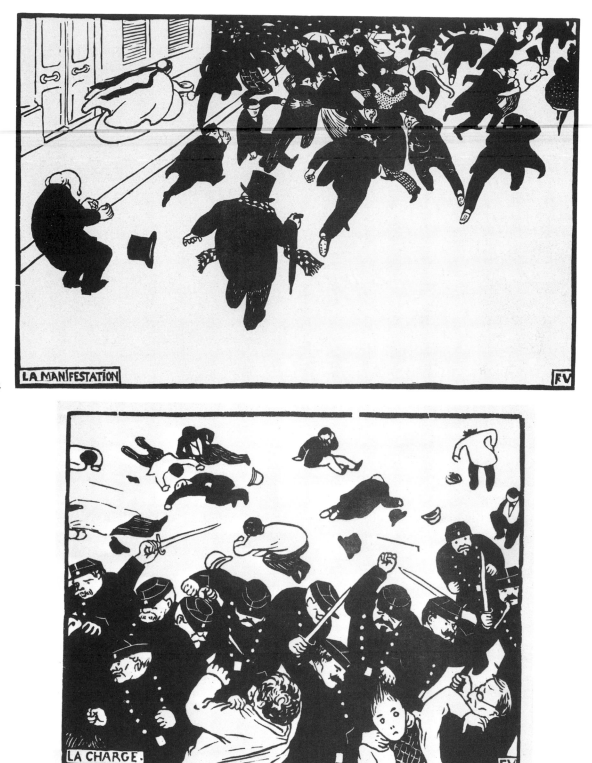

224

225 LA CHARGE. 225

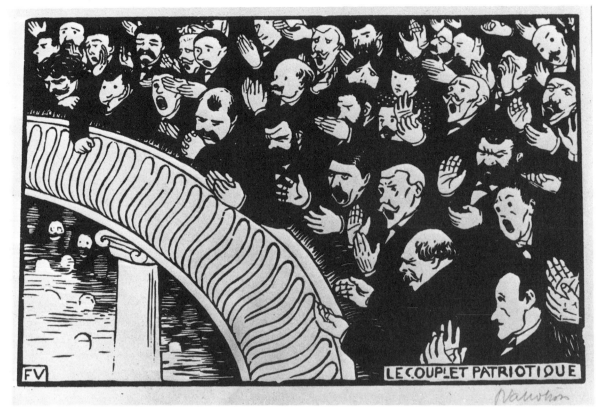

LE COUPLET PATRIOTIQUE

226

entire issue of *L'Assiette au Beurre,* the weekly left-wing gadfly, but as he devoted himself more and more to serious painting, his interest in the social struggle waned. For awhile he was a Nabi—a fanatical prophet—but with touches of realism and irony, and ultimately this naturalized Parisian of Swiss Huguenot extraction achieved a measure of success with nudes and landscapes painted with a hard, dry style.

H. G. Ibels (1867–1936) was a frequent and quite savage contributor to various socialist magazines and to *Père Peinard,* and while his general level was consistently

effective for the time, he never achieved an inspiration of more than topical value. Adolphe Willette (1857–1926) was a popular lithographer and a highly contradictory man and artist. Both his lacy, pink, sexy grisettes in the Gavarni tradition (though he is reported to have blushed at the thought of a woman's breasts) and his Pierrots were chic and piquant; he created a charming dreamworld. Yet he appeared often—and stridently—in the Left press.

The generosity of spirit that characterized Pissarro and Luce was the outstanding quality of Théophile-Alexandre Stein-

226 "Patriot's Speech." Félix Vallotton. 1893. 8x12¼. Woodcut. Gift of Mary Turley Robinson, 1950. Metropolitan Museum of Art, New York.

len (1859–1923), another contributor to the radical press in the 1890's. Son and grandson of landscape painters, Steinlen left his native Switzerland for Paris in 1879, drawn by "inevitable sympathy" to the industrial suburbs after reading Zola's *L'Assommoir*, according to his close friend Anatole France. He won an audience fairly quickly in the eighties with his gently humorous fables—"Histoires sans parler"—of animals, especially cats, in *Le Chat Noir*, published by the popular cabaret of that name. He illustrated song sheets for Aristide Bruant, and in the nineties did a wide variety of illustrations for songs, novels, and periodicals, especially *Gil Blas*. He earned a large following through his posters and the *Gil Blas* drawings, and in the first two decades of the twentieth century his graphic art found a ready audience. Throughout his drawing was traditional, often lyrical, untouched by *l'art nouveau*.

Steinlen drew upon his remarkable visual memory as he prowled the streets of Paris with an eye observant of the daily drama and with a humanistic sympathy for the man in the street, the homeless, the prostitute. There is a pervasive expression of humanity and fraternity in much of his work; it is difficult to separate the artist from the man. "The Millet of the streets," this gentle and serene man has been called. Anatole France commented: "He has suffered and laughed with the people who pass by. The soul of the angry and joyous crowds has passed into him."

But he identified not only with the poor and humble on the streets; his pen and crayon were drawn to all forms of suffering and revolt. "You will find Steinlen at the entrance of the shipyard, at the door of the workshop, at the exit of the factory; he is everywhere where the masses assemble, on days of celebration, of insurrection, or of strikes," Claude Roger-Marx wrote in his introduction to the *catalogue raisonné* of Steinlen's graphic work. Picasso in his early years was drawn to the social content in Steinlen's work.

Steinlen was lavish in his contributions of drawings and lithographs to the radical press—the anarchist *Père Peinard, Les Temps Nouveaux, La Feuille,* and the socialist *Le Chambard*—and he often illustrated novels or poems with strong social content. If he had any firm orientation, it was toward the anarchists but seems to have lacked any formal philosophy.

Steinlen has been accused of being sentimental. Some of his work was obviously executed in haste and was oversimplified. But Steinlen meant his message to be quickly and easily grasped and if it were sometimes outright propaganda, it was propaganda executed with sincerity and humility and with a great skill—one-sided, perhaps, and often too literal, but not exaggerated in implication. For all of Steinlen's gentleness of disposition, he could be violent in his attacks on avarice and cruelty.

In one of his favorite devices, he placed a cruel, menacing symbolic figure in the foreground overshadowing resentful, hungry, and brutalized strikers or protesters, as

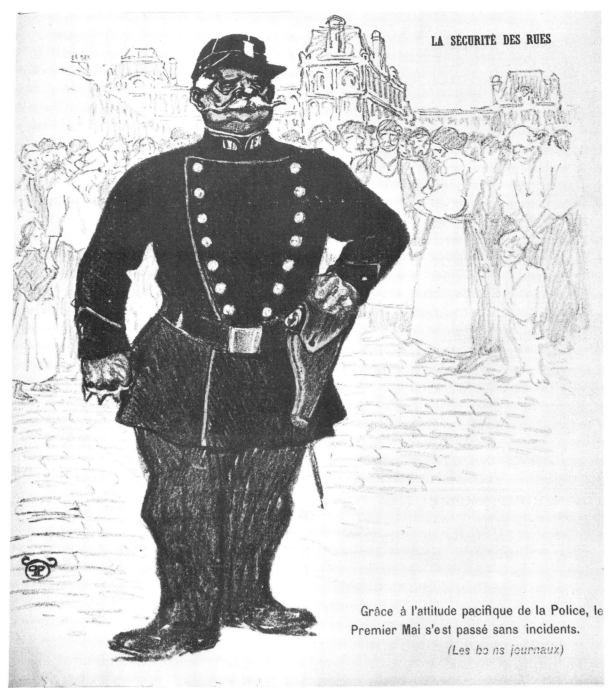

LA SÉCURITÉ DES RUES

Grâce à l'attitude pacifique de la Police, le Premier Mai s'est passé sans incidents.

(Les bons journaux)

227

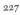

227. "La Sécurité des Rues." Théophile-Alexandre Steinlen. 1894. 14⅛x11¹³⁄₁₆. Lithograph. From *Le Chambard*, May 5, 1894. New York Public Library.

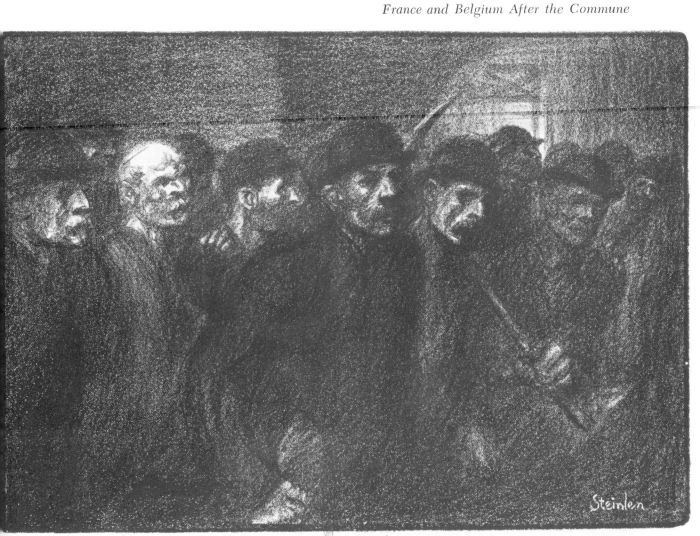

Lithographie originale de Steinlen_ Studio

8

in "La Sécurité des Rues." Sometimes his victims speak eloquently for themselves, as in "Workmen leaving the factory," and "The widows of Courrière," grieving after a mine tragedy. Steinlen had a rare gift for expressing common anguish. For a special issue of *La Feuille* he captured the howling frenzy of mob action in "The Mob"— "bosses" and their thugs stomping a lone worker, a pictorial allegory of the Dreyfus case—propaganda but extremely lively composition.

228. "Ouvriers Sortant de l'Usine." Théophile-Alexandre Steinlen. 1903. 8⁷⁄₁₆x12³⁄₁₆. Lithograph. Bibliothèque Nationale, Paris.

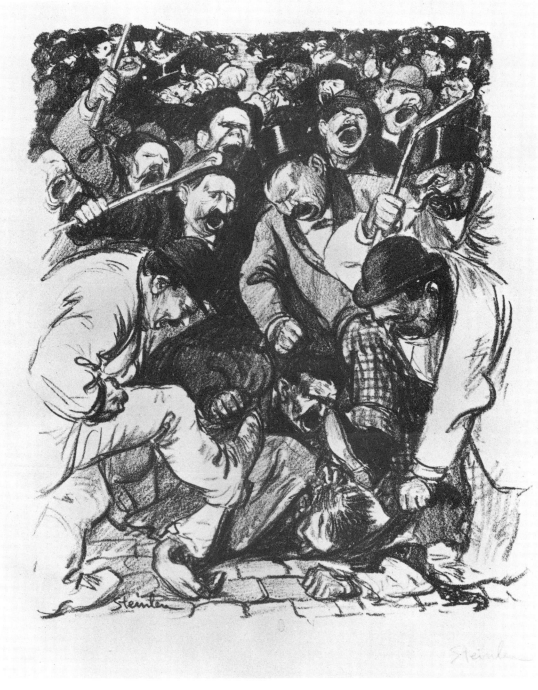

229

229. "The Mob." Théophile-Alexandre Steinlen. 1898. 13⅞x11½. Lithograph. Bibliothèque Nationale, Paris.

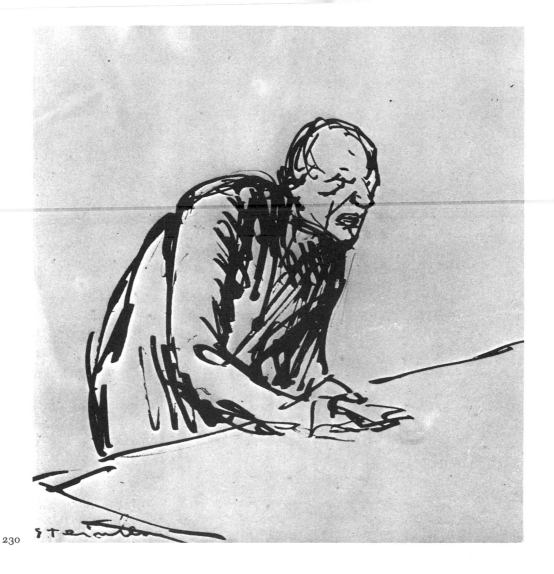

230

Steinlen's "The Argument" is almost uncharacteristically sharp; it may lack Daumier's satirical touch, but its savage, wolfish quality is certainly effective. Like Daumier, Steinlen was no bohemian, but middle class in taste and life—a rebel rather than a revolutionary. He owed much to Daumier's precedents, but he lacked Daumier's bite and satiric flair.

In temperament and sense of purpose, although obviously not in artistic stature or in attitude toward social message in art, Steinlen was closer to Pissarro. "Both cherished the best in the art of the past, and also responded generously to the innovation of their contemporaries," Alain De Leiris has written. "Both had faith in humanity and in social progress. Both viewed their art as a form of beneficent social action, and both held dear the simple life of the people, and their own steady labors as artists and craftsmen."

230. "The Argument." Théophile-Alexandre Steinlen. No date. 6½x6¼. India ink drawing. Charles E. Slatkin Galleries, New York.

There could hardly be greater contrast between the personality of Steinlen and that of Jean-Louis Forain (1852–1931). Forain was a far-ranging satirist of the 1880's and 1890's who attacked the Panama scandals in *Les Temps Difficiles*, striking blows against the rich bourgeoisie, the corrupt, and the hypocritical. But Forain almost always strained for effect, overreached his grasp, and rarely revealed a leavening touch of pity or understanding. Drawings of his moustached businessmen buying their women betray a hint of envy along with satire. Jean Grave was perceptive enough to realize this: "Forain has the artist's hatred of the bourgeois, but how reactionary he is and what a bourgeois soul he often hides beneath this hatred . . . especially when it is a question of social problems." Shortly afterward, in the Dreyfus

231. "The Unwed Mother." Jean-Louis Forain. 1909. 15⅜x19. Etching. Bibliothèque Nationale, Paris.

affair, most socially critical artists lined up solidly with Zola in attacking the army and the government, while Forain and another satirist, Caran d'Ache, launched an anti-Semitic, anti-Dreyfus journal, *Psst.*

But ten years later, Forain returned to etching and executed a powerful series of accusing courtroom scenes with a humanity that he had hitherto lacked. In "La Fille-Mère," there is pity for the young unwed mother as well as scorn for the bored lawyer and the arrogant judge.

Although the anarchist and socialist publications benefited from artistic support by the Neo-Impressionists and their allies, none of the ventures could compare in influence, long life, variety of attack, and artistic level with a journalistic phenomenon, the Paris weekly *L'Assiette au Beurre* (roughly translated as "graft"), which ran from 1901 to 1912 and circulated throughout Europe. Despite harassments reminiscent of *Le Charivari* days, editor S. Scwarz, his successors, the staff, and the contributing artists satirized, pilloried, and violently attacked every aspect of a society which they saw as corrupt, decadent, and degenerate—militarism, colonialism, royalty of any type, vice in every imaginable form, and corruption in high places and low. And they did this each week for twelve years, with drawings that filled all the sixteen to forty-eight pages, in every conceivable style, mood, and technique, from cartoon and caricature to realism and fantasy, from hilarity to poignancy to anger, from slapstick to subtlety. Special issues

covered anything that struck an editor's or artist's fancy: Christmas in a hypocritical society, lesbianism, legal racketeers, priests, soldiers, homosexuals, quacks, spinsters. Known and unknown artists contributed, and the level of competence was not often reflected in the artist's later fame. Juan Gris, Jacques Villon, Kees van Dongen, and Franz Kupka joined such veterans as Steinlen, Hermann-Paul, Vallotton, H. G. Ibels, Willette, and numerous lesser-known artists to fill the sparkling pages.

The variety of styles in *L'Assiette au Beurre* is reflected in the following reproductions. D'Ostoya's "La Police" is unsubtle but powerfully composed; the figures are in silhouette like a Japanese tableau, but the drama is hot and angry. Juan Gris' "Conférence" of diplomats rises far above commonplace caricature. Front's contrast between the rich general and the crippled soldier is obvious in sentiment ("Baptiste, throw him a sou; he is an old soldier"), but the draftsmanship is strong. Michael's "Four Sous?" bears comparison with a Toulouse-Lautrec lithograph. Miklos Vadasz, whose airily graceful drawings brilliantly mirrored the *fin de siècle* decadence, revealed great illustrative talent in capturing the dissolute abandon of the mid-Lent ball. One of the most versatile was Grandjouan, represented here with his dynamic "A Patriot" and "The Strike." Landlords were a frequent target; Roubille's dark, massive figure of a bailiff is dramatically poised against the dead tenant whom he had expected to dispossess.

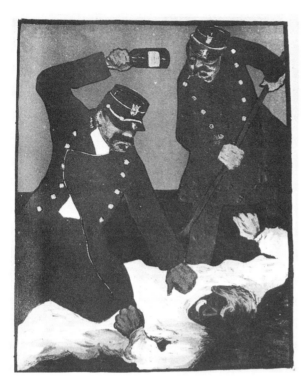

232

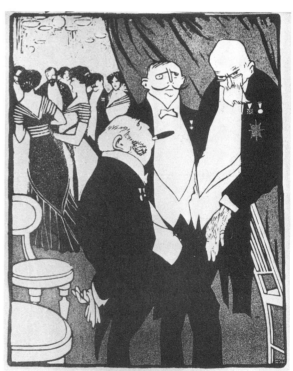

233

232. "The Police." D'Ostoya. 1903. Reproduced from *L'Assiette au Beurre,* May 23, 1903. New York Public Library.

233. "Conference." Juan Gris. 1908. Reproduced from *L'Assiette au Beurre,* Oct. 1908. New York Public Library.

234

235

234. "Old Soldier." F. Front. 1901. Reproduced from *L'Assiette au Beurre,* May 23, 1901. New York Public Library.

235. "Four Sous? Too Much!" A. Michael. 1901. Reproduced from *L'Assiette au Beurre,* Aug. 15, 1901. New York Public Library.

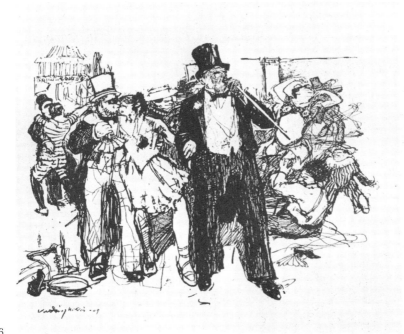

236

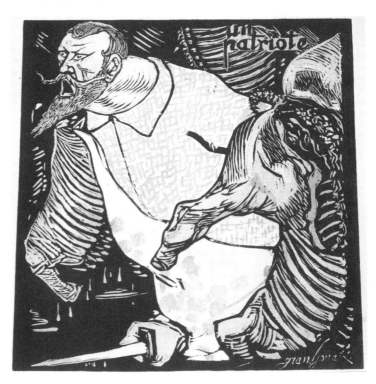

237

236. "Mid-Lent Ball." Miklos Vadasz. 1909. Reproduced from *L'Assiette au Beurre*, May 1, 1909. New York Public Library.

237. "A Patriot." Grandjouan. 1902. Reproduced from *L'Assiette au Beurre*, April 19, 1902. New York Public Library.

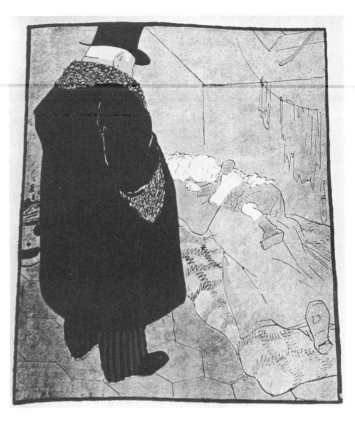

239

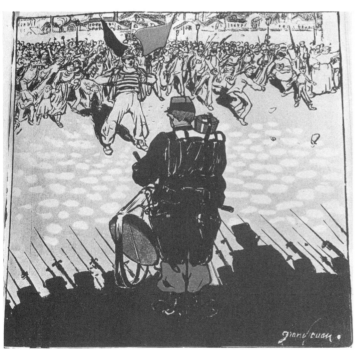

238

238. "The Strike." Grandjouan. 1907. Reproduced from *L'Assiette au Beurre,* May 2, 1907. New York Public Library.

239. "Landlord." R. Roubille. 1905. Reproduced from *L'Assiette au Beurre,* Sept. 23, 1905. New York Public Library.

At first glance there would seem to be little connection between the rousing political hurly-burly of *L'Assiette au Beurre* and the demonic twilight world of James Ensor (1860–1949), but Ensor, too, was protesting in his own way. He grew up in Ostend where his family operated a souvenir shop whose stock of carnival masks and puppets later inspired his use of the mask as a major theme in painting. Ensor suffered in a petty, bickering, platitudinous family environment that he was to detest all his life. Quite early his painting branched off on a path of its own—symbolic, expressionist. Like Bosch and Bruegel, he found the world a ship of fools, and his attitudes toward its grotesqueries were reflected in his work. To Ensor, most people played out the folly of life behind masks, and he painted them that way. In 1884 he joined Félicien Rops, Van Rysselberghe, Van de Velde, and other nonacademic artists in the formation of Les XX to exhibit as a group together with Seurat, Van Gogh, Cézanne, Manet, and other French artists who were also revolting against the official Academy. Not only did the critics flay Les XX, but in 1889, the organization refused to exhibit Ensor's "Entry of Christ into Brussels in 1888." By 1900, as Ensor was beginning to win some recognition, his creativity began to dim and he tended to be repetitive. Perhaps his family's constant taunts at his lack of "success" had an ultimate draining effect.

Ensor was bitter, derisive, and sensitive toward attacks on his work. He hid emotional wounds behind clowning and practical jokes, laughed scornfully at a foolish world, and continued to work elements of inventive whimsy into many of his paintings.

He hated Belgium's oppressive middle-class society. Basically his impulses and sympathies were anarchistic. He expressed the plight of the poor in several drawings and etchings but fundamentally felt that everyone was caught up in a mad game. His satirical, derisive attitude toward society bursts out in some of his graphics, of which he was a master.

In "Entrance of Christ into Brussels," an etching based upon an earlier painting, Ensor pricked all the pomposities of life in Brussels in the year of our Lord, 1888. Christ, with the face of Ensor, enters Brussels under a Colmans Mustard sign, preceded by a masked crowd waving slogans and banners. In the painting, the largest banner proclaimed "Long live the Social State." The crowd, so skillfully rendered—as all his crowd scenes were—swarms before and around Christ-Ensor who is surrounded by madmen, wearing masks of pomposity, of foolishness, and of corruption. It is many things, among them a powerful social tract and a personal release. On the latter point, as Paul Haesaerts has postulated, it may be "Ensor before the hordes of his detractors, dreaming like Jesus of beauty understood, but like Jesus meeting with nothing but incomprehension and contempt."

Ensor's anarchist sympathies and his un-

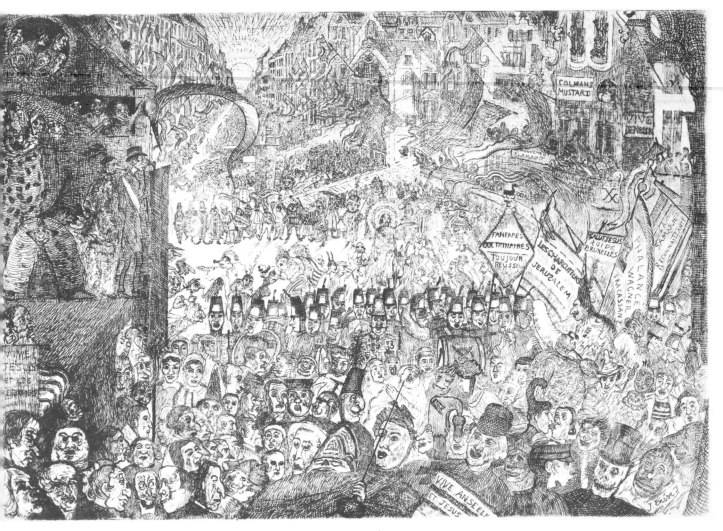

40

240. "Entrance of Christ into Brussels." James Ensor. 1898. 9¾x14. Etching. Mrs. John D. Rockefeller, Jr., Purchase Fund, Museum of Modern Art, New York.

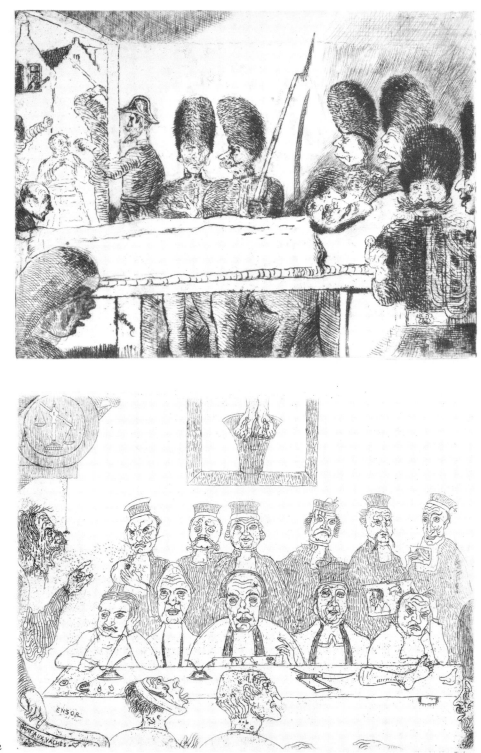

241. "Gendarmes." James Ensor. 1888. 7x9. Etching. Bibliothèque Royale, Brussels.

242. "The Good Judges." James Ensor. 1894. 7x9. Etching. Bibliothèque Royale, Brussels.

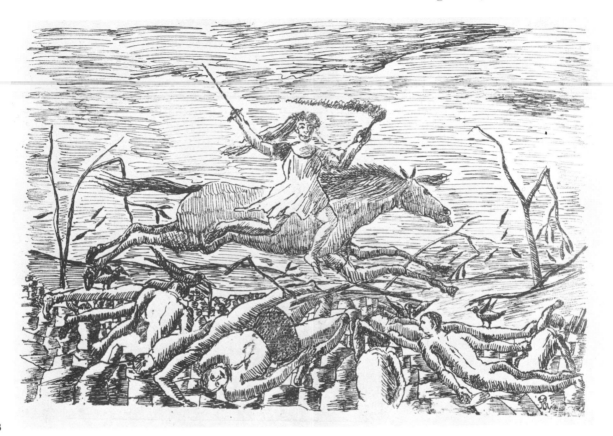

243

failing irreverence prompted him to make several graphic attacks on authority, with irony as his main weapon. His "Gendarmes" and "The Good Judges" have the uninhibited exaggeration of Gillray in their lively caricature. But his flashes of social criticism were sporadic and tangential; he was much too sardonic and too individual to join any organized attack or even to carry on his own guerrilla campaign with any semblance of consistency.

World War I was long anticipated by the radical press. Although many French workers and some of their leaders joined in the cries for revenge after 1871, most socially conscious writers and artists deplored the arms race and the futility of war—none so effectively as the apolitical artist Henri Rousseau, the douanier, in his lithograph "War," commissioned by a small review.

But when the armaments race, colonial rivalries, and rampant nationalism did fi-

243. "War." Henri Rousseau. 1895. 8¾x13. Transfer lithograph. Museum of Modern Art, New York.

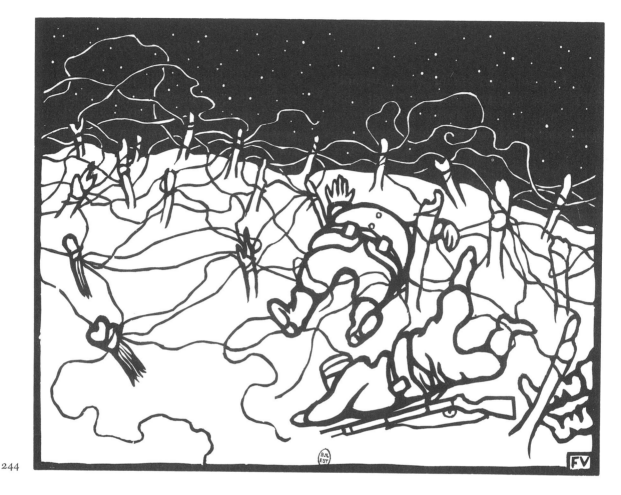

244

nally shatter the peace of Europe in 1914, most of the radical artists, like the socialist parties, reluctantly supported their governments. Signac, as has been noted, reproved Jean Grave for supporting the war. Félix Vallotton wrote "Art and War," denouncing "military" painters. To dramatize war, he wrote, is "to scream weak argument." His conception of a war picture—in the series "C'est la Guerre"—was to portray human puppets caught on barbed wire. In numerous drawings, Steinlen caught the pathos of war's civilian victims, typified in his "Exodus." Forain, superpatriot during the Dreyfus Affair, produced excellent reportorial sketches, but his propaganda was anti-German rather than antiwar.

Fashionable, chic artist André Dunoyer

244. "Les Fils de Fer." Félix Vallotton. 1916. 7x8¾. Woodcut. From "C'est la Guerre." Bibliothèque Nationale, Paris.

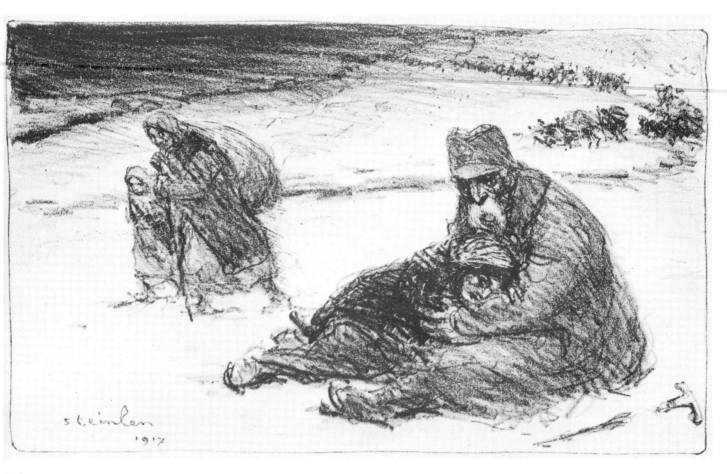

245

de Segonzac, serving as an infantry sergeant, sent sensitive and moving sketches to *Le Crapouillot*, like that of his two bundles of misery. Dunoyer de Segonzac was deeply moved by his wartime experiences and for several years afterward transmuted them with etchings of great delicacy which were used to illustrate two books by Roland Dorgelès—*Les Croix de Bois* and *La Boule de Gui*. Luc-Albert Moreau (1882–1948) also contributed to the magazines, with more emphasis on the horror of the bloodbath, and with even starker reality, as in the impaled figure of "Attaque du Chemin des Dames Oct. [1]917."

Although the impact of the war was greatest among German artists, it was the Frenchman Georges Rouault who pro-

245. "Exodus." Théophile-Alexandre Steinlen. 1917. 6x10. Lithograph. Collection of the author.

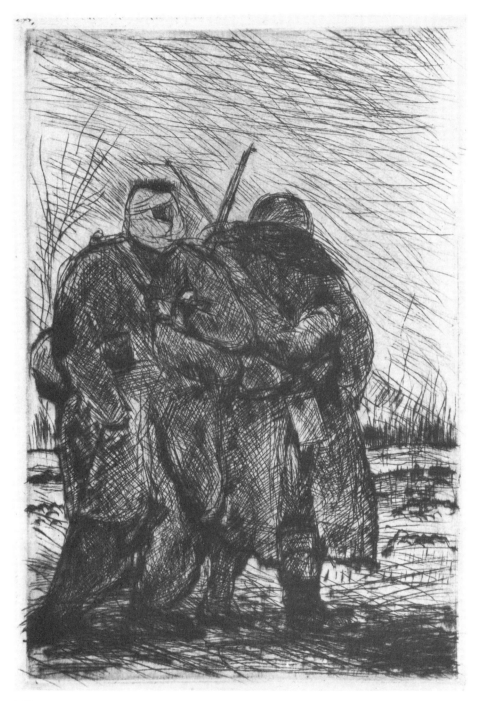

246

246. "Wounded Soldier." André Dunoyer de Segonzac. 1921. 6¼x4⅜. Drypoint. From *Les Croix de Bois*. Frank Crowninshield Collection, National Gallery of Art, Washington.

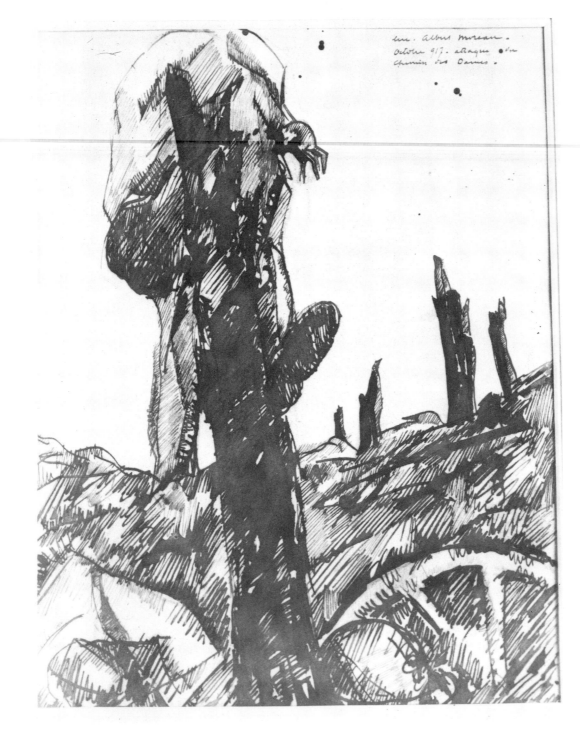

247

247. "Attaque du Chemin des Dames Oct. [1]917." Luc-Albert Moreau. 1917. 13⅝x11. Pen drawing. Université de Paris, Musée de la Guerre, Vincennes.

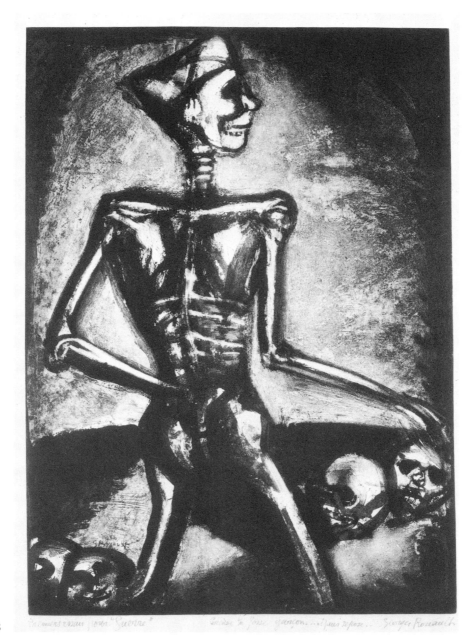

248

duced the most masterful comment with his "Miserere et Guerre." Rouault (1871–1958) labored between 1916 and 1918 and from 1922 to 1927 to create "Miserere et Guerre," a twentieth-century successor to Callot's "Miseries of War" and Goya's "Disasters of War." Commissioned by Ambroise Vollard, this remarkable series of fifty-eight etchings was originally intended as illustrations for a projected but unpublished two-volume text by Rouault's friend André Suarès, with the separate titles, "Miserere"

248. "Man is wolf to man." Georges Rouault. 1927. $23\frac{9}{16}$x$16\frac{11}{16}$. Aquatint, drypoint, and roulette over heliogravure. Plate No. 44 from "Miserere et Guerre." Museum of Modern Art, New York.

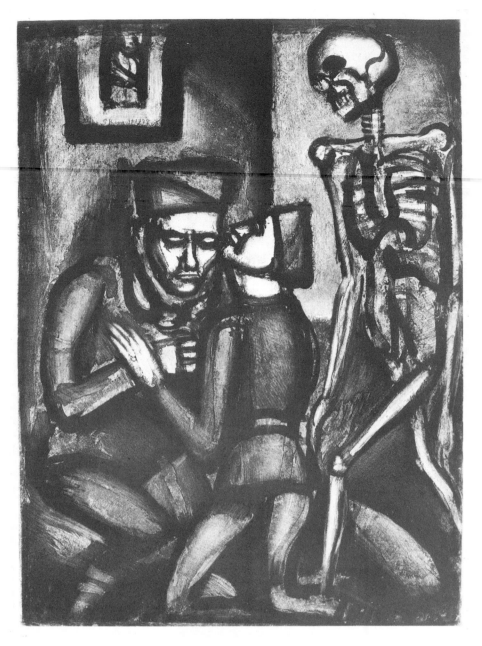

249

and "Guerre." A searing indictment of man's betrayal, the prints achieve a haunting universality in their attack on war and exploitation. They are pervaded throughout with Rouault's compassion, pity, and faith. Man's fate is linked to that of Christ, whose life and death dominate many of the prints.

The second half of "Miserere et Guerre" is devoted to the theme of war, handled with an eloquence, a pain, a spiritual depth that is difficult to rival. The mood varies from the tender to the sardonic "Man is

249. "This will be the last time, little father." Georges Rouault. 1927. 23⅜x17. Aquatint, drypoint, and roulette over heliogravure. Plate No. 36 from "Miserere et Guerre." Museum of Modern Art, New York.

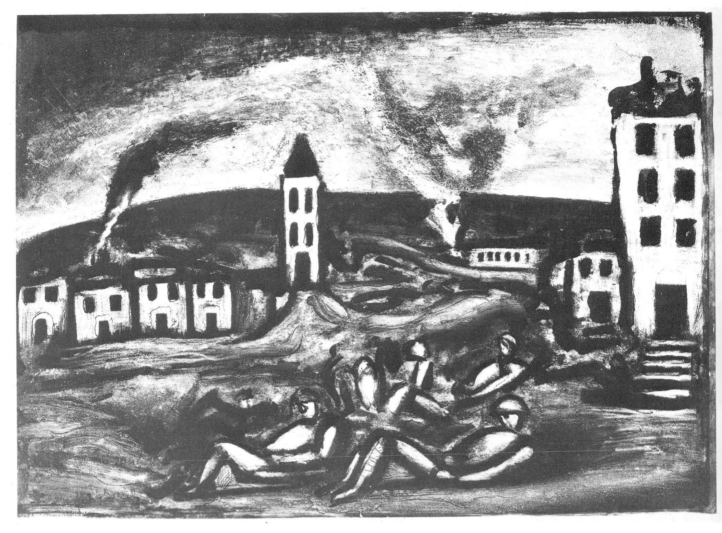

250

wolf to man," the bitter "This will be the last time, little father" as Christ's antagonist, Death, grins triumphantly, and the agonized "My sweet homeland, what has become of you?" The latter represents soldiers either dead or resting in a gloomy, twilit world, with flames and smoke erupting in the background.

Rouault's lifelong hatred of the predatory is reflected when he contrasts his exploited prostitutes with "The society lady [who] fancies she has a reserved seat in

250. "My sweet homeland, what has become of you?" Georges Rouault. 1927. 23⅜x17. Aquatint, drypoint, and roulette over heliogravure. Plate No. 55 from "Miserere et Guerre." Museum of Modern Art, New York.

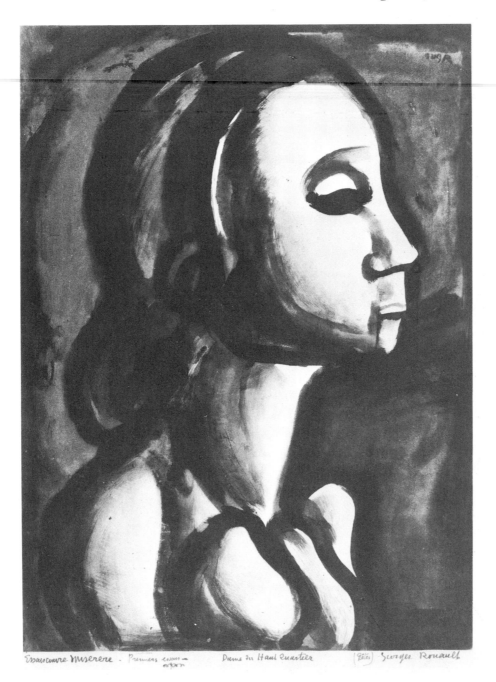

Essai cuivre Miserere - Premiers essais - refait Dame du Haut Quartier (état) Georges Rouault

251

251. "The society lady fancies she has a reserved seat in heaven." Georges Rouault. 1922. 22$\frac{7}{16}$x16$\frac{13}{16}$. Aquatint, drypoint, and roulette over heliogravure. Plate No. 16 from "Miserere et Guerre." Museum of Modern Art, New York.

heaven," and the slender, naked civilian with the rotund officer, and, again, in his portrait of an arrogant German officer—to Rouault the essence of militarism—titled "With neither love nor joy."

Technically, these Expressionist prints went far beyond any methods previously attempted. His studies, done in gouache, were transferred photographically to the copper plate—thus laying the base for their unusual painterly quality—then executed by etching or aquatint and worked on by drypoint, roulette, or other tool. Some went through as many as fifteen states before Rouault was satisfied.

Rouault was born in Paris during the bombardment of the Commune by the Versailles troops. Apprenticed to the stained glass artist Hirsch, later a pupil of medievalist Gustave Moreau, and an ardent Catholic, Rouault developed a technique in which his paintings took on the appearance of stained glass windows. His accented contours certainly bring to mind the lead in such windows, and his luminous colors complete the association. Perhaps the most tactile of modern painters, Rouault seemed to wrest his paintings from the canvas.

Like Rembrandt's art, Rouault's expressed his innermost emotions; a deep spirituality pervaded all his work. His frame of reference was always that of a Christian, his identification with suffering mankind, his dream that of a brotherhood of man, his goal as painter to provide a "harmony between the visible world and inner light." Catholic Rouault hated man's sins, but he didn't hate man; he pitied him, suffered with him, and prayed for his redemption.

Rouault's philosophy was pithily expressed in a letter-preface he wrote for a book by Georges Charensol:

Don't mention me unless it be to glorify art; don't present me as a firebrand of revolt and negation. What I have done is nothing, don't make much of it. A cry in the night. A sob that miscarried. A strangled laugh. Throughout the world, every day, thousands of obscure, needy people who are worth more than I am, die at their tasks.

I am the silent friend of all those who labor in the fields, I am the ivy of eternal wretchedness clinging to the leprous wall behind which rebellious humanity hides its vices and its virtues alike. Being a Christian in these hazardous times, I can believe only in Christ on the Cross.

Rouault lived humbly, identified with the poor and oppressed, and was constantly stirred by an active sense of social justice. However, he saw the righting of wrongs not through political action, but through redemption and regeneration. His pity was all-embracing—for the sinner as well as for the sinned against. Closer to Dostoevsky than to Zola, he was no activist. But he confronted society with its sins: his prostitutes eternally express man's shame; his judges incarnate judicial corruption; his tragic clowns weep for all humanity.

"My father," Isabelle Rouault wrote,

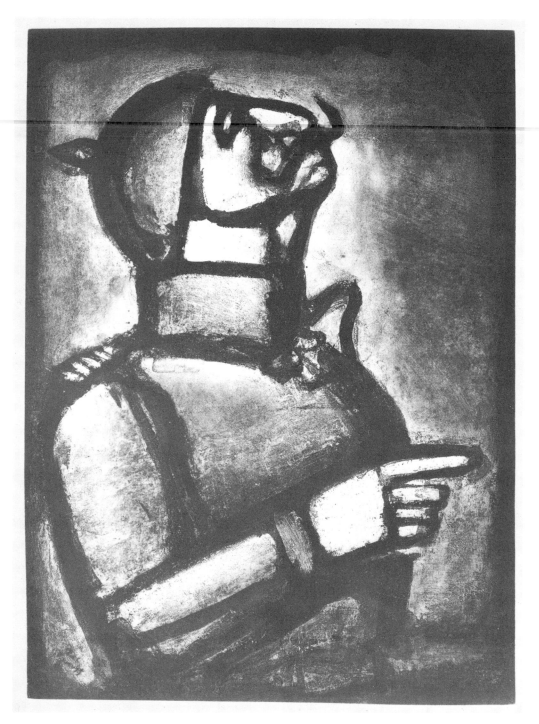

252

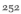

252. "With neither love nor joy." Georges Rouault. 1926. 23x16⅝. Etching. Plate No. 49 from "Miserere et Guerre."
Prints Division, Astor, Lenox and Tilden Foundation, New York Public Library.

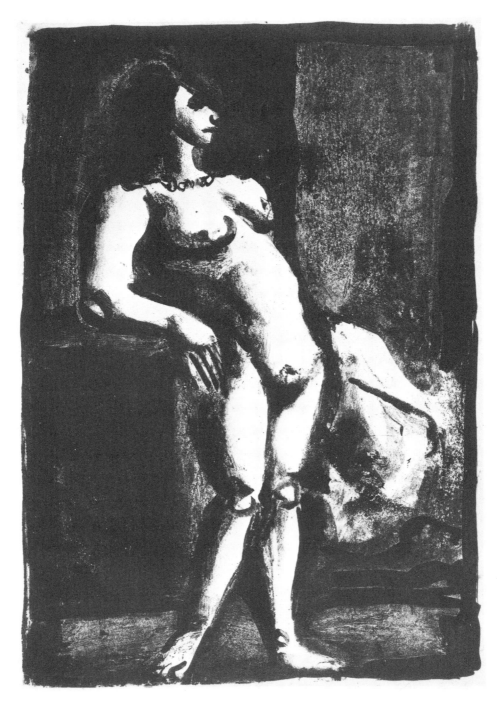

253

253. "The Prostitute." Georges Rouault. 1924–27. 12⅜x9. Lithograph. Gift of Abby Aldrich Rockefeller, Museum
of Modern Art, New York.

"protested against the lack of insight of certain judges, against their inadequacy for the position they were called upon to fill. He had seen and heard some scandalous things in the courtrooms." Yet sardonic as were his portraits of judges and his courtroom scenes, pity rather than condemnation is the dominant quality.

In the early 1900's, Rouault executed painting after painting of prostitutes. He distorted their bodies into gelatinous mounds of decaying flesh, confronting the onlooker with the handiwork of his society, expiatory victims of man's lusts and bourgeois society's degradation. In the "Miserere et Guerre," he tempered his physical portraiture of prostitutes but endowed them with a corrosive bitterness.

Rouault acknowledged his debt to Daumier, to Goya, and, perhaps surprisingly, to Forain, his spiritual antithesis. When Rouault was struggling with conventional academic drawing in art school, a drawing of Forain's awakened him to the possibilities of looser technique and satirical content.

Rouault died in 1958 at the age of 87. To the end, his indignation was tempered by love.

Social protest was a continuing theme of French graphic art between the two World Wars, but it lacked the wide involvement of French critical art at the turn of the century. Some of the radical artists of the prewar era became fashionable and successful in the twenties and thirties; others were by then too old and too self-absorbed. As mentioned before, it was the German artists who were most deeply affected by the first World War; it is to Germany we must turn for the most original, most exciting, and most comprehensive protest art in the years after World War I.

CHAPTER X
Germany After 1871: Kollwitz, Beckmann, Grosz, Dix

I T was almost twenty years after the end of the Franco-Prussian War in 1871 before social protest art of consequence appeared in defeated France. It took even longer in victorious Germany, where there was no nineteenth-century tradition of political comment by major artists. Except for occasional, mildly satirical thrusts by artists such as Chodowiecki in the eighteenth century, German political art had had little graphic comment of significance and no major figure since the seventeenth century. The continued division of Germany into many petty principalities after the Thirty Years War and the oppressive and parochial atmosphere discouraged bold social criticism. Urbanity and political sophistication—essential ingredients for effective satire—were lacking. Also, the failure of the Revolution of 1848 in Germany led to violent repression and the emigration of many talented dissidents.

Soon nationalism, the desire for unity, replaced liberalism as the main political drive. It found fulfillment in 1871 when Bismarck completed the unification of Germany. Bismarck's carrot-and-whip policy of combining advanced social legislation—sickness, accident, and old-age insurance—with repression of radical movements blunted organized protest. In the nineties however, after Kaiser William II dropped the coercive legislation against the Socialists, protest against the aftermath of the Industrial Revolution took political as well as intellectual and artistic form. By 1912 the Social Democrats held one hundred seats and comprised the largest party in the Reichstag.

As in France and England, the Industrial Revolution had brought long hours, low pay, and slum conditions for the majority in Germany. The middle class and the new industrial rich were materialistic, smug and parochial. The military aristocracy was more powerful than ever as the new nation plunged into the armaments race and joined the struggle for colonies and raw materials that was to lead to World War I. In the prevailing authoritarian atmosphere, the petite bourgeoisie were always ready to obey their "betters." This sycophancy was brilliantly satirized by Paul Klee (1879–1940) in "Crown Mania," with its Jugendstil curvilinear forms bent into ridiculous abjection.

As the nineteenth century ended, a growing number of artists were agitated by the economic injustices and the spiritual poverty. Many were to find an outlet in the emotional mystique of Expressionism. Others were to combine the passion of Expressionism with the detail of realism in a uniquely German comment on their times.

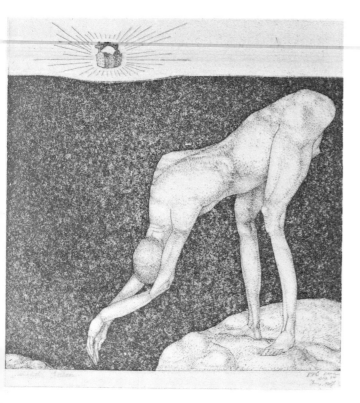

254

Käthe Kollwitz (1867–1945) veered from naturalism to Expressionism during her long career. Aside from the intrinsic interest of her work, her career spanned vital years and is worth exploring in some detail.

Boundless compassion and lifelong commitment to her fellow man were the qualities that made her so rare a person and so uniquely compelling an artist. Her life was marked by a deeply felt empathy for the struggling men and women whose burdens pressed on her daily in the working-class district of Berlin where she lived.

Käthe's father was a socialist, her grandfather an independent minister who had been expelled from the official state church. Socialism, religion, and her sense of commitment were the motifs of her moral and social growth. "Man is not here to be happy, but to do his duty" reads the inscription on her grandfather's gravestone.

Her father early recognized her talent for drawing and encouraged her to train for a career as an artist. Her first teacher was an engraver. She studied art in Munich and Berlin, but to her father's disappointment—he doubted that she could pursue two careers at once—she married, at twenty-three, a young doctor, Karl Kollwitz. Her husband headed a tailors' medicare clinic in a Berlin working-class district, where they lived for fifty years.

In the mid-nineties "a milestone in my work" took place, she wrote. She attended a performance of Gerhart Hauptmann's *The Weavers*, a drama about an abortive strike of 1840. Its overtones for the Germany of her time inspired her to begin work immediately on her own version. The six-part cycle of prints was submitted to the Great Exhibition at the Lehrter Bahnhof in Berlin in 1898. The jury voted her the gold medal, but the Kaiser, who hated what he called "gutter art," set aside the award. Overnight she had won an audience, and years later copies of "The Weavers" sequence were still found in workers' homes throughout Germany.

254. "Crown Mania." Paul Klee. 1904. 6¼x6¼. Etching and aquatint. Museum of Modern Art, New York.

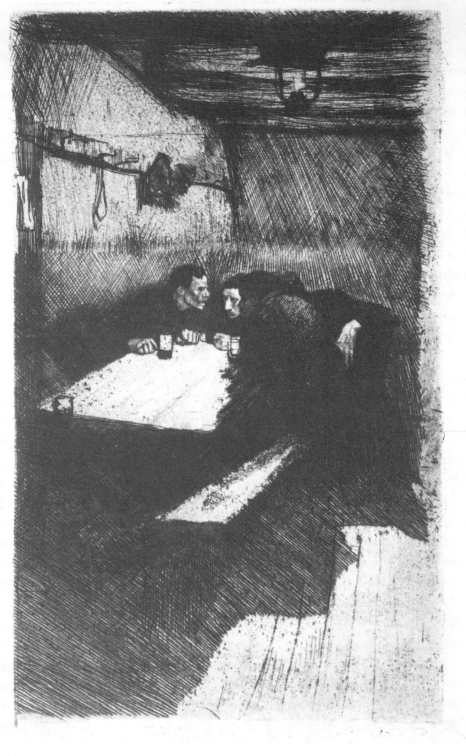

255

255. "Conspiracy." Käthe Kollwitz. 1895. 11½x7. Etching. Plate No. 3 from *The Weavers*. Rosenwald Collection. National Gallery of Art, Washington.

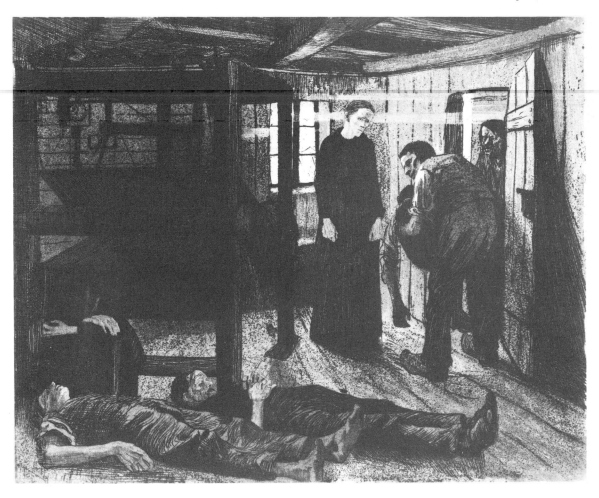

256

Two of these prints will suffice to show why the Kaiser was made uneasy. "Conspiracy" captures a scene repeated all over Europe: a huddle of desperate men plotting to fight against their miserable living conditions. The dim light, the tense faces, the hunched postures, all combine to make the sympathetic viewer hope that no government police are near. The inexorable loom in "The End" dominates the cottage where the dead are brought after the revolt fails. The mother—one of the first of Kollwitz's unforgettable mothers—looks on.

In "The Weavers," Kollwitz employed a pictorial naturalism. The prints have the weakness of story illustration; only later

256. "The End." Käthe Kollwitz. 1897. 9½x12. Etching and aquatint. Plate No. 6 from *The Weavers*. Library of Congress, Washington.

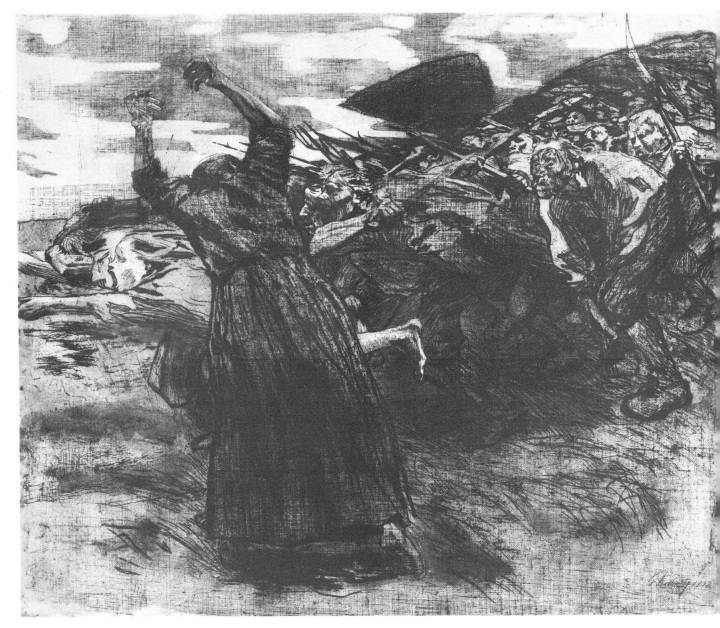

257

257. "Outbreak." Käthe Kollwitz. 1903. 19¾x23. Etching. Plate No. 5 from "The Peasant's War." Library of Congress, Washington.

was she to develop a much greater economy of means as she evolved toward a less detailed Expressionism.

Despite her liberal-radical upbringing, Käthe Kollwitz was dominated at this time more by artistic than political considerations in the selection of subject. In her diary, she notes:

> I should like to say something about my reputation for being a "socialist" artist, which clung to me from then on. Unquestionably my work at this time, as a result of the attitudes of my father and brother and of the whole literature of the period, was in the direction of socialism. But my real motive for choosing my subjects almost exclusively from the life of the workers was that only such subjects gave me in a simple and unqualified way what I felt to be beautiful.
>
> For me the Koenigsberg longshoremen had beauty; the Polish *jimkes* on their grain ships had beauty; the broad freedom of movement in the gestures of the common people had beauty. Middle-class people held no appeal for me at all. Bourgeois life as a whole seemed to be pedantic. The proletariat, on the other hand, had a grandness of manner, a breadth to their lives.
>
> Much later on, when I became acquainted with the difficulties and tragedies underlying proletarian life, when I met the women who came to my husband for help and so, incidentally, came to me, I was gripped by the full force of the proletarian's fate. Unsolved problems such as prostitution and unemployment grieved and tormented me, and contributed to my feeling that I must keep on with my studies of the lower

classes. And portraying them again and again opened a safety valve for me; it made life bearable.

The theme of revolt against oppression was employed even more dramatically in a series of seven plates she executed from 1901–08, based on the sixteenth-century Peasants' War. "Outbreak" is an impassioned call to arms. Even the peasants in "The Prisoners," the final etching in the series, give one the feeling that their hatred is implacable, that whatever their fate, the struggle will continue. There is strength, movement, and passion in these etchings, revealing the sure hand of a decisive artist, if a still primarily representational one.

War was a constant motif in Käthe Kollwitz's art and life. Within a few years after completing the Peasants' War cycle, she and most of Germany's artists were swept into the vortex of World War I. Perhaps never before had a single event had so shattering an effect on so many artists.

One of the most interesting groups of artists to emerge in the early twentieth century was Die Brücke or The Bridge, founded in 1905 by Karl Schmidt-Rottluff, Erich Heckel, and Ernst Ludwig Kirchner (later joined by Emil Nolde, Otto Mueller, and Max Pechstein). Alienated by German society, they assailed bourgeois values by the shock of their Expressionism, but their rebellion was more artistic than social or political. All six served in the army, Kirchner suffering a breakdown.

Many other German artists, interrupted in their peacetime search for new modes of

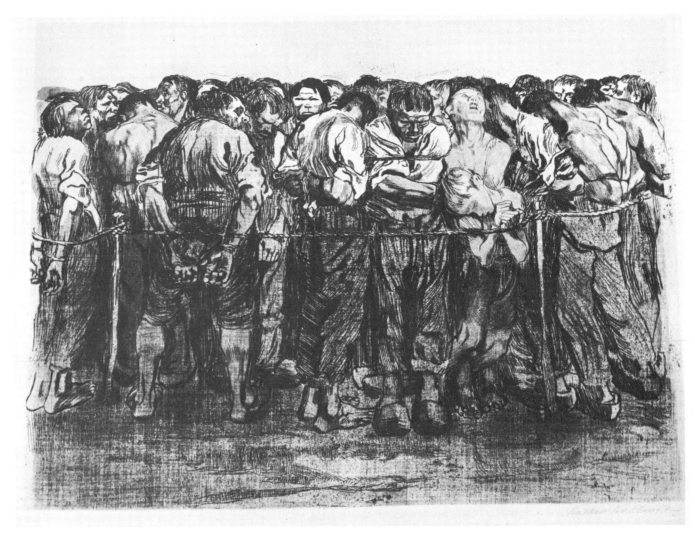

258

258. "The Prisoners." Käthe Kollwitz. 1908. 12⅞x16⅝. Etching. Plate No. 7 from "The Peasant's War." The Galerie St. Etienne, New York.

expression in painting, were killed or wounded or underwent severely traumatic experiences in the war. Franz Marc and August Macke of Der Blaue Reiter (The Blue Rider) group were killed; Oskar Kokoschka and Otto Dix were wounded; Ludwig Meidner, Max Beckmann, and George Grosz served in the German army and survived, but with psychological scars that deeply affected their outlook and their work. The mood of agitation and despair that characterized much of Germany's postwar art certainly was a direct by-product of the war.

Käthe Kollwitz's eighteen-year-old son Peter volunteered for what he believed to be the defense of Germany. She was torn between respect for his sense of duty and revulsion against the act of war. "In such times it seems so stupid that the boys must go to war," she wrote in her diary. "The whole thing is so ghastly and insane. Occasionally there comes the foolish thought: how could they possibly take part in such madness? And at once the cold shower: they *must*, must!"

A month later Peter was killed. Her bitterness and hatred of war mounted. As her son Hans noted, "To her dying day, she held to the belief, 'No more war.'" Her lithographs, woodcuts, and posters in the postwar years caught in a few strokes the universal grief of the shattered women and children left behind. The flaming poster, "Never Again War!" powerfully expresses her militant pacifism. In contrast to her early work, there is no detail here, no back-

ground, no pictorial treatment—only emotion expressed with swift, broad, sure strokes.

For several years she worked on a "War" cycle, which finally emerged in 1925 as a series of seven woodcuts, almost wholly Expressionist. "The Parents," reproduced here, is massive, overwhelming and eternal. Now master of several media, she turned to woodcuts as the best way to express grief. "Sorrow is all darkness," she wrote when reworking the "Parents" block, noting that her first attempts were "much too bright and harsh and distinct."

Disillusionment, widespread hunger, despair, violence, and chaos gripped Germany. Workers' and sailors' revolts brought an end to imperial rule. Moderate Social Democrats gained power and the inevitable clash occurred with the left-wing Socialists who advocated a social and economic as well as a political revolution. A revolt in Berlin in 1919 by left-wing Socialists known as Spartacists was crushed by the government and the army, and its leaders, Karl Liebknecht and Rosa Luxemburg, were brutally slain. Käthe Kollwitz's Expressionist woodcut, "Memorial to Karl Liebknecht," is a moving visualization of grief, bitterness, and betrayal. She noted in her diary that she felt she had "the right to portray the working class's farewell to Liebknecht, and even to dedicate it to the workers, without following Liebknecht politically." And, typically, she added, "Or isn't that so?"

Much of the agony of the Weimar Re-

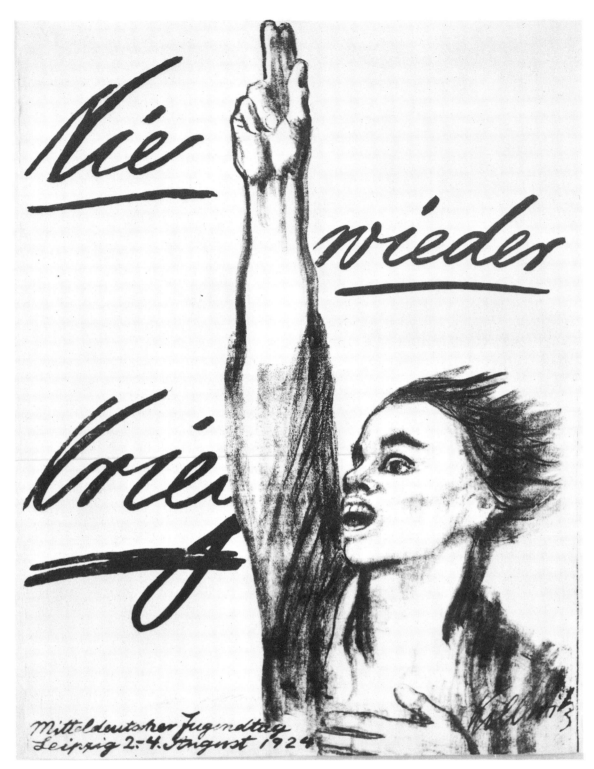

259

259. "Never Again War!" Käthe Kollwitz. 1924. 36½x27¼. Lithograph. The Galerie St. Etienne, New York.

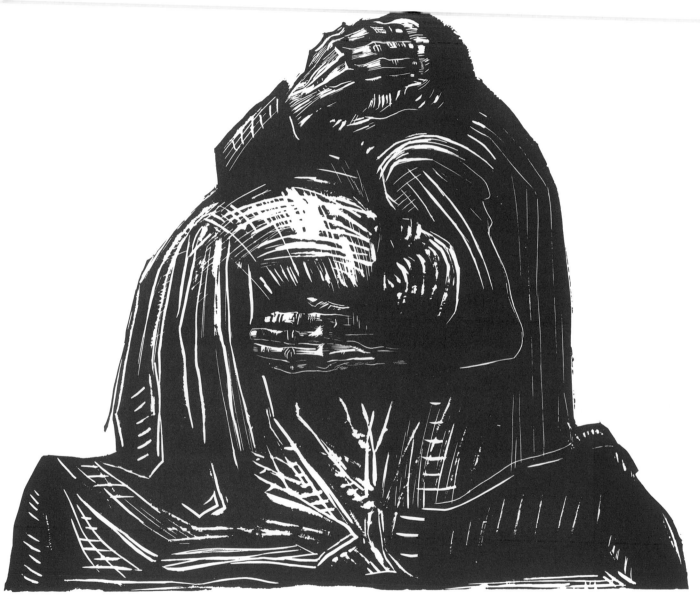

260

260. "The Parents." Käthe Kollwitz. 1923. 13½x16¼. Woodcut. New York Public Library.

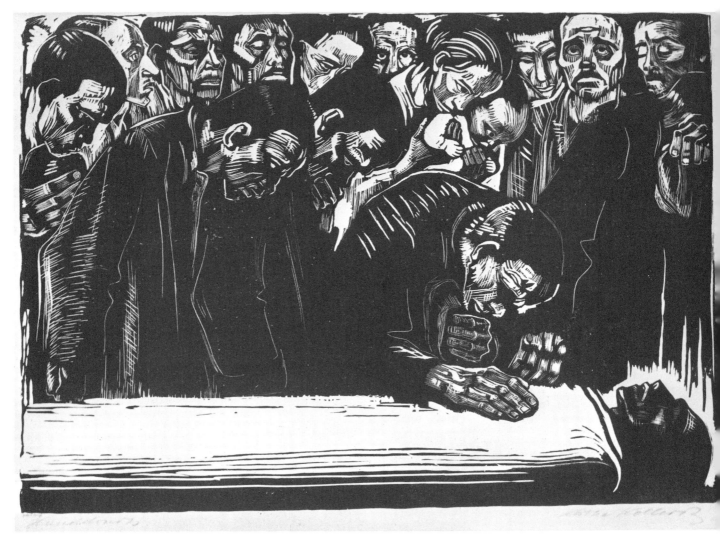

261

public is reflected in the work of Kollwitz and other German artists. The social Democrats pinned their hopes on President Wilson's Fourteen Points, only to see them betrayed. Combating the militant left-Socialists and Communists, they made an alliance with the monarchist, right-wing, antirepublican military establishment that was to prove fatal to German democracy. The "war guilt" label pinned to the German and the French occupation of the Ruhr spurred the propaganda mills of the right-wing nationalists. The fall of the mark—from seventy-five to the dollar in

261. "Memorial to Karl Liebknecht." Käthe Kollwitz. 1919–20. 13¾x19¾. Woodcut. The Galerie St. Etienne, New York.

1921, to a million to the dollar, and then to worthlessness in 1923—wiped out the savings of the middle and lower classes and benefited the industrialists and large landlords.

It was a period of hopeless misery for the poor. The bleak lives of the workers who were her neighbors and her husband's patients continued to elicit Käthe Kollwitz's compassion. She listened sympathetically to the wives' stories of poverty and struggle, absorbed their experiences, and transmuted them into art. In "Lunch Hour" she sketched the workers' emptiness and hopelessness. Her magnificent posters for hungerwracked Germany—"Germany's Children Are Starving!" and "Bread!"—were powerful, direct statements.

Many other German artists also protested the brutality of the times, especially George Grosz and Otto Dix, the Verists. But in place of their harsh, strident angry attacks, Kollwitz manifested anguish. Instead of lashing out, as they did, at society's exploiters, she expressed her feelings through its victims. Where they displayed contempt for humanity, she projected love and empathy.

Deep as her sympathies were, she found herself repelled by violence. "I have been through a revolution," she wrote in her diary, "and I am convinced that I am no revolutionist. My childhood dream of dying on the barricades will hardly be fulfilled, because I should hardly mount a barricade now that I know what they are like in reality."

Her identification with the struggle for existence, however, never faltered. She wrote: "Everyone works the way she can. I am content that my art shall have purpose outside itself. I would like to exert influence in these times when human beings are so perplexed and in need of help." It is difficult to estimate whether her work did actually "exert influence," but there is no question that her haunting, emaciated faces stirred consciences, and her humanistic woodcuts and lithographs moved thousands for a generation.

Her later years were filled with anxiety, pain, and repression. Hitler's seizure of power led inevitably to the banning of her works, and although she was offered a home in America, she remained in Germany until the end. Her beloved husband died, and her oldest grandson was killed in action. Characteristically, her last work, a defiant plea for peace, "Seed for the Planting Must Not Be Ground," shows a mother protecting her three children from the threat of war.

As Romain Rolland wrote of her,

The work of Käthe Kollwitz which reflects the ordeal and the pain of the humble and simple is the grandest German poem of the age. This woman of virile heart has looked on them, has taken them in her motherly arms, with a solemn and tender compassion. She is the voice of the silence of the sacrificed.

At various times until 1933 Käthe Kollwitz contributed drawings to Germany's

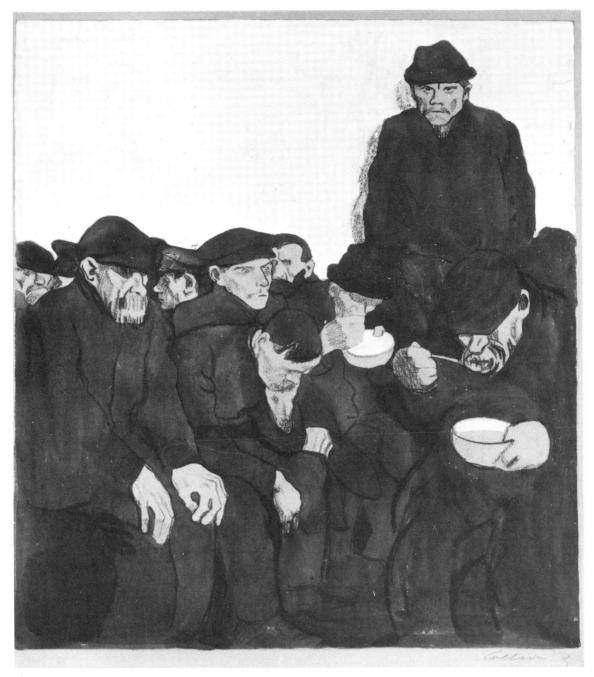

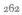

262. "Lunch Hour." Käthe Kollwitz. 1909. 18½x17. Pen and wash drawing. The Galerie St. Etienne, New York.

266

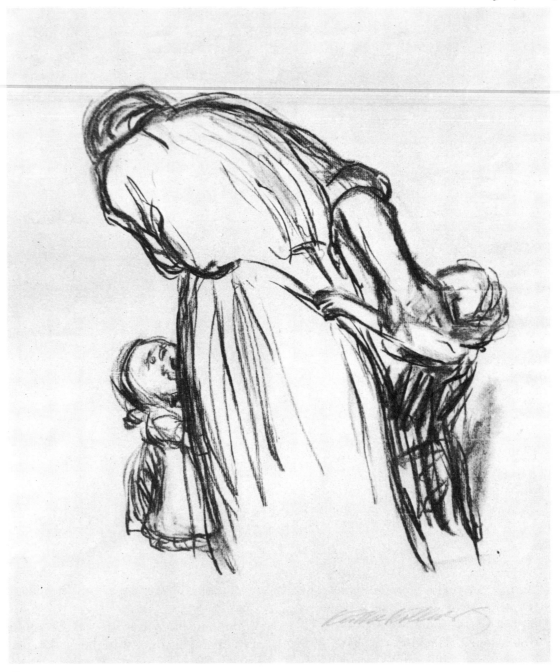

263

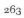

263. "Bread!" Käthe Kollwitz. 1924. 31½x12. Drawing. The Galerie St. Etienne, New York.

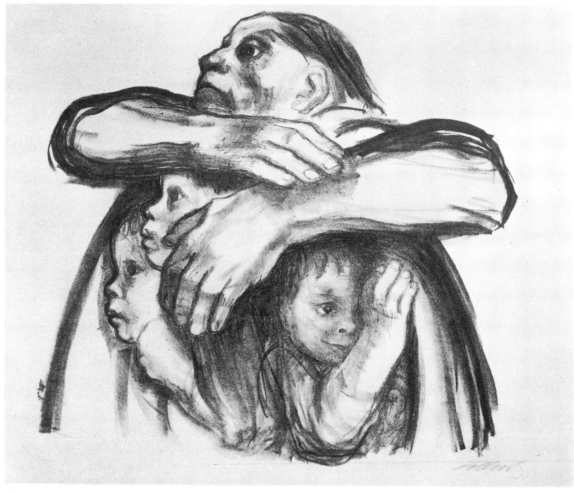

264

lively satirical weekly, *Simplicissimus*. This rather elegant magazine of political and social protest was cofounded in 1896 by Th. Th. (for Thomas Theodore) Heine (1867–1948), whose graphic satires needled two generations of Germans until he fled the Nazis in 1933.

Simplicissimus was essentially middle-class liberal in contrast to the working-class appeal of *L'Assiette au Beurre* in France.

264. "Seed for the Planting Must Not Be Ground." Käthe Kollwitz. 1942. 14½x15½. Lithograph. The Galerie St. Etienne, New York.

It often carried advertisements for champagne, motorcars, cameras, and other symbols of affluence. Its approach was often graceful, witty, sarcastic, and less emotional than the head-on slugfests in *L'Assiette au Beurre* but far more intellectual. Among the early contributors to *Simplicissimus* were Thomas Mann, Rainer Maria Rilke, Arthur Schnitzler, and Hermann Hesse.

Heine was joined in *Simplicissimus* by many of Germany's leading graphic satirists: Heinrich Zille, Bruno Paul, Rudolf Wilke, Eduard Thöny, Wilhelm Schulz, Olaf Gulbransson, and others who were primarily painters, such as Jules Pascin (1885–1930); illustrators such as Alfred Kubin (1877–1959); and sculptor-graphic artists, including Ernst Barlach (1870–1938). Their main targets were the nationalism and militarism of prewar Germany and the reigning class that fostered them—the Junkers and generals, monarchists, big industrialists, government officials, and the Catholic hierarchy. The weekly often featured satire on prostitution and the hypocrisies of married life, and other tawdry petticoats of German society hidden under a dress of respectability. After World War I, it often reviled the Allies—particularly the French—for their harsh insistence on the letter of the peace treaties while hunger was widespread.

Simplicissimus suffered at the hands of the Nazis. The pressures were increased until after one last thrust of expression in March 1933, the weekly became a propaganda organ. Most of the editors stayed on, grinding out meaningless cartoons. Heine fled for his life, first to Prague, then to Oslo, where the Gestapo interrogated him in 1940. "Were you a Socialist or a Communist in Germany?" they asked. "Impressionist," Heine replied. Friends smuggled him into Sweden, where he drew anti-Nazi cartoons. In 1945, at seventy-eight, he wrote a satirical autobiographical novel. He died three years later.

In the early days of *Simplicissimus*, many of the artists were influenced by the *fin de siècle* style called Art Nouveau in France and Jugendstil in Germany. A primarily decorative, stylized approach to nature, it was characterized by flowing, curving lines, arabesque patterns. But the artists used a variety of styles to gain emphasis or impact, from boldly expressive to subtly linear, as the selections below indicate, taken from *Simplicissimus* before World War I.

In Heine's "The Freedom of the Sciences," the goose-stepping professors—unmodeled, flat as the figures in Japanese prints so popular at the time—form a dramatic, striking poster design. In "Ein Märchen," Heine modifies his style to suit the subject matter, portraying the family with strokes as broken and ragged as the people themselves. Whatever style he employed, Heine was an uncompromising draftsman, relentless in his portrayal of the aberrations of society.

Unlike the cartoonist who uses distortion to make the meaning clear, Bruno Paul (1874– ?) employed distortion in his two saluting soldiers as the Expressionists did—

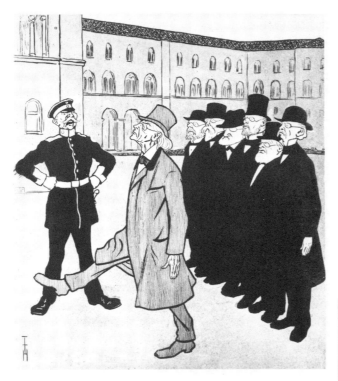

265

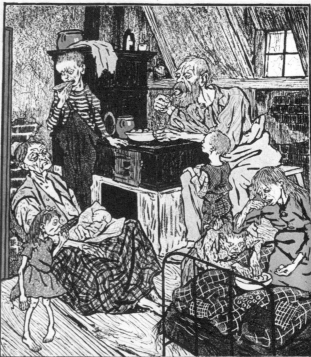

266

265. "The Freedom of the Sciences." Th. Th. Heine. 1900. Reproduced from *Simplicissimus*. Stadt. Galerie, Munich.

266. "A Fairy Tale." Th. Th. Heine. 1898. Reproduced from *Simplicissimus*. New York Public Library.

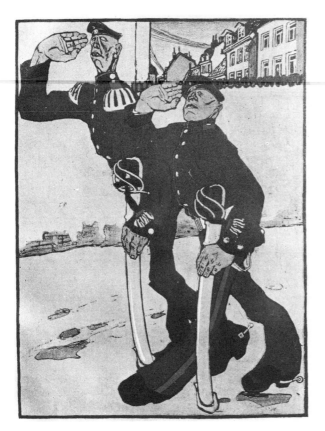

267

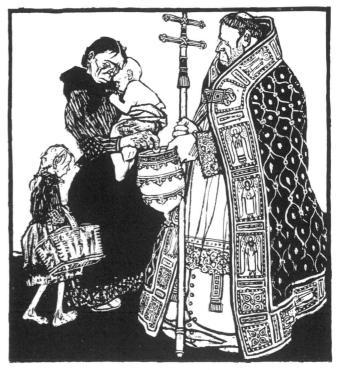

268

267. "Two Soldiers." Bruno Paul. 1903. Reproduced from *Simplicissimus*. New York Public Library.
268. "Peter's Pence." Bruno Paul. 1904. Reproduced from *Simplicissimus*. New York Public Library.

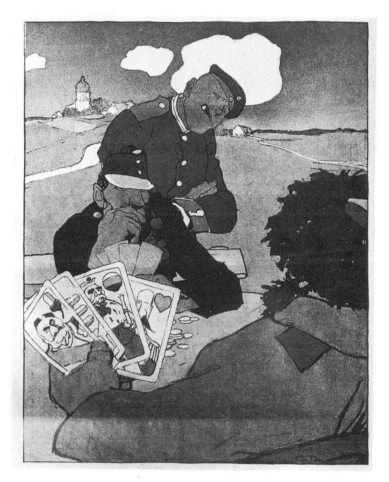

269

for aesthetic effect to please his sense of design and for emotional purpose to emphasize his contempt for the military. The result is poster-like—large, flat shapes combined in a striking design. The caption tells us that the head serves simply as a guide so that the soldiers know how high to raise their hands when they salute.

Back in the sixteenth century, Erasmus chided the church for collecting tithes from hungry peasants and using the money for gold chalices and satin vestments. Now, in 1904, Bruno Paul lashes at the same theme as he shows a shabby mother dropping her mite into the jeweled tiara of a richly garbed churchman.

269. "European Poker Game." Eduard Thöny. 1912. Reproduced from *Simplicissimus*, Dec. 23, 1912. New York Public Library.

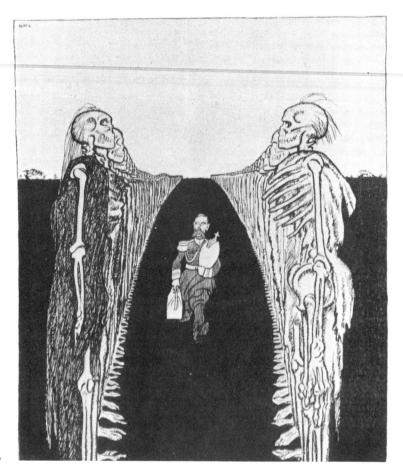

270

Eduard Thöny's prophetic 1912 "European Poker Game" is reminiscent in content, if not in style, of the earliest political cartoon of 1499. The poster-like technique is similar to Bruno Paul's, with the bold effect intensified by the distorted perspective and by the dramatic viewer's angle over the Russian's shoulder.

Olaf Gulbransson (1873–1958), for decades a contributor to *Simplicissimus*, revealed a striking sense of design in his sardonic comment on the Czar's Siberian victims.

The contributions of Jules Pascin (1885–1930) and Ernst Barlach (1870–1938), and those of Käthe Kollwitz did little to shape

270. "Welcome to Siberia." Olaf Gulbransson. 1917. Reproduced from *Simplicissimus*. Sept. 11, 1917. New York Public Library.

271

the style of *Simplicissimus* and hence should be considered separately. Bulgarian-born Pascin contributed to *Simplicissimus* in its early years while he was living in Munich and before he moved to Paris.

Pascin's vignettes of prostitution rely on delicate draftsmanship to evoke a kind of dainty morbidity in these pencil drawings from *Simplicissimus*. Pascin used a great range of tones and skillful modeling, as well as sinuous and insinuating lines to project the sly inhabitants of his demiworld. In "Revery," Pascin's girls wonder, wistfully, if there are men who are not drunk.

271. "Revery." Jules Pascin. 1906. Reproduced from *Simplicissimus*. Dec. 3, 1906. New York Public Library.

272

As a lamb is bathed and brushed before the slaughter, the young girl in the other Pascin is being brushed and made beautiful for the procuress. These wryly bitter scenes make a comment that was not present in his later work. Soon his drawings were to become ironic reportage, devoid of any emotion. His expressive line became more violent, more nervous, more disquieting, perhaps as his life did. He committed suicide in his Paris home in 1930.

Barlach's always dynamic figures reflect his sculptor's orientation. The committee members in his satire on bureaucracy, "The

272. "The Preparation." Jules Pascin. 1905. Reproduced from *Simplicissimus*. New York Public Library.

273

Far-Sighted Members of the Commission Report," are sculptural in mass, weight, and volume. As in many of his woodcuts he accentuates the solidity and three-dimensional quality by twisting his figures to give them movement. The symbolism of blindness and hypocrisy above and misery below could hardly be more forceful. His "Justice"—typically Barlach in its rhythm and flow—backs away from the evil-smelling scales and almost forces the other figure out of the picture. The thrust of the heavy, dark masses of the figures to the left is balanced by the implied weight of the unseen half of the scale. The background is empty. Barlach, primarily a sculptor, always thought in terms of figures in space, rather than as a picturemaker who integrates figures and background. This is reflected in his satire on the munitions makers, "Bethlehem Steel," where the massive sculptural figure dominates, and the satirical thrusts have to be sought out.

"The things that arrest my attention are

273. "The Far-Sighted Members of the Commission Report." Ernst Barlach. 1907. Pen and ink drawing. Reproduced in *Simplicissimus,* Nov. 25, 1907. New York Public Library.

274

that a human being has suffered," Barlach wrote. Like his friend Käthe Kollwitz, who drew inspiration from some of his work, Barlach had a deeply humanistic compassion for the suffering poor. Like her, too, he hated the militarism and unfeeling materialism of the middle and upper classes. But there the similarity ends. Barlach had a spirituality, a mystic seeking that Kollwitz lacked, and stylistically his Expressionism had little relationship to hers.

Barlach was considerably influenced by the peasants he observed in a trip to Russia in 1906. He made many wood carvings that physically resembled stumpy, flat-faced, Slavic peasants (Hitler hated Barlach's peasants!) but were elevated spiritually from suffering. Like other German Expressionists he received from the Gothic an exaltation that he transmitted to much of his work. Perhaps he was closer to Van Gogh in his mystic compassion and earthiness.

274. "Justice." Ernst Barlach. 1907. Reproduced from *Simplicissimus*, Aug. 26, 1907. New York Public Library.

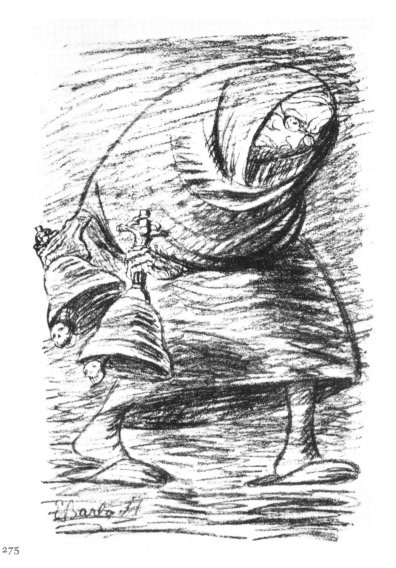

275

No radical, but a pacifist and generally sympathetic to the left, Barlach was doomed as the Nazis gained strength. As early as January 1929, he wrote that "all rightist groups are up in arms against me . . . even worse are diatribes of the patriotic organization, especially the Stahlhelm." As early as 1931 his work was banned from an exhibit, and in the ensuing years his work was removed from museums

275. "Bethlehem Steel." Ernst Barlach. 1915. 15¾x10¾. Drawing. From *Kriegzeit,* July 1915. Prints Division, Astor, Lenox and Tilden Foundation, Geisberg Collection, New York Public Library.

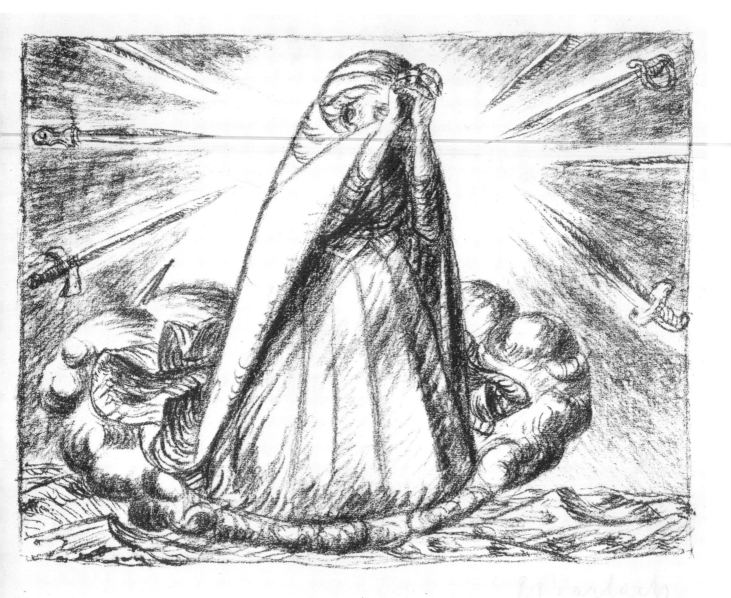

276

and churches. He refused to emigrate and remained isolated in his studio in provincial Guestrow until he died in 1937.

When the first World War ended, almost all of Germany's artistic community was aroused to political involvement of some sort. German society was partially disintegrated, with the prewar social and political fabric tattered but not destroyed. Added to the searing traumas of the war and postwar

276. "Dona Nobis Pacem." Ernst Barlach. 1916. 7⅛x9¾₁₆. Lithograph. Gift of Samuel A. Berger, Museum of Modern Art, New York.

chaos stirred by an ugly threat of right-wing militarism after the left revolts were brutally crushed, were bloody street fighting, widespread hunger, unemployment, prostitution, and general demoralization. The power of the prewar trio—the military, the Junkers, and the big industrialists—was curbed but still dominant, along with its satellites—the bureaucrats and the court officials.

A drawing by George Grosz in 1920, "Cross-Section," captures much of the atmosphere of immediate postwar Berlin: maimed veteran, gaunt worker, cigar-smoking profiteers on the way to deals, naked prostitute, firing squad in action, with civilians being mowed down by the military. By ignoring conventional approaches to space planes, Grosz was able to combine successfully a dozen varied elements into a powerfully expressive kaleidoscope. It has one omission, however. The mélange reflects the chaos, but the violence is too "official." There is no indication of the bloody mayhem committed daily in the streets in the early postwar years.

Representatives of all the artistic and cultural fields banded together in 1919 to create a Workers' Council for Art and for a few years arranged exhibits and in other ways actually succeeded in bringing art to "the people." Max Pechstein and Ludwig Meidner issued a socialist manifesto in 1919, "To All Artists," a passionate appeal for social justice in the name of the brotherhood of man. But the Expressionists' efforts were doomed from the start. The official art world and the middle class were repelled by their distorted forms at the exhibits. The working class gave political support but was unprepared to accept the Expressionist vision. The dream of socialism faded quickly as Allied errors played into the hands of the right wing. Although the government did pass a number of social reforms, the basic structure of society was unchanged. The shady deal was the predominant way of life.

Expressionists were no longer capable of expressing the mood, "the scene," the jangling, jaded, abrasive cacophony that was postwar Germany. The New Objectivity emerged to reflect the agony and torment of the period. Much of German art became transcendental, expressive of a battered spirit. However, some German artists did relate directly to the cataclysmic scene swirling around them. Of this trend, the Verists, such as George Grosz, Otto Dix, and the early Max Beckmann, were the most successful exponents.

Max Beckmann (1884–1950) had no political affiliation but he felt a commitment. "We must take part in the whole misery that is to come," he wrote shortly after the war. "We must surrender our heart and our nerves to the dreadful screams of pain of the poor, disillusioned people. . . . Our superfluous, self-filled existence can now be motivated only by giving our fellow men a picture of their fate and this can be done only if you love them."

The "dreadful screams of pain" were captured on lithographic stone not long

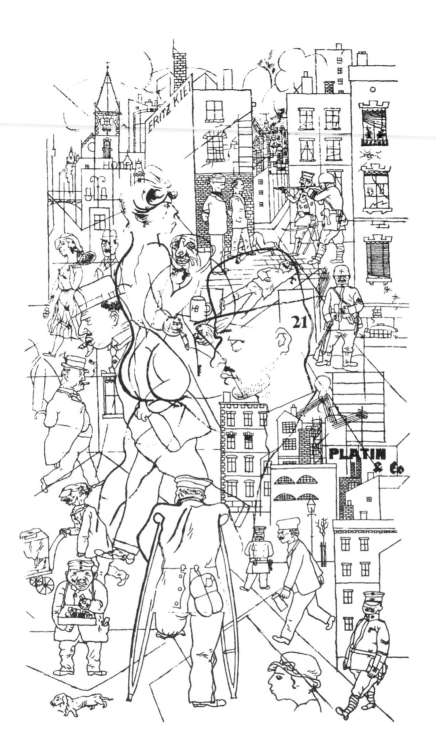

277

277. "Cross-Section." George Grosz. 1920. Drawing. Reproduced from *Ecce Homo* (Plate No. 68).

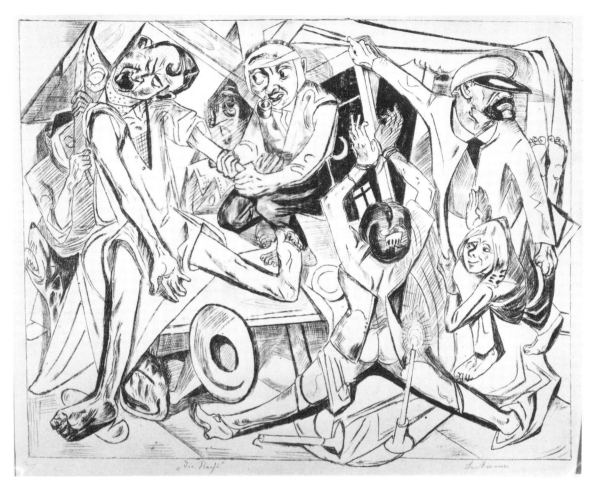

278

after, when Beckmann's series of ten lithographs, "Hell," was published in 1919. They included the nightmarish, unforgettable "The Night," similar to his famous painting of the same name. The gruesome atrocity he pictures was perpetrated often in the battle to fill the postwar political vacuum.

Beckmann's lines are harsh and tense; his Gothic angularity and distortion, reminiscent of the work by Master E.S. discussed in the opening pages of this book, are remarkably appropriate for expressing the random violence. The methodical efficiency

with which the thugs go about their work in secrecy and silence is startlingly prophetic of the ruthless violence of Hitler's storm troops.

But Beckmann's intent seems to have been more allegorical than literal. Although he was deeply traumatized by the war and its aftermath, he was also combining immediate commentary with a more philosophical comment on man's collapse and decay. This is even more apparent in other lithographs in this series, such as "The Ideologists" and "The Last Ones."

278. "The Night." Max Beckmann. 1919. 21⅞x27⅝. Lithograph. Plate VI from *Die Holle*. Museum of Modern Art, New York.

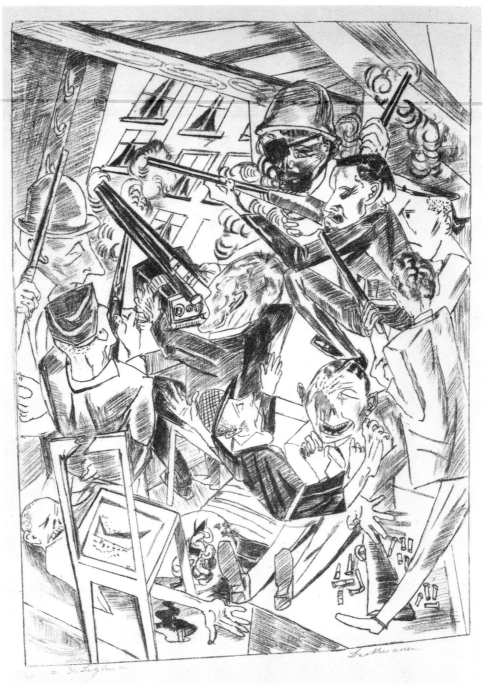

279

279. "The Last Ones." Max Beckmann. 1919. 26¼x18¹³⁄₁₆. Lithograph. Plate IX from *Die Holle*. Larry Aldrich Fund, Museum of Modern Art, New York.

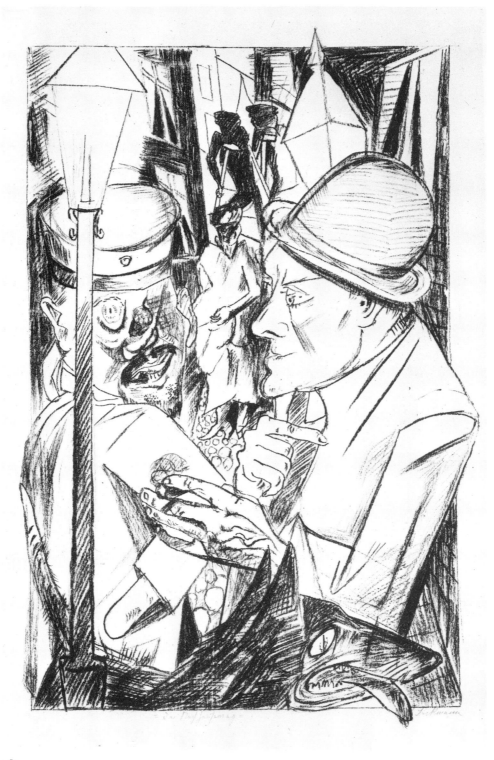

280

280. "The Way Home." Max Beckmann. 1919. 29½x19⅛. Lithograph. Plate I from *Die Hölle*. Museum of Modern Art, New York.

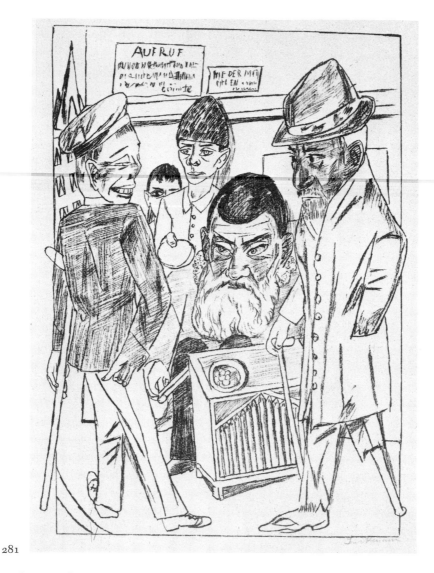

281

Beckmann's macabre, bitter "The Way Home," brilliantly melds in a vertical Gothic morality tale the mutilated veteran, the pimp, the prostitute, the harsh lights and the symbolic, snarling dog. This is one of the most explicit of Beckmann's social comments.

Born in Leipzig of well-to-do parents, Beckmann was a successful prewar painter, with several one-man shows. He volunteered for the medical corps, an experience that was to affect his life and his work. His drawings and etchings sustained him in his daily contact with death and comprise a memorable record of the violence and tragedy he witnessed.

Beckmann's graphic work of the early twenties was a sensitive reaction to the harsh inhumanity of the time, but it was not political. His later work lacked any element of comment except in the broadest philosophical sense. He devoted himself

281. "The Beggars." Max Beckmann. 1922. 18⅜x13⅛. Lithograph. From *Berlin, 1922.* Abby Aldrich Rockefeller Fund, Museum of Modern Art, New York.

282

mostly to his painting, which was deeply emotional, Gothic, and symbolistic. In 1937, he fled to Amsterdam where he suffered terrible privation during the occupation, but was sustained by painting. In 1947, he accepted a teaching position in the United States where he died in 1950.

While Käthe Kollwitz has given us an unforgettable gallery of the faces of the poor, the starving, and the widowed in postwar Germany, and Beckmann has cap-

tured that period's violence, George Grosz has left us a horror-filled portrait of a sordid wasteland, a society almost beyond redemption.

George Grosz (1893–1959) grew up in Berlin and Pomerania, where his father managed a Freemason lodge. He studied at art schools in Dresden and Berlin and patterned his early style on the work of Bruno Paul and other caricaturists for *Simplicissimus*. He led a young man's bohemian life, haunted the cafes, and began to evolve a more mature, semicubist style when World War I broke out. He enlisted as an infantryman, but his patriotism rapidly left him. He hated being a cog in a vast, impersonal machine, hated the filth, the stupidity, the arrogant officers. After receiving a temporary discharge for brain fever and dysentery, he made a series of bitter drawings expressing, as he wrote later, his "despair, hate, and disillusionment. I had utter contempt for mankind in general." He drew mutilated soldiers and spiritually mutilated civilians—the profiteers. A few appeared in *Neue Jugend*, a left-wing, antiwar magazine, one of a remarkable group of short-lived wartime magazines that managed to elude the censors and publish artists' front-line impressions and critical reportage. Typical of Grosz' cynicism was his cartoon-like drawing, "Street Corner," with suicide, murder, and lovemaking in a tenement.

He was redrafted (later he drew his famous cartoon "KV"—*Kriegs verwendungsfahig*—of a doctor pronouncing a skeleton fit for service) and wound up in a military

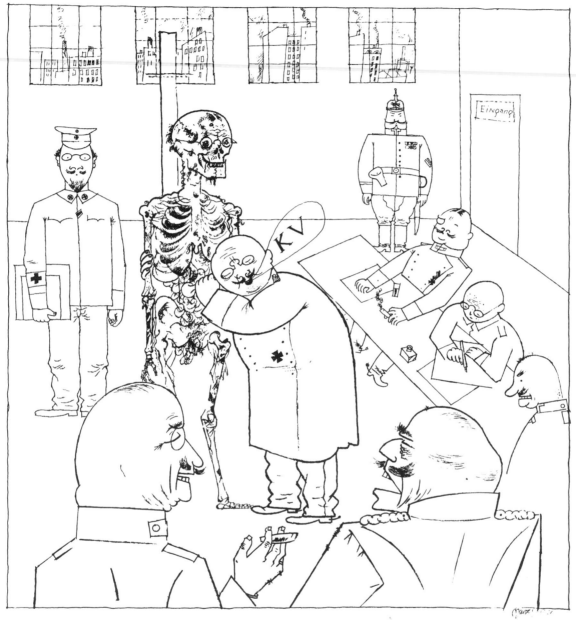

283

283. "Fit for Active Service." George Grosz.. 1918. 20x14⅜. Pen and brush drawing. A. Conger Goodyear Fund, Museum of Modern Art, New York.

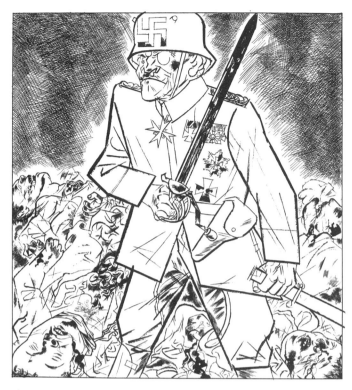

284

Grosz plunged into the chaotic, agitated life of postwar Berlin, became actively involved with the left, joined the Dada movement, which in Berlin had a very political and very left orientation, helped put on art shows and made street-corner speeches. He did work for the Spartacists, and when Kokoschka seemed to place culture above the revolution, declared that the entire art world was not worth a hair from the head of a worker fighting for his bread.

Grosz engaged in all this activity despite a profound pessimism that seemingly deprived him of any faith in the future or any sympathy with the working class. At least, in his autobiography he reiterates that his lack of faith in man made it impossible for him to be a reformer. But Grosz wrote his autobiography years later in the United States, where he identified with the American middle class, and since it was partly an *apologia pro sua vita*, it is possible he may not have been quite as alienated as he later sounded.

In any case, he drew, lithographed, and painted a *Walpurgisnacht*—the moral decay of Germany in the twenties and early thirties. The smug, greedy, upper-middle class, indifferent to the misery around them, was a constant target, as pictured in "Christmas Eve." Here the line is relaxed, flowing, pictorial—unusual for Grosz in that period. The bullet-headed, bull-necked bourgeois, leering and lustful, appears again and again, as in "The Uncle," and profiteering, greedy, or satiated as in *"in Mienem Gebiet..."* and "Restaurant."

asylum for the shell-shocked and insane just before the war ended. "I was disappointed," he wrote, "not because the war was lost, but because the people had tolerated it and suffered it for so long a time, refusing to follow the few voices that were raised against the mass slaughter." His voice was raised for all time in "The White General," a haunting portrait of a fanatical Prussian general, his sword bloodied, surrounded by corpses, relentless and unyielding in his pursuit of death. Grosz made dozens of satirical drawings of the officer class for whom he held a lifelong hatred.

284. "The White General." George Grosz. 1919. 22¼x20½. Pen and ink drawing. Collection of Erich Cohn, New York.

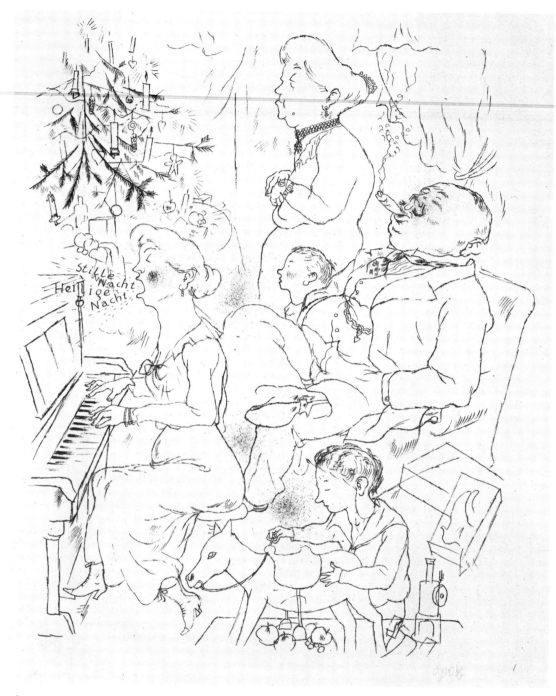

285

285. "Christmas Eve." George Grosz. 1921. 18¹⁵/₁₆x14¹⁵/₁₆. Transfer lithograph. Gift of Paul J. Sachs, Museum of Modern Art, New York.

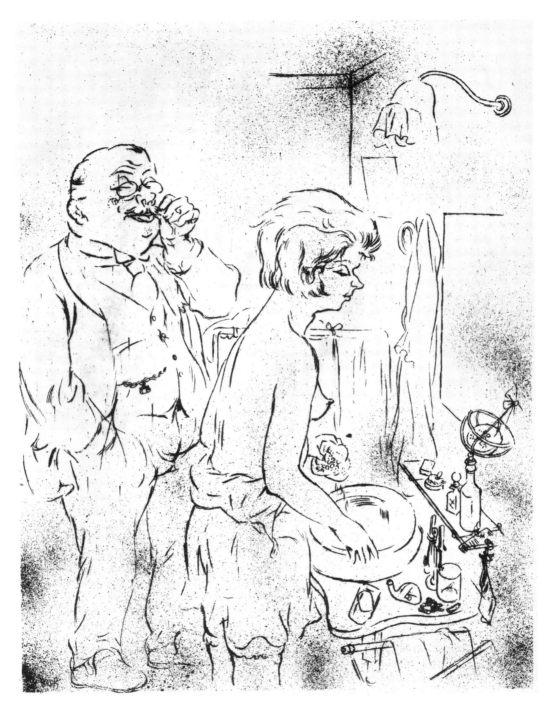

286

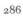

286. "The Uncle." George Grosz. 1921. 24½x18⅜. Drawing. Collection of Erich Cohn, New York.

287

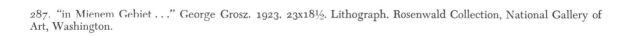

287. "in Mienem Gebiet . . ." George Grosz. 1923. 23x18½. Lithograph. Rosenwald Collection, National Gallery of Art, Washington.

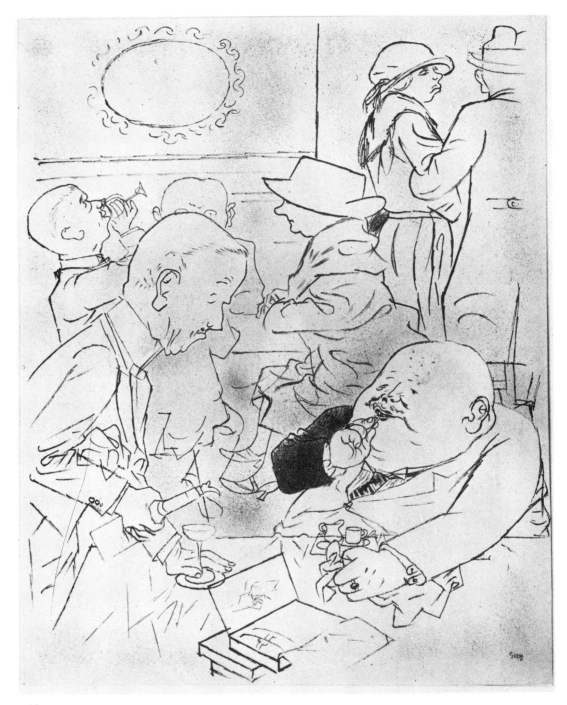

288

288. "The Restaurant." George Grosz. No date. 23⅜x18⅛. Drawing. Rosenwald Collection, National Gallery of Art, Washington.

The unbridled sexuality of the time lent itself perfectly to Grosz' harsh, jagged *danse macabre,* but he seemed to be obsessed by it. His effective device of revealing the sex organs beneath clothes was repeated too often. His satirical book on jungle sex morals, *Ecce Homo,* brought him in 1923 a 6,000-mark fine for defaming public morals. On two other occasions he landed in court—in 1920 for attacking the Reichswehr in his portfolio, "Gott mit Uns," for which he was fined, and in 1928 for blasphemy in his portfolio "Hintergrund," for a drawing of a crucified Christ in a gas mask. This latter judgment was later reversed.

As the decade passed, Grosz' paintings and drawings became less harsh and angular, less abstract, with more attention to detail. As the thirties approached, Grosz actually became prosperous. Many of the newly rich snapped up his satires of them.

As the Nazis became more powerful, Grosz was increasingly threatened. In 1932, he eagerly accepted an invitation to teach in the United States, a country he had always admired. It was a time of depression, and many of his followers in the United States expected that his satirical talents would flourish in the new soil, but the motivation was no longer there. He wanted to exchange the armor of a gladiator for a double-breasted business suit. He wanted to forget the past. "In Germany I had poured forth venom in the form of pen-and-ink caricatures," he wrote. "Hate and proselytizing rancor seemed out of place here. I wanted to be rid of it. . . ." He turned to landscapes and nudes in his painting. Grosz did publish in 1936 a portfolio, "Interregnum," containing sixty-five plates, most of them on Germany as Hitler was rising to power. The anti-Nazi statements were direct, even if they lacked the excitement of his agitated style of the twenties. However, there was a new element that was to mark the end of his satirical efforts; his innate pessimism now fathered an apocalyptic vision of doom, of a world destroying itself, as in "The Riders of the Apocalypse (I Was Always Present)." His dark forebodings were expressed in a group of brilliant paintings culminating in what Grosz critic John I. H. Baur regards as the artist's masterpiece, a Bosch-like creation, "The Pit," and in a fantastic series on "The Stickmen," symbolic of the madness of war.

Grosz never quite succeeded in the role he assumed of a total American. When he visited Germany in 1953 he was greatly disappointed that the Germans still regarded him as a social satirist and had no interest in the painting he had been doing in America for twenty years. Six years later he returned to Berlin, where he died shortly afterward.

Grosz' fellow *enfant terrible* of the immediate postwar period was Otto Dix (1891–1969). Like Grosz, Dix was revolted and embittered by the war, in which he was wounded several times, and repelled by postwar society. He too joined the anarcho-communist Dada movement and etched and painted the flotsam washed up on the streets of postwar Berlin. Dix was

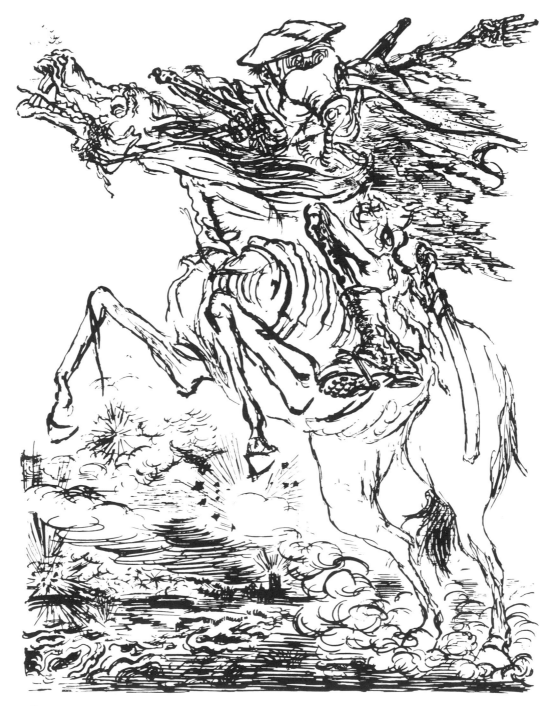

289

289. "The Riders of the Apocalypse (I Was Always Present.)" George Grosz. 1936. 22¼x17⅛. Pen and ink drawing.
Collection of Erich Cohn, New York.

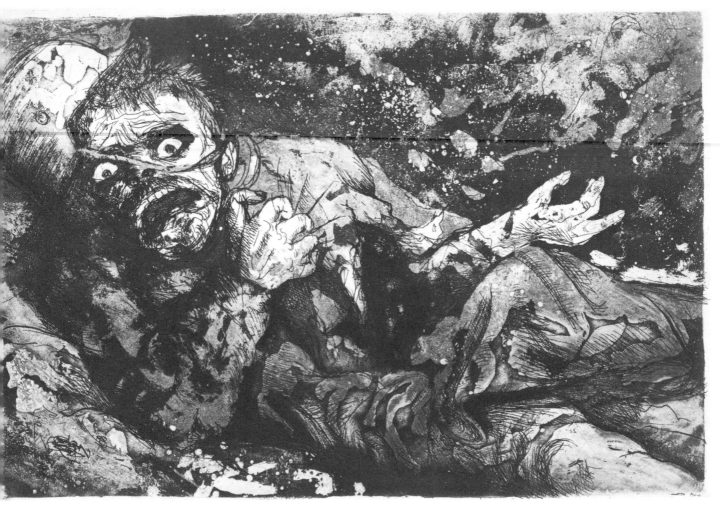

brutal; he often seemed to shock for shock's sake. His observation, unlike Grosz', was limited to the surface. But in 1924 he created a masterpiece, a "War" cycle of fifty etchings and aquatints. It is a pitiless, harrowing, collective portrait of war's cruel effects on soldiers. Coldly impersonal, it contrasts with the hot anger of Goya. As Bernard Myers has pointed out in his brilliant and authoritative survey of the Expressionists:

Dix is concerned with what happens after the immediate moment of war's cruelty, whereas Goya's chief interest was in castigating the invader and his behavior. In terms of social criticism, Dix's art rests on a more conscious political and social level.

Confronting Dix' "Wounded" is like bumping into a living corpse in a graveyard at midnight. It twists nerves like a shriek in the dark. The accusing eyes force the viewer to share the guilt for the in-

290. "Wounded." Otto Dix. 1916. 7¾x11⅜. Etching and aquatint. From *The War*. Gift of Abby Aldrich Rockefeller, Museum of Modern Art, New York.

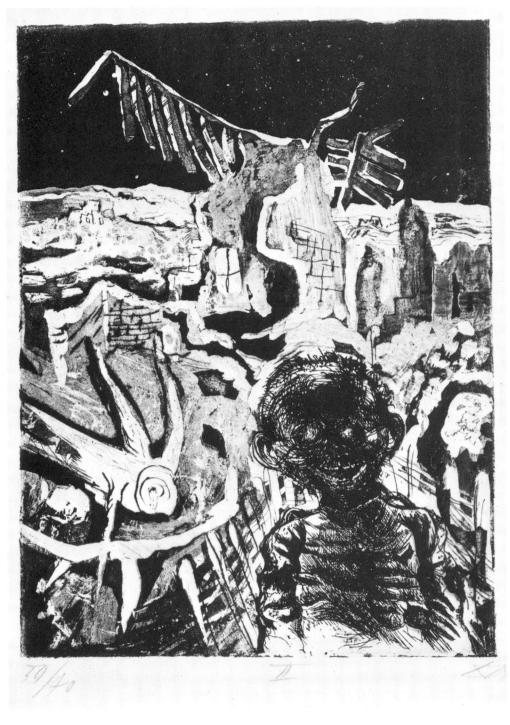

291

291. "Meeting a Madman at Night." Otto Dix. 1924. 10¼x7⅝. Etching, aquatint, and drypoint. From *The War*. Gift of Abby Aldrich Rockefeller, Museum of Modern Art, New York.

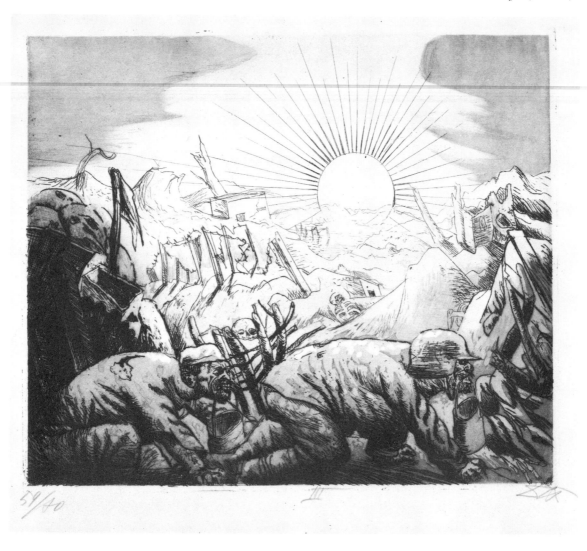

292

sanity of war. In "Wounded" and in "Meeting a Madman at Night," Dix etches knotted, jagged forms and adds aquatint to make harsh contrasts of dark and light. It is the darkness of a nightmare and the whiteness of a stark landscape lit by the flashing explosion of shells, making the impact instantaneous in its unspoken horror.

Dix' mood turns to irony in "Messtime at Pilkem." The sun, beautiful and life-giving, rises over the battlefield to reveal a hideous land, pitted and stripped by man, and man

292. "Messtime at Pilkem." Otto Dix. 1924. 9¾x11⁹⁄₁₆. Etching. From *The War*. Gift of Abby Aldrich Rockefeller, Museum of Modern Art, New York.

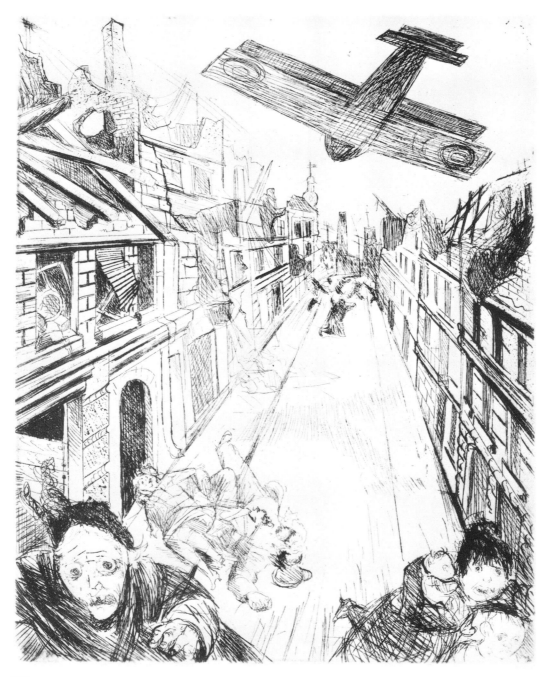

293

293. "The Bombing of Lens." Otto Dix. 1924. 11¾x9⅝. Etching. From *The War*. Gift of Abby Aldrich Rockefeller, Museum of Modern Art, New York.

himself crawling on all fours, messkit in mouth, like an animal foraging for food.

"The Bombing of Lens" captures forever the hideous terror that seizes civilians when they undergo a sudden air raid. Goya, in his "Ravages of War," effectively uses contrasting dark and light tones to emphasize the horror of the wanton slaughter of the innocents. Dix, by contrast, sets his scene outdoors and uses full light to accentuate the naked vulnerability of the fleeing people, the lack of any cover. His street perspective brilliantly suggests that the terror is endless.

Like Grosz, Dix gradually abandoned his violent social criticism and concentrated more on his painting. He suffered considerably under the Nazis. He was deprived of his teaching position, forbidden to exhibit, and as a final indignity, was drafted at the age of fifty-three.

In his autobiography George Grosz remarks that he could not be a reformer because "A reformer had to have faith in the good in man . . ." and he cites his friend Frans Masereel (1889–1971) as one who did have the faith. Masereel was born and grew up in Belgium, then studied and worked in Paris. During the war years he took refuge in Switzerland along with several other artists hostile to the war. His frequent and passionate newspaper cartoons were widely reproduced. He spent the early 1920's in Germany. Masereel's books of woodcuts, *Passion of a Man*, done in Switzerland, and his *Stories Without Words* and others executed in Germany, were pub-

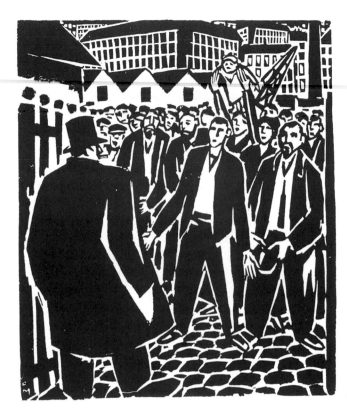

294

lished in several countries and won a wide following in postwar Germany. Masereel found woodcuts, with their possibilities for violent contrasts, the perfect medium for expressing his social messages. In spirit Masereel is close to the late nineteenth-century artists such as Steinlen, who were socialist in philosophy, concerned for the poor, and mordant and biting in portraying injustice. In technique he owed much to the early Expressionists.

The strike scene from *Passion of a Man*, as with the other woodcuts from his books, tells a story in itself. Here Masereel uses

294. "The Strike." Frans Masereel. 1918. 4⅞x4⅛. Woodcut. From *Die Passion Eines Menschen*. Prints Division, Astor, Lenox and Tilden Foundation, New York Public Library.

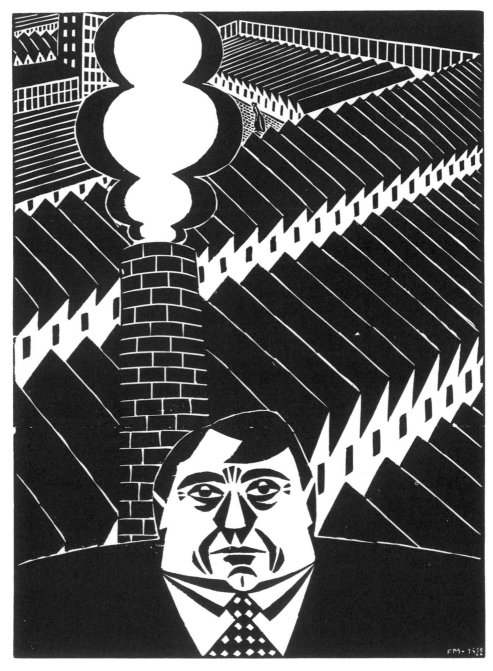

295

295. "Le Parvenu." Frans Masereel. 1922. 10⁷⁄₁₆x7⁹⁄₁₆. Woodcut. Philadelphia Museum of Art.

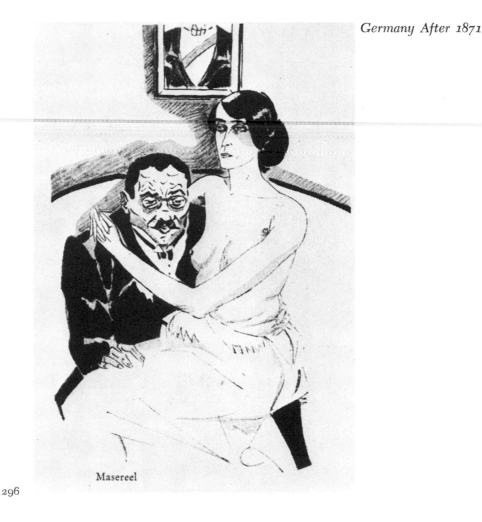

Masereel

296

the broad mass of the overcoated "boss" to accentuate the contrast with the gaunt, coatless workers. His "Parvenu," done in Germany in 1922, has a Bauhaus-like flavor. Masereel is ingenious in his use of the powerful industrialist's frame to anchor the drawing and of the endless rows of factory structures to emphasize the drabness and sterility of factory life. In a drawing for the satirical magazine, *Der Quer-* *schnitt,* Masereel's industrialist is engaged in hollow, purchased sex, a reflection of his joyless, acquisitive existence.

The socialism and militant pacifism advocated in drawing and word by many German artists fitted the mood of the German people, but as the decade of the thirties approached, a growing nationalist spirit permeated Germany when militarism and authoritarianism regained their hold over the

296. Untitled. Frans Masereel. 1931. Drawing; process reproduction from *Der Querschnitt,* June 1931. Courtesy Europa Verlag, Zurich.

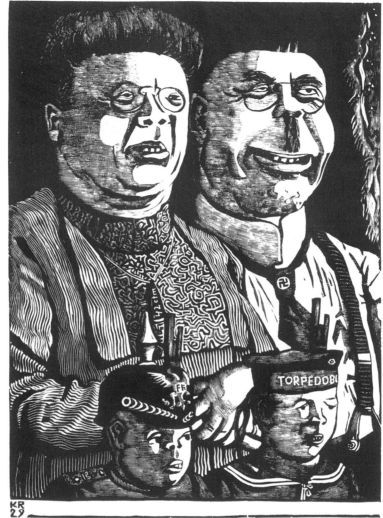

German middle class. Karl Rössing's chilling family portrait, "The Stahlhelm (ex-servicemen's organization) Passes By," was painfully reflective of the new pride in the right-wing militarism. The tramp of marching feet and the roar of "Heil Hitler" increasingly drowned out the voices of reason and moderation. Alfred Kubin's "Brown Column" imperishably captured mesmerized Germany's hallucinatory march straight back into the middle ages. Soon the majority of Germans joined in hailing their new leader. Protest art in Germany was again silenced.

297. "The Stahlhelm Passes By." Karl Rossing. 1932. 7x5. Woodcut. From *Mein Vorurteil Gegen Diese Zeit*. Prints Division, Astor, Lenox and Tilden Foundation, New York Public Library.

298

298. "Brown Column." Alfred Kubin. 1933. 16½x13¼. Drawing and watercolor. Courtesy Spangenberg Verlag, GmbH, Munich.

CHAPTER XI
The United States Since 1870

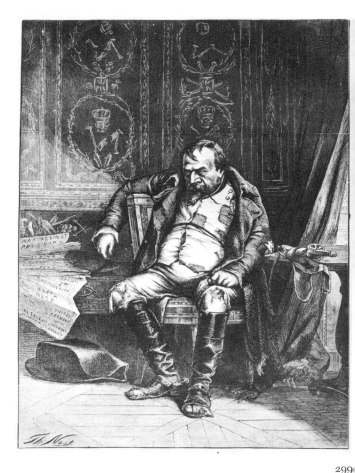

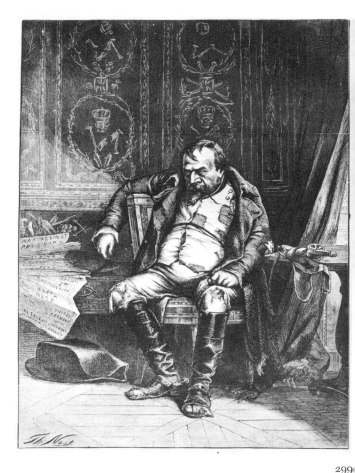T<small>HE</small> Franco-Prussian War, a turning point in the development of France as a republic and Germany as an empire, contributed to the suppression of protest art in both countries. Across the Atlantic it helped stir the United States from its isolation, a fact that did not go unnoticed by America's leading political cartoonist, Thomas Nast (1840–1902). In *Harper's Weekly*, the influential Nast drew a defeated Louis Napoleon in the ragged remnants of his uncle's uniform, with the caption, "Dead Men's Clothes Soon Wear Out." The German-born, republican Nast was hostile to the self-crowned emperor and sympathetic to an emerging, seemingly progressive Germany. But a few months later, as casualty reports mounted, Nast reacted to the human and social toll and drew War as a skeleton on a throne of cannon, with corpses, fleeing refugees, and burning cities in the background.

Nast's graphic style derived in line and texture from the *Punch* drawings of Sir John Tenniel, his artistic political inspiration from Daumier and other French artists, and his philosophy from the liberalism of mid-nineteenth century Germany. There was little in the American artistic tradition from which Nast could draw as he evolved

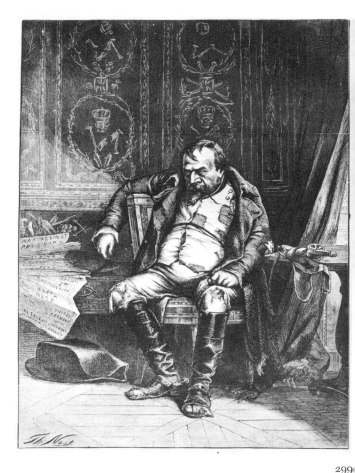299

into America's first major figure in the area of political and social graphic comment.

Protest "art"—if it can be dignified by that term in nineteenth-century America—consisted mainly of caricature and cartoons, with its quality of indignation almost wholly confined to the topical vagaries of American politics and public life. America's singular contribution in the nineteenth century was its political democracy. So much attention was focused on this arena

299. "Dead Men's Clothes Soon Wear Out." Thomas Nast. 1870. 13⅞x9¼. Wood engraving. From *Harper's Weekly*, Sept. 10, 1870. New York Public Library.

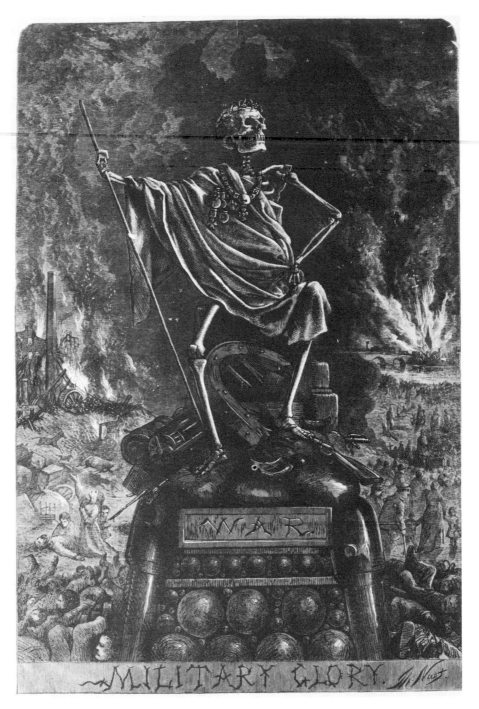

300

300. "Military Glory." Thomas Nast. 1870. 13⅞x9¼. Wood engraving. From *Harper's Weekly*, Nov. 12, 1870. New York Public Library.

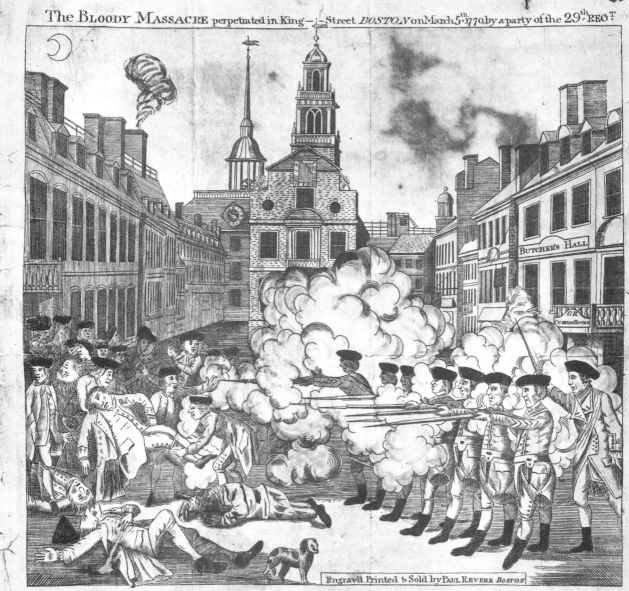

The BLOODY MASSACRE perpetrated in King—│—Street BOSTON on March 5.th 1770, by a party of the 29th REGT

Engrav'd Printed & Sold by PAUL REVERE BOSTON

Unhappy BOSTON! see thy Sons deplore,
Thy hallow'd Walks besmear'd with guiltless Gore.
While faithless P—n and his savage Bands,
With murd'rous Rancour stretch their bloody Hands;
Like fierce Barbarians grinning o'er their Prey,
Approve the Carnage, and enjoy the Day.

If scalding drops from Rage from Anguish Wrung
If speechless Sorrows lab'ring for a Tongue,
Or if a weeping World can ought appease
The plaintive Ghosts of Victims such as these;
The Patriot's copious Tears for each are shed,
A glorious Tribute which embalms the Dead.

But know Fate summons to that awful Goal,
Where JUSTICE strips the Murd'rer of his Soul:
Should venal C—ts the scandal of the Land,
Snatch the relentless Villain from her Hand,
Keen Execrations on this Plate inscrib'd,
Shall reach a JUDGE who never can be brib'd.

The unhappy Sufferers were Mess.rs SAML GRAY, SAML MAVERICK, JAMS CALDWELL, CRISPUS ATTUCKS & PATK CARR
Killed. Six wounded; two of them (CHRISTR MONK & JOHN CLARK) Mortally

301

301. "The Bloody Massacre." Paul Revere. 1770. $7^{13}/_{16} \times 8^{3}/_{8}$. Engraving. Prints Division, The I. N. Phelps Stokes Collection of American Historical Prints, New York Public Library.

that, inevitably, American satirical art was largely political rather than social.

It had been very minor art; in fact, in the late eighteenth century and the first half of the nineteenth there were few trained artists.

As in eighteenth-century England, early American caricature was either ferocious, free-swinging, and unprincipled or bland pictorialization of the events of the day. It was descriptive rather than interpretive. The subjects were often allegorical and the conceptions stilted and pompous. Most of these early woodcuts and engravings were crude, with stiff figures and large text-filled balloons of explanation. The few superior ones were usually by English-born artists, and these were plainly derivative of Rowlandson or Gillray.

Occasionally, either the drawing or the conception does merit more than antiquarian interest.

The best-known "protest" print of this early period, of course, is Paul Revere's "The Bloody Massacre," overflowing with passion if woefully lacking in technique. It was widely copied and reprinted, helped stir a continent, and made the Boston Massacre (and Revere) known to all, despite the inadequacy of the draftsmanship. There is doubt that the conception was original; possibly it was copied from a drawing by Henry Pelham. Some of the prints were hand-colored red, blue, green, and brown, and although Revere made no effort in the engraving to distinguish Cris-

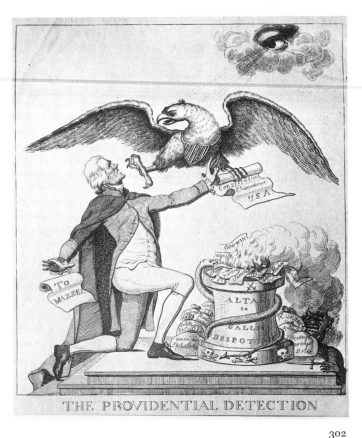

THE PROVIDENTIAL DETECTION

302

pus Attucks as a Negro, one of the victims seems to be colored in brown.

An anonymous 1800 engraving, "The Providential Detection," shows Thomas Jefferson genuflecting before the "altar to Gallic despotism," where the works of Godwin, Voltaire, and others are ablaze. The American eagle prevents him, in the nick of time, from burning the Constitution. The engraving is far superior in composition to its contemporaries; it is also typical of the political exaggeration of the times.

302. "The Providential Detection." Anonymous. 1800. 19x17. Etching. Ridgeway Library of Philadelphia.

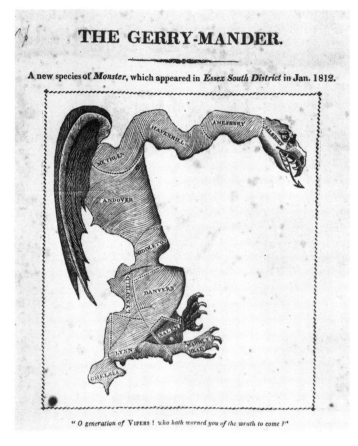

THE GERRY-MANDER.

A new species of *Monster*, which appeared in *Essex South District* in Jan. 1812.

" O generation of Vipers *! who hath warned you of the wrath to come ?"*

303

Boston newspaper, it stirred up so much opposition that the redistricting was repealed the next year. It was obviously only a temporary and local victory; "one man, one vote" continued to agitate the nation 150 years later.

During the Jackson administration the political cartoon became abundant and its utterances much more ironical. The figures were drawn more carefully, the movements more naturally. Jackson's controversial policies undoubtedly stimulated the proliferation of these cartoons. Clearing the way was the recent introduction of lithography, with its versatility and the relative ease of drawing with a lithographic crayon.

The sale of lithographed, individual caricatures flourished. Like the old German broadsheets and the broadsides of Gillray, these single lithographic sheets were distributed widely, particularly after Currier and Ives and other firms entered the field. To many of the relatively sophisticated and conservative caricaturists, Jackson was a natural target, with his frontier manners, his egalitarianism, and his hatred of monopoly and special privilege, but they hardly ever rose above the level of partisan political cartooning.

When depression struck Edward W. Clay (1799–1857) produced "The Times," a lithograph of more than ephemeral interest. It was campaign propaganda, blaming Jackson for the panic of 1837. Jackson's white top hat floats over a spectacle which includes a run on the Mechanics Bank, ships

Elkanah Tisdale's "Gerry-mander" coined a word and wrought a political reform—albeit a temporary one—in Massachusetts. When Governor Elbridge Gerry rearranged the voting districts of Essex County to assure a Republican majority, Tisdale added claws, wings, and fangs to the map, so that it looked like a salamander. He called it a "Gerry-mander." When it appeared in a

303. "Gerry-mander." Elkanah Tisdale. 1812. 19½x8¾. Broadside. Reprinted in *Boston Gazette*, March 12, 1812. Rare Book Room, New York Public Library.

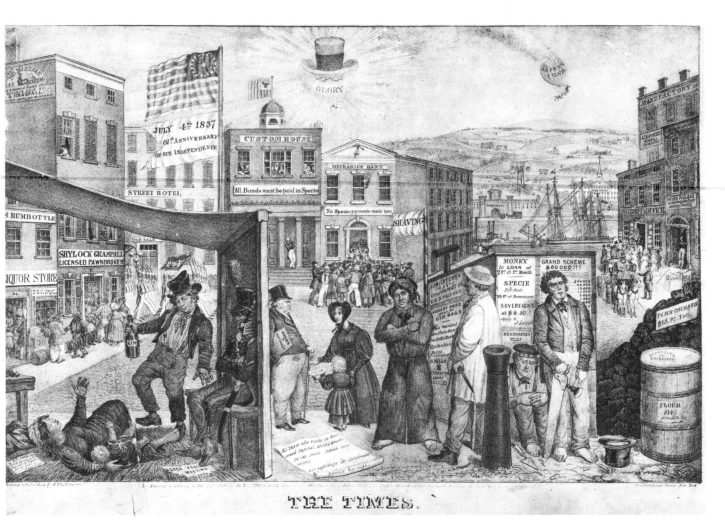

THE TIMES.

lying idle, the sheriff auctioning foreclosed property, unemployed workers passing the day in despairing inaction, the liquor store and pawnbroker's shop busy, and a widow and child begging from the stone-faced man of property. The composition is well balanced and lively, despite the quantity of detail.

Although single lithographed sheets continued into the seventies, their popularity and influence were gradually usurped by graphic comment appearing in the new weekly magazines. The trend began in 1846 when *Yankee Doodle* magazine published a cartoon of political comment in every issue. Unlike the publishers of single sheets who would circulate caricatures on both sides of any issue, the magazines and their artists usually had a point of view and a particular frame of reference.

During the Civil War, *Harper's Weekly* and *Frank Leslie's* weekly won wide fol-

304. "The Times." Edward W. Clay. 1837. 12⅛x19. Lithograph. Library of Congress, Washington.

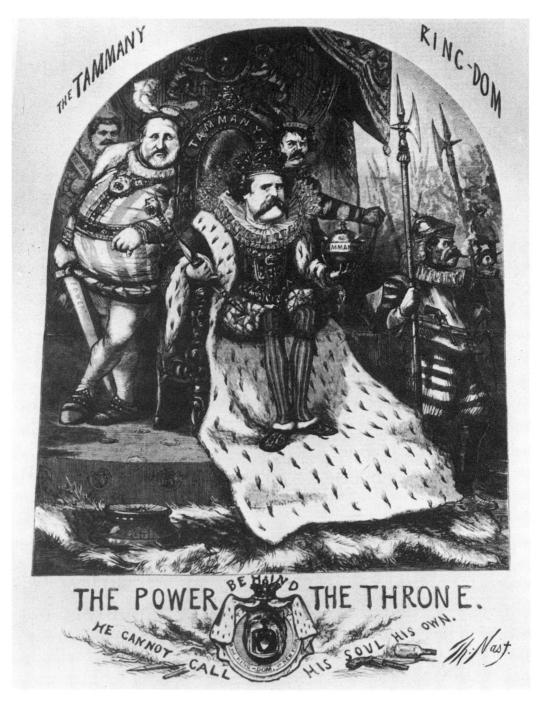

305

305. "Tammany Ringdom." Thomas Nast. 1870. 14x9. Wood engraving. From *Harper's Weekly,* Oct. 29, 1870.
Metropolitan Museum of Art, New York.

lowings for their front-line reports and artists' sketches. But *Harper's Weekly* was to outstrip its competitor, mainly because of the popularity of its star graphic artist, Thomas Nast.

When only fifteen, the precocious Nast began to work for Leslie's weekly. At twenty, he was a veteran in his field and an enthusiastic artist-correspondent-participant in Garibaldi's Sicilian campaign. Two years later he joined *Harper's Weekly* in an association that was to last twenty-five years. Lincoln is reputed to have called Nast "our best recruiting sergeant" for his front-line Civil War sketches and occasional cartoons which aroused support for the Union cause. After Lincoln's death, Nast pilloried President Andrew Johnson as a betrayer of Lincoln's principles. The drawings were often overloaded in detail and allegory, in the style of the day. Within a few years, however, Nast's style was to achieve a powerful, graphic simplicity as he centered on an issue that was ideal for his moralistic, perhaps simplistic, ethic.

During the sixties, a small group of corrupt officials under the Tammany "Boss," William Marcy Tweed, gained control of New York City and in a short time milked the treasury of millions of dollars while running up a public debt of fifty million. The Tweed Ring bullied bondholders, contractors, merchants, and lesser fry into collaboration, bought influence with the state legislature, and ruled the courts. This was an issue made for the idealistic Nast, whose Protestant-Republican morality was partic-

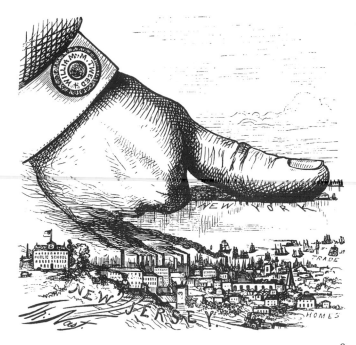

306

ularly incensed by the fact that the thieves were Democrats, and most of them Irish Catholics. In 1869, Nast and *Harper's Weekly* launched a courageous, single-handed campaign against the corrupt city bosses. Nast regarded Tweed and his cohorts as criminals and plunderers and pictured them as such, although there was little concrete evidence. His "Tammany Ringdom," depicting the mayor on the throne with Tweed and his henchmen as the powers behind it, was typical of his devastatingly effective conceptions. Some were done in broad cartoon style, but several were meticulous wood engravings, such as this one, drawn with closely packed lines and generous use of cross-hatching, Nast's trademarks.

Nast had an infallible ability to get swiftly to the heart of an issue. He drew a huge thumb pressing down on the city. "Well, what are you going to do about it?" is Tweed's own derisive reply to a mass

306. "Under the Thumb." Thomas Nast. 1871. 5x4¾. Wood engraving. From *Harper's Weekly*, June 10, 1871. Metropolitan Museum of Art, New York.

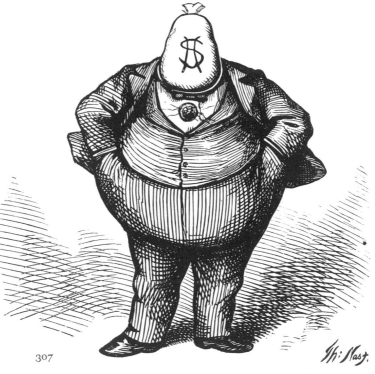

307

meeting that had denounced him. Another famous Nast symbol was "The Brains," a portrait of Tammany, with the body of Tweed and the head of a moneybag.

The increasingly effective campaign accelerated swiftly in July 1871, when *The New York Times,* which had joined the crusade, published evidence of fantastic invoice padding and other "municipal rascality."

Nast then drew a series of inspired graphic attacks that have become classics of American political satire. Tweed is reputed to have lamented, "I don't care what they print about me, most of my constituents can't read anyway—but them damn pictures!" When the details of the looting became public, Nast drew his famous "Who Stole the People's Money? Do Tell—'Twas Him," in which Tweed and his henchmen are standing in a ring and each points an accusing finger at his neighbor. When the mayor remarked that the scandal would soon "blow over," Nast followed with his classic and best engraving, "A Group of Vultures Waiting for the Storm to Blow Over." Tweed and his gang are pictured as vultures, huddled together on a storm-swept crag. Strewn at their feet are the skeletons of their victims—"justice," "law," "the treasury." Lightning has just struck a huge boulder which prophetically is about to crush them. Here Nast makes superb use of wood engraving. The fine line gave scope to his sharp eye for detail, while the spare highlighting accentuated the stormy atmosphere. Nast often cut the smaller blocks himself.

307. "The Brains." Thomas Nast. 1871. 5x4½. Wood engraving. From *Harper's Weekly,* Oct. 21, 1871. Metropolitan Museum of Art, New York.

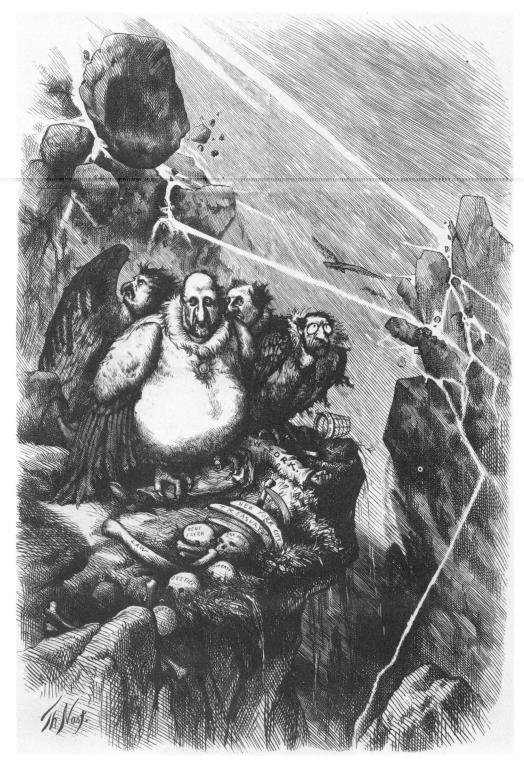

308

308. "A Group of Vultures." Thomas Nast. 1871. 13⅞x9¼. Wood engraving. From *Harper's Weekly*, Sept. 21, 1871. Library of Congress, Washington.

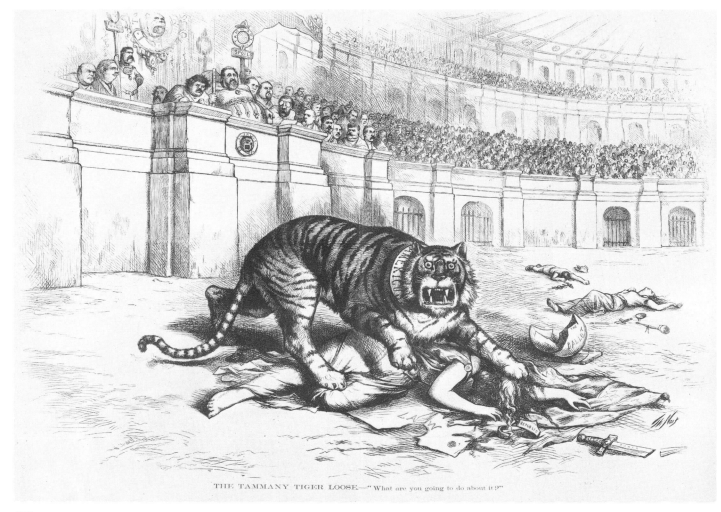

THE TAMMANY TIGER LOOSE.—"What are you going to do about it?"

309

Two days before the November elections, *Harper's Weekly* published six Nast cartoons attacking the ring. Included was probably the most effective political cartoon in the nineteenth century, "The Tammany Tiger Loose—What are you going to do about it?" The tiger mauls the prostrate Republic while the Tweed gang looks on.

The voters, stirred to a fighting pitch by Nast and the revelations in the *Times*, turned most of the Tweed ring out of office. Curiously, Tweed himself was reelected as

309. "The Tammany Tiger Loose." Thomas Nast. 1871. Wood engraving. 14¾x20¾. From *Harper's Weekly*, Nov. 11, 1871. Dick Fund 1928, Metropolitan Museum of Art, New York.

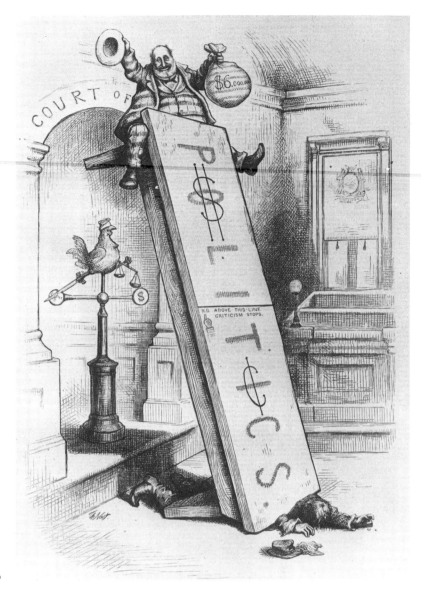

310

a state senator. Many of the defeated office-holders fled into exile, and Tweed was finally arrested, tried on felony charges, and sentenced to twelve years in prison. Released after serving only one year, he was rearrested on charges stemming from a civil suit which sought to recover $6,000,000 in stolen funds. Tweed escaped and fled to Spain where a Nast cartoon led to his identification and return for trial. Nast persisted with an inspired "Upright Bench" in which Tweed and his moneybag were shown riding high in the court. But the battle was done; on April 12, 1878, "Boss" Tweed died in his cell.

Nast's influence became nationwide. His

310. "Upright Bench." Thomas Nast. 1875. 13⅞x9¼. Wood engraving. From *Harper's Weekly*, Sept. 1, 1875. New York Public Library.

famous symbols, the Republican elephant, the Tammany tiger, and the Democratic donkey (which he popularized from a previous conception) became an integral part of the American political tradition.

For years Americans turned to Nast as their political mentor. He was often a constructive force; he made many notable drawings defending the rights of Chinese, Indians, and Negroes.

As a Radical Republican, he consistently attacked the Democrats' Negrophobia and the KKK's anti-Negro violence, upheld the Negro's right to vote and civil rights legislation to enforce that right. His "Patience on a Monument" was a tribute to the Negro's forbearance. In the late seventies, however, as the Republicans' concern for Negro rights diminished, Nast's commitment faded. He drew Negro voters unfavorably and labeled civil rights "A Dead Issue."

His insights were not always the sharpest. His worship of Grant as a war hero kept him loyal to the general through eight years of misrule in the presidency. His opposition to aid for parochial schools and other measures that would end separation of church and state were sometimes handled in such a way as to feed anti-Catholic prejudices. His masterful drawing, "Liberty Is Not Anarchy," approving the execution of the anarchist Haymarket Square leaders who were convicted after a bomb killed several policemen, reflected a naïveté about social forces and little or no understanding of the harsh conditions that were creating

a radical labor leadership. Although Nast's veneration of Grant made him the most powerful voice the Republicans had, his loyalty wavered as he became disillusioned with the party leaders. In 1884 he refused to endorse the Republican candidate because of the corrupt forces behind him.

Four years later, Nast and *Harper's Weekly* parted company. Public tastes were changing; lighter satire and the "joke," were supplanting the crusade. Society was becoming more complex, with giant industrial monopolies and trusts creating issues far more complex than city corruption. Nast free-lanced, hobnobbed with leading figures, and accepted honors. But as the political and social climate changed, his messages lost force and significance. His role diminished to the point where he was glad to accept the post of American Consul General in Ecuador, where he died. In his later years, Nast made many illustrations and several oil paintings, but he will be remembered for a small group of wood engravings. They stand with the best in political caricature.

In the eighties, *Harper's* had several rivals, notably *Puck*, founded in 1876 by Joseph Keppler (1838–94); the Republican-backed *Judge*, whose star was Bernard Gillam; and the frothier but eventually reformist *Life*. Keppler, Gillam, and F. B. Opper were capable satirists, but most of their comments were confined to the parochialism of national politics, and they were usually more amused than stirred by the political scene. Only occasionally did they

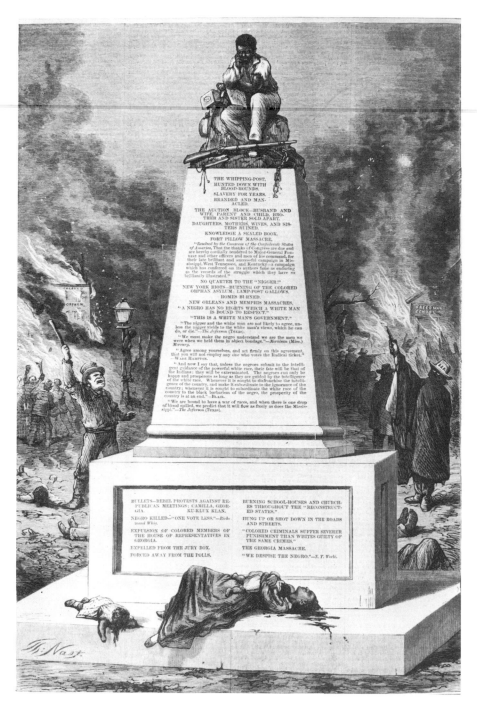

311

311. "Patience on a Monument." Thomas Nast. 1868. 13⅞x9¼. Wood engraving. From *Harper's Weekly*, October 10, 1868. New York Public Library.

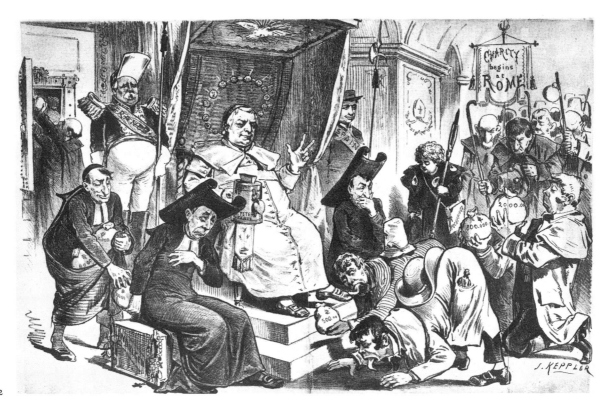

get below the surface of American life or touch upon world issues. The German-born Keppler is noteworthy. He drew directly on the stone, freely and loosely, in contrast with Nast's meticulously drawn wood engravings. It was Keppler who originated the now familiar whiskered version of Uncle Sam. His "The New Pilgrim's Progress" is slapstick in approach, unlike many of his carefully drawn and composed political subjects, but it has the quality of exuberant irreverence reminiscent of *La Caricature* in Paris and especially Raffet's antipapal barbs.

But even the few superior artists in the weeklies suffered from too-elaborate composition and too much detail. They lacked the incisiveness of Nast and composed tableaux rather than inspired, quickly grasped symbols. When the daily cartoon began to appear in the eighties and nineties—simple and forceful, if often crude, hasty and without form—the weeklies began to fade in their political influence.

The period of the seventies to the mid-nineties, when the weeklies flourished, was a time of swift economic expansion that brought turmoil, violence, and clash of warring interests. It was a time when the vast natural resources of the country were exploited and when powerful, ruthless trusts and monopolies developed in all the basic industries. The old, relatively intimate employer-employee relationship disappeared. It was an era when muscle counted. Between 1881 and 1905 there were 37,000 strikes, including bloody ones in the basic industries—railroads and steel.

312. "The New Pilgrim's Progress." Joseph Keppler. 1877. 12x18⅛. Lithograph. From *Puck*, June 1877. New York Public Library.

313

Little of this, however, was reflected in the graphic comment of the period. Occasionally, labor was attacked for the violence of the conflict. Commentators in this area were conservative; none reflected on the conditions which created the violence.

There was one theme that appealed to artist and public alike at the turn of the century—the frightening, all-pervasive power of the trusts. When the government initiated moves to regulate trusts, some of the graphic artists joined effectively in the attack on powerful monopolies and big business. One of the most popular satires was Keppler's "The Bosses of the Senate." A twist on Daumier's "The Legislative Paunch," it is even broader in its satire than Daumier's but lacks Daumier's plastic

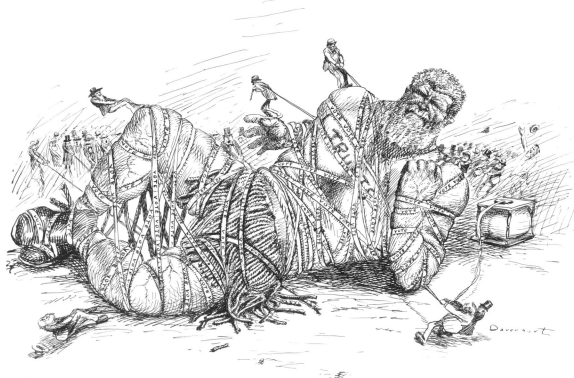

314

handling of form. However, it was the most effective of many attacks on trust influence in the Senate, where practically the entire leadership represented top-level social, industrial, or utility interests.

Two of the nation's most popular newspaper cartoonists, Homer Davenport (1867–1912) and "Tad" (Thomas A. Dorgan, 1875–1928), joined in the assault. Davenport, star of the Hearst newspapers, has the "little people" hamstringing the giant trust with their votes. "Tad's" contrast between the top-hatted, fur-coated industrialists and the wan, ragged working girl staggering along

"The Road to Dividends" was an astonishingly strong statement for a very popular, if acerbic, cartoonist.

Walter Appleton Clark's "The Boss" was not produced for a radical socialist newspaper. Its appearance in *Collier's Magazine* typified efforts of national-circulation magazines seeking to unveil the "invisible government" of machine politics. The muckraking exposés that shocked the country at the turn of the century were reflected in cartoons like these. However, there were no graphic artists of stature comparable to the group in France at the time, nor did any

314. "This Is the Day for the Little People." Homer Davenport. c.1900. 12¾x21½. Pen drawing. Library of Congress, Washington.

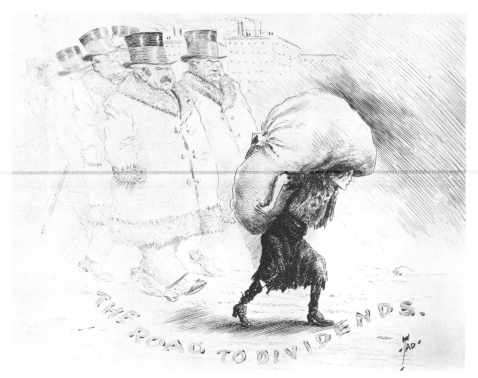

315

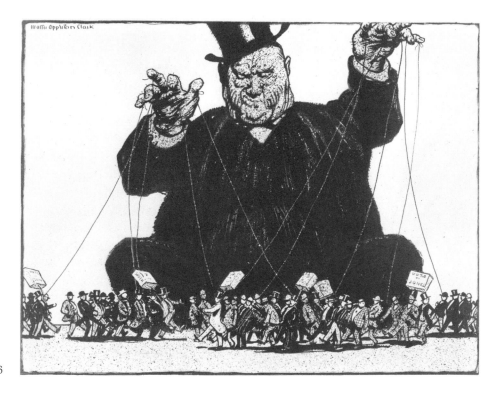

316

315. "The Road to Dividends." Tad (Thomas A. Dorgan). Drawing. Library of Congress, Washington.

316. "The Boss." Walter Appleton Clark. 1906. Pen drawing reproduced from *Collier's Weekly*, Nov. 10, 1906.

317

318

of the caricaturists have any philosophical or emotional ties to the labor movement, as they did in France.

As the nineteenth century faded, the United States became infected with a war fever brought on by champions of jingoism and expansionism. Cartoonists helped newspapers whip up enthusiasm for the Spanish-American War and the new imperialism which led to acquisition of the Philippines. Surprisingly, one of the few publications which consistently satirized the jingoistic spirit was *Life*, whose strongest satire in its early years had been a gentle ribbing of women's fashions. It still had its share of he-she jokes, gossamer-thin humorous stories, standard cartoons, Gibson girls, and a sprinkling of anti-Semitic and anti-Negro cartoons, but its forceful drawings by William H. Walker (1871–1938), Hy Mayer (1868–1954), Frederick Thompson Richards (1864–1921) and others strongly opposed the militaristic spirit and imperialism, spoke up for the rights of the Indians, and identified with the Filipino insurgents rather than with the American troops.

Walker bucked the currents of hysteria consistently and courageously. Too literal in his conception, too precise in his drawing, he could have benefited from a freer style. Nonetheless, he was far superior to most of his contemporaries, both in draftsmanship and thoughtful content.

"Our Expansive Uncle" displays an exceptional freedom of form as Uncle Sam dances happily with Death. The figure of Uncle Sam, particularly, has a plasticity

317. "Our Expansive Uncle." William H. Walker. 1899. Reproduced from *Life*, Dec. 28, 1899. New York Public Library.

318. "White Man's Burden." William H. Walker. 1899. Reproduced from *Life*, March 16, 1899. New York Public Library.

319

and flowing movement that indicate Walker's potential. "White Man's Burden" suffers from diffuseness but is nevertheless a classic comment on colonialism. In 1902, when muckrakers were first baring the enormous gaps between rich and poor,

Walker revealed a broadly satirical side with his irreverent "Fortune Favors the Few." The pompous boss, swollen with pride, adds a magnificently farcical touch to an inspired conception.

During the first decade of this century,

319. "Fortune Favors the Few." William H. Walker. 1902. Reproduced from *Life*, Oct. 16, 1902. Library of Congress, Washington.

320

the contradictory *Life* continued to sprinkle among its frothy cartoons and lightweight humor occasional muckraking pieces that attacked the meat packers, the railroads, and the trusts. The editor even let Art Young (1866–1943) jab at capitalism itself. Young brought a new element to *Life*'s pages—social rather than political satire. The genial Young either drew people simply, with humanity, or dealt with symbols—plutocracy or capitalism. His most striking drawing for *Life* was his satire on respectability, "The World of Creepers." It was one of the few drawings Young ever made that lacked a touch of gaiety.

But *Life*'s attacks were peripheral and incidental. Its editorial policies were disparate and its political satire commingled with a mixed bag of trivia. Only in *The Masses* did the United States have a full-

320. "The World of Creepers." Art Young. Reproduced from *Life*, Nov. 14, 1907. Library of Congress, Washington.

SERENE ON-LOOKER: (To The Striker)—"VERY UNFORTUNATE SITUATION, BUT WHATEVER YOU DO, DON'T USE FORCE."

1

than a Marxian socialism, and a release from the cultural, social, and sexual restrictions of the Victorian age. It was a readable, attractive potpourri of art, literature (especially poetry), and propaganda. The poet Genevieve Taggard, herself a contributor, said of *The Masses* editors, "It was their combination of sophistication and naïveté that made what they said so hard to resist."

The art was taken seriously, although it was not always serious art. Artists sat on the board of editors; some of them fought against having political captions added to their work. All of their work was well displayed. Many of America's leading artists of the first quarter of the twentieth century made drawings—without pay—for *The Masses*, including John Sloan (1871–1950), Boardman Robinson (1876–1952), George Bellows (1882–1925), and Stuart Davis (1894–1964). Under the editorship of Max Eastman, poetry, reportage, and short stories by Sherwood Anderson, Floyd Dell, Louis Untermeyer, Amy Lowell, John Reed, and Carl Sandburg appeared in its pages.

In its earlier years, the pages of *The Masses* teemed with the class struggle—hardly surprising in view of the amorphous dreams of "the revolution" and the brutal realities of the Paterson silk strike and the Ludlow Massacre. Art Young's "Serene On-Looker" is typical of the artist's easy, often superficial line. Young, an unwavering socialist, varied his style little as he contributed to various radical magazines—as well as to "respectable" ones—and drew

fledged magazine of social protest in which editorial content and art joined in radical assault upon the social and political structure.

From 1911 until it ended in 1917, when five of its editors were indicted under the Espionage Act, *The Masses* represented a joyous crusade for social, artistic, and political radicalism, urging a utopian rather

321. "Serene On-Looker." Art Young. Reproduced from *The Masses*, March 1913. Columbia University Library, New York.

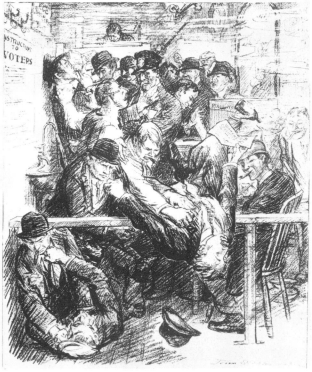

323

322

a few classic, hilarious cartoons. John Sloan's "Ludlow, Colorado, 1914" offers a glimpse of the humanity and quick eye for incident which already distinguished his prints and paintings. It was based upon the Ludlow Massacre in which troops shot up a tent city of striking miners and their families, killing many. Sloan reacted almost viscerally to injustice and violence, as in his "Political Action" and the post-*Masses* drawing, "State Police in Philadelphia." The black-and-white heroics seem melodramatic and dated today, but they are understandable in the light of the crude vio-

322. "Ludlow, Colorado, 1914." John Sloan. 1914. Reproduced from *The Masses*, Oct. 1914. Library of Congress, Washington.

323. "Political Action." John Sloan. Reproduced from *The Masses*, Jan. 1913. Library of Congress, Washington.

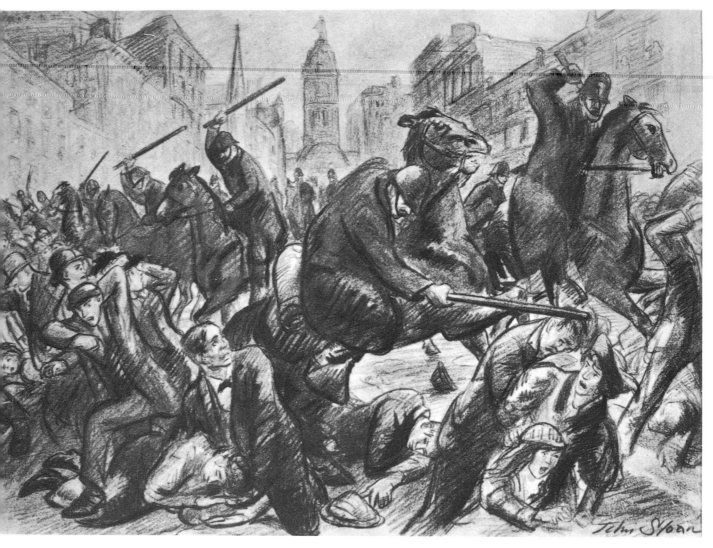

4

lence to which he was reacting. The Ludlow incident was indeed a massacre; strikers *were* assailed by police, and reformers and radicals who attempted political action were often unceremoniously beaten up. Today the artistic statement would proba-

324. "State Police in Philadelphia." John Sloan. 21x30. Crayon drawing. Private collection.

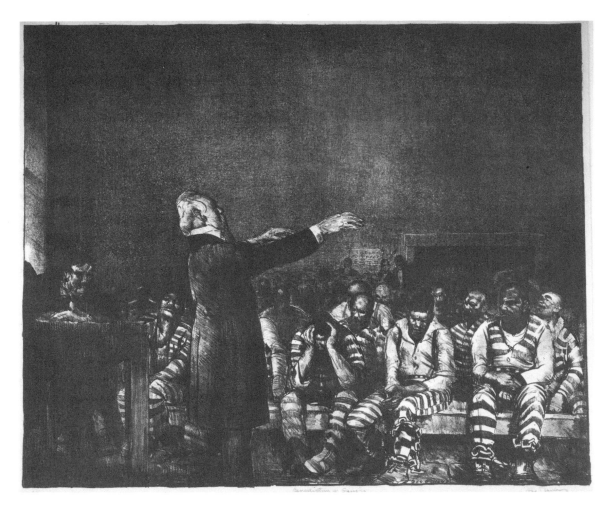

325

bly be less explicit. But Sloan was a realist, trained in newspaper work, and he drew or painted realistically. These drawings of Sloan indicate the limitations of emotional involvement without selectivity.

On one subject, the Negro, *The Masses* editors were equivocal. Along with passionate attacks on lynching and powerful fiction or reportage on the Negro's conditions in the South, *The Masses* ran cartoons of the Negro as a stereotype, and naïvely expressed astonishment when readers chided them. Occasionally, cartoons or drawings protesting white supremacy appeared, but the only art of distinction on this subject was George Bellows's "Benediction in Georgia," which he later made into a lithograph. It is a wry comment on the hypocrisy of the blessing being given to prisoners. The convicts' faces are understandably expressionless, and the parson is obviously not even convincing himself.

A few years later, Bellows drew as a magazine illustration a stirring visualization of a lynching. It was deliberately undramatized, the horror enhanced by the

325. "Benediction in Georgia." George Bellows. 1917. 16x20. Lithograph. *The Masses*, May 1917. Leonard C. Hanna, Jr., Collection, Cleveland Museum of Art.

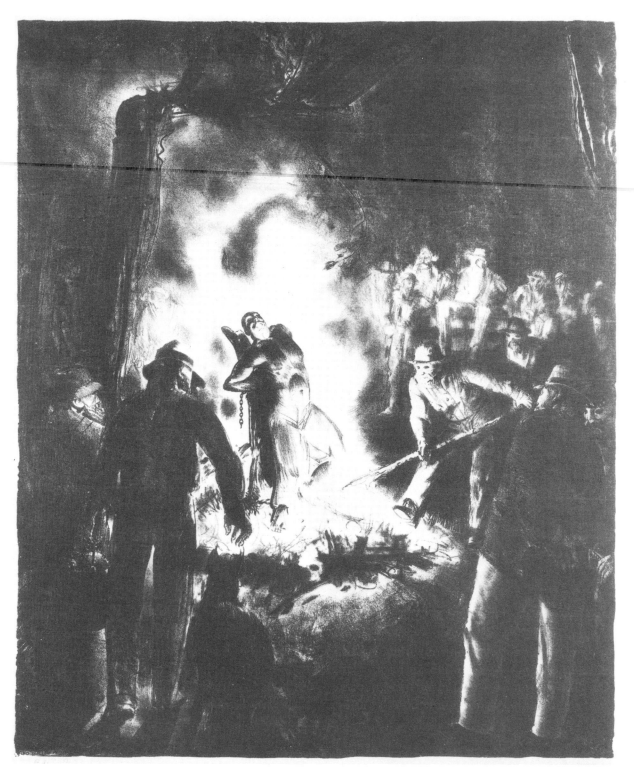

326

326. "The Law Is Too Slow." George Bellows. 1923. 17¾x14½. Lithograph. The Art Institute of Chicago.

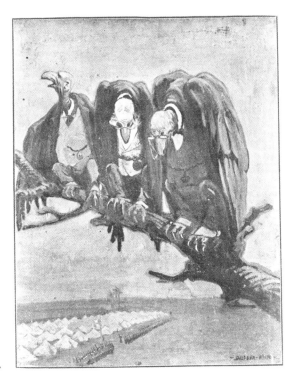

327

unmoving and unmoved participants. Bellows's love of shadows and dramatic lighting is employed to the full here, as in some of his famous boxing lithographs and paintings.

Bellows, a genial athlete, loved the world of boxing, as well as the noise and color of city streets, the waterfront, and the bars. He was an exuberant associate of the Ash Can Group of artists, and his zest spilled over into his work. Although he was an excellent draftsman and lithographer, his work was often shallow.

Sloan often quarreled with the editors of *The Masses* over attaching political labels to nonpolitical work. He resigned in 1916 when the controversy among staff members over World War I grew bitter. Many conservative socialists swung around to supporting the war, but *The Masses* remained steadfast. The editors' attitude did not change from that reflected in a prewar (1912) *Masses* drawing by William Balfour Ker, "The Beneficiaries of War." In their prescient view, only bankers and other "vultures" gained from war. Robert Minor's "At Last a Perfect Soldier!" may lack the macabre incisiveness of Grosz' treatment of a similar theme, but it has its own power, and it became the forerunner of many imitators. Minor's use of crayon, with ease of stroke and shading for bold effects, was also imitated later by several radical artists. Minor, who had been a cartoonist on the St. Louis *Post-Dispatch* and on the New York *World,* stayed on with the suc-

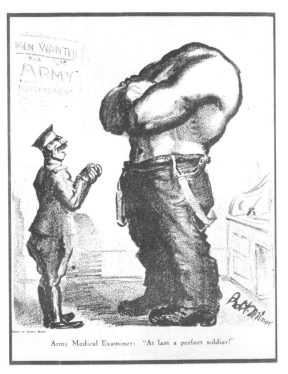

Army Medical Examiner: "At last a perfect soldier!"

328

327. "The Beneficiaries of War." William Balfour Ker. Reproduced from *The Masses,* Aug. 1912. Library of Congress, Washington.

328. "At Last a Perfect Soldier!" Robert Minor. Reproduced from *The Masses,* July 1916. Library of Congress, Washington.

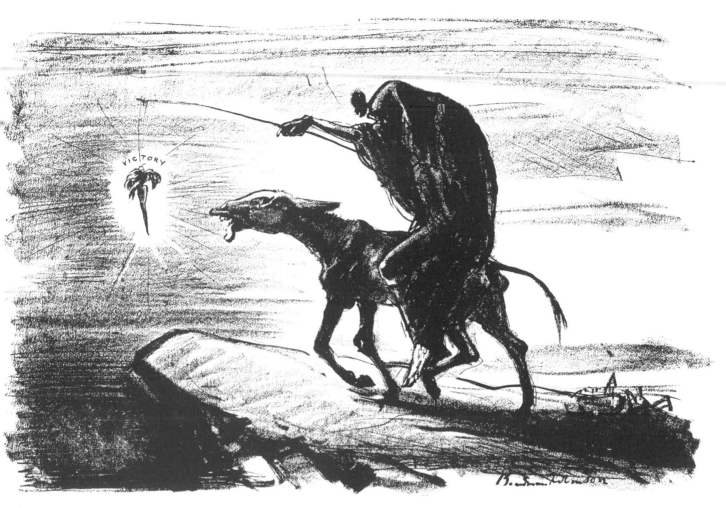

329

cessor to *The Masses—The Liberator—*and its successor in turn, *The New Masses.*

Boardman Robinson's Daumier-like "Victory, 1916" expressed the editors' feelings about the mirage of "victory" and the absurdity of each nation's claim to divine sanction. The drawing does not have the full bravura quality that distinguished much of Robinson's work, but the conception is solid and the drawing sure.

The Masses editors resisted the preparedness drive and fought to the bitter end

329. "Victory, 1916." Boardman Robinson. 1916. Reproduced from *The Masses*, Oct. 1916. Columbia University Library, New York.

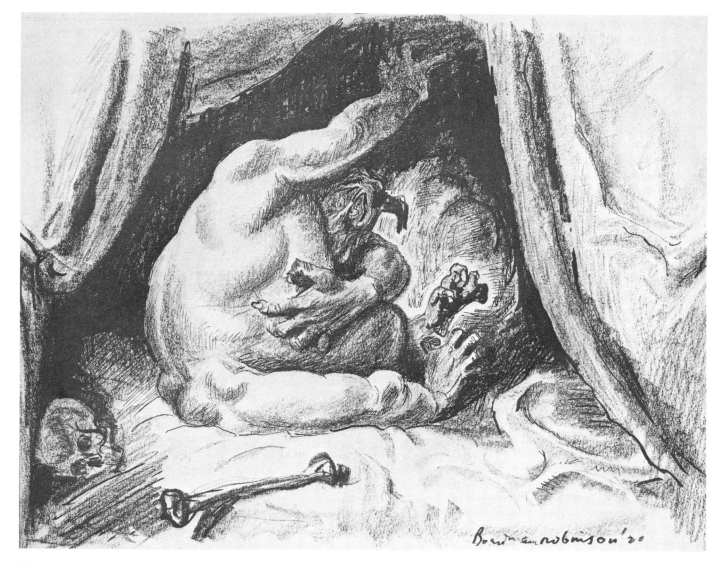

330

330. "The System Investigates Itself." Boardman Robinson. 1921. Reproduced from *The Liberator*, March 19, 1921. Columbia University Library, New York.

against the war, even after America's entrance. But in August 1917, the post office withdrew the magazine's mailing privileges, and by the year's end the magazine folded when five of the editors were indicted (but never convicted) under the Espionage Act—partly because of antiwar drawings by Art Young and Henry J. Glintenkamp.

In March 1918, the editors launched *The Liberator*, owned by Eastman and his sister. Under Eastman's direction, *The Liberator* was more moderate on the war and somewhat more disciplined in editorial approach. In the beginning, however, the art was nearly the same. Boardman Robinson's "The System Investigates Itself" certainly reflects no retreat. Robinson was referring to the convenient arrangement by which Congressional investigations of such industries as meat packing and shipping were often dominated by senators or congressmen subservient to those very industries. Much more than in "Victory, 1916," this drawing shows Robinson's élan, his sure line that holds the form firmly, with depth and tone. Robinson drew with spontaneity and often, whether it was political cartoon or mountain landscape, with passion. The buoyant, zestful Robinson was one of the most attractive of *The Masses* figures, perhaps the closest to Art Young in temperament and political attitude. Basically unpolitical, he had a compassion for the needy. Stimulated in part by a year's experience with the Association for the Improvement of the Poor, he showed a con-

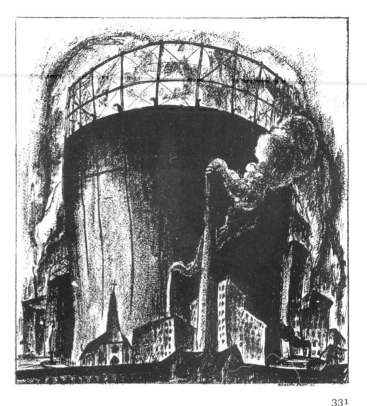

331

tempt for pomposity and hypocrisy and had an instinctive distrust of those in power, whether in government or industry.

Occasionally he overreached himself in his drawings and murals. As his friend Adolf Dehn (1895–1968) pointed out, Robinson was "the greater artist and more heroic" when he tried less hard to be great and heroic. Dehn contributed to *The Liberator* an effective comment on the gasoline domination of American life and countryside, "The Petroleum Age," all the more convincing because of its restraint. Dehn spent most of the twenties as an expatriate

331. "The Petroleum Age." Adolph Dehn. Reproduced from *The Liberator*, July 21, 1921. Columbia University Library, New York.

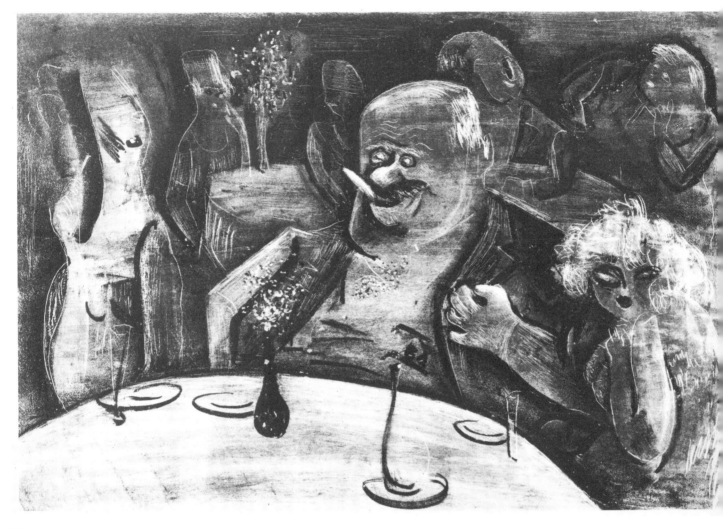

332

in Europe and returned as a consummate caricaturist and landscapist. "All for a Piece of Meat" is typical of his witty, sharply satirical lithographs of the "upper classes," whom he pilloried during the thirties in *The New Masses*.

After an excess of editors (the Eastmans left in 1922) and a dearth of funds, *The Liberator* in 1924 was turned over to the Communist Party which merged it with two other publications into *The New Masses*. In 1934, it became a weekly and

332. "All for a Piece of Meat." Adolph Dehn. 1928. 8x11½. Lithograph. Brooklyn Museum, Gift of Mrs. Albert de Silver.

was no longer officially connected with the Communist Party. For a quarter-century *The New Masses* combined strident propaganda with occasionally brilliant reportage and comment. It lacked the broad political spectrum and the single-minded innocence of the old *Masses* and the remarkably high level of its predecessors' contributors, but it endeavored to maintain the tradition of quality art. Many of the contributors, both writers and artists, were not Communists. This was especially true during the "Popular Front" days of the thirties. *The New Yorker* artists occasionally provided satirical cartoons; sometimes decorative, nonpolitical art appeared. Unhappily, the butcher paper on which the magazine was printed marred most reproduction.

Although many capable artists contributed to *The New Masses*, relatively little of their output is of artistic relevance today. There was good reason why so much of it was ephemeral; art that is war propaganda usually has little lasting significance. The editors, in a sense, were in a war—a war against a society that was failing to meet the needs of its citizens, against the threat of fascism, and against the threat of a new world war. In the agonized thirties, unemployment at one point reached twelve million; some people literally starved or ate from garbage heaps, and many slept in parks or shantytowns; breadlines were part of every city's life; and hundreds of thousands of Americans roamed the country on foot or freight rod, seeking jobs. No social security existed during half the Depression; only inadequate "relief" stood between many and starvation. Labor's efforts to organize the mass industries, eventually successful, were met at first with ferocious violence. War clouds threatened constantly to burst over a harried world. Italy's fascism was now joined by a militant Nazism. The Spanish war made it clear that no country was safe from an expanding fascism.

It is not surprising that much of the art in *The New Masses* was exhortatory and in a "war propaganda" mold. Although the artists were often very capable, and many later developed considerable reputations, most of their art was of short-lived interest. However, it would be a distortion to assume that all protest art in *The New Masses* during the thirties was one prolonged cliché. The following trio of drawings from its pages indicates that style was not always overwhelmed by content.

John Mackey often graced the magazine in the mid-thirties with elegant line. His "People's Court" has strong design, and the impact is sharpened by the white gleaming out of the pitch-black background, reminiscent of the false, over-dramatic staging of Nazi spectacles.

Mitchell Siporin (1910–) did a series of eight drawings on the Haymarket Square meeting of 1886 which erupted in a bomb-throwing and the eventual execution of four anarchists. "The Meeting on the Haymarket" is a forceful, tightly composed handling of a subject usually treated with a deadening banality.

During the thirties Boardman Robinson

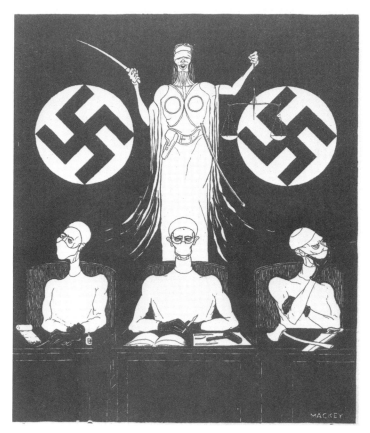

333

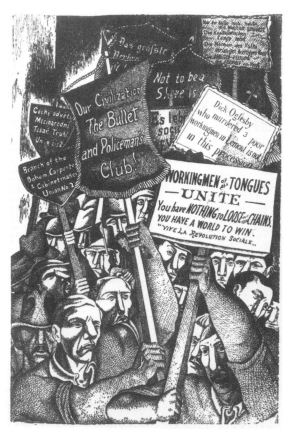

334

333. "The People's Court." John Mackey. Reproduced from *The New Masses*, July 30, 1935. Columbia University Library, New York.

334. "The Meeting on the Haymarket." Mitchell Siporin. Reproduced from *The New Masses*, May 7, 1935. Columbia University Library, New York.

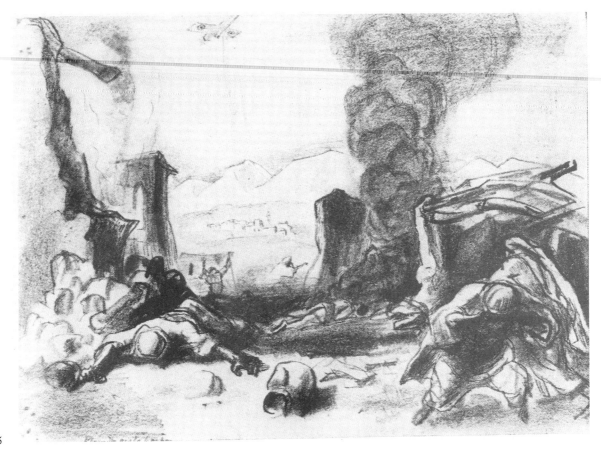

335

taught art in Colorado and painted murals. One of his drawings, "The Civilizer," published in *The New Masses* in 1936, indicated that he had lost none of his sensitivity to the events of his time. The composition is beautifully handled; the drawing has a painterly quality.

William Gropper (1897–) was the star satirist in *The New Masses* galaxy. A student of Robert Henri and George Bel-

lows, Gropper frequently drew cartoons for *The Liberator*. They were lively, funny, and full of zest. A natural draftsman and superb satirist, Gropper seemed to take sheer delight in swinging at the Establishment. With crayon or brush or both, his strokes crackled with vivacity and tension. His line was invariably exclamatory. In *The New Masses*, however, Gropper's cartoons became more somber, more shrill, and oc-

335. "The Civilizer." Boardman Robinson. Reproduced from *The New Masses*, May 12, 1936. Columbia University Library, New York.

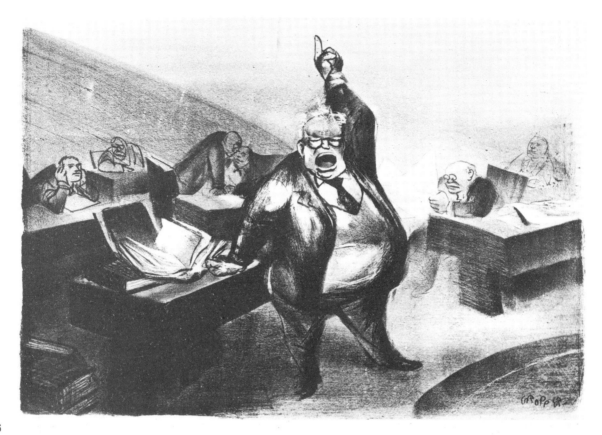

336

casionally even routine. Perhaps life in the depressed thirties was too serious; the feeling that art was at war was undoubtedly inhibitory.

Gropper was and is a consummate satirist who has created some memorable work. "The Speaker," based on his painting, is perhaps his best known. Like Gropper's bloated plutocrat, his windy senator is drawn with contagious gusto, the pulsating

dynamism of his figure in delightful contrast with the immobility of his dozing colleagues.

"Farmers' Revolt," done in brush, is like a Japanese print and has the formal quality of a charade. It is an inspired conception of what in other hands could have been a conventional political cartoon—farmers rising up against the National Recovery Administration, better known as the NRA (of

336. "The Speaker." William Gropper. Before 1942. 11½x17. Lithograph. Dick Fund 1942, Metropolitan Museum of Art, New York.

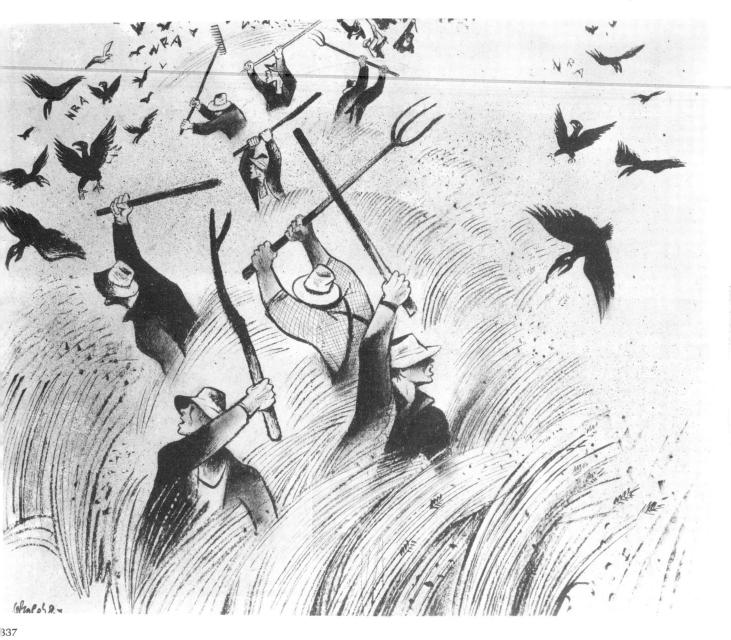

337. "Farmers' Revolt." William Gropper. 1933. 16x19. Ink drawing. Whitney Museum of American Art, New York.

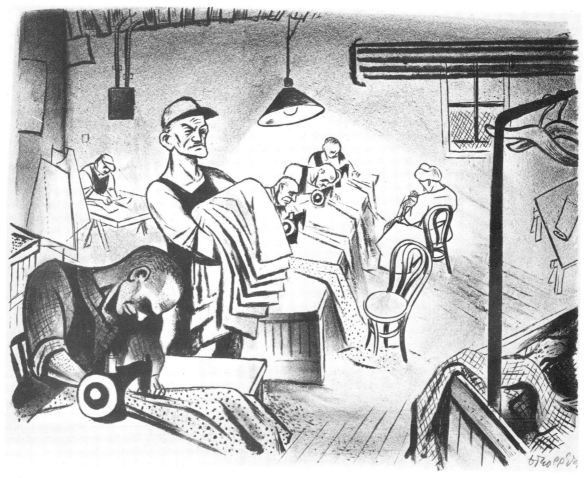

338

which the eagle-now-vulture was the symbol). "Sweatshop," also could have been a cliché of protest. Gropper hated the sweatshops in which his mother worked when he was growing up in New York's lower-eastside slums. He makes his protest so much more effective by indirect statement—by the weary stance of the figures as they hunch over their piecework, by the dreary nakedness of the setting, and by the overall grimness.

Miserable as the sweatshops were, they at least represented some sort of employment. Reginald Marsh (1898–1954), who

338. "Sweatshop." William Gropper. No Date. 9⁹⁄₁₆x12⅛. Lithograph. Gift of the Junior Council, Museum of Modern Art, New York.

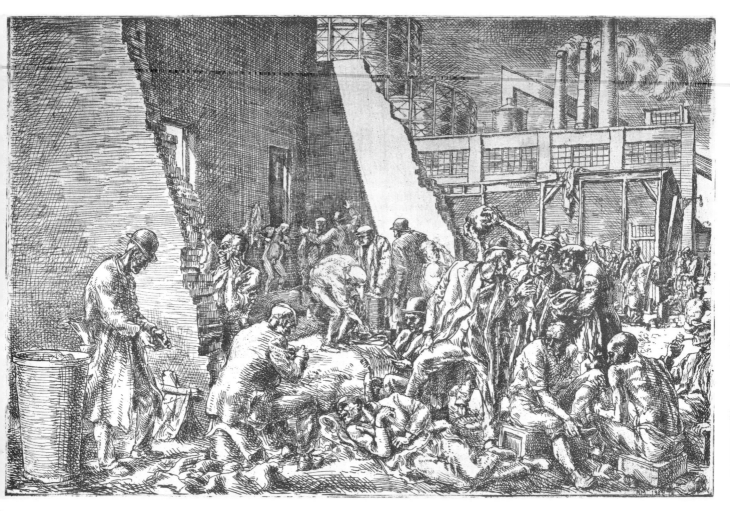

339

roamed the streets of New York endlessly
sketching the swarming humanity, has cap-
tured the frightening makeshift existence
of the unemployed in two memorable etch-
ings, "The Jungle" and "Breadline—No One
Has Starved." In both cases, the sharp bite

and thin line of etching were ideal for
Marsh's objective. Perhaps "The Jungle"
swarms with too much humanity; Marsh's
love of profuse detail trapped him into lack
of focus. But for all its weaknesses, it is an
unforgettable picture on a theme attempted

339. "The Jungle." Reginald Marsh. 1934. 7¹⁵⁄₁₆x11⅞. Etching. Prints Division, Astor, Lenox and Tilden Founda-
tion, New York Public Library.

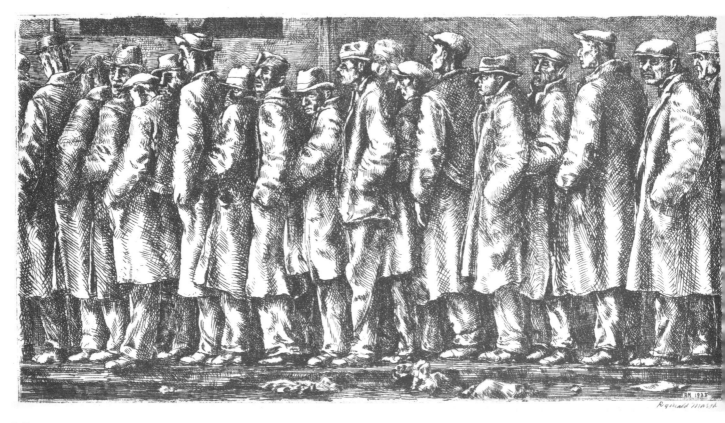

340

unsuccessfully by dozens of artists in the thirties who permitted their work to overflow into pathos. In his bitterly titled "Breadline—No One Has Starved," the highlighting accentuates the shabbiness of the men's coats, and the regularity of the line emphasizes the uniform bleakness of their lives. Will Barnet (1911–) also succeeds in forcing the viewer to share the wracking despair of a man with powerful but idle hands.

Just as German artists banded together in 1919 to make common cause, American artists assembled in 1936 in a broad coalition of diverse talents and political views—from the Communists to the nonpoliticals

—to form the American Artists' Congress against the threats of fascism, war, and depression. By the end of the year more than 600, including most leading artists, had joined. They were able to survive mainly by the $23 a week paid by the Federal Arts Project, and even that payment was uncertain. When sharp cuts were threatened in the Project, 219 artists invaded the Works Progress Administration (WPA) offices in protest. Philip Evergood described what happened: "They beat me insensible, but just because I was standing in the front line and refused to ungrip my arms with the others around me, and refused to leave the building. My nose was broken, blood

340. "Breadline—No One Has Starved." Reginald Marsh. 1932. 6⅜x11⅞. Etching. Prints Division, Astor, Lenox and Tilden Foundation, New York Public Library.

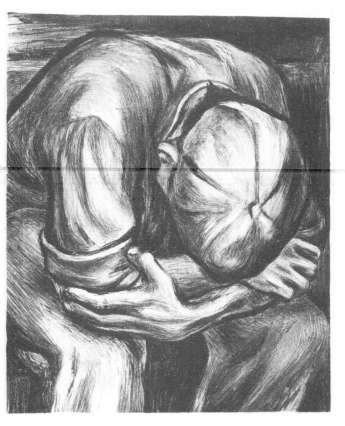

341

Anton Refregier, Robert Gwathmey, Joseph Hirsch, Jack Levine, Hale Woodruff, Charles White, and Jacob Lawrence. "There was no dearth of talent among all these painterly consciences, white and black, old-timers or new-comers," Larkin wrote. "What they seemed to lack was time for the event to ripen in their minds, for the image to gather about itself richer implications and deeper human meaning." In the work of Ben Shahn and Philip Evergood, Larkin saw the additional essential element of maturity.

Among other activities, the American Artists' Congress encouraged the production and distribution of prints—the ideal medium for "messages"—as did the Federal Arts Project, which had many members of the Congress. Thousands of prints were created under the aegis of the Project. The most notable were the silk-screen color prints in which the project pioneered. Surprisingly, relatively little of the content was direct social protest (perhaps it would not have been discreet to attack society directly while on a federal payroll). In addition to the conventional subjects, ranging from atrocious to excellent, there was considerable oblique social comment on cityscapes, mining town scenes, and workers in mines or in industry. Most of these indirect statements had the uniformity of a cookie cutter. It was the age of the heroic worker, bigger than life.

The non-Project prints of the period included a great deal of social criticism. Unfortunately, to quote Oliver Larkin again,

was pouring out of my eyes, my ear was all torn down, my overcoat had been taken and the collar ripped off . . . they put us in cells where the toilets had overflowed and we were standing, ankle deep, men and women, all night in that filth. We were tried *en masse*, and escaped with a warning."

It is not surprising that social protest should replace regionalism as the dominant trend in American art. Although this trend had its obvious limitations, some noteworthy paintings and murals with social themes were produced. Art historian Oliver Larkin in reviewing the period cites particularly the paintings of Gropper, George Biddle, the Soyer brothers, Peter Blume,

341. "Idle Hands." Will Barnet. 1936. 14x11¾. Lithograph. Courtesy of the artist.

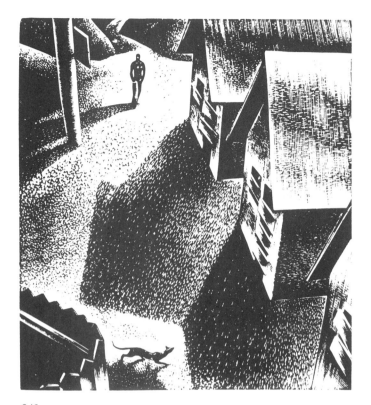

342

the urgency of the situation "produced the violently obvious rather than the thoughtfully original." In no other period of American history was graphic protest so universal, so intense, so "respectable," as in the agonized thirties, yet so little of it carries a compelling artistic message to the viewer today.

There were several reasons for this. As previously noted, the art was often horta-

tory. Today our taste is more sophisticated; we see grays among the blacks and whites. Many of the best artists of the period were engaged in murals or painting rather than printmaking. Also, many artists proceeded from the point of view of a newly discovered, often ill-digested Marxism. When content is planned within a rigid framework of assumption, it is very likely to suffer. But it is easy to exaggerate this factor. "Social realism" does not automatically have to be a cliché, either in content or execution. Perhaps many artists were so emotionally involved—at times even physically involved—in the desperate struggle for decent living conditions for themselves and for others that they lost the touch of cool detachment. In the best of circumstances, protest art is successful only when form, technique, and content are all effectively fused in a clearly conceived vision. Under the pressing political and social conditions of the thirties, when hunger, brutality, the threat of fascism were day-to-day realities, it is not surprising that this fusion was rare.

Lynd Ward (1905–) managed to convey the dull regularity, the tensions, and the emptiness of life in a company town without using the clichés of gaunt children or miners standing listlessly outside broken-down shacks. In a night setting, with only a lone man and dog in sight, Ward's wood engraving dramatizes the spiritual isolation, the unspoken terror, the void of life in a community owned by an abstract, absent corporation. Ward's creation was one of

342. "Company Town." Lynd Ward. 1932. 5x4½. Wood engraving. From *Wild Pilgrimage,* 1932. Prints Division, Astor, Lenox and Tilden Foundation, New York Public Library.

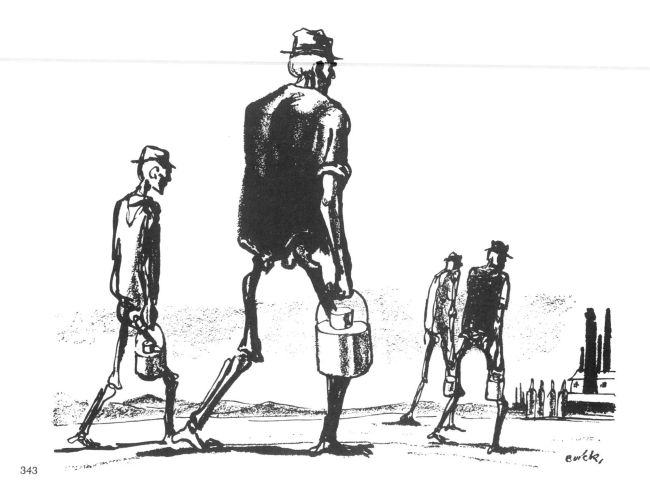

343

100 prints exhibited simultaneously by Congress in 30 cities. Among the titles were "Civilization at the Crossroads" and "It Can't Happen Here," and subjects included scenes of mining towns, faces of miners and Negroes, apple sellers, men on a bench, and Depression dust bowl towns.

Jacob Burck's vigorous exhortations against war and fascism were usually simplistic in concept and handling, but occasionally he created a striking drawing, as in "Half Time," a Daumier-like vision.

343. "Half Time." Jacob Burck. c.1932. From *The Daily Worker*, reprinted in *Hunger and Revolt: Cartoons by Burck*, New York. 1935. Prints Division, Astor, Lenox and Tilden Foundation, New York Public Library.

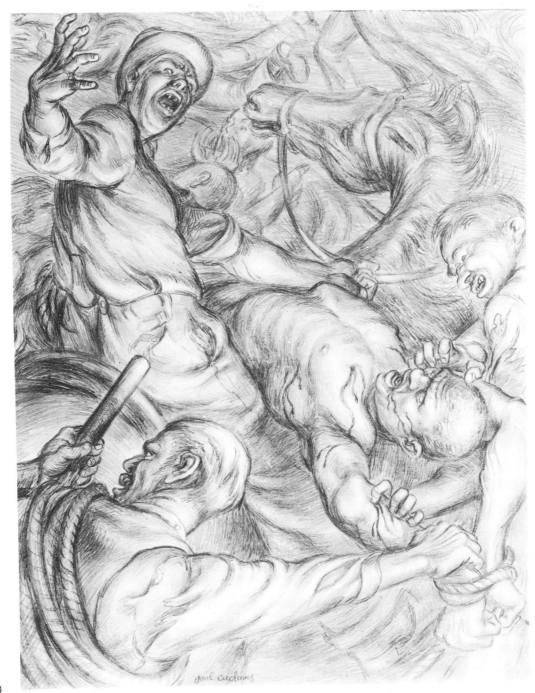

344

344. "To the Lynching." Paul Cadmus. 1935. 20⅜x15⅞. Pencil and Chinese white on buff paper. Whitney Museum of American Art, New York.

345

Lynching was another "popular" subject, with the drawing often far below the purpose. In Paul Cadmus' "To the Lynching," the insane brutality has the swirling turbulence of a violent storm at sea. You are there, unforgettably, in Cadmus' drawing, reminiscent of scenes in Callot or de Hooghe.

American graphic artists were particularly vehement in their hatred of the Italian and German dictators who banned or imprisoned their colleagues, but their indignation often outran their creative selectivity. Peter Blume's pencil study "Jack-in-the-Box" was one of the exceptions. In a preliminary study for his "The Eternal City," Blume effectively used surrealist allegory to make his political point.

345. "Jack-in-the-Box." Peter Blume. 1933. 10⅛x7⅛. Pencil drawing. Mrs. Simon Guggenheim Fund, Museum of Modern Art, New York.

346

348 346. "Libertad." Arthur Szyk. 1944. 13½x10½. Pencil and ink drawing. From *PM*, Aug. 20, 1944. Private collection.

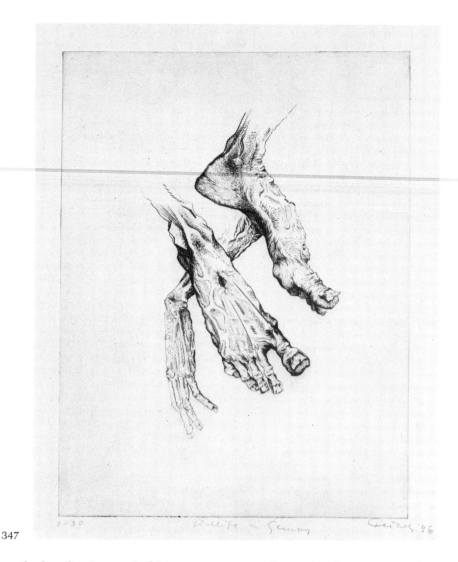

347

Not until the forties and fifties were American artists—interestingly, most of them foreign-born—able to go beyond the "violently obvious" and effectively transmit that fascism was a betrayal of mankind. With infinite detail and lines drawn with a jeweler's precision, Polish-born Arthur Szyk (1894–1951) assailed the dictators in a series of exquisitely delineated satires, treating the men like figures in a folk tale. In "Libertad," Simon Bolivar, the Latin American liberator, looks down on Hitler, Franco and two South American fascist allies who betrayed their heritage. The dictators parade through a Gothic landscape.

Shortly after the war, Hungarian-born Gabor Peterdi (1915–) harked back to Dürer and Grünewald in his "Still Life in Germany," a classic line engraving in the Gothic tradition that either repels or deeply moves the viewer. The gnarled feet and hand have an eloquence and haunting imagery far beyond the unsubtle horror of more direct images. Peterdi fought in the

347. "Still Life in Germany." Gabor Peterdi. 1946. 12x8⅞. Line engraving on copper. Brooklyn Museum, Gift of the Artist.

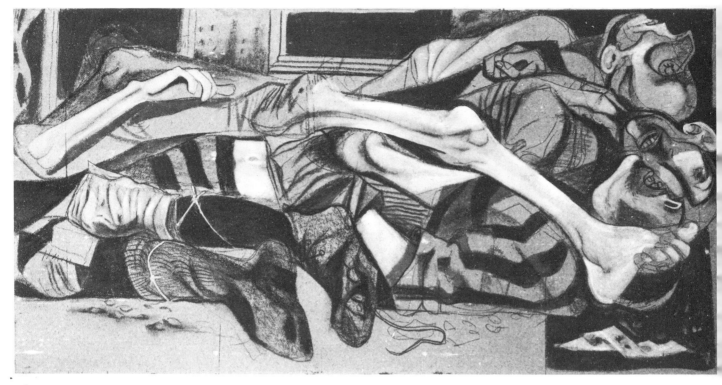

348

American army during World War II, an experience that deeply affected his work. A leading printmaker and a master of technique, the brilliantly versatile Peterdi today creates mostly abstract color forms and designs based upon elemental forces in nature.

To Italian-born Rico Lebrun (1900–64) the carnage heaps of Buchenwald epitomized the madness that was Nazism. One of the greatest of contemporary draftsmen, Lebrun executed a series of drawings that distilled his impressions from photographic documentation of the Buchenwald concentration camp. "After having gone through days of absorbed and almost hallucinatory recording of these awesome fragments," he wrote, "I remember wanting to brush the whole thing away from me: the draftsman made their sight unbearable to me as a man—a just price to pay." Out of the bodies and bones, Lebrun has wrought designs of magnetic power. The centripetal force of "Floor of Buchenwald #1" and the horror of peering into "Buchenwald Pit" stand stark and accusing—"a just price to pay" for

348. "Floor of Buchenwald #1." Rico Lebrun. 1957. 48x96. Casein and ink drawing. Collection of the artist.

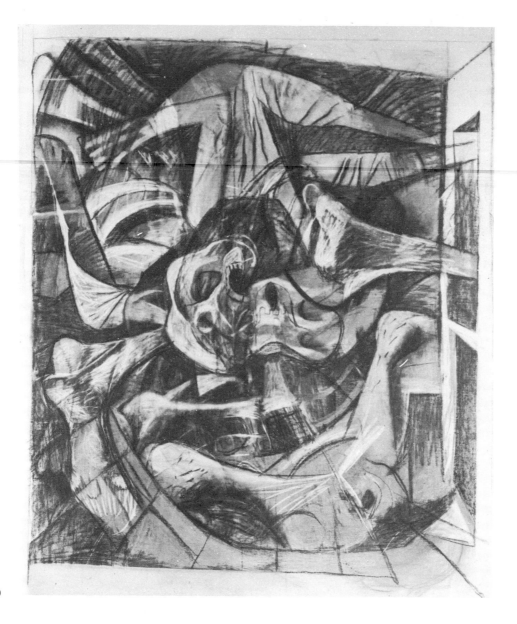

349

all viewers. Lebrun was always compassion-
ately involved in mankind's self-immolatory
impulses, most notably expressed in his
"Crucifixion" and "Goyescas" series. As
James Thrall Soby remarked before Le-
brun's death, "His protests against man-
kind's brutality are never overly satirical,
but they remain a terrible indictment of
those whose cruelty, dissemblance, and
corruption have caused the scars of this
and earlier times."

For five years Argentine-born Mauricio

349. "Buchenwald Pit." Rico Lebrun. 1956. 98x80¼. Charcoal drawing on canvas. Collection of the artist.

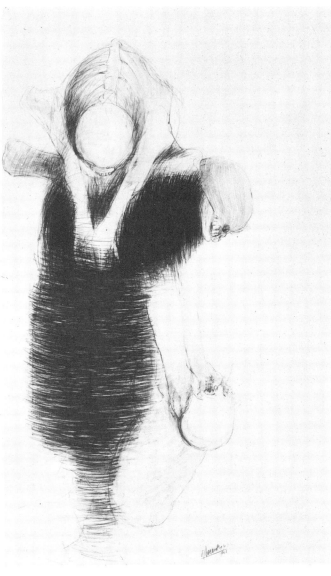

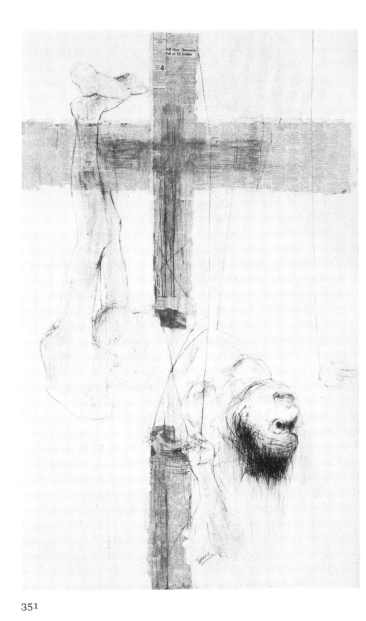

350

351

Lasansky (1914–), master printmaker and influential teacher of the graphic arts, labored to produce the definitive artistic indictment of the Nazi era. "Man's dignity is a force and the only modus vivendi by which man and his history survive. When mid-twentieth century Germany did not let man live and die with this right, man be-

came an animal," Lasansky declared. "No matter how technologically advanced or sophisticated, when man negates this divine right he not only becomes self-destructive, but castrates its history and poisons our future. This is what 'The Nazi Drawings' is all about."

"The Nazi Drawings" is a dance of death,

350. "The Nazi Drawings #14." Mauricio Lasansky. 1961–66. 73x45. Pencil and red and brown wash drawing. On extended loan from the Richard S. Levitt Foundation, University of Iowa Museum of Art. Reprinted by permission of the University of Iowa Press.

351. "The Nazi Drawings #18." Mauricio Lasansky. 1961–66. 75½x45½. Pencil and red and brown wash drawing. On extended loan from the Richard S. Levitt Foundation, University of Iowa Museum of Art. Reprinted by permission of the University of Iowa Press.

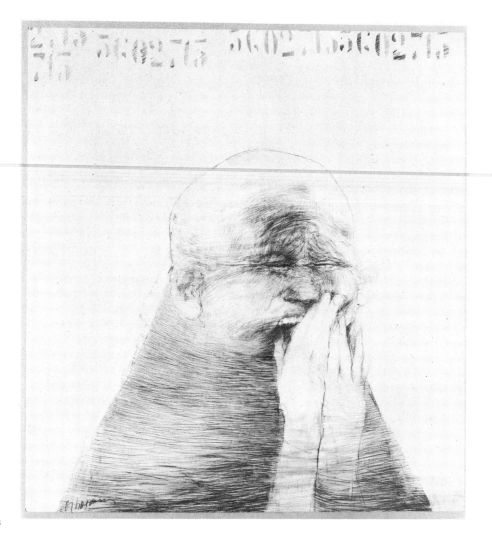

352

of which we are "the prurient observers, the guilty bystanders who survived these terrors of human history," as Edwin Honig has pointed out. The shattering impact on the viewer is heightened by the size of the drawings; most of the figures are life-size.

One symbol Lasansky employs haunts the viewer forever—his executioners wear a skull helmet suggestive of the German military campaign hat, with a skeleton's teeth replacing the visor. In Lasansky's drawing #14, the executioner finishes off a child as a praying skeleton dangles on his back. The dark form of the executioner against the light outline of the child's form provides chiaroscuro contrast between death and life. In drawing #18, an infant lies asleep—or dead—on his mother's belly as she is being hoisted onto a blood-spattered cross. This slaughter of the innocents ends with a series of portraits of the child victims. The unbearable grief of the child with the swollen head in drawing #24 speaks for all children everywhere who have been abused.

352. "The Nazi Drawings #24." Mauricio Lasansky. 1961–66. 43½x39¼. Pencil and red and brown wash drawing. On extended loan from the Richard S. Levitt Foundation, University of Iowa Museum of Art. Reprinted by permission of the University of Iowa Press.

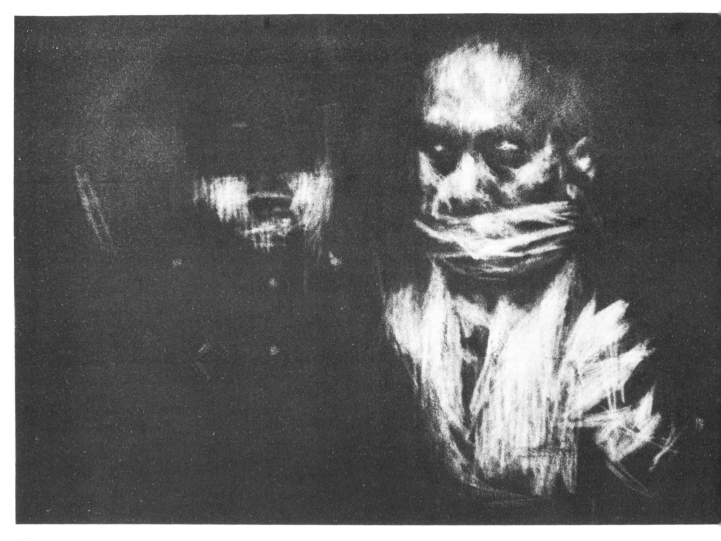

353

The Franco dictatorship also elicited strong protest, not only from the political cartoonists but from the painters and printmakers as well. None was more eloquent than Jack Levine's gagged "The Spanish Prisoner," done in 1961. Here Levine (1915–) uses the perfect medium, aquatint, for contrast and irony: the unfettered turnkey retreats into the darkness; the gagged but unconquered prisoner emerges boldly in the light. The prisoner's character and intellect shine forth, etched in the classical tradition.

"Acidulous" and "biting," two qualities of etching, are peculiarly appropriate words for his portrait of "The General." The bars near the window may indicate Levine's wish that the dictator be behind bars, or could imply that the dictator needs the protection of a fortress.

353. "The Spanish Prisoner." Jack Levine. 1963. 12⅝x17½. Scraped aquatint. Courtesy of Associated American Artists, New York.

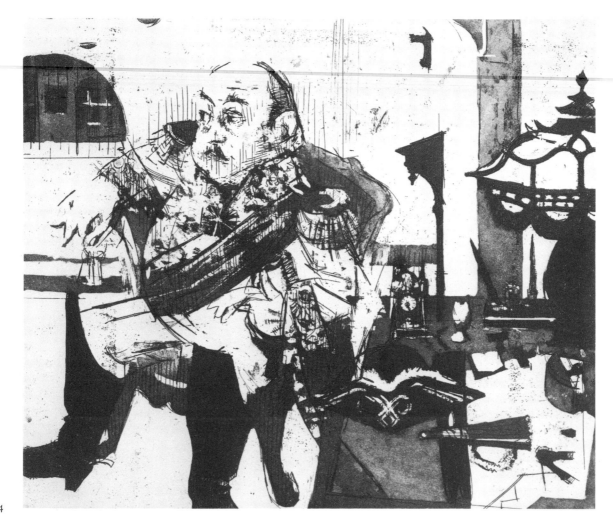

354

Levine has only recently turned to print-making; he is primarily a painter who, as Frank Getlein wrote, "has taken a noble idiom of painting, one fashioned by generations of great artists, all of them at peace, not to say in union, with their societies, and used it for his own strictly modern purposes of incisive social criticism and social compassion."

Levine, Philip Evergood, and Ben Shahn were the leading painters of the thirties whose work combined biting social com-

354. "The General." Jack Levine. 1963. 14x17½. Etching and aquatint. Courtesy of the artist.

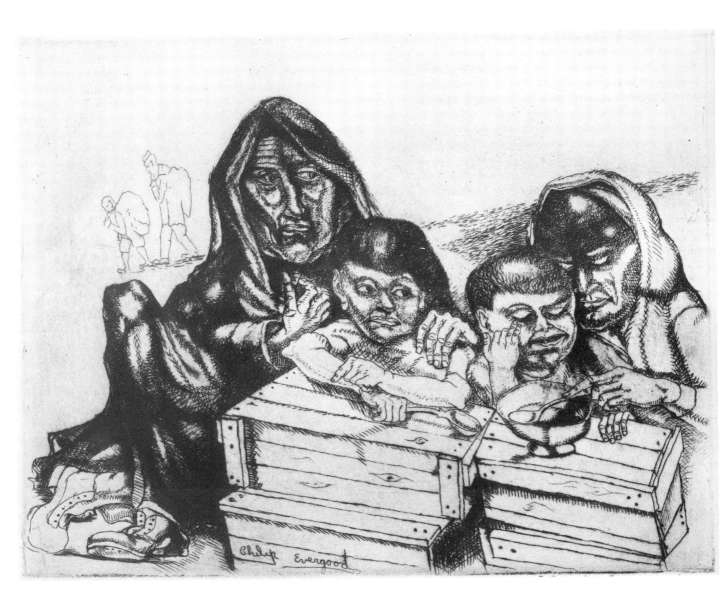

355

ment with a distinctive personal vision. They were—and are—"protest artists," but they are not social realists. Each evolved a unique artistic statement, yet none produced any significant graphic art in the thirties when their primary artistic focuses were painting or murals. Not until later

decades did they turn to graphics for comment on society.

Shortly after the war, Philip Evergood (1897–1973) combined etching and drypoint to create "Aftermath of War," a moving portrayal of refugees that avoids pathos by the strength of the biblical faces and

355. "Aftermath of War." Philip Evergood. 1945. 6⅞x9. Etching and drypoint. Museum of Modern Art, New York.

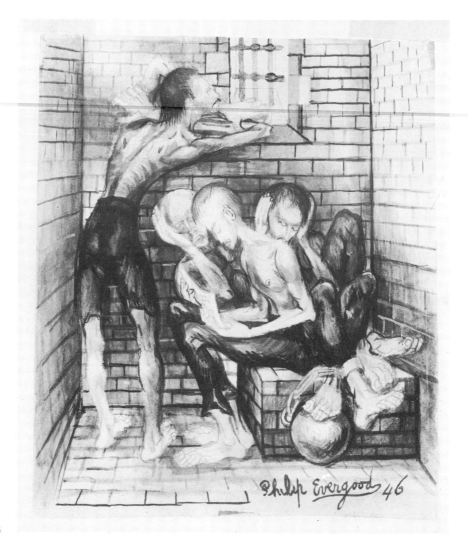

356

the vigor of the dark massing against the blank background. They could be any of war's flotsam, anywhere. Evergood, who had once studied etching in Stanley William Hayler's famous studio in Paris, often combined tenderness and exuberance. In "Aftermath of War," a somber tenderness is the mood, as it is in his 1946 drawing "The Indestructibles." Evergood's sketch of Spanish Loyalists still confined to Franco's prisons, "still reading, still alive, still with a little hope," is typical of his work in the thirties and forties.

In the fifties and sixties, Evergood's so-

356. "The Indestructibles." Philip Evergood. 1946. 16¼x13½. Pencil and watercolor. Collection of Ida and Moses Soyer, New York.

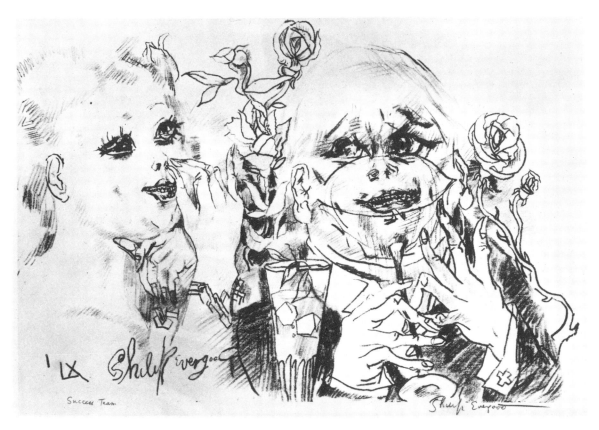

357

cial comment grew subtler and his satire broadened. "Success Team" is a Grosz-like portrait of the grasping predator with his painted-doll wife or mistress. But Evergood embellishes his "success" pair, 1960 successors to the nightclubbing Berliners of the twenties, with flowers and jewels. He draws his victims with gusto, adds a customary dash of fantasy, contrasts the gay atmosphere with the self-seeking faces, and creates a uniquely Evergoodian satire.

In 1927, two Italian-American anarchists, Nicola Sacco and Bartolomeo Vanzetti, were executed for murder. Many throughout the world, convinced of their innocence, protested that they were executed because of their philosophy. Deeply im-

pressed by the tragedy, the human conflicts, the social implications, perhaps the very pageantry of the event, Ben Shahn (1898–1969) created in 1931–32 a series of 23 gouaches and two large panels of the trial. They marked the assertion of a unique artistic personality.

Shahn became the leading social painter and muralist of the Depression years and an outstanding painter and graphic artist in the postwar years. However, the vision of two humble anarchists never left him, and in 1958 he made a serigraph, "Passion of Sacco and Vanzetti," a stark, harshly linear, imperishable tribute to the "good shoemaker and the poor fish peddler." It is poignant yet powerful. The faces are rough

357. "Success Team." Philip Evergood. 1960. 12¾x18¾. Lithograph (on zinc). ACA Gallery, New York.

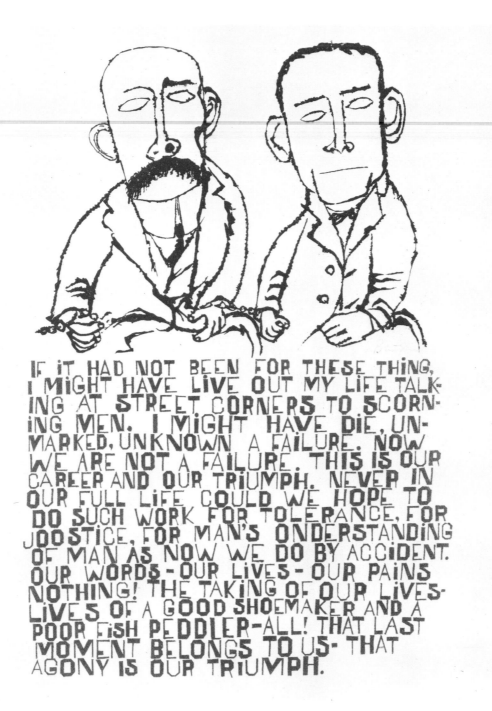

IF IT HAD NOT BEEN FOR THESE THING,
I MIGHT HAVE LIVE OUT MY LIFE TALK-
ING AT STREET CORNERS TO SCORN-
ING MEN. I MIGHT HAVE DIE, UN-
MARKED, UNKNOWN A FAILURE. NOW
WE ARE NOT A FAILURE. THIS IS OUR
CAREER AND OUR TRIUMPH. NEVER IN
OUR FULL LIFE COULD WE HOPE TO
DO SUCH WORK FOR TOLERANCE, FOR
JOOSTICE, FOR MAN'S ONDERSTANDING
OF MAN AS NOW WE DO BY ACCIDENT.
OUR WORDS - OUR LIVES - OUR PAINS
NOTHING! THE TAKING OF OUR LIVES-
LIVES OF A GOOD SHOEMAKER AND A
POOR FISH PEDDLER-ALL! THAT LAST
MOMENT BELONGS TO US- THAT
AGONY IS OUR TRIUMPH.

358

358. "Passion of Sacco and Vanzetti." Ben Shahn. 1958. 25¾x17½. Serigraph. Philadelphia Museum of Art.

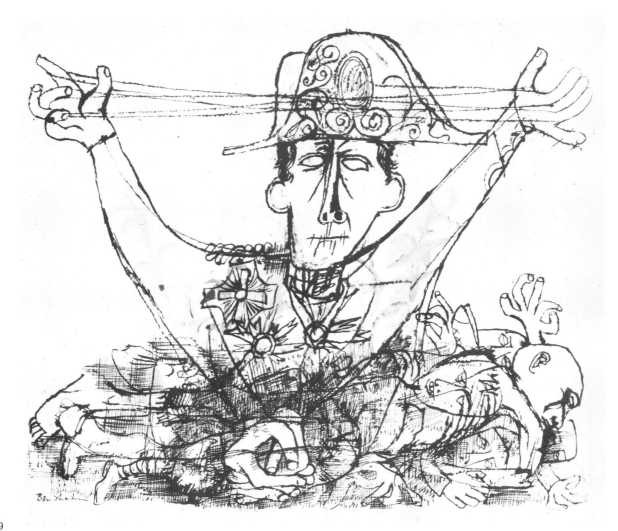

359

likenesses, but it is the indomitable spirit that shines through. The heads loom large in comparison with the bodies, to emphasize the triumph of mind over flesh. The unique lettering is by Shahn, who is a master calligrapher and typographer.

Shahn was usually—and inaccurately—regarded as the leading "social realist" until he turned his back on social themes in the fifties to become a "personal realist." Although his painting became more allegorical and symbolical, it never became less concerned with the human condition; it was in the late fifties and early sixties that some of Shahn's most expressive graphic comment was made. In his "Study for 'Goyescas'" a Spanish officer (his face the more repulsive for its lack of expression)

359. "Study for 'Goyescas.'" Ben Shahn. 1956. 25½x30. Watercolor. Collection of M. J. Stewart.

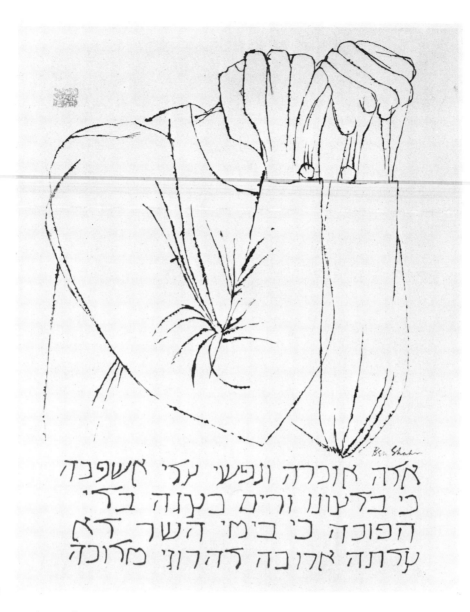

אֵלֶּה אֶזְכְּרָה וְנַפְשִׁי עָלַי אֶשְׁפְּכָה
כִּי בְלָעוּנוּ זָרִים בְּעֻגָה בְּלִי
הֲפוּכָה כִּי בִימֵי הַשַּׂר רָאִי
עָרְתָה אֲרֻבָּה לַהֲרוֹגֵי מְלוּכָה

360

spreads a cat's cradle of barbed wire over the corpses of his victims. Few comments in modern times on military dictatorships have been so powerfully graphic. A dozen years later, during the Vietnam war, Shahn mixed drawing, watercolor, and painting to transform the Spanish officer into a helmeted American officer, facing in all directions, his chest covered with campaign ribbons. The corpses had now become skeletons.

To commemorate the twentieth anniversary of the destruction of Warsaw, Shahn again combined calligraphy and simplicity of drawing for a deeply moving statement in the serigraph, "Warsaw, 1943." The lines are softer and the mood is a blend of pity, bitterness, and compassion, as in so much

360. "Warsaw, 1943." Ben Shahn. 1963. 33½x24. Serigraph.

of his work. The clenched hands (always eloquent in Shahn's drawings) completely hiding the face express the anguished pain. The text is from an ancient prayer: "These martyrs I will remember, and my soul is torn with sorrow. In the days of our trials there is no one to help us."

With few exceptions, Shahn's most powerful comments are in his paintings and posters. Hence this selection from his prints unfortunately can give no indication of the broad satire or sharp wit he has used to prick pomposity or to attack those who would crush the human spirit.

In the welter of abstract art that dominated the fifties, a new voice was heard speaking up for humanism: Leonard Baskin (1922–), printmaker, sculptor, and typographer. Baskin's focus has been the anatomy of man, figuratively and literally, and, as John Canaday has pointed out, "the invincibility of the spirit against all degradations that assail it"—degradation of the body, of the mind, of society, and often all three at once.

In the early 1950's, when McCarthyism was rampant, Baskin carved his magnificent woodcut, "Man of Peace." It is literally in man's image—six feet tall. He is imprisoned behind barbed wire. His dove lies bleeding, and his outlook is far from sanguine. The undaunted man of peace asks in the Thoreau tradition, "What are you doing out there?" Baskin's mastery of the woodcut and his sculptural qualities shine through in the artist's uniquely forceful signature of bold, strong lines in a veined body.

Two years later, Baskin carved a companion woodcut, "Hydrogen Man," powerful and apocalyptic. Again he spoke out on a theme disturbing to all mankind, atomic war. Again his work is free of cliché and endowed with a haunting eloquence. The medium and the vigorous carving are remarkably appropriate for the theme. Here Baskin's man still seems to have life in death. In his "Sheriff" (discussed in the following chapter), he is decaying. In recent years, Baskin seems to be more preoccupied with death than life. "Our age is a landscape of death," he says. He may be right that a spiritual death has already overcome many, and a physical death by annihilation threatens all, but it is not clear if Baskin has lost faith in "the invincibility of the spirit."

Although abstract expressionism dominated American art in the fifties and the "social injustice" school of the thirties had all but evaporated, social commentary did not wholly disappear, as these examples indicate. Paradoxically, Shahn, Evergood, and Baskin did some of their greatest critical graphic comment in this period, despite the hostile atmosphere created by McCarthyism. Their output in this area, however, was small. Evergood was one of the first witnesses called up before a congressional investigating committee. He replied with a drawing in defense of the right to think and speak freely that was proudly reminiscent of the nineteenth-century French tradition. Shahn, fiercely civil libertarian, spoke up that "without the non-

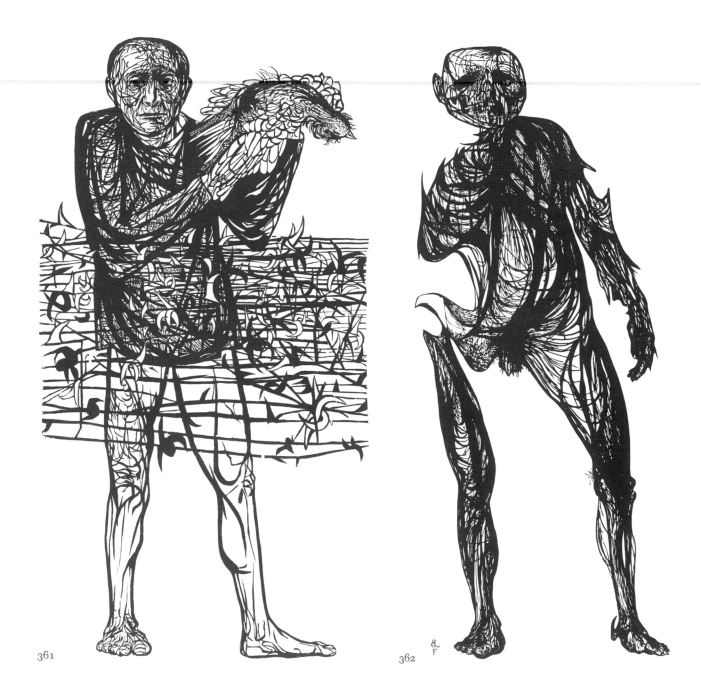

361 362

361. "Man of Peace." Leonard Baskin. 1952. 59½x30⅝. Woodcut. Museum of Modern Art, New York.

362. "Hydrogen Man." Leonard Baskin. 1954. 59½x30⅝. Woodcut. Photo courtesy Museum Color Slides Association, Boris Mirski Gallery, Boston.

363

363

conformist, any society of whatever degree of perfection must fall into decay." As the fifties ended, Shahn was finishing an eloquent series of symbolic paintings on the incident of the Japanese trawler that was covered with radioactive ashes from the fallout of an American H-bomb.

Perhaps it was a newspaper cartoonist, Herblock (1909–), who did the most to keep the tradition of dissent alive. Herblock's work suffers from the exigencies of producing a drawing—and an idea—a day. His draftsmanship is inevitably hasty, superficial and one-dimensional. His pithy comment, nevertheless, has remained at a remarkably high level, and occasionally his drawings have been so inspired as to be the ultimate comment on an issue or a period. His shivery "Mr. Atom" symbolized the dangers of nuclear war for millions. His famous "Fire" cartoon epitomized the hysteria of the McCarthy era. Herblock may not have played as singular a role in ending McCarthyism as Nast did in bringing down the Tweed ring, but his courageous attacks helped clear the way for McCarthy's downfall.

Most American artists in the fifties were much more concerned with themselves than with society. The withdrawal continues for many, but two events in the sixties drew others back into the orbit of identity with their fellow men: the struggle for civil rights and the war in Vietnam.

The greatest failure in American society —white America's failure to interweave black America into the social fabric with equality and dignity—is paralleled in American art. The traumatic institution of slavery and the cataclysmic Civil War evoked little artistic response. With the notable exceptions of Homer and Eakins, only occasionally was the black American portrayed as a visible man. In the thirties some American painters finally began to paint him with insight, and many reacted to the obvious violence of physical lynching. Although the civil rights movement of the

363. "Measuring the Girl Friend for a Strait Jacket." Philip Evergood. No date. Drawing. Private collection.

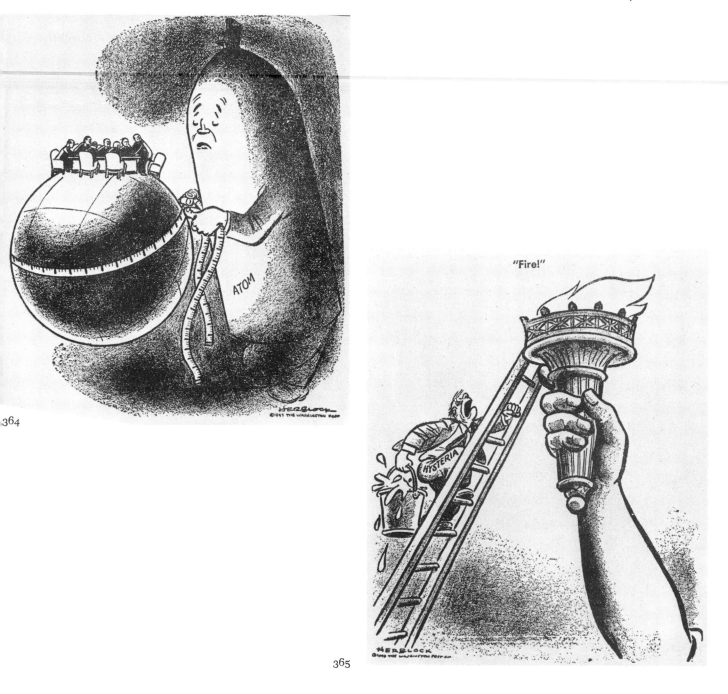

364

365

364. "Don't Mind Me, Just Go On Talking." Herblock (Herbert Block). 1947. Reproduced from *The Herblock Book*, 1952.

365. "Fire." Herblock (Herbert Block). 1949. Reproduced from *The Herblock Book*, 1952.

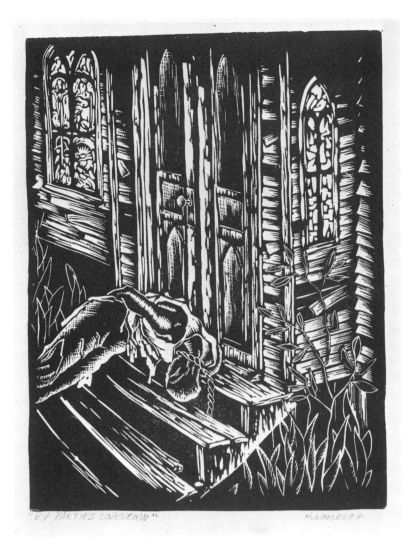

"BY PARTIES UNKNOWN" H. WOODRUFF

366

sixties involved many American white artists, their commitment often has not been mirrored in their art. It is the black artist who continues to be his own most eloquent graphic spokesman.

The quiet understatement of Hale Woodruff's (1900–) block print of the late thirties, "By Parties Unknown," is much more effective than the more obvious treatments by his white contemporaries. His use of the woodblock, of white on black, accentuates the nighttime horror and the stillness of death. The lonely body dumped on the church steps penetrates with quiet eloquence. Woodruff is a muralist and teacher as well as printmaker.

John Biggers' (1924–) strikingly designed "Cradle" succeeds in evoking the role of the black mother with depth of feeling but without pathos. The weary, troubled mother and the dependent children are skillfully held together by the powerful, elongated arms to form a pyramidal mass of love and oppression.

366. "By Parties Unknown." Hale Woodruff. 1935. 12x8⅞. Blockprint. Courtesy of the artist.

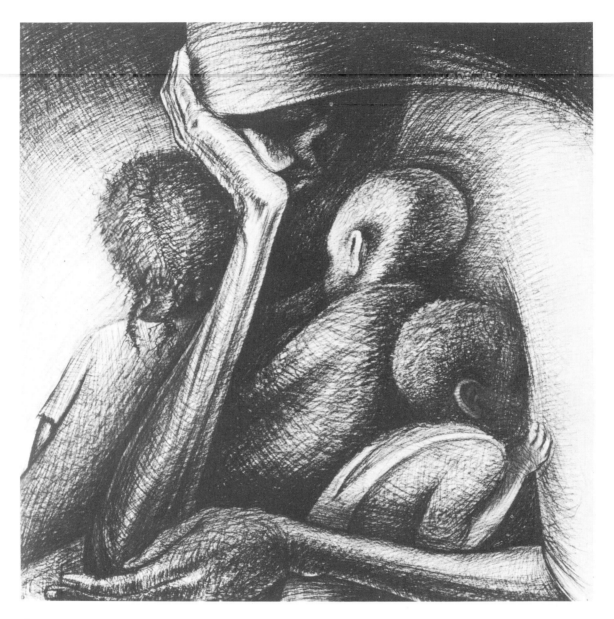

367. "Cradle." John Biggers. 1950. 22⅜x21½. Carbon drawing. Museum of Fine Arts, Houston.

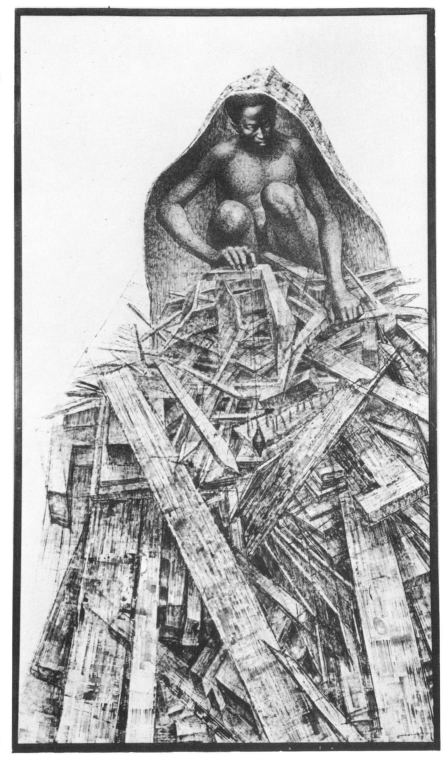

368

368. "Birmingham Totem." Charles White. 1964. 71x40. Ink drawing. ACA Gallery, New York.

The outrages committed against blacks in Birmingham in the middle sixties stirred consciences everywhere and prodded artists to distill their emotions. None was quite so successful as draftsman Charles White (1918–) in his ink drawing "Birmingham Totem." White succeeded where so many others failed, perhaps because he avoided a literal depiction of the church bombing or any of the other tragedies. His conception is ingenious and his composition artful. The cowled figure, patiently and determinedly beginning to put the pieces together after a bombing, is beautifully drawn, and is an inspired apogee for the totem pole of shattered planks, symbols of man's destructive force. The drawing has the force, the strength, and the dignity of a throbbing black spiritual.

White was one of many young artists who gained both subsistence and vital experience from the Federal Arts Project, where he developed as a muralist and painter. He later studied lithography at the Taller de Gráfica in Mexico City where his interest in graphic work was stimulated. Although he continued to paint, drawing became his principal medium of expression. His realistic drawings of American Negroes have a transcendent humanity which often, though not always, avoids both the elements of illustration and sentimentality. In an uneven series titled "J'Accuse!" White's most effective protest-portraits are his understatements. The figure in his #5 apparently is ready to shed the outer coat, with its empty sleeves and,

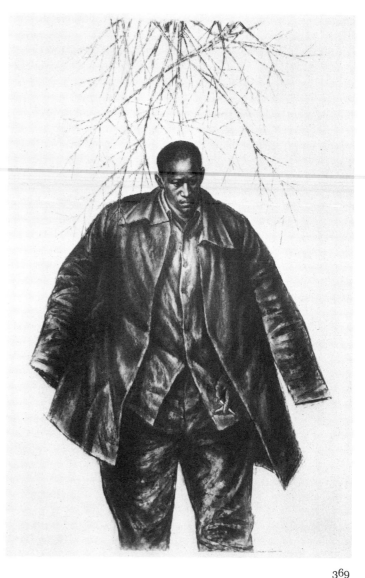

369

like the branch above, fulfill his obvious promise.

If the civil rights issue shook many American artists out of their self-preoccupation, the Vietnam war brought them into active agitation. "For the first time in my life as an artist I felt I *had* to engage a social theme," Chaim Koppelman has declared. His statement reflected the new involvement of many of his fellow artists.

369. "J'Accuse! #5." Charles White. 1966. 59x42. Charcoal and crayon drawing. Private collection, Heritage Gallery, Los Angeles.

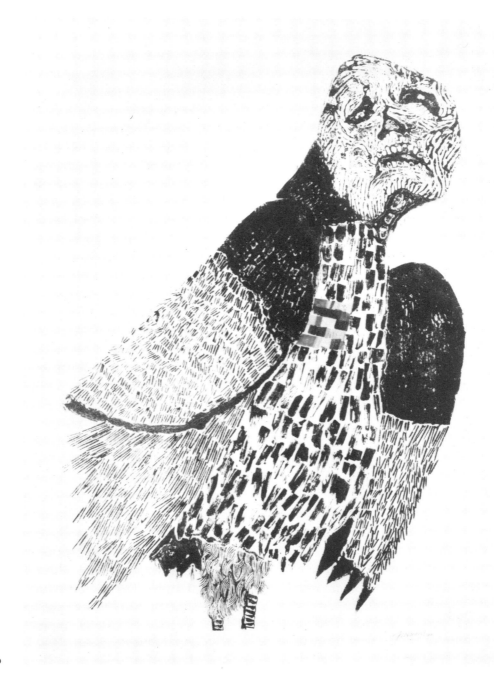

370

370. "The Hawks, VI." Antonio Frasconi. 1966. 36x24. Woodcut. Terry Dintenfass Gallery, New York.

Artists who had immersed themselves in abstract expressionism and pop art now endeavored to lend their talents to protest against a government they felt to be neglecting the racial crisis at home while pursuing an unjust war in Vietnam. Unfortunately, many of them had been too long immersed in subjective withdrawal. Some could only continue to paint or draw in wholly abstract forms which they tagged with protest titles in the futile hope that it would add social meaning. Others proved themselves inadequate, over-emotional, superficial, or tangential. Often war photographs used iconographically in painted constructions were more substantial than the basic art itself. The social and moral implications of the Vietnam war were so vast that perhaps only Bosch's "Mad Meg" or Picasso's "Guernica" could be relevant.

On the whole, the most effective comment has come from those who are primarily graphic artists or who have been experienced printmakers or draftsmen. One of the most forceful is Antonio Frasconi's (1919–) woodcut, "The Hawks, VI." Rarely has wood been cut with such passion as in the vitriolic portrait of this agonized, bewildered, death's-head figure, its claws and teeth sharp, its chest bedecked with campaign ribbons. But its warlike defiance is lost and without purpose. The work of Uruguayan-born Frasconi in woodcut and wood engraving is in the tradition of the German expressionists and of Posada.

The grieving mother with a dead child in her arms has become a cliché in antiwar protest. Chaim Koppelman (1920–), however, has made expert use of aquatint to add a new dimension to this now obvious concept. The mother, as well as child, has the aura of approaching death. Mother and background both reflect the disorder, the filth, and the shadowy nature of war and death. Koppelman's protest springs from the art and is not superimposed on it.

Saul Steinberg's delightful graphic fantasies are always overflowing with elusive symbols, their meaning obscure or teasingly, vaguely familiar. In his color lithograph, "Vietnam," however, Steinberg's symbolism is much more explicit, his visual presentation relatively direct, and he supplies an unprecedented explanation: "The pyramid, the eagle, the seeing eye, the barrows, and the 13 olives are symbols of the American coat of arms found on the back of the one dollar bill." But the eagle has pushed down the seeing eye from the top of the pyramid, the olives are bombs, and Uncle Sam is fighting the Indians again—this time in Vietnam.

The crises of violence that have convulsed the United States in recent years have shaken many artists out of the subjective shells into which they had withdrawn for the past quarter-century. Unaccustomed to social and political commentary, these artists have only infrequently been successful in this sphere. It is possible that with time they can reconcile their involvement with their artistic drives. Meanwhile social content is finding a place again in American art.

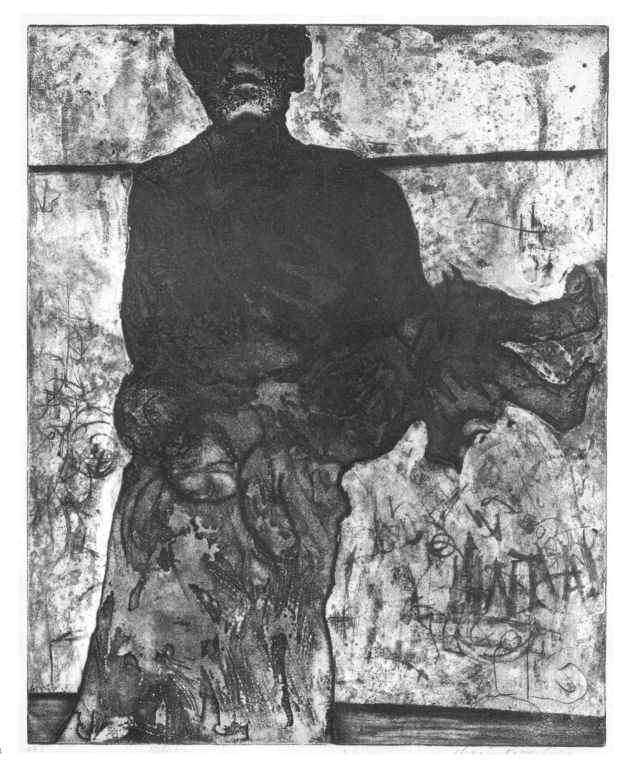

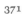 371. "Vietnam." Chaim Koppelman. 1965. 19⅞x15¾. Aquatint. Courtesy of the artist.

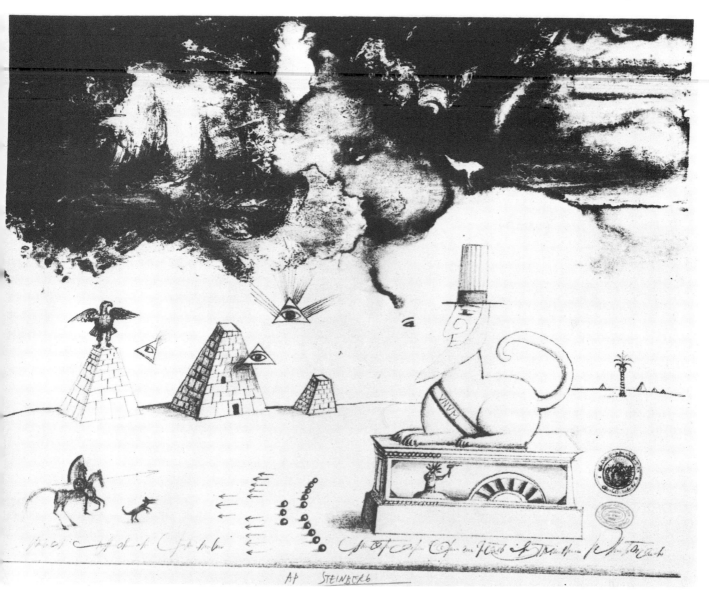

372. "Vietnam." Saul Steinberg. 1967. 17x22. Colored lithograph. Hollander Workshop Gallery, New York.

CHAPTER XII
Protest Art in Mexico

OCCASIONALLY during the 1930's some American artists painted or drew bulging, massive figures, often heroic in pose but with few structural details. It was a period of considerable influence by Mexican muralists Rivera, Orozco, and Siqueiros on American artists. The influence of Orozco, not always well assimilated, was particularly evident. In contrast, Mexican art was little affected by the art of its dominant neighbor; it was, for the most part, indigenous and original with its roots deep in the Indian past. For much of the twentieth century, Mexican art—especially graphic art—was an important social instrument for protest against dictatorship and for the furtherance of the Mexican Revolution against oppressive, strong-arm governments struggling to keep the lid on the explosive agrarian revolts.

In a nation that until recently had a high degree of illiteracy, popular art has had a traditionally important role. During the nineteenth century inexpensive "penny sheets" were distributed throughout the country, celebrating, in pictures and text, current happenings, stories, festivals, legends, and almost anything that struck the artist's fancy. Sometimes they satirized the current dictator in the constant struggle between dictatorial and relatively democratic forces that has marked Mexican history of the past century. Mostly woodcuts, they were simple and direct and at times achieved a primitive beauty.

Greatest of the folk artists, and the man who exerted a major influence on twentieth-century Mexican graphic art, was a self-taught, part-Aztec Indian, José Guadalupe Posada (1851–1913), whose 15,000 popular prints captured the everyday events, the mythology, the mystique, and the demonology of turn-of-the-century Mexico. Through his publisher, Posada's woodcuts and relief etchings, often satirical, were distributed to every corner of Mexico, for the enlightenment, entertainment, lip-smacking horrification, and occasional political needling of his vast audience. Posada illustrated every possible kind of event, story, song, and prayer. Especially popular were his *corridos* and his *calaveras. Corridos* were ballads of derring-do and of love-making. In many, the blood flowed torrentially, with the traditional Indian accent on death and bloody realism reinforced by the blood-spilling violence of the Spanish conquest and the Inquisition.

The *calaveras*, literally skeletons and skulls, were vigorous, even gay, bony figures who "acted out" Posada's satirical tableaux, reminiscent of the medieval Dance of Dance and of pre-Columbian temple paintings. Their mood ranged from gaiety

373

to terror. Posada's flippant skeletons were often pictured dancing, drinking, running over pedestrians with their bicycles, attired in the latest foolish fashion. Occasionally the satirical thrust bit deeply, as in "Calavera Huertista," in which strong-arm President Huerta is portrayed as a revolting spider, crawling with maggots, holding the bones of his victims. Posada here used the form of the spider to weave a stunning design, balanced and uncluttered, focusing on the predatory skull of Huerta. Huerta is

373. "Calavera Huertista." José Guadalupe Posada. 1913. 8½x8½. Zinc engraving. Prints Division, Astor, Lenox and Tilden Foundation, New York Public Library.

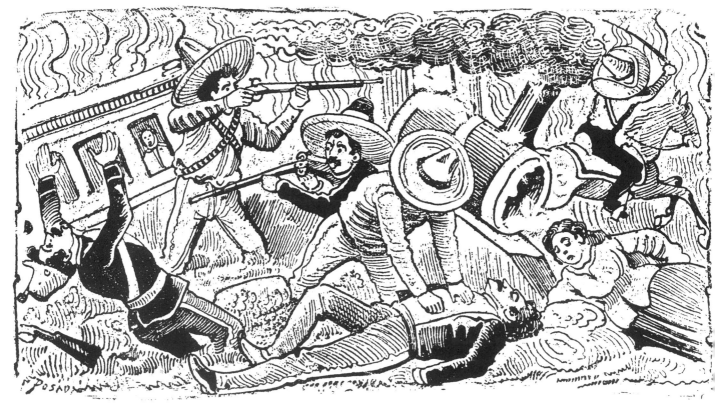

374

reported to have become so incensed that he ordered the printing house razed.

Most of Posada's prints, even his *cala-veras*, were more representational than this one. Among other subjects, he often drew historical scenes from the Revolution to remind his audience of a glorious tradition. His action-filled "Revolutionary Scene," with the revolutionaries blowing up a train and fighting federal troops, is typical of his simple naturalism.

Posada might have been forgotten if years after his death the painter Jean Charlot had not discovered his original blocks, arranged exhibitions, and acknowledged the debt of Mexican graphic artists to their great pioneer.

When the Mexican dream of a permanent Revolution finally seemed near realization, there was no dearth of artists to express the Revolution's aspirations and relate its history. In the forefront were the dominating murals of Diego Rivera (1886–1957), José Clemente Orozco (1883–1949), and

374. "Revolutionary Scene." José Guadalupe Posada. 3⅜x6⅛. Relief etching on zinc. Gift of Jean Charlot, 1930, Metropolitan Museum of Art, New York.

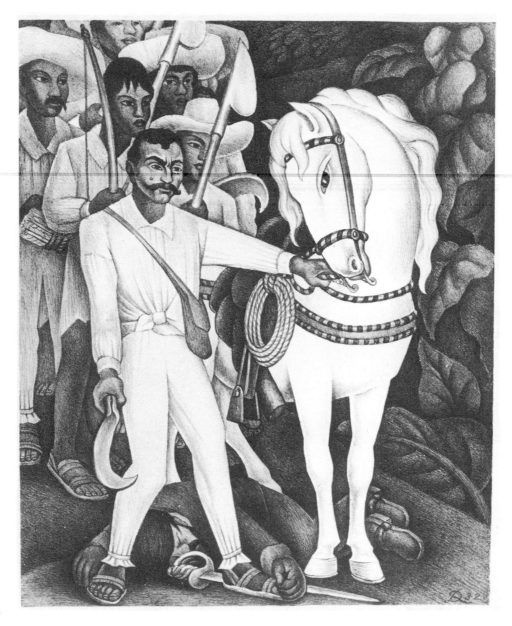

375

David Alfaro Siqueiros (1896–1974). Al-
though primarily muralists, all three of
these artists, and especially Orozco, also
created prints.

"Zapata," by Rivera, who worked in Paris
for years, reflects both Gauguin and Aztec
influences. The static, mural-like qualities
of this tribute to the Revolutionary leader
stem from Rivera's principal artistic inter-
est as a muralist. Rivera is more the pic-
torial historian than the commentator, but
in this lithograph his identification is ap-
parent.

Orozco brought an Expressionist simplic-

375. "Zapata." Diego Rivera. 1932. 16¼x13⅛. Lithograph. Dick Fund 1933, Metropolitan Museum of Art, New York.

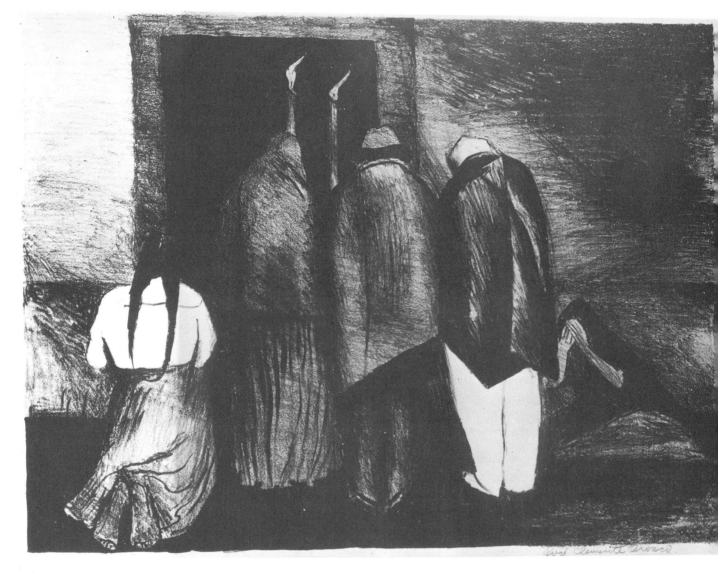

376

376. "Requiem." José Clemente Orozco. No date. 11⅞x15⅞. Lithograph. Dick Fund 1929, Metropolitan Museum of Art, New York.

377

ity of form and compassion to his print-
making. Both qualities are evident in his
moving "Requiem," where he makes full
use of the chiaroscuro of lithography to
heighten the somber atmosphere of mourn-
ing for the Revolutionary dead.

He often drew inspiration from his ex-
periences with the Revolutionary armies in
the field. In "The Fusillade," drawing for a
fresco, Orozco captures with remarkable
economy one of the bitterest memories—
when captured Revolutionaries were forced
to dig their own graves. The slain peasant
toppling, his body hunched from the vio-
lence of the bullets, the shovels outlined
against the sky, the faceless officer—his fea-
tures unimportant—the waiting grave, all
make an unforgettable tableau. Mourn-
ing and death were recurrent themes in
the work of Orozco and other artists of the
Revolution. They derived in part from the
blood and tears of the Revolution itself and

377. "The Fusillade." José Clemente Orozco. 1940. Drawing for fresco. Gabino Ortiz Library, Jiquilpan, Mexico.

378

partly from their pre-Columbian heritage.

Orozco's sensitivity to human suffering was universal. His "Unemployed, Paris," made on a trip to Paris in 1932, expresses with just a few bold strokes the despair and hopelessness of the jobless.

Siqueiros, enthusiastic revolutionary, who fought with Carranza's army and with

378. "Unemployed, Paris." José Clemente Orozco. 1932. 14⅝x10½. Lithograph. Gift of Abby Aldrich Rockefeller, Museum of Modern Art, New York.

379

the Loyalists in Spain, distilled his ideological convictions in his work. In his painting, Siqueiros is blunt, powerful and explosive in conception but finished in treatment, where Orozco is compassionate in outlook but dynamic in handling. In his graphic work, Siqueiros is versatile. "The Trinity of Leeches" represents a more satirical mood, a stylized and sophisticated version of the folk woodcuts of Posada and others. His parasitical trio has a "Three-

penny Opera" amorality as its members bribe or are bribed.

In 1937, when the Mexican Revolution reached its height under the Cárdenas administration, a unique establishment was set up in Mexico City—the Taller de Gráfica Popular, or Workshop of People's Graphics —as a center for collective work in engraving and painting. Its purpose was to improve the quality of the plastic arts, and to promote the "progress and the democratic

379. "The Trinity of Leeches." David Alfaro Siqueiros. No date. 13⅝x15¹⁄₁₆. Woodcut. Gift of Jean Charlot, 1929, Metropolitan Museum of Art, New York.

380

interests" of the Mexican people. A great deal of propaganda poured forth from the Taller—*corridos* and *calaveras*, cartoons, posters—all with political messages, and often with antifascist or occasionally anti-"Yankee imperialism" themes celebrating the expropriation of the oil fields. These artists also created graphic portraits of Mexican people in every kind of daily activity. They drew Indian faces galore—faces of beauty, dignity, and tragedy, as well as an infinite number of stereotypes—and

380. "Dream of the Poor." Leopoldo Mendez. 4⅞x4⅞. Woodcut. Collection of the Author.

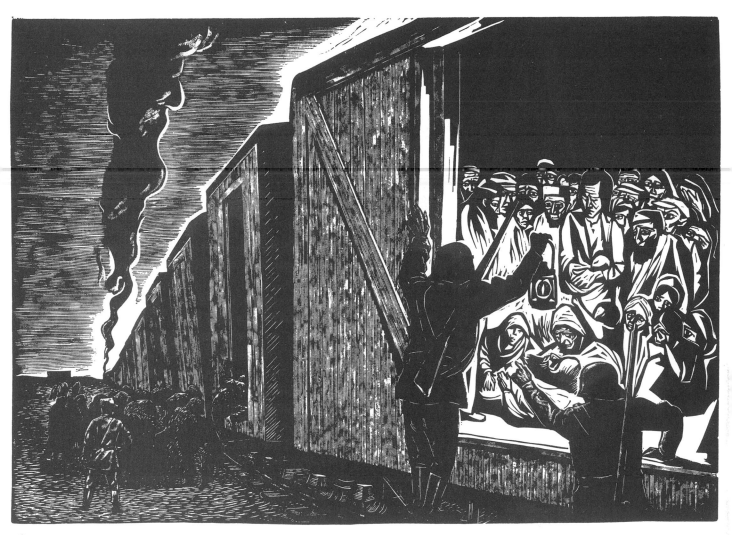

381

made numerous exhortatory prints to combat illiteracy and the high cost of living. With half the population illiterate, prints were the ideal medium for communicating social messages. They were often deliberately primitive, simple in concept, crude in execution, to ensure that the content was comprehensible. Block prints and lithographs, simple to run off in large editions, were the most popular media.

Leopoldo Mendez (1902–), one of the founders and first leader of the Taller, was prolific in his graphic treatment of social themes. His "Dream of the Poor," a dream of public restaurants for the poor instead of charity, deliberately has the didactic quality of catechism, but nonetheless has a tightly balanced composition. His "Expatriation to Death" reflected the Taller's anti-Nazi concern. The linocut of a seemingly endless train of huddled Jewish refugees has an appropriate medieval flavor.

381. "Expatriation to Death." Leopoldo Mendez. 1942. 13½x19¼. Linocut. Museum of Modern Art, New York.

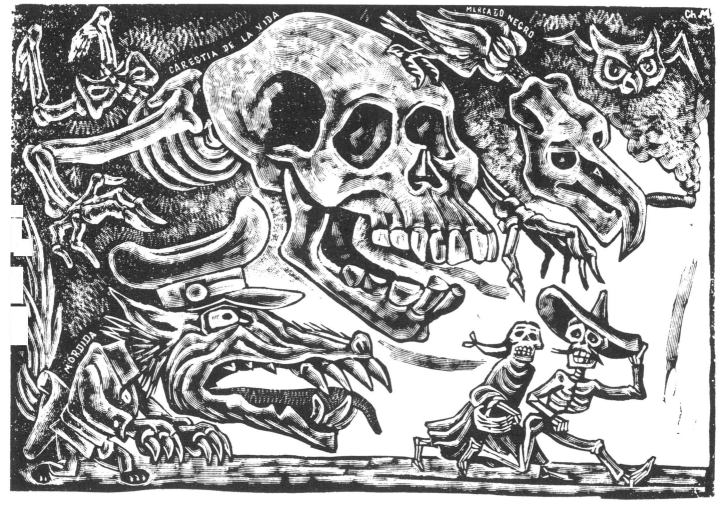

382

The *calaveras* executed by members of the Taller usually had a much more political flavor than those by Posada. José Chavez Morado's *calavera*, "The Skeleton against the People" is typical of his frequent combination of social criticism and imaginative fantasy. His woodcut of poor Juan and his wife being pursued by the demons of the black market, the high cost of living, and graft is far superior in execution and sweep of movement to most of his contemporaries' *calaveras*.

382. "The Skeleton against the People." José Chavez Morado. 1945. 11¼x12½. Woodcut. Galeria d'Arte Mexicano, Mexico City.

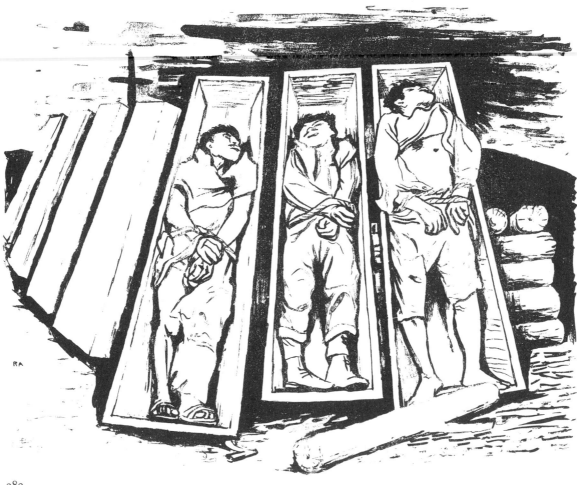

383

One of the functions of the Taller was to keep the only-too-recent bitter memories of the Revolution alive. Raul Anguiano's unforgettable "Executed" is stark and unrelenting in his presentation of a dictator's victims, but the effect is weakened by the inept and unanchored cross, which looks like a hasty afterthought.

During the forties and fifties the Revolutionary pace slowed, and the emphasis shifted to developing Mexico's industrial potential. Huge and imposing skyscrapers

383. "Executed." Raul Anguiano. 1940. 9½x12. Lithograph. Private collection.

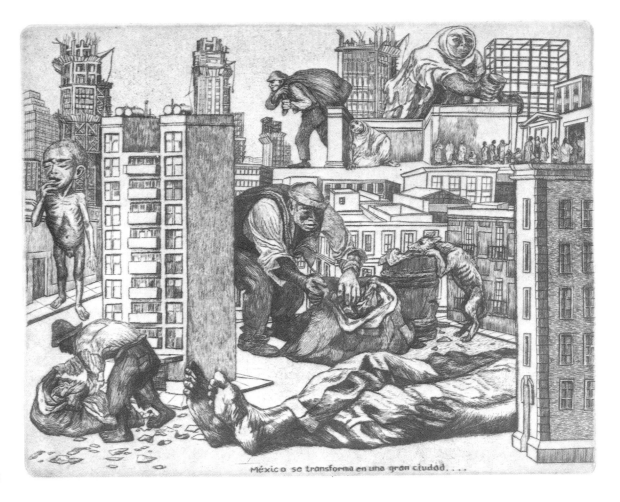

384

México se transforma en una gran ciudad. . . .

sprang up in Mexico, but behind the façade lived the poor and the unemployed. "Mexico Transforms Itself into a Great City" is the title of Alfredo Zalce's caustic and effective etching in which his impoverished people are larger and more important than the rising towers.

As the mood shifted, so did the style and content of many Mexican artists. Still concerned with social themes, they were no longer wholly dominated by them, and while retaining their purely Mexican qualities they began to reflect the graphic experimentation of Peterdi, Lasansky, Hayter, and others.

José Luis Cuevas (1934–) is by far the most brilliant draftsman in Mexico today. His roots in Mexican folk art, especially the Indian festivals of the dead, are combined with a nightmarish morbidity —all executed with an extraordinarily sensitive line. Cuevas has dropped social content from his art, but it is hoped that his contemporaries will recognize that his is a unique vision and not abandon the Mexican tradition of relating art to people.

384. "Mexico Transforms Itself into a Great City." Alfredo Zalce. 12¼x15½. Etching. Courtesy Roger L. Crossgrove.

Epilogue: Social Protest in Art Today

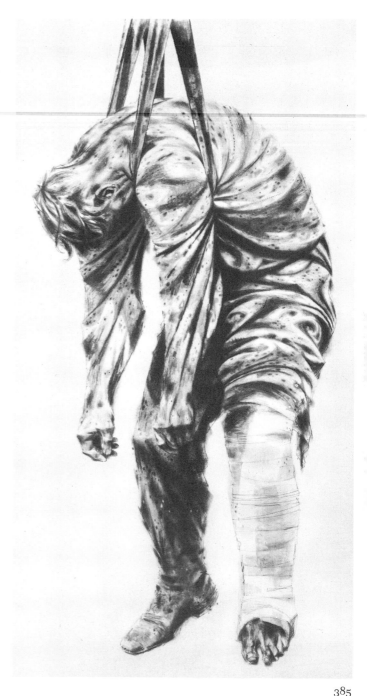

ALTHOUGH abstract expressionism, pop art, and the other trends and fashions since World War II have dominated art in the entire non-Communist world and have even penetrated into the Communist countries, the venerable tradition of graphic social protest still remains. It may, in fact, regain a strong foothold as the new engagé generation gains power and influence.

In West Germany, an interesting magazine of the arts, *Tendenzen*, often publishes graphic comment by artists of several countries. London's *Private Eye* provides lively satirical reportage and occasional social comment. Graphic social comment still appears regularly, if without fanfare, in other countries. There is no *L'Assiette au Beurre* or *Simplicissimus* or *Masses*, but one may appear out of the ferment and challenges of the era ahead.

Much of this art is representational, often with symbolic overtones, like Joseph Hirsch's dexterous "Hanging Man," but the examples that follow indicate how protest art can also be expressed in a less representational idiom.

Bruno Caruso's "Spain, 1963" was published in *Tendenzen* in 1965. It would have been at home in *Simplicissimus* in the twenties, reminiscent as it is of Heine's strong

385

385. "Hanging Man." Joseph Hirsch. 1968. 63x29. Pastel and ink drawing. Forum Gallery, New York.

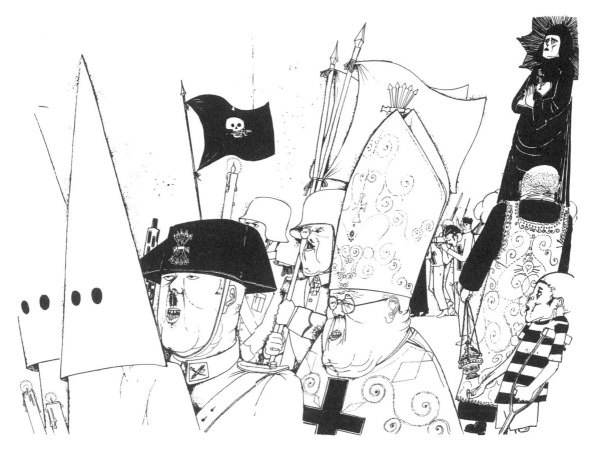

386

linear construction and the vertical thrust of many German artists. It may be traditional satire, but it is certainly not dated.

The figurative symbolism Lorenzo Vespignani employs in "The German on the Skulls" is as old as art. The bloated figure, drawn in 1945, comes right out of George Grosz and prewar German Expressionism.

The deliberate carelessness of the powerful line, the condensed treatment, and the primitive symbolism are contemporaneous in feeling with the older artists. Yet this brutally savage satire on German militarism has much more kinship to today's draftsmanship, more "message" for today's viewer than any photograph.

386. "Spain, 1963." Bruno Caruso. 1963. Ink drawing. Reproduced from *Tendenzen*, Feb. 1965, No. 31.

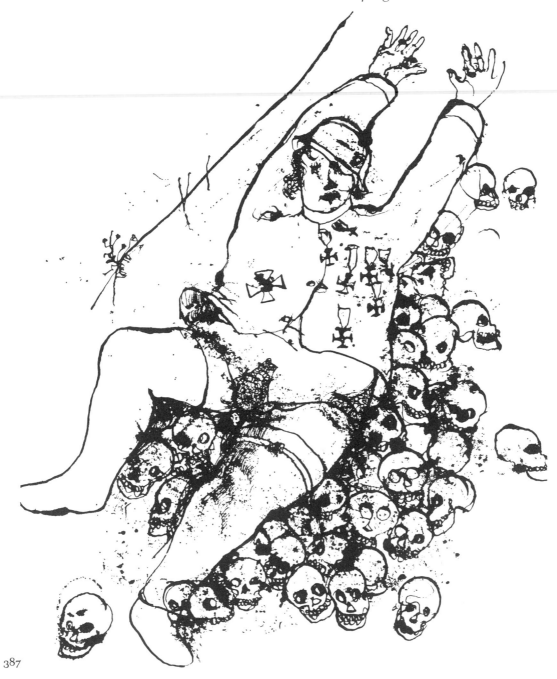

387

387. "The German on the Skulls." Lorenzo Vespignani. 1945. 10x7¼. Drawing. Reproduced from *Tendenzen*, Sept.–Oct. 1965.

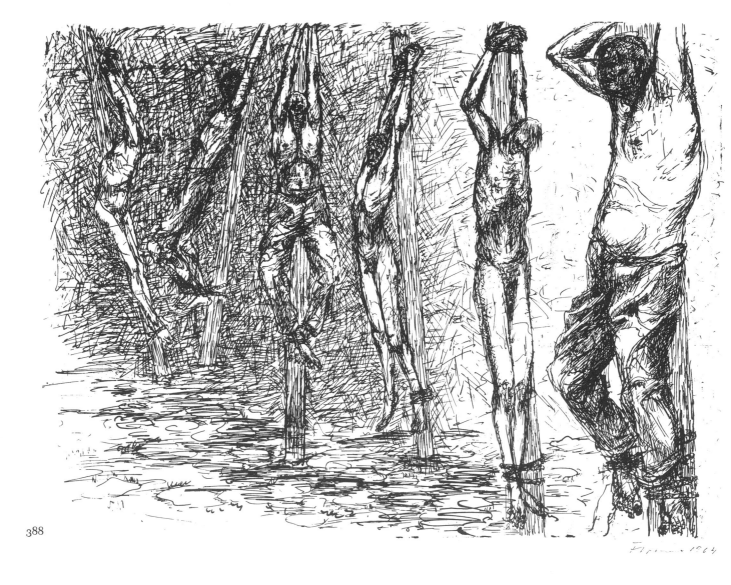

388

Fritz Cremer's 1964 lithograph, the symbolic "Buchenwald," is even more Gothic in origin, but the elongations serve to accentuate the agony, and the harsh draftsmanship and conception are purely mid-twentieth century.

The 1965 exhibit "Art and Resistance in Europè," held to commemorate the twentieth anniversary of the Resistance in Italy, showed that the art stemming from World War I was on the whole far more effective than that from the later period. Antifascist art created during World War II was understandably passionate, but most of it was topical and ephemeral. One of the few artists whose deep involvement didn't obscure his artistic vision was Renato Guttuso (1912–). His implacable "Partisan" is projected with power and economy.

Surprisingly from England, and not pre-

388. "Buchenwald." Fritz Cremer. 1964. Lithograph. Reproduced from *Tendenzen*, Feb. 1965, No. 31.

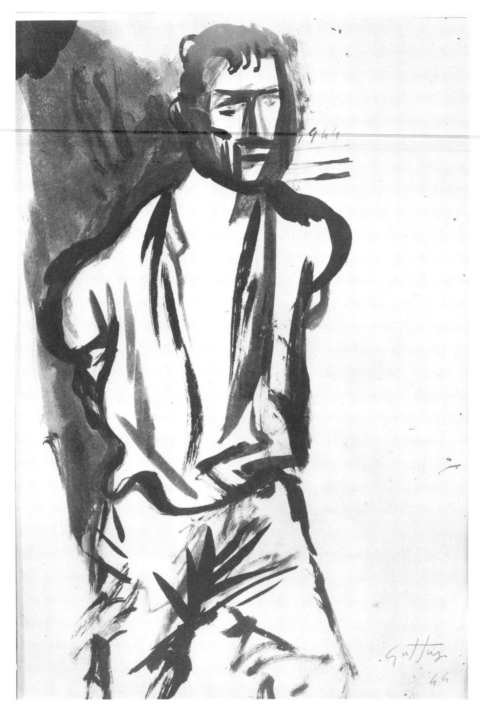

389

389. "Partisan." Renato Guttuso. 1944. 13¼x7¼. Wash drawing. Collection of Mr. and Mrs. Sol Fishko, New York.

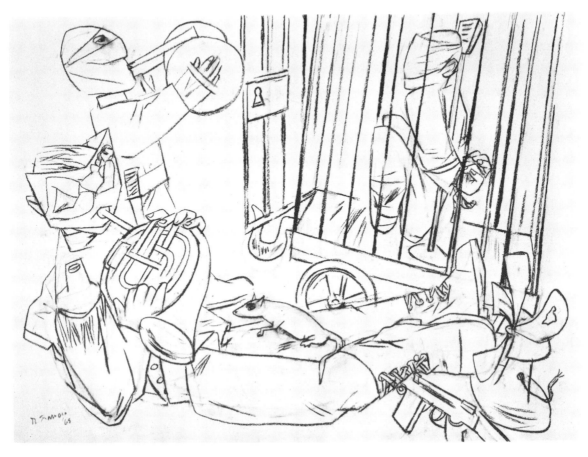

390

war Germany, comes Peter de Francia's 1968 drawing, "The Generals." Beckmann-like in its spiritual horror, the masked, posturing generals serenading their symbolic gagged and bound captive, are figures out of a Walpurgisnacht, their linear expressiveness rooted deep in Gothic art.

The contemporary eye has become so accustomed to abstraction that the literalness of social realism is rarely effective. In an age of photography and television, the strictly representational in social comment usually lacks the relevancy it once had. Aside from artistic reasons, the contemporary mind with any sensitivity to the compelling problems and injustices of today boggles at direct confrontation with social realism. A glancing blow, an indirect expostulation, is more bearable. But it would be premature to assign realism permanently

392 390. "The Generals." Peter de Francia. 1968. 24x30. Charcoal drawing. Collection of the artist.

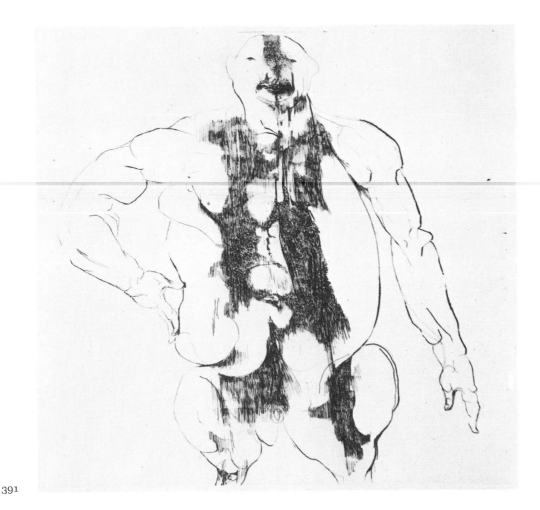

391

to the graveyard of art styles. It is always possible that there will appear a representational artist of sufficient power and masterful draftsmanship to overcome prejudices against his images.

Meanwhile, the most successful protest art is that which communicates to the reader with contemporaneity, with immediacy, and with visual images that are undeniably of this particular time. To assume, as many critics do, that protest in art means the obviously representational is to ignore the stylistic spectrum of art that is making a significant comment.

The highly personal realism of Shahn and Baskin, for example, bears little relationship to social realism. Baskin's "The Sheriff," hand on hip, exudes all the menace of a gun-toting, primordial southern sheriff. But this brutal anatomical man, bloodied in face and hairy in body, is naked and vulnerable, and decaying. A literal representation would be superfluous to an audience that has seen certain southern sheriffs on television. Baskin's art transcends the literal, appeals to the imagination as well as the emotions, and endows his sheriff with broader human implications.

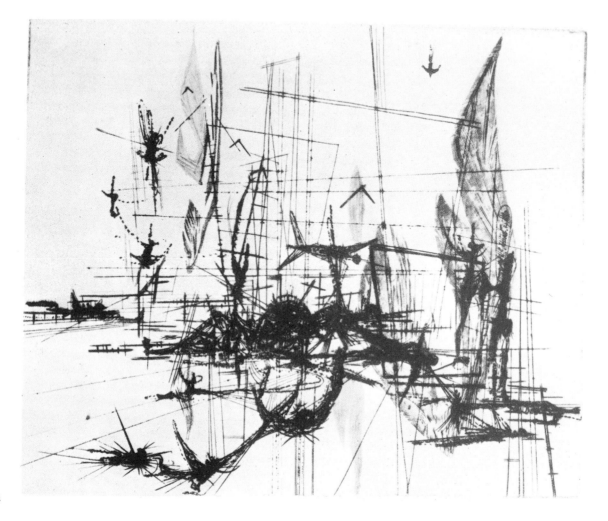

392

Semiabstract art also can be employed to make incisive social comment. The theme of Gabor Peterdi's "The Massacre of the Innocents" is as old as Christian art, the style as young as today, the effect, if studied, as shocking as that of Bruegel's painting. Bombers attack. Tracer bullets make patterns in the sky. The earth is a shambles of horror, chaos abounds. It is a study in planes, lines, forms—and is a powerful comment.

The "Third Reich" figure of Walter Tafelmeir (1935–) is one of those expressively distorted images that have emerged

392. "The Massacre of the Innocents." Gabor Peterdi. 1954. 19⅞x20. Etching and engraving. Collection of the artist, Yale University, New Haven, Connecticut.

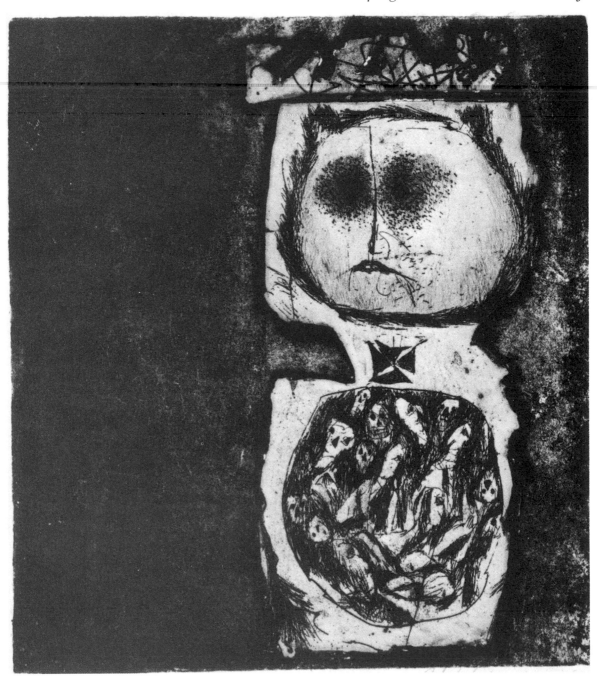

393. "Third Reich." Walter Tafelmeir. 1964. 9x8. Etching. Reproduced from *Tendenzen*, Nov. 1965.

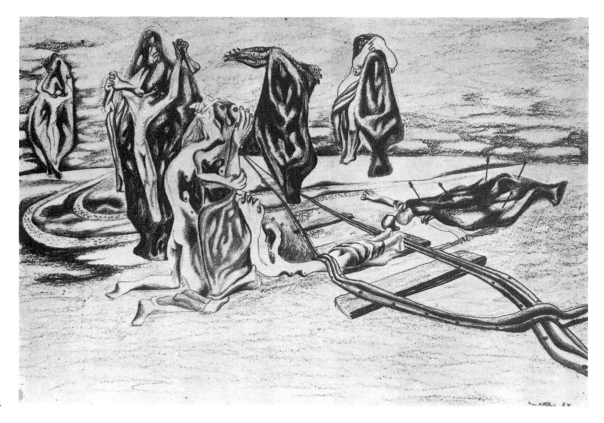

394

in recent years out of the disturbed subconscious of the artist groping for vision in an alienated world. Tafelmeir employs this imagery for social purpose. Perhaps he is saying that all members of the Third Reich were devoured and became its victims, or perhaps he is making explicit comment on the concentration camp inmates. In either case, all are consumed by a predatory, unseeing, cruel-mouthed monster. Tafelmeir's image is a nightmarish shriek of protest, but it can hardly be called "representational."

For that matter, the most celebrated painting in the twentieth century, Pablo Picasso's "Guernica," is far from representational. It employs distortion and symbolism. It is fitting that we close this narrative with a brief look at this greatest of all twentieth-century graphic expressions of indignation. Although "Guernica" as a painting lies outside our scope in this book, it was preceded and followed by many of Picasso's drawings and several etchings on its basic theme. These are our concern.

When Franco rose against the Spanish

394. "Spain." Roberto Sebastian Matta. 1937. 11⅞x19⅛. Colored drawing. Collection of the artist.

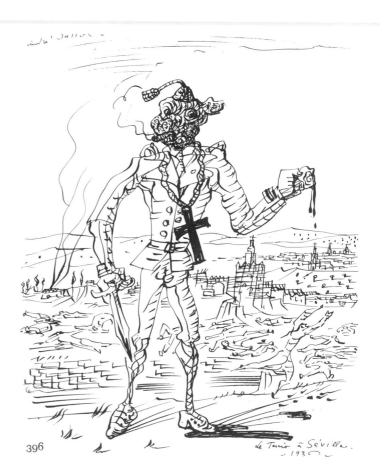

Republican government, artists throughout the world rallied to the Loyalist cause. This trio of two drawings and a poster by surrealistic Chilean artist Roberto Sebastian Matta (1912–), Joan Miró (1893–) from Spain, and André Masson (1896–) from France, indicates how surrealism can be used for social message.

Until 1936, when the Spanish Civil War erupted, there had been little political content in Picasso's work. In his early years, particularly in his Blue Period, he showed

much compassion for the poor and was greatly influenced by Steinlen, but his treatment, while deeply felt, was usually generalized. But the threatened rape of his native land stimulated reactions in Picasso that propelled him and his art into its defense. A rumor that he was profascist

395. "Aidez Espagne." Joan Miró. 1937. 9¾x7⅝. Poster. Gift of Pierre Matisse, Museum of Modern Art, New York.

396. "Le Tercio a Sevilla." André Masson. 1936. 18x14⅛. Drawing. Galerie Louise Leiris, Paris.

397

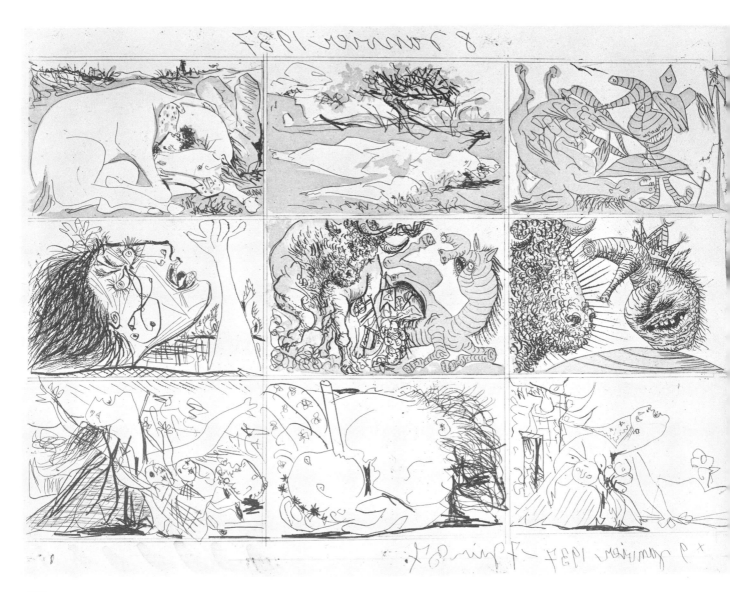

397

proved groundless; shortly after the Franco revolt he accepted appointment from the Spanish Republican government as director of the Prado Museum.

Early in January of 1937 Picasso began work on "The Dream and Lie of Franco," a double etching of 18 panels, and a poem, expressing his abhorrence of the then would-be dictator. The panels, originally to be published separately, read like a comic strip, but from right to left. Franco, in various disguises, is a weird, hairy monster with tubular feelers. He is finally crushed, in the fourteenth panel, by a bull, representing brute force.

Some of the symbolism, revealed in the poem accompanying the etching, is a Joycean outpouring of his disgust: ". . . fandango of shivering owls source of evil-omened polyps scouring brush of hairs from

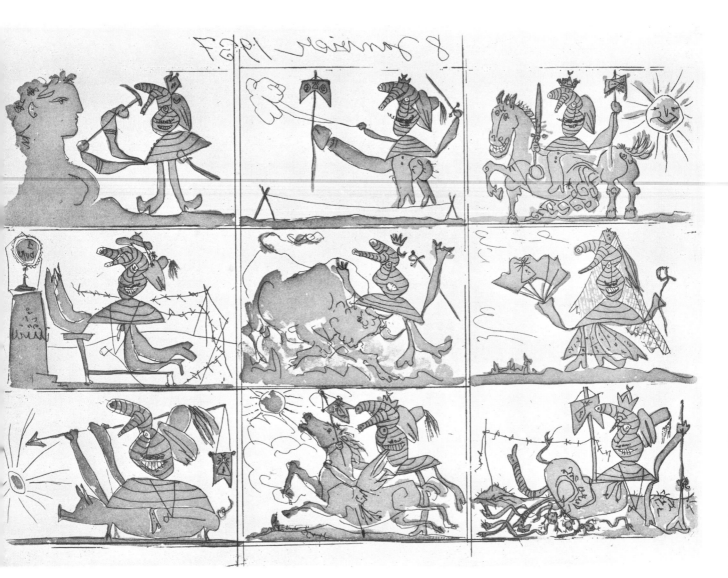

priests' tonsures standing naked in the middle of the frying-pan—placed upon the ice cream cone of codfish fried in the scabs of his lead-ox-heart—his mouth full of the chinch-bug jelly of his words. . . ."

The last four panels, added in the third state, are themes later reproduced in Picasso's "Guernica," which he was working on during his production of the etching.

On April 26, 1937, for precisely three hours and a quarter, waves of German bombers and fighter planes bombed and machinegunned the civilian population of the proud, ancient Basque town of Guernica. Within a week Picasso began work on a mural for the building of the Spanish Government-in-Exile at the World's Fair in Paris. He had been asked in January to paint the mural; now he had a theme.

Picasso did study after study, detail after

398. "The Dream and Lie of Franco." Pablo Picasso. Jan. 8–9, 1937. 12⅜x16⁹⁄₁₆. Etching and aquatint. Gift of Mrs. Stanley Resor, Museum of Modern Art, New York.

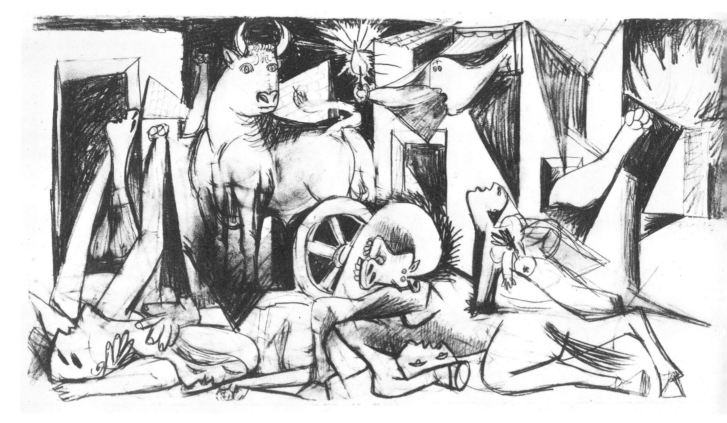

399

detail, in pen or pencil, during that fever-ish month of May. On the ninth he made a pencil drawing, the final study for the composition as a whole, which contained most of the elements that were to appear in the painting.

Chaos prevailed in both sketch and painting, although in the latter he brought some order. For example, he anchored the scene at both ends by moving the bull to the left and adding, at the right, a falling woman with hands upraised. The chaos is singu-larly appropriate: the chaos left when all of man's moral standards disintegrate, the physical chaos when bombs tumble humanity and buildings into a tangled mass, as in Goya's etching "Ravages of War" in the "Desastres."

Except for the fallen warrior at the lower left, the victims are women. How better could Picasso, who loved woman and women, express his loathing of the brutality of the act? How could he more effectively demonstrate the defenselessness of

399. "Composition Study." Pablo Picasso. May 9, 1937. 9½x17⅞. Pencil on white paper. On extended loan from the artist to the Museum of Modern Art, New York.

humanity in such an air raid than by portraying the agony of women under attack, as indeed, they were—it was market day and Guernica was filled with women and children from the countryside.

In the top center an unscathed townswoman thrusts out a candle that lights up the scene. "Behold what has been wrought!" she seems to be saying, like the commentator in one of Shakespeare's tragedies when the bodies are piled up on stage.

The indomitable, threatening bull, to which all eyes are drawn, has baffled interpretation. In 1945 Picasso, denying that the bull represented fascism, declared, ". . . it is brutality and darkness. . . . The horse represents the people. . . . The Guernica mural is symbolic . . . allegoric." But later he told another interviewer, "The bull is a bull. The horse is a horse. These are animals, massacred animals. That's all, so far as I am concerned." Perhaps Picasso was tired of the controversy and later not sure what he originally had in mind. Even at the moment of execution one would have to peel away layers of subconsciousness to determine an artist's motivation for a particular piece of symbolism. The most logical explanation is that the bull stands for the "imperturbable image of Spain," as Rudolf Arnheim has suggested. But the soul of Spain has its dark, primitive side, as Goya has shown.

There are no planes, no bombs, no towns, no recognizable landmarks in "Guernica," but instantly recognizable is the cry of protest against wanton destruction. The vio-

400

lated bodies shriek with the distortion of pain, as agonized martyrs writhed when they were subjected to torture. The detailed drawings show this anguish in closeup.

The sketch for the head of a horse expresses the piercing outcry of the wounded animal. These few strokes are typical of Picasso's genius: the dynamic upward thrust, the stiff, pointed tongue, the tense lines of the neck, the open jaw—all shriek with unbearable pain.

400. "Head of Horse." Pablo Picasso. May 2, 1937. 8½x6. Pencil on blue paper. On extended loan from the artist to the Museum of Modern Art, New York.

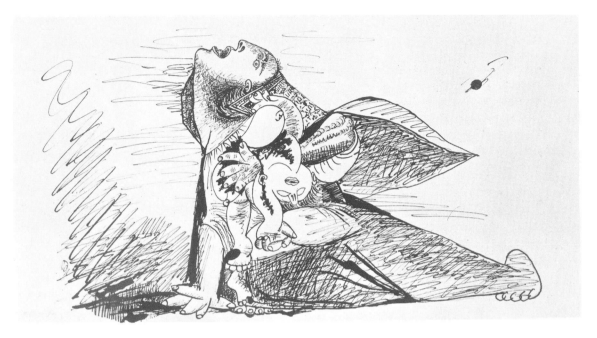

401

402

The pen drawing of the mother with dead child also has an unparalleled intensity, with the mother, her head pulled back in agony, crying out in terror as she clutches her stillborn child between her overflowing, unfulfilled breasts.

Missing from the final overall pencil composition, but included in the painting, is a woman falling, hands upraised beseechingly as flames lick around her. Two weeks after Picasso painted her into the mural, he sketched a bearded man falling. The sex is changed, but the emotion and the means for expressing this emotion are the same. The head is turned at right angles to the neck, perhaps to emphasize the pull of gravity, just as one eye and one nostril are

401. "Mother with Dead Child." Pablo Picasso. May 9, 1937. 9½x17⅞. Pen and ink on white paper. On extended loan from the artist to the Museum of Modern Art, New York.

402. "Falling Man." Pablo Picasso. May 27, 1937. 9½x11½. Pencil and gray gouache on white paper. On extended loan from the artist to the Museum of Modern Art, New York.

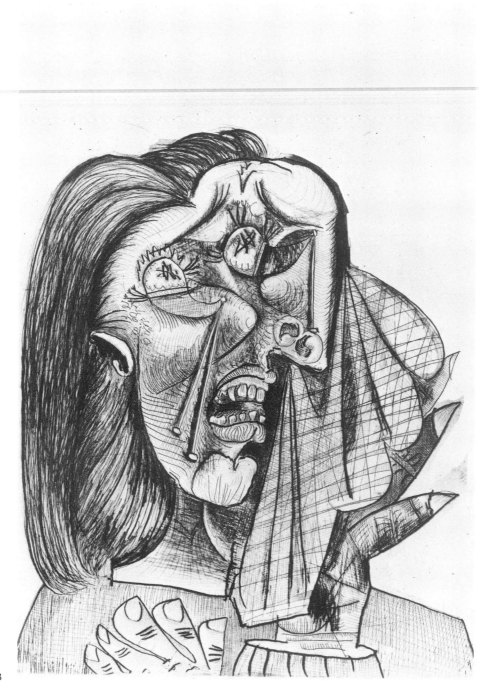

403

403. "Weeping Woman." Pablo Picasso. July 2, 1937. 27¼x19½. Etching and aquatint. On extended loan from the artist to the Museum of Modern Art, New York.

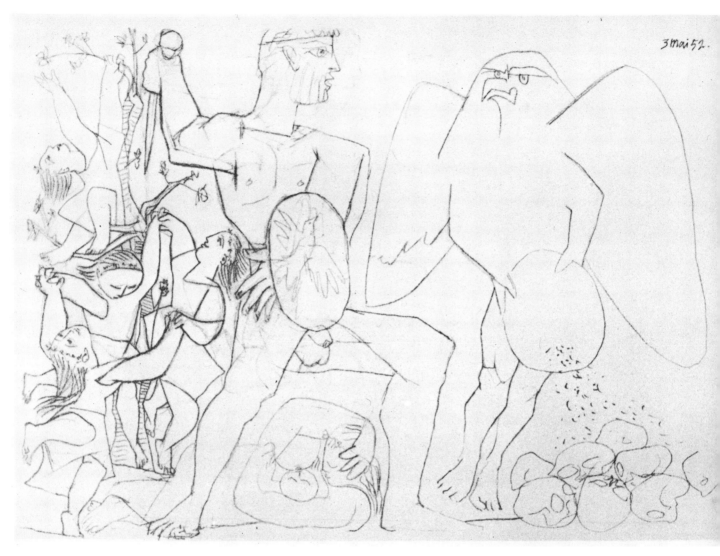

vertical, the other horizontal. Like the woman and the horse, he, too, cries out as he hurls through space.

"Guernica" was vigorously attacked and defended when it was exhibited. Picasso was criticized for being obscure, for not using color, for being too cold and abstract. Stephen Spender remarked that the critics were "merely making the gasping noises they might make if they were blown off their feet by a high explosive bomb."

After "Guernica" was completed, Picasso continued to elaborate on some of the motifs, particularly that of the "Weeping Woman." In July he completed an etching and aquatint on the subject, reproduced here. Rarely, if ever, has the paroxysm of grief been expressed so shatteringly. She

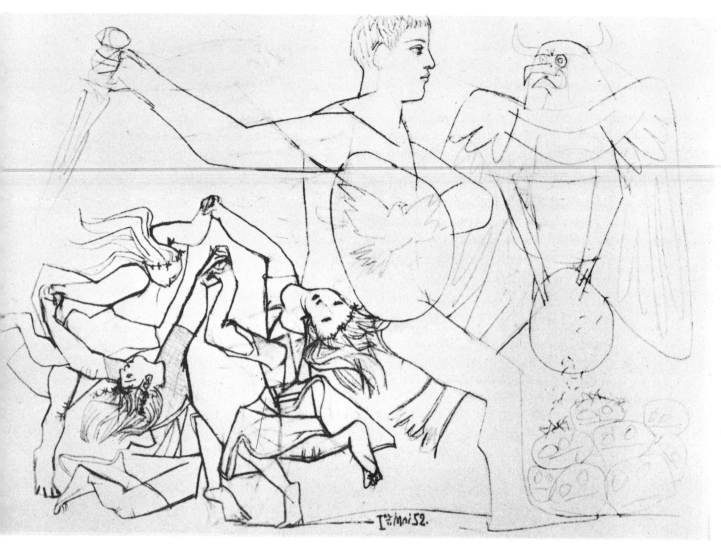

weeps for death, perhaps for her destroyed beauty, surely for the senseless waste of war. The image is heartbreaking, despite the fact that Picasso stylized the hair, eyes, eyelids, and tears.

Picasso returned many times to the theme of war and peace. In 1952 his drawings for a mural, "La Guerre et La Paix," were published in a beautiful series depicting the symbols of his recurring theme. The flowing line, aesthetically so pleasing, often deprived the content of any force. In a few of the drawings, however, where he confronted his figures of war with those of peace, the contrast strengthened the image. In this drawing, while children dance or climb a tree and a woman suckles her babe, a warrior faces the war god who is spilling

405. Drawing. Pablo Picasso. 1951. Reproduced from "La Guerre et La Paix," 1952.

his harvest of skulls. The symbolism is obvious, but Picasso's masterful line gives it compelling power and saves it from being maudlin. As a comment on war, its simplistic statement provides a stunning contrast to the hidden recesses of "Guernica."

Obviously, artists can draw upon a variety of approaches to express their indignation at society's failings. It is also self-evident that not all styles provide a means for communicating a social message; triangles and squares are not exactly ideal for communicating criticism. Some figurative component will nearly always be necessary. But as long as there is passionate concern, as long as some artists combine commitment with mastery of technique and depth of perception, involved art will be created that is neither dull, crude, nor obvious.

The styles and techniques will evolve, just as the issues themselves are shifting and growing subtler. Anticlericalism, for example, is no longer relevant in many areas, including some of those in which it was a dominant issue for most of the period covered by this survey. In an era of powerful unions, the forces of labor and capital are approaching a more even balance, at least in some parts of the western world.

But war still threatens, the struggles for freedom from discrimination or dictatorship or colonialism still continue. The most critical issue facing mankind today—race relations—has been touched only superficially by black as well as white artists and is obviously an area which will absorb many artists in the future. As the relationship between the individual and his government grows more complex and the very nature of social and political organization is transformed in many nations, other issues arise. For five hundred years artists have taken up burin or needle or pen to portray injustice or inequity. It is most likely that there will continue to be artists of sufficient compassion and skill to carry on that honorable tradition of the indignant eye with artistic relevancy and integrity.

Notes and Bibliography

Since this book is a survey, the bibliography serves mainly to indicate the principal sources of information and to cite specific references. It is obviously not meant to be definitive. The periodical literature references are highly selective. Since most of the vast literature is tangential to this subject, only the minimal references to the most pertinent are listed.

GENERAL REFERENCES

(Note: Detailed bibliographies for specific subjects will be found under each chapter listing below.)

Of general histories of prints or surveys of printmaking, most valuable are Arthur M. Hind, *A History of Engraving and Etching* (New York: paperback edition, 1963), which stops at 1914; the much less detailed but more up-to-date general survey by Carl Zigrosser, *The Book of Fine Prints* (New York: 1956); and Jean Laran, *L'Estampe*, 2 vols. (Paris: 1959). Also useful have been F. L. Leipnik, *A History of French Etching* (London: 1924); Herman J. Wechsler, *Great Prints and Printmaking* (New York: 1967); Douglas P. Bliss, *A History of Wood Engraving* (London: 1928); James Cleaver, *A History of Graphic Art* (London: 1963); Anthony Bertram, *1000 Years of Drawings* (London: 1966).

Specialized surveys include: Jean Adhémar, *Graphic Art of the 18th Century* (New York: 1964); Claude Roger-Marx, *Graphic Art of the 19th Century* (New York: 1963); Paul J. Sachs, *Modern Prints and Drawings* (New York: 1954); Frank Weitenkampf, *American Graphic Art* (New York: 1924).

Useful biographies of individual artists appear in Ulrich Thieme and Felix Becker, *Allgemeines Lexikon der Bildenden Künstler,* 35 vols. (Leipzig: 1907–50).

The basic *catalogues raisonnés* are indispensable, of course: Adam von Bartsch, *Le Peintre Graveur,* 21 vols. (Würzburg: 1920); Johann David Passavant, *Le Peintre Graveur,* 6 vols. (Leipzig: 1860–64); F. W. H. Hollstein, *German Engravings, Etchings, and Woodcuts, ca. 1400–1700,* 5 vols. (Amsterdam: 1954); F. W. H. Hollstein, *Dutch and Flemish Etchings, Engravings, and Woodcuts, ca. 1450–1700,* vols. 1— (Amsterdam: 1949); and the various volumes by Loys Delteil on prints of the 19th and 20th centuries.

The basic historical approach to art in its social context is Arnold Hauser's *The Social History of Art,* 4 vols. (New York: 1958); but invaluable as it is, Prof. Hauser's wide-ranging work embraces all the arts, especially literature, and rarely touches upon the specifics in the world of prints with which we are concerned here. Also useful for background in any discussion of the artist and his relation to society are Bernard S. Myers' historical review, *Art and Civilization* (New York: 1957); Sir Herbert Read, *The Grass Roots of*

Art (Cleveland: 1961); D. W. Gotshalk, *Art and the Social Order* (New York: 1962); Geraldine Pelles, *Art, Artists and Society* (Englewood Cliffs, N.J.: 1963), challenging although specifically concerned with painting in England and France, 1750–1850; Jacques Maritain, *The Responsibility of the Artist* (New York: 1960; the chapters on laughter and caricature in Charles Baudelaire, *The Mirror of Art* (New York: 1956). The Gotshalk, Pelles, and Maritain books examine, with varying reservations, the artist's involvement with society. The Marxist approach to the artist's role as social critic is found in Louis Harap, *Social Roots of the Arts* (New York: 1949); Sidney Finkelstein, *Art and Society* (New York: 1947); and Sidney Finkelstein, *Realism in Art* (New York: 1954). For criticism of Marxist analysis of art history, see John R. Martin, "Marxism and the History of Art," *College Art Journal*, XI, no. 1, Fall, 1951. The most eloquent treatment of the need for content in art, by artist or critic, is Ben Shahn's *The Shape of Content* (New York: 1960). On the specific subject of the artist and war: Hélène Parmelin, *Le Massacre des Innocents* (Paris: 1954), emotional impressions rather than a scholarly review, useful but not always reliable in references; *War and Peace,* Man Through His Art, vol. 1 (Greenwich, Conn.: 1964), a UNESCO-sponsored publication on war and peace in painting and sculpture.

Basic source books of satirical or critical art are: Eduard Fuchs, *Der Weltkrieg in der Karikatur* (Munich: 1916); Eduard Fuchs and Hans Kraemer, *Die Karikatur der Europäischen Völker,* 2 vols. (Berlin: 1906); Otto Rühle, *Illustrierte Kultur und Sittengeschichte des Proletariats* (Berlin: 1930).

There have been a few recent books concerned with some aspect of the printmaker or draftsman as social critic: Frank and Dorothy Getlein, *The Bite of the Print* (New York: 1963), a collection of unfailingly stimulating essays on the leading social printmakers, discusses "satire and irony in woodcuts, engravings, etchings, lithographs, and serigraphs"; Eugenia M. Herbert, *The Artist and Social Reform: France and Belgium, 1885–1898* (New Haven: 1961), an exemplary study of the artist as social reformer, which successfully integrates the radical artists of late nineteenth-century France with the cultural, economic, social, and political atmosphere; Oliver W. Larkin's biography, *Daumier: Man of His Time* (New York: 1966), a rare biography of an artist that relates his work to the historical, social, and political developments; Paul Hogarth's brief study, *The Artist as Reporter* (London and New York: 1967).

Histories of caricature: Champfleury [Jules Fleury], *Histoire de la Caricature,* 5 vols. (Paris: n.d.); Thomas Wright, *A History of Caricature and Grotesque in Literature and Art* (London: 1864); James Parton, *Caricature and Other Comic Art* (New York: 1877); Bohun Lynch, *A History of Caricature* (Boston: 1927); Werner Hofmann, *Caricature from Leonardo to Picasso* (New York: 1957); E. H. Gombrich and Ernst Kris, *Caricature* (London: 1940); Arthur B. Maurice and Frederic T. Cooper, *The History of the Nineteenth Century in Caricature* (New York: 1904). For more specialized histories of caricatures, see individual chapters below.

The most useful exhibition catalogues in this area have been: Jean Adhémar, *L'estampe satirique et burlesque en France,*

1500–1800 (Paris: 1950); *Cartoon and Caricature from Hogarth to Hoffnung* (London: 1962); *Arte e Resistenza in Europa* (Bologna and Torino: 1965); and *Engagierte Kunst: Gesellschaftskritische Grafik Seit Goya* (Linz: 1966).

Useful books on printmaking techniques are: Jules Heller, *Printmaking Today* (New York: 1958); Gabor Peterdi, *Printmaking Methods Old and New* (New York: 1959); Kristian Sotriffer, *Printmaking, History and Technique* (New York: 1968).

Introduction

Panofsky reference from Erwin Panofsky, *Life and Art of Albrecht Dürer* (Princeton, N.J.: 1955), p. 45.

Shahn quote on print as essay from *Fine Prints*, International Graphic Arts Society booklet (New York: 1956), p. 2.

Quotation by Charles H. George from his *Revolution: Five Centuries of Europe in Conflict* (New York: 1962), p. 10.

Baudelaire statement in Charles Baudelaire, *The Mirror of Art*, p. 171.

Passage from Ben Shahn, *The Shape of Content*, p. 95.

1. Prologue: The Fifteenth Century

General background: Useful reviews were Edward P. Cheyney, *The Dawn of a New Era, 1250–1453* (New York: 1936); *Cambridge Medieval History*, vol. 7 (Cambridge: 1932); Henry Osborne Taylor, *The Medieval Mind*, 2 vols. (Cambridge: 1949); J. Huizinga, *The Waning of the Middle Ages* (New York: 1954); Henri Pirenne, *Medieval Cities, Their Origins and the Revival of Trade* (New York: 1956); George Trevelyan, *England in the Age of Wycliffe* (London: 1925).

For printmaking in the fifteenth century, see A. M. Hind, *An Introduction to a History of Woodcut*, 2 vols. (New York: 1963); Hugo Schmidt, *Bieder-Katalog zu Max Geisberg: Der Deutsche Einblatt-Holzschnitt in der ersten Hälfte des XVI Jahrhunderts* (Munich: 1930); Wilhelm Ludwig Schreiber, *Manuel de l'Amateur de la Gravure sur Bois et sur Métal du XVe Siècle*, 8 vols. (Berlin: 1891–1911); Max Lehrs, *Geschichte und Kritischer Katalog des Deutschen, Niederländischen, und Franzosischen Kupferstichs in 15 Jahrhunderts*, 9 vols. (Vienna: 1908–34); Paul Kristeller, *Kupferstich und Holzschnitt in Vier Jahrhunderten* (Berlin: 1922); André Blum, *The Origin of Printing and Engraving* (New York: 1940); Elizabeth Mongan and Carl O. Schniewind, eds., *The First Century of Printmaking, 1400–1500* (Chicago: 1941), a catalogue of representative prints.

L. Maeterlinck's *Le Genre Satirique dans la Peinture Flamande*, 2nd ed. (Brussels: 1907) is the only study of satirical Flemish art, but unfortunately not always reliable.

The literature on the Master E.S. is extensive. Particularly useful were: Max Geisberg, *Die Kupferstiche des Meisters E.S.* (Berlin: 1924) reproduces every E.S. engraving known to Lehrs and Geisberg. Max Geisberg, *Der Meister E.S.*, Meister der Graphik series (Leipzig: n.d.); Peter P. Albert, *Der Meister E.S.*,

sein Name, sein Heimat und sein Ende (Strasbourg: 1911); Sir Lionel Cust, *The Master E.S. and the Ars Moriendi* (Oxford: 1898); Max Geisberg, "The Master E.S.," *Print Collector's Quarterly,* IX, October 1922; Arthur M. Hind, *A History of Engraving and Etching,* pp. 24–27; M. Hirsch, "Das Figurenalphabet des Meisters E.S.," *Kunstwissenschaftliche Forschungen,* II, 1933.

For a detailed description of the peasant revolts that swept Europe and England in the late fourteenth century, see especially Charles H. George, *Revolution,* chs. 1, 2, and 3; Edward P. Cheyney, *The Dawn of a New Era, 1250–1453* (New York: 1962), chs. 4 and 7; B. Jarrett, *Social Theories of the Middle Ages, 1200–1500* (New York: 1942).

Definitive book on Bosch is Charles de Tolnay, *Hieronymus Bosch* (New York: 1966). Also useful: Jacques Combe, *Heronimus Bosch* (Paris: 1946); L. Van Baldass, *Hieronymus Bosch* (New York: 1960); M. Brion, *J. Bosch* (Paris: 1938); R. L. Delevoy, *Jerôme Bosch* (Geneva: 1960); the chapter on Bosch in Carel van Mander, *Dutch and Flemish Painters* (New York: 1936); and O. Benesch, "Hieronymus Bosch and the Thinking of the Late Middle Ages," *Kunsthistorik Tidskrift,* vol. 26, 1957.

The symbolism of "The Mussel Shell Boat" (still another name for the Bosch print) is discussed by S.W.R. in the *Boston Museum Bulletin,* vol. LXII, no. 330, 1964, pp. 152–153.

The quotations from *The Ship of Fools* are taken from the English edition translated by Alexander Barclay, published in London in 1509, vol. 1, p. 99, and vol. 2, p. 99, respectively. The woodcuts are based on the Basel designs either directly or through one of numerous editions of copies, according to Hind's *An Introduction to a History of Woodcut,* p. 730.

For further reading on *The Ship of Fools'* illustrations see: Friedrich Winkler, *Dürer und die Illustrationen zum Narrenschiff* (Berlin: 1951); Werner Weisbach, *Die Baseler Buchillustration des XV Jahrhundert* (Strasbourg: 1896); Hans Kogler, *Gesellschaft der Bibliophilen* (Weimar: 1906).

Thomas Wright calls "Le Revers du jeu des Suisses" the "earliest political cartoon" and gives a lengthy explanation of this print in his *History of Caricature,* p. 348.

II. *The Artist Fights the Church Establishment: The Sixteenth Century*

General Background: Roland H. Bainton, *The Age of the Reformation* (Princeton, N.J.: 1956); James A. Corbett, *The Papacy* (Princeton, N.J.: 1956); Harold Grimm, *The Era of the Reformation* (New York: 1954); F. C. Palm, *Calvinism and the Religious Wars* (New York: 1932); O. Benesch, *The Art of the Renaissance in Northern Europe* (Cambridge: 1947).

For Holbein: Alfred Woltmann, *Holbein and His Time* (London: 1872); F. Saxl, "Holbein's Illustrations and the 'Praise of Folly,'" *Burlington Magazine,* no. 83, 1943, pp. 275–279; F. Saxl, ch. "Holbein and the Reformation" in *Lectures, I* (London: 1957); Carel van Mander, *Dutch and Flemish Painters.*

Reformation pamphlets and broadsheets: F. Saxl, ch. "Illustrated Pamphlets of the

Reformation," *Lectures I*, p. 255; A. Hyatt Mayor, "Renaissance Pamphleteers—Savonarola and Luther," *Metropolitan Museum Bulletin*, October 1947, pp. 66–72.

For general account of Luther's political polemicism: H. Grisar and F. Heege, *Luther's Kampfbilder*, 3 vols. (Freiberg: 1921–23). Also, R. H. Bainton, *Here I Stand: A Life of Martin Luther* (New York: 1950).

Cranach: Pierre Descarques, *Cranach* (New York: 1961).

Dürer's Diary quotation, May 17, 1521, see Wolfgang Stechow, ed., *Northern Renaissance Art, 1400–1600, Sources and Documents* (Englewood Cliffs, N.J.: 1966). For study of Holbein's *Praise of Folly* drawings, see Facsimile Edition of Erasmus' 1515 Basel *Moriae Encomium* 2 vols. (Basel: 1931), with an introduction and translation by H. A. Schmid; quotations cited, p. 30. For background of "Dance of Death" theme: J. M. Clark, *The Dance of Death* (London: 1947). Erasmus' disillusionment with Holbein quoted in Saxl article in *Burlington Magazine*, no. 83, 1943.

A standard general history of the Netherlands during the Spanish occupation is Pieter Geyl, *The Revolt of the Netherlands, 1555–1609* (New York: 1958).

Catalogues raisonnés of Bruegel drawings are: Ludwig Münz, *Bruegel, the Drawings* (London: 1961); and Charles de Tolnay, *The Drawings of Pieter Bruegel the Elder* (London: 1952). Also helpful: Charles de Tolnay, *Pierre Bruegel l'Ancien* (Brussels: 1935); H. Arthur Klein, *The Graphic Worlds of Peter Bruegel the Elder* (New York: 1963); Adrian J. Barnouw, *The Fantasy of Pieter Brueghel* (New York: 1947); Robert L. Delevoy, *Bruegel* (Geneva: 1959); Fritz Grossman, *Bruegel*

(London: 1966); René van Bastelaer, *Les Estampes de Peter Bruegel l'Ancien* (Brussels: 1908); Gustave Glück, *The Large Bruegel Book* (Vienna: 1952); Howard McParlin Davis, "Fantasy and Irony in Peter Bruegel's Prints," *Metropolitan Museum Bulletin*, June 1943, p. 291; Irving L. Zupnick, "Bruegel and the Revolt of the Netherlands," *Art Journal*, vol. 23, no. 4, Summer 1964; Introduction by Ebria Feinblatt to exhibit catalogue, *Prints and Drawings of Peter Bruegel the Elder*, Los Angeles County Museum (1961).

Quotation from Hauser, *The Social History of Art*, vol. 2, p. 246. Bruegel-Bosch comparison made by Feinblatt, *op. cit.*, p. 10. Reference to Bruegel's wife burning inscriptions from van Mander, *Dutch and Flemish Painters*, p. 156. For interpretation of hidden political motifs in Bruegel's paintings, see Delevoy, *op. cit.*, pp. 69–95. De Tolnay comment from his *Drawings*, pp. 75–76.

Netherlands caricatures will be found in: C. A. Veth, *Geschiedenis van de Netherlandsche Caricatuur* (Leyden: 1921) and his *De Politicke Prent in Nederland* (Leyden: 1920); J. Van Kuyk, *Oude politicke Spotprenten* (The Hague: 1940).

For French 16th and 17th century background, good surveys are: *Cambridge Modern History*, vols. 3 (1904) and 5 (1908).

For French 16th century satirical prints, see Michel Rogan, *Le Dessin D'Humour* (Paris: 1960); André Blum, *L'Estampe Satirique en France pendant les Guerres de Religion* (Paris: 1916).

For background on Perrissin and Tortorel prints, see *Les Grandes Scènes Historiques due XVIᵉ Siècle:* Reproduction Facsimile du Recueil de J. Tortorel et J. Perrissin (Paris: 1886).

Cornélis Dusart's caricatures of Louis XIV and the Archbishop of Rheims taken from *Les Héros de la Ligue* ou *La Procession Mo-* *nacale Conduitte par Louis XIV pour la Conversion des Protestans de son Royaume* (Paris: 1691).

<p style="text-align:center">III. *The Artist, the Peasant, and War:*
The Seventeenth Century</p>

For general background, David Ogg, *Europe in the Seventeenth Century* (New York: 1962); *Cambridge Modern History*, vols. 4 (1906) and 5 (1908); C. V. Wedgwood, *The Thirty Years War* (New York: 1961).

For specialized studies, see William A. Coupe, *The German Illustrated Broadsheet in the Seventeenth Century* (Baden-Baden: 1967), for an exhaustive historical and iconographical study of this popular art form. Also: H. Wäscher, *Das Deutsche Illustrierte Flugblatt*, vol. I (Dresden: 1955); E. A. Beller *Propaganda in the Thirty Years War* (Princeton: 1940).

For critical study of Urs Graf, see Emil Major, *Urs Graf* (London: 1947).

Catalogue raisonné of Callot is J. Lieure, *Jacques Callot*, 8 vols. (Paris: 1924–29). Also valuable are: Edwin deT. Bechtel, *Jacques Callot* (New York: 1955); Édouarde Meaume, *Recherches sur la Vie et les Ouvrages de Jacques Callot*, 2 vols. (Paris: 1860). Edwin de T. Bechtel, "Jacques Callot, and His Prints from the 'Battles of the Medici' to 'The Miseries of War'", *Print Collectors Quarterly*, vol. 29, no. 1, February 1942; William Gaunt, "Jacques Callot: The Interpreter of an Age," *London Studio*, April 1936. See also A. Hyatt Mayor's brilliant essay, "Jacques Callot," *The Massachusetts Review*, Autumn 1961, and his "Callot and Daumier," *Metropolitan Museum of Art Bulletin*, Summer 1958; Ebria Feinblatt's Introduction to catalogue of Callot exhibition, Los Angeles County Museum, 1957; and Elizabeth Mongan's Introduction to catalogue of Callot exhibition, National Gallery of Art (Washington: 1963).

J. Lieure quotation, *op. cit.*, p. 119.

DeT. Bechtel quotation, *Jacques Callot*, p. 33.

Romeyn de Hooghe's illustrations of the French invasion of the Netherlands are reproduced in George Hirth, *Kulturgeschichtliches Bilderbuch*, 6 vols. (Leipzig and Munich: n.d.).

<p style="text-align:center">V. *The English Artist as Social Critic:*
From Hogarth to Cruikshank</p>

For general background of the period, R. W. Harris, *A Short History of Eighteenth Century England, 1689–1793* (London and New York: 1963); J. H. Plumb, *England in the Eighteenth Century (1714–1815)* (Baltimore: 1964); T. S. Ashton, *An Economic History of England, The Eighteenth Century* (London: 1955); M. S. Anderson, *Eighteenth-Century Europe, 1713–1789* (London and New York: 1966); M. Dorothy George, *London Life in the Eighteenth Century* (New York: 1965).

The basic reference book for the history of prints in this period is the British Museum, *Catalogue of Prints and Drawings in the Brit-*

ish Museum, Division I: Political and Personal Satire, 11 vols. [vols. 1–4 ed. by F. G. Stephens, vols. 5–11 by M. Dorothy George] (London: 1870–1954). More selective and more pertinent to this purpose is M. Dorothy George, *English Political Caricature: A Study of Opinion and Propaganda,* vol. I: to 1792; vol. II: 1793–1832 (Oxford: 1959). A more

popularized skimming is M. Dorothy George, *Hogarth to Cruikshank: Social Change in Graphic Satire* (New York: 1967). Also Jean Adhémar, *Graphic Art of the Eighteenth Century* (London: 1964), pp. 60–70, 191–194; and George Paston, *Social Caricature in the Eighteenth Century* (London: 1905).

HOGARTH

The *catalogue raisonné* of Hogarth's etchings is Ronald Paulson, *William Hogarth's Graphic Works,* 2 vols. (New Haven: 1965). For his drawings, see A. P. Oppe, *The Drawings of William Hogarth* (New York: 1948). For bibliography, see Stanley E. Reed, *A Bibliography of Hogarth Books and Studies, 1900–1940* (Chicago: 1941). See also William Hogarth, *The Analysis of Beauty, 1753,* edited by Joseph Burke (London: 1955).

For life and assessment of Hogarth's works, see Frederick Antal, *Hogarth and His Place in European Art* (London: 1962); Marjorie Bowen, *William Hogarth, The Cockney's Mirror* (New York: 1936); Peter Quennell, *Hogarth's Progress* (London: 1955); F. D. Klingender, *Hogarth and English Caricature* (London: 1946); Austin Dobson, *William Hogarth* (London: 1907); *Hogarth's Times* (London and Emmaus, Pa.: 1956).

Among recent periodical articles, see "New Light on Hogarth's Graphic Works," Ronald

Paulson, *Burlington Magazine,* vol. 109, May 1967, pp. 281–286; "An inexplicable miracle rationalized," *Apollo,* No. 77, August 1967, pp. 464–469; "Morals and Mime: Essential Hogarth," J. Summerson, *Art News,* vol. 65, February 1967, pp. 22–25.

Reference to Hollar's "The Patenty," Paulson, *William Hogarth's Graphic Works,* vol. I, p. 5.

Hogarth quotation on bold strokes to express passion, from Adhémar, *op. cit.,* 66.

Bowen comment on "Identity and Idleness," Bowen, *op. cit.,* p. 127.

Hogarth's quotation on *The Four Stages of Cruelty,* from Quennell, *op. cit.,* p. 208.

For an interesting description of gin consumption in mid-eighteenth-century London and the effects of Hogarth's *Gin Lane,* see T. G. Coffey, "Beer Street, Gin Lane: Some Views of 18th Century Drinking," in *Quarterly Journal of Studies on Alcohol,* vol. 27, no. 4, December 1966.

ROWLANDSON

The *catalogue raisonné* of Rowlandson is Joseph Grego, *Rowlandson the Caricaturist,* 2 vols. (London: 1880).

Other documentation in Arthur W. Hein-

tzelman, *The Watercolor Drawings of Thomas Rowlandson* (New York: 1947); Adrian Bury, *Rowlandson Drawings* (London: 1949); *Rowlandson Drawings for the English Dance of*

Death, introduction by Robert R. Wark (San Marino, Calif.: 1966); Bernard Falk, *Thomas Rowlandson, His Life and Art* (London: 1949); Art Young, *Thomas Rowlandson* (New York: 1938); A. Hyatt Mayor, "Rowlandson's England," *Metropolitan Museum Bulletin*, vol. 20, February 1962, pp. 185, 201.

GILLRAY

Joseph Grego, *The Works of James Gillray the Caricaturist* (London: 1873); Thomas Wright and R. H. Evans, *Historical and Descriptive Account of the Caricatures of James Gillray* (London: 1851). A recent valuable study is Draper Hill, *Mr. Gillray, the Caricaturist* (London and Greenwich, Conn.: 1965).

Gillray's manners reference, Hill, *op. cit.*, p. 45.

GEORGE CRUIKSHANK

Catalogues raisonnés of George Cruikshank are George W. Reid, *A Descriptive Catalogue of George Cruikshank*, 2 vols. (London: 1871), and Albert M. Cohn, *George Cruikshank: A Catalogue Raisonné of the Works Executed During the Year 1806–77* (London: 1924).

The chief pamphlets by William Hone with illustrations by George Cruikshank are: *Facetiae and Miscellaneous* (London: 1827), including *The Political House that Jack Built*, *The Political Showman at Home*, and *A Political Christmas Carol*.

George reference to historical significance of Hone pamphlets, George, *op. cit.*, vol. II, p. 185.

A file of *The Political Drama*, with cartoons by Charles J. Grant will be found in the British Museum.

VI. *Goya*

For background of Spain in Goya's time, see any standard history of Spain, such as Charles E. Chapman, *A History of Spain* (New York: 1931), or C. E. Kany, *Life and Manners in Madrid, 1750–1800* (Berkeley, Calif.: 1932). Some particularly vivid statistics are in Chapter I of F. D. Klingender, *Goya in The Democratic Tradition* (London: 1948), but for counterbalance to Klingender, see Arturo Borea's review, *Burlington Magazine*, May 1950.

The *catalogue raisonné* of Goya's prints: Tomás Harris, *Goya: Engravings and Lithographs*, 2 vols. (Oxford: 1964). Collections with text include Enrique Lafuente Ferrari, *Goya: Complete Etchings, Aquatints, and Lithographs* (London: 1963), a scholarly and reliable interpretation; *The Complete Etchings of Goya* with Foreword by Aldous Huxley (New York: 1943); F. J. Sánchez-Canton, *Los Dibujos de Goya* (Madrid: 1954); *Goya Drawings and Prints: from the Museo del Prado and the Museo Lazaro Galdiano, Madrid, and the Rosenwald Collection* (Washington: 1955); André Malraux, *Goya: Drawings from the Prado* (London: 1947); Robert Th. Stoll, *Goya, Drawings* (New York and

Basel: 1954); José Lopez-Rey, *A Cycle of Goya's Drawings* (New York: 1956); José Lopez-Rey, *Goya's Caprichos: Beauty, Reason, and Caricature* (Princeton, N.J.: 1953).

Among the many studies of Goya are: F. J. Sánchez-Canton, *Goya* (New York: 1964); André Malraux, *Saturn: An Essay on Goya* (New York and London: 1957); Xavière Desparmet Fitz-Gerald, *Goya* (New York: 1956); Vyvyan D. Holland, *Goya: A Pictorial Biography* (London: 1961; Elie Faure and Xavier de Sales, *The Disasters of War* (New York: 1956).

Some of the most useful of the innumerable periodical articles on Goya: C. O. Schniewind, "Los Caprichos," in the *Chicago Art Institute Bulletin*, vol 42, 1948; A. Hyatt Mayor, "Goya's Creativeness," *Metropolitan Museum Bulletin*, vol. 5, December 1946, and "Goya's Disasters of War," *American Magazine of Art*, November 1936; for a Freudian interpretation, see Frederick S. Wight, "The Revulsions of Goya: Subconscious Communication in the Etchings," *Journal of Aesthetics and of Criticism*, September 1946; and Enriqueta Harris, "A Contemporary Review of Goya's Caprichos," *Burlington Magazine*, January 1964.

Descriptions of Goya's liberal friends from Jean Adhémar, *Graphic Art of the 18th Century* (London: 1964), pp. 201–210.

Goya letter on withdrawing the "Caprichos" because of "Santa" quoted from Lafuente Ferrari, *op. cit.*, p. xi.

Malraux quote on the "Caprichos" from *Saturn*, p. 123.

Huxley quotation from his Foreword to *The Complete Etchings of Goya*, p. 13.

Moratín description of Goya's arrival in Bordeaux, quoted in Sánchez-Canton, *Goya*, p. 24.

VII. *The French Revolution and the Restoration: Prologue to the Nineteenth Century*

For description of eighteenth-century French satirical art, see André Blum, "L'Estampe Satirique et la Caricature en France au XVIIIᵉ Siècle," in *Gazette des Beaux Arts*, Année 52, 1910. The same historian has made the only major study of satirical art during the Revolution, *La Caricature Révolutionnaire* (Paris: 1914). For the Napoleonic period, the most comprehensive collection of graphic satire is A. M. Broadley, *Napoleon in Caricature, 1795–1821*, 2 vols. (London: 1911).

The basic work on Géricault is Charles Clément, *Géricault: Étude biographique et critique avec le catalogue raisonné de l'oeuvre du maître* (Paris: 1867). A *catalogue raisonné* of his prints will also be found in Loys Delteil, *Théodore Géricault*, vol. 18 of *Le Peintre-Graveur Illustré* (Paris: 1924). A selection of 58 of his drawings will be found in Charles Martine, *Théodore Géricault* (Paris: 1928).

Of recent studies, the most valuable are by Klaus Berger: *Géricault and His Work* (Lawrence, Kansas: 1955) and *Géricault, Drawings and Watercolors* (New York: 1946).

Among periodical articles, see especially Suzanne Lodge, "Géricault in England," *Burlington Magazine*, December 1965; Frederick Antal, "Reflections on Classicism and Romanticism," *Burlington Magazine*, September 1940 and January 1941; F. D. Klingender, "Géricault as seen in 1848," *Burlington Magazine*, October 1942; Benedict Nicolson, "Raft from

the Point of View of Subject Matter," *Burlington Magazine,* vol. 96, August 1954.

Government decree forbidding "misleading" art quoted in Adhémar, *Graphic Art of the Eighteenth Century,* p. 184.

Quotation by Klaus Berger on the influence of Géricault from *Encyclopedia of World Art,* vol. VI (London: 1962), p. 154.

Alexandre Dumas' description of Delacroix' fears during the Revolution described in Agnes Mongan, *One Hundred Master Drawings* (Cambridge, Mass.: 1949), p. 148. See also, Hélène Adhémar, "La Liberté sur les Barricades," *Gazette des Beaux Arts,*" vol. 43, February 1954.

VIII. *Daumier and His Contemporaries: France, 1830–71*

Useful and inexpensive background histories of the period are D. W. Brogan, *The French Nation from Napoleon to Pétain, 1815–1940* (New York: 1963); John B. Wolf, *France 1814–1919: The Rise of a Liberal-Democratic Society* (New York: 1963); Alfred Cobban, *A History of Modern France,* vols. 1 and 2 (Baltimore, Md.: 1963).

The principal histories of caricature covering this period and part of the following chapter are Champfleury [Jules Fleury], *Histoire de la Caricature Moderne* (Paris: 1878); Armand Dayot, *Les Maîtres de la Caricature Française au 19ᵉ Siècle* (Paris: 1888); Raoul Deberdt, *La Caricature et l'Humour Français au 19ᵉ Siècle* (Paris: n.d.); Georges Veyrat, *La Caricature à Travers les Siècles* (Paris: 1895); Arsène Alexandre, *L'Art du Rire et de la Caricature* (Paris: n.d.); Arthur B. Maurice and Frederic T. Cooper, *The History of the*

Nineteenth Century in Caricature (New York: 1904); Michel Ragon, *Le Dessin d'Humour: Histoire de la Caricature et des Dessins Humouristiques en France* (Paris: 1960). Also see *Les Français Peints par Eux-Mêmes,* 9 vols. (Paris: 1841), for illustrated social encyclopedia of the period. For review of print-making in the nineteenth century, especially useful is Claude Roger-Marx, *Graphic Art of the 19th Century* (New York: 1963).

For the period of Louis Philippe, André Blum, "La Caricature Politique Sous la Monarchie de Juillet," in *Gazettes des Beaux-Arts,* March–April 1920. Philipon's duel with the regime is described in William Makepeace Thackeray's *Paris Sketch Book* (Boston: 1882), pp. 156–174; also, Edwin deT. Bechtel, *Freedom of the Press and L'Association Mensuelle: Philipon vs. Louis Philippe* (New York: 1952).

GRANDVILLE

For interpretation of Grandville, see Laure Garcin, "Grandville visionnaire, surréaliste, espressioniste," *Gazette des Beaux-Arts,* vol. 34, December 1948; Baudclaire, *The Mirror*

of Art, pp. 162–163 and 171–172. See also John Rayner, *J-J Grandville,* Paris: and Marguerite Mespoulet, *Creators of Wonderland* (New York: 1934).

RAFFET

Among Raffet biographies see Atherton Curtis, *Auguste Raffet* (New York: 1903); August Bry, *Raffet, Sa Vie et ses Oeuvres* (Paris: 1861); and Armand Dayot, *Raffet et son Oeuvre* (Paris: 1893). Raffet's diary is Denis A. M. Raffet, *Notes et Croquis de Raffet* (Paris: 1878). See also A. Raffet, *Album* (Paris: 1828).

TRAVIÈS

A description of the various Mayeux originated by Charles Traviès is in Félix Meunié, *Les Mayeux, 1830–1850* (Paris: 1915). See also pp. viii–x in Dayot, *Les Maîtres de la Caricature Française.*

MONNIER

Champfleury [Jules Fleury], *Henry Monnier, sa vie, son oeuvre* (Paris: 1879) captures the flavor of Monnier and his Prudhomme, but a more reliable up-to-date study is Edith Melcher, *The Life and Times of Henry Monnier* (Cambridge, Mass.: 1950). Baudelaire statement on Monnier from *The Mirror of Art*, p. 171.

DAUMIER

The *catalogue raissoné* of Daumier is Loys Delteil, *Le Peintre-Graveur Illustré*, 10 vols. (Paris: 1925–1930). Partial collections of Daumier's prints are reproduced in Eduard Fuchs, *Honoré Daumier: Lithographien*, 3 vols. (Munich: n.d.); Jean Laran, *Cent Vingt Lithographies d' Honoré Daumier* (Paris: 1929); Wilhelm Wartmann, *Honoré Daumier* (Zurich: n.d.), reproduces 240 lithographs with data; Eugène Boury, *L'Oeuvre Gravé du maître*, 2 vols. (Paris: 1933); *Daumier und die Politik* (Leipzig: 1925); Henri Mondor, *Doctors & Medicine in the Works of Daumier* (Boston: 1960); K. E. Maison, *Daumier Drawings* (New York: 1960).

An outstanding and the most recent biography is Oliver W. Larkin, *Daumier: Man of His Time* (New York: 1966). Also helpful in this chapter were Arsène Alexandre, *Honoré Daumier, l'Homme et l'Oeuvre* (Paris: 1888); Michael Sadleir, *Daumier, the Man and the Artist* (London: 1923); Jacques Lassaignes, *Daumier* (London: 1938); Pierre Courthion, ed., *Daumier Raconté par Lui-Même et ses Amis* (Geneva: 1945); Jean Adhémar, *Honoré Daumier* (Paris: 1954); Paul Valéry, *Daumier* (London: 1947).

Among the numerous catalogues of Daumier exhibits, helpful comment will be found in Jean Valery-Radot's Preface to Catalogue of Exhibit at Bibliothèque Nationale (Paris: 1958). Ebria Feinblatt's Introduction to Honoré Daumier, Exhibit of Prints, Drawings, Watercolors, Paintings, and Sculpture

(Los Angeles: 1958); and Claude Roger-Marx in Catalogue of Pennsylvania Museum of Art exhibition (1937).

Larkin quote on Daumier from *op. cit.*, p. 13.

Paul Valéry quotation, *op. cit.*, p. 4.

Henry James quotations from *Picture and Text* (New York: 1893), p. 136.

Baudelaire comment on the people of Paris from *The Mirror of Art*, p. 167.

GAVARNI

A representative selection of Gavarni's work, with comment by the Goncourt brothers, will be found in *Oeuvres choisis de Gavarni* (Paris: n.d.). Among the studies of Gavarni, that of the Goncourt brothers, *Gavarni l'Homme et l'Oeuvre* (Paris: 1873); Philippe Burty, *Maîtres et Petite Maîtres* (Paris: 1877) pp. 253–269; Georges Duplessis, *Gavarni Étude* (Paris: 1876); Jeanne Landre, *Gavarni* (Paris: 1912); Paul André Lemoisne, *Gavarni Peintre et Lithographe* (Paris: 1924).

MANET

Manet's return to Paris during the Commune is described in Théodore Duret, *Histoire d'Edouard Manet et de son Oeuvre* (Paris: 1902), p. 78. Also see E. Moreau-Nélaton, *Manet Raconté par Lui-Même* (Paris: 1926); and Léon Rosenthal, *Manet Graveur et Lithographe* (Paris: 1925).

COURBET

Courbet's philosophy stated in Gerstle Mack, *Gustave Courbet* (New York: 1951), p. 53. For discussions of his drawings and philosophy, also see Théodore Duret, *Gustave Courbet* (Paris: 1918), pp. 138–141, p. 169. P. J. Proudhon, *Du Principe de l'Art et de sa Destination Sociale*, chs. XVII, XVIII (Paris: 1875); and Meyer Schapiro, "Courbet and Popular Imagery," *Journal of Warburg & Courtauld Institute*, vol. IV, no. 3.

IX. FRANCE AND BELGIUM AFTER THE COMMUNE: FROM PISSARRO TO ROUAULT

Inexpensive guides to the political and social developments may be found in D. W. Brogan, *The Development of Modern France, 1870–1939*, 2 vols. (New York: 1966); and see the bibliography for the previous chapter for Wolf, *France, 1814–1919*, and Cobban, *A History of Modern France*, vol. 3. For review of printmaking in nineteenth century, see Claude Roger-Marx, *Graphic Art of the 19th Century*.

Considerable protest—art representative but not often distinguished—is to be found in the files of the radical newspapers and magazines of the period: *Père Peinard, Le Chambard,*

Almanach de la Question Sociale, Les Temps Nouveaux, La Révolte, La Sociale, La Feuille, La Revue Blanche, La Plume, L'Assiette au Beurre, L'Escarmouche.

Many of the books on caricature listed in the bibliography for the previous chapter discuss protest artists of this period, especially Dayot, *op. cit.*, Deberdt, *op. cit.*, and Maurice and Cooper, *op. cit.* Also, Jacques Lethève, *La Caricature et la Presse sous la III^e République* (Paris: 1961), which contains a useful list of caricaturists and of satirical magazines in the years 1870–1960.

Source for Renoir's attitude toward Pissarro: Benedict Nicolson, "The Anarchism of Camille Pissarro," *The Arts*, vol. 2 (1947), p. 44.

Definitive history of the Neo-Impressionists and their anarchist views is Eugenia W. Herbert's *The Artist and Social Reform: France and Belgium, 1885–1898* (New Haven: 1961). A preliminary study will be found in Robert L. and Eugenia W. Herbert, "Artists and Anarchism: Unpublished letters of Pissarro, Signac and others," *Burlington Magazine*, vol. 102, November 1960 and December 1960. These are indispensable for any study of the social views of the Neo-Impressionists.

Signac quotation on role of anarchist painter from unpublished letter, p. 4 of Signac Collection, Mme. Ginette Signac, Paris, quoted in Herbert, *op. cit.*, p. 190.

Pissarro's statement on anarchism and art, from letter to his son Lucien April 15, 1891, in *Camille Pissarro: Letters to His Son Lucien*, ed. by John Rewald (New York: 1943), p. 163.

Millet's letters on the Commune quoted in *Pissarro Letters*, p. 105. Pissarro's comments, *ibid.*

VAN GOGH AND SEURAT

Van Gogh comments on Daumier and Gavarni from letter no. 240, p. 476, vol. 1, in Vincent Van Gogh, *Complete Letters*, 3 vols. (Greenwich, Conn.: 1958). Background to "Sorrow," *ibid.*, letters no. 186–189, vol. 1, pp. 382–389. His quotation on "The Potato Eaters," from *ibid.*, letter no. 404, vol. 2, p. 369. Van Gogh's graphic work is listed in J. B. de la Vaille, *L'Oeuvre de Vincent Van Gogh* (Paris and Brussels: 1928).

Fénéon's comment on Seurat's views quoted in John Rewald, *Georges Seurat* (New York: 1946), p. 47. *Catalogue raisonné* of Seurat in César M. de Hauke, *Seurat et Son Oeuvre*, 2 vols. (Paris: 1961). For discussions of Seurat and his philosophy, see Herbert, *op. cit.*, Herbert and Herbert, *op. cit.*; Rewald, *op. cit.*; Germain Seligman, *Drawings of George Seurat* (New York: 1945); Robert L. Herbert, *Seurat's Drawings* (New York: 1962); John Russell, *Seurat* (New York: 1965). Quotation from Herbert, *Seurat's Drawings*, pp. 96–97.

PISSARRO

Pissarro's views on capitalism, in *Pissarro's Letters*, May 5, 1891, p. 166. Pissarro's life and social views are discussed in Herbert, *op. cit.*; Herbert and Herbert, *op. cit.*; *Pissarro Letters*; A. Tabarant, *Pissarro* (London: 1925); John Rewald, *The History of Impressionism* (New

York: 1961); John Rewald, *Post-Impressionism, from Van Gogh to Gauguin* (New York: 1956). Also, Nicolson, "The Anarchism of Pissarro"; L. Rodo, "The Etched and Lithographed work of Camille Pissarro," *The Print Collector's Quarterly*, IX, October 1922; John Rewald, "Camille Pissarro, His Work and Influence" *Burlington Magazine*, vol. 72, June 1938. His oeuvre will be found in Loys Delteil, *Le Peintre-Graveur Illustré*, vol. XVII, *Camille Pissarro, Alfred Sisley, Auguste Renoir* (Paris: 1923); and L. R. Pissarro and Lionel Venturi, *Camille Pissarro: son art—son oeuvre*, 2 vols. (Paris: 1939).

Pissarro letters to Monet on financial straits quoted in Tabarant, *op. cit.*, p. 53. Statement on Gauguin, from John Rewald, *Camille Pissarro* (New York: n.d.), p. 42. Letters to Lucien on arrests, April 26, 1892, in *Pissarro's Letters*, pp. 195–196 and May 8, 1892, *ibid.*, p. 197.

Quotation from Herbert and Herbert, "Artists and Anarchism," *Burlington Magazine*, November 1960, p. 478.

Pissarro's letters to Lucien on Dreyfus, January 21, 1898, February 10, 1898, and November 19, 1898, in *Pissarro's Letters*, pp. 319, 321, 332. His statement to Signac, from Signac's Diary, February 11, 1898, quoted in John Rewald, "Extraits du journal inedit du Paul Signac," *Gazette des Beaux-Arts*, 6th series, vol. 36, July–September 1949.

SIGNAC, LUCE, AND OTHERS

Rewald statement about Signac, *ibid.*, vol. 39, April 1952. Signac on staying young, quoted by George Besson in *Catalogue of Retrospective Exhibit*, Marlborough Fine Art Ltd. (London: 1954). Signac discussed in Herbert, *op. cit.*; Herbert and Herbert, *op. cit.*; Rewald's *Extraits* article; George Besson, *Paul Signac* (Paris: 1950). Signac's theories on painting are expressed in *De Delacroix au Neo-Impressionisme* (Paris: 1899). Signac's statement on the "solid blow of the pick" quoted in Herbert and Herbert, *op. cit.*, p. 479. Signac's reproach to Grave on World War I in letter of August 1, 1916, quoted in Herbert and Herbert, *op. cit.*, December 1960, p. 520.

Maximilien Luce's role as anarchist-Neo-Impressionist discussed in Herbert, *op. cit.*; Herbert and Herbert, *op. cit.*; A. Tabarant, *Maximilien Luce* (Paris: 1928); and Arsène Alexandre, "Maximilien Luce," *Cahiers de Belgique*, December 1929.

Vallotton: A brief biography of Félix Vallotton in Charles Fegdal, *Félix Vallotton* (Paris: 1931). Also see, Michael Puy, "Vallotton," *Le Carnet des Artistes*, no. 7, May 1, 1917; and "Un defenseur oublié de l'art moderne," *Oeil*, no. 90, June 1962.

Steinlen: The *catalogue raisonné* of Steinlen in E. Crauzat, *L'Oeuvre Gravé et Lithographié de Steinlen* (Paris: 1913), with sympathetic preface by Claude Roger-Marx. The quotation by Anatole France is from France's Introduction to Catalogue, *Exposition d'Ouvrages Peints, Dessinés, ou Gravés par Théophile-Alexandre Steinlen* (Paris: 1903). Especially useful studies of Steinlen will be found in the Bibliothèque Nationale booklet *Steinlen*, Catalogue no. 53, Paris, May–June 1953, and the catalogue of the Steinlen exhibition of drawings, pastels, and watercolors, published by the Charles E. Slatkin Galleries, New York, October–November 1963, with

Preface by Alan M. Fern, 'and a particularly informative introduction by Alain de Leiris. Also see the chapter on Steinlen in A. E. Gallatin, *Certain Contemporaries* (New York: 1916). Among the periodical articles, Anatole France, "Steinlen," in *Le Carnet des Artistes*, no. 4, March 15, 1917; M. Amaya, "Price of Innovation," *Apollo*, no. 76, October 1962; "Art of Steinlen," *Arts*, vol. 38, November 1963.

Forain: For appreciation of Forain, see Campbell Dodgson, *Forain; Draughtsman, Lithographer, Etcher* (New York, 1936); Claude Roger-Marx, *Graphic Art*, pp. 211–216; M. Amaya, "Forain Reconsidered," *Apollo*, vol. 79, June 1964; and "Forain: Genius at the Periphery," *Art News*, vol. 62, April 1963.

Ensor: Ensor's graphic work is catalogued in Albert Croquez, *L'Oeuvre Gravé de James Ensor* (Paris: 1935); also Delteil, *Le Peintre-Graveur Illustré*, vol. XIX. A comprehensive biography is Paul Haesaerts, *James Ensor* (New York: 1959).

Vallotton statement on war from Fegdal, *Vallotton*, p. 47.

De Segonzac: Dunoyer de Segonzac's drawings and graphics are described in Claude Roger-Marx, *L'Oeuvre Gravé de Dunoyer de Segonzac* (Paris: 1937). His war drawings served to illustrate Roland Dorgelès, *Les Croix de Bois* (1919), and *La Boule de Gui* (1922), and were reproduced in "Huit Illustrations de la Guerre," Paris (1926).

Rouault: Prime sources of information on Rouault are Pierre Courthion, *Georges Rouault* (New York: 1961); James Thrall Soby, *Georges Rouault: Paintings and Prints* (New York: 1947); Jacques Maritain, *Georges Rouault*, with notes on Rouault's prints by William S. Liberman (New York: 1954); Lionello Venturi, *Georges Rouault* (Paris: 1948); Rouault's *Miserere* (New York: 1952).

x. *Germany After 1871*

Inexpensive reviews of the historical background will be found in Vol. 2 of Kurt F. Reinhardt, *Germany: 2000 Years* (New York: 1961); E. J. Passant, *A Short History of Germany, 1815–1945* (Cambridge and New York: 1959); L. Kochan, *The Struggle for Germany, 1914–1945* (New York: 1967; Erich Eyck, *A History of the Weimar Republic* (New York: 1967); William L. Shirer, *The Rise and Fall of the Third Reich* (Greenwich, Conn.: 1967).

By far the best general review of German art during this period is Bernard S. Myers, *The German Expressionists, A Generation in Revolt* (New York: 1966), including considerable material on the graphic arts. Also useful for information on the various German schools of painting was René Huyge, ed., *Histoire de l'Art Contemporain* (Paris: 1935). For prints, the chapter on prints by William S. Lieberman in the Museum of Modern Art's *German Art of the Twentieth Century* (New York: 1957); Curt Glaser, *Graphik der Neuzeit* (Berlin: 1923). Individual biographies of artists appear in Thieme and Becker, *Lexikon der Bildenden Künstler*.

Representative examples of German graphic art during this period, with brief comment, will be found in Carl Zigrosser, *The Expres-*

sionists (New York: 1957); Lothar-Günther Buchheim, *The Graphic Art of German Expressionism* (New York: 1960), and in Wolf Stubbe, *Graphic Arts in the Twentieth Century* (New York: 1963).

Examples of German late nineteenth-century and early twentieth-century caricature or more direct graphic protest are in Hofmann, *Caricature from Leonardo to Picasso;* Fuchs and Kraemer, *Die Karikatur der Europäischen Völker;* Fuchs, *Der Weltkreig in der Karikatur;* Rühle, *Illustrierte Kultur und Sittengeschichte des Proletariats;* and George Hermann, *Die Deutsche Karikatura in 19 Jahrhundert* (Bielefeld: 1901).

Discussion of Paul Klee's "Crown Mania" will be found in James Thrall Soby's Introduction to *The Prints of Paul Klee* (New York: 1945).

KOLLWITZ AND HEINE

The *catalogue raisonné* of Käthe Kollwitz's work is August Klipstein, *The Graphic Work of Käthe Kollwitz* (Berne and New York: 1955). Also indispensable are Hans Kollwitz, ed., *The Diary and Letters of Kaethe Kollwitz* (Chicago: 1955); Herbert Bittner, *Kaethe Kollwitz: Drawings* (New York: 1959); Carl Zigrosser, *Kaethe Kollwitz* (New York: 1946); Fritz Schmalenbach, *Käthe Kollwitz* (Berne: 1948); Adolf Heilborn, *Käthe Kollwitz* (Berlin: 1949); Gerhard Strauss, *Käthe Kollwitz* (Dresden: 1950). Of the many exhibit catalogues, one of the most interesting is *Kaethe Kollwitz, in the Cause of Humanity*, Galerie St. Etienne (New York: 1967), on her hundredth anniversary. Of the numerous periodical articles, a particularly sensitive tribute is that of Leonard Baskin in *The Massachusetts Review*, vol. 1, no. 1, October 1959.

Quotations from Kollwitz's diary taken from *The Diary and Letters of Kaethe Kollwitz*, pp. 2, 42, 43, 63, 98, 100, 104, 105.

Hans Kollwitz quotation, *Ibid.*, p. 11.

Romain Rolland quotation on Kollwitz, frontispiece to Bittner, *Kollwitz: Drawings.*

Th. Th. Heine's work is discussed in *Art News*, vol. 28, May 10, 1930; *Graphis*, vol. 4, no. 22, 1948; *Gebrauchs*, vol. 38, August 1967, among others. For a glimpse of *Simplicissimus* in the immediate pre-Nazi years, see chs. 1, 25, and 26 of Franz Schoenberner, *Confessions of a European Intellectual* (New York: 1965).

BARLACH

For a brief but perceptive review of Barlach, see pp. 70–77 of Myers, *German Expressionists.* Fuller discussion of Barlach's graphic work will be found in Carl D. Carls, *Ernst Barlach, Das Plastische, Graphische und Dichterische Werke* (Berlin: 1931), and Friedrich Schult, *E. Barlach, Das Graphische Werke* (Hamburg: 1958). Barlach's social views are expressed in Friedrich Dross, *Ernst Barlach: Leben und Werk in Seinen Briefen* (Munich: 1952), and more briefly, in "Selected Letters of Ernst Barlach," quoted in

Art and Artist (Berkeley: 1956). See also "Ernst Barlach: Artist Under a Dictatorship," by Alfred Werner in *Art Journal*, vol. 22, no. 2, Winter 1962–63, and by the same writer, "The Draftsmanship of Ernst Barlach," *Art Journal*, vol. 26, no. 3, Spring 1967. Useful exhibit catalogues are those of Marlborough Gallery, London, *Ernst Barlach–Käthe Kollwitz, 1967*, introduction by Wolfgang Fischer,

and National Gallery of Canada, *The Graphic Art of Ernst Barlach, 1962*, introduction by Naomi Jackson Groves.

Barlach's philosophy quoted in Leonard Baskin's preface to Kollwitz exhibit catalogue, Smith College Museum of Art, Northampton, Mass., p. 1. Barlach's statement about Stahlhelm from *Art and Artist*, letter of January 22, 1929, to Hans Barlach.

BECKMANN, GROSZ, AND OTHERS

Beckmann quotation on "screams of pain" from Peter Selz, *Max Beckmann* (New York: 1964), p. 32. This exhibit catalogue, with additional essays by Harold Joachim and Perry T. Rathbone, together with Rathbone's Introduction to *Max Beckmann, 1948*, exhibit catalogue of the City Art Museum of St. Louis, provide an invaluable guide to Beckmann and his work, including his graphics. There are many monographs on Beckmann. Especially useful are Lothar-Günther Buchheim, *Max Beckmann* (Feldafing: 1959); Curt Glaser and others, *Max Beckmann* (Munich: 1924).

Grosz quotations from George Grosz, *A Little Yes and a Big No: The Autobiography of George Grosz* (New York: 1946), pp. 146–147, 161, 301. Grosz reply to Kokoschka from Edith Hoffmann, *Kokoschka: Life and Work* (London: 1947), p. 143, quoted in Myers, *op. cit.*, footnote 34.

Many of Grosz's drawings are reproduced in his *Ecce Homo* (Berlin: 1922), *Abrechnung Folgt* (Berlin: 1922), *Der Spiesser Spiegel* (Dresden: 1932), *Die Gezeichneten* (Berlin: 1930), *Ueber Alles die Liebe* (Berlin: 1930), and others. His *Interregnum* (New York:

1936) reproduces 64 lithographs. An extensive bibliography as well as a critical assessment, and reproduction of a representative selection of drawings and prints, is in Herbert Bittner, with Introduction by Ruth Berenson and Norbert Muhlen, *George Grosz* (New York: 1960). Among valuable critical surveys are those of John I. H. Baur in the Whitney Museum of American Art's exhibition catalogue, *George Grosz, 1954* and Hans Hess in a Grosz Retrospective Exhibit Catalogue published by the Forum Gallery and E. V. Thaw & Co. (New York: 1963).

Among the numerous periodical articles on Grosz, especially see E. M. Benson, "George Grosz, Social Satirist," *Creative Art*, vol. 12, May 1933; "George Grosz—A Survey of His Art," *Chicago Art Institute Bulletin*, vol. 32, December 1938; "Grosz Rated with Hogarth and Daumier," *Art Digest*, vol. 13, January 1, 1939; and Milton Brown's critical attack on Grosz' work in America, "Death of an Artist," *Parnassus*, vol. 13, May 1941.

Otto Dix, *Der Krieg* (Berlin: 1924). For discussion of "The War," see *Art Digest*, August 1934, and *Art News*, October 2, 1937. Also see Alfred H. Barr, "Otto Dix," *Arts*, January

1931, and for an interesting comparison with Goya, Myers, *The German Expressionists,* p. 240.

Grosz quote on Masereel from *A Little Yes and a Big No,* p. 172. Typical of Masereel's books of woodcuts are *Le Soleil* (Geneva: 1919), *Geschichte Ohne Worten* (Munich: 1927), *Die Passion Eines Menschen* (Munich: 1928), *Landschaften und Stimmungen* (Munich: 1929), *Apokalypse Unser Zeit* (Nice:

1953). Biographies include Joseph Billiet, *Frans Masereel, L'Homme et l'Oeuvre* (Paris: 1925), and Louis Lebeer, *Frans Masereel* (Antwerp: 1950). A catalogue with listing is that of *Frans Masereel, L'Oeuvre Gravé* (Paris: 1958).

Examinations of Karl Rossing's work will be found in *Gebrauchsgraph,* vol. 12, December 1935, and *Graphis,* vol. 6, no. 30, 1950, among others.

XI. *The United States Since 1870*

Oliver W. Larkin's *Art and Life in America,* revised edition (New York: 1966), is a comprehensive and invaluable social interpretation of America's art heritage, but prints and drawings receive relatively minor attention.

There is no history of American graphic social criticism as such, but several histories of American political cartooning or graphic humor are useful, particularly for the nineteenth century. William Murrell, *A History of American Graphic Humor,* vol. I: 1747–1865 (New York: 1933), and vol. II: 1865–1938 (New York: 1938), is a useful compendium, including much political and some social satire. Allan Nevins and Frank Weitenkampf, *A Century of Political Cartoons* (New York: 1944), covers the nineteenth century. Stephen Becker, *Comic Art in America* (New York: 1959), is concerned mainly with comic strips and general cartoons, but includes some political satire. The most recent and most comprehensive survey of American political graphics, with informative text, is Stephen Hess and Milton Kaplan, *The Ungentlemanly Art: A History of American Political Cartoons*

(New York: 1968). Of related interest is Frank Weitenkampf, *Social History of the United States in Caricature: how the comic artists saw us* (New York: 1953); College Art Association exhibit catalogue, *Salon of American Humorists: A Political and Social Pageant from the Revolution to the Present Day* (New York: 1933).

Many of the outstanding political cartoons that played a role in American history are reproduced in Roger Butterfield, *The American Past* (New York: 1966), and *Year's Pictorial History of America* (Los Angeles: 1954).

For general collections of American prints and drawings, see especially Charles E. Slatkin and Regina Shoolman, *Treasury of American Drawings* (New York: 1947); Albert Reese, *American Prize Prints of the Twentieth Century* (New York, 1949); Una E. Johnson, *10 Years of American Prints, 1947–1956* (Brooklyn: 1956).

Paul Revere's "Boston Massacre" is discussed in William L. Andrews, *Paul Revere and His Engraving* (New York: 1901); Clarence S. Brigham, *Paul Revere's Engravings* (Worcester, Mass.: 1954); Louise P. Kellogg,

"The Paul Revere Print of the Boston Massacre," *The Print Connoisseur,* October 1926; and George H. Sargent, "Paul Revere's Boston Massacre," *Antiques,* vol. 11.

THOMAS NAST

Reproductions of many of Nast's political cartoons, with historical background, will be found in Morton Keller, *The Art and Politics of Thomas Nast* (New York: 1968). The only biography is Albert Bigelow Paine, *Th. Nast: His Period and His Pictures* (New York: 1904). The files of *Harper's Weekly* are indispensable for any study of Nast. There are collections of individual Nast engravings in the Print Rooms of the Metropolitan Museum of Art, New York, and the New York Public Library. Tweed on "Them damned pictures," quoted in Alfred Frankfurter, "Political Cartoons Today," *Art News,* vol. 53, no. 6, October 1954. Most useful among the periodical articles are: Walter Gutman, "An American Phenomenon," *Creative Art,* vol. 5, 1929; Frank Weitenkampf, "Thomas Nast—Artist in Caricature," *New York Public Library Bulletin,* vol. 37, 1933; and John A. Kowenhoven, "Thomas Nast as We Don't Know Him," *Colophon,* no. 2, 1939.

KEPPLER AND OTHERS

Joseph Keppler is discussed in "Keppler and Political Cartooning," *New York Public Library Bulletin,* vol. 42, 1938. Some of his outstanding cartoons are reprinted in Joseph Keppler, *Cartoons from Puck* (New York: 1893).

Homer Davenport's cartoons are reproduced in his *Cartoons* (New York: 1898).

For the making of a revolutionary political cartoonist—if a sunny and exuberant one, see *Art Young, His Life and Times* (New York: 1939); Art Young, *On My Way* (New York: 1928). Also, *Art Young's Inferno* (New York: 1934) and *The Best of Art Young* (New York: 1936).

For the story of *The Masses,* see William L. O'Neill, *Echoes of Revolt: The Masses, 1911–1917* (Chicago: 1966).

Genevieve Taggard quotation from her article, "May Days," *The Nation,* CXXI, September 30, 1925, quoted in Albert Christ-Janer, *Boardman Robinson* (Chicago: 1946), p. 30.

JOHN SLOAN: Albert E. Gallatin, *John Sloan* (New York: 1925). Frank Weitenkampf, "John Sloan in the Print Room," *American Magazine of Art,* vol. 12, October 1929, and Carl Zigrosser, "The Graphic Work of John Sloan," *Philadelphia Museum Bulletin,* vol. 51, no. 248, Winter 1956.

GEORGE BELLOWS: *George W. Bellows: His Lithographs* (New York: 1927), and Peyton Boswell, Jr., *George Bellows* (New York: 1942). Periodical articles include Frank Weitenkampf, "George W. Bellows, Lithographer" (with checklist), *Print Connoisseur,* vol. 4, 1924; Ruth Pielkova, "George Bellow's Lithography," *Creative Art,* vol. II, 1928; Henry S. Francis, Jr., "The Lithographs of George W. Bellows," *Print Collectors Quarterly,* vol.

27, 1940; and Carl O. Schniewind, Introduction to Catalogue Exhibit of *George Bellows: Paintings, Drawings and Prints*, Art Institute of Chicago (1946).

BOARDMAN ROBINSON: See Christ-Janer, *op. cit.*, and chapter on Robinson in Albert E. Gallatin, *Certain Contemporaries* (New York: 1916). Many of his drawings are reproduced in Boardman Robinson, *Ninety-Three Drawings*, with Introduction by George Biddle (Colorado Springs: 1937), and his cartoons in *Cartoons on the War* (New York: 1915). Dehn quotation on Robinson from Christ-Janer, *op. cit.*, pp. 76–78.

WILLIAM GROPPER: *William Gropper: Retrospective*, with critique by August L. Freundlich (Los Angeles: 1968). Ernest Brace, "William Gropper," *Magazine of Art*, vol. 30, no. 8, August 1937; "Twenty Years of Gropper," *Time*, February 19, 1940; *Parnassus*, April 1941. Gropper Exhibit Catalogue, ACA Gallery, New York (1938), and Alan Fern's Introduction to Catalogue of *Gropper: 12 Etchings*, Associated American Artists Gallery, New York (1967).

REGINALD MARSH: Norman Sasowsky, *Reginald Marsh: Etchings, Engravings, Lithographs* (New York: 1956). Lloyd Goodrich, "Reginald Marsh," *American Artist*, vol. 19, September 1955; William Benton, "Reginald Marsh—American Daumier," *Saturday Review of Literature*, vol. 38, December 24, 1955.

WILL BARNET: Una E. Johnson, *Will Barnet: Prints, 1932–1964* (Brooklyn: 1965). Also, "Barnet Preaches No 'Angry Propaganda,'" *Art Digest*, vol. 14, December 1938; Dore Ashton, "Will Barnet," *Art Digest*, vol. 26, November 1, 1951; James Schuyler, "Will Barnet," *Art News*, vol. 57, October 1958.

Evergood's description of violence at WPA offices from John I. H. Bauer, *Philip Evergood* (New York: 1960), p. 52.

Larkin quotations on painters of the thirties from his *Art and Life in America*, pp. 437 and 431. For description of first meeting of Artists' Congress, see Larkin, pp. 430–431.

Lynd Ward's "Company Town," from *America Today: A Book of 100 Prints* (New York: 1936), representing the prints exhibited by the American Artists Congress.

Jacob Burck's "Half Time" from *Hunger and Revolt: Cartoons by Burck* (New York: 1935.)

PAUL CADMUS: Una E. Johnson, *Paul Cadmus/Prints and Drawings, 1922–1967* (Brooklyn: 1968). For nineteen-thirties view of Cadmus, see Harry Salpeter, "Paul Cadmus: Enfant Terrible," *Esquire*, July 1937.

Arthur Szyk's antifascist drawings are collected in his *The New Order* (New York: 1941).

GABOR PETERDI: Una E. Johnson, *Gabor Peterdi, 25 Years of His Prints* (Brooklyn: 1959); Print Club of Cleveland, *Peterdi*, Catalogue of an exhibit of his prints and drawings, Cleveland (1962); Vincent Longo, "Peterdi as Printmaker," *Arts*, December 1959; Getlein, *Bite of the Print*, p. 264.

RICO LEBRUN: *Rico Lebrun Drawings* with Foreword by James Thrall Soby (Berkeley and Los Angeles: 1961). Lebrun quotation, p. 18; Soby quotation, p. vi of Foreword.

MAURICIO LASANSKY: *The Nazi Drawings of Mauricio Lasansky* (Philadelphia: 1960). Also Carl Zigrosser, *Mauricio Lasansky* (New York: 1960).

LEVINE AND EVERGOOD

JACK LEVINE: For perceptive assessment of Levine as painter and printmaker, see Frank Getlein, *Jack Levine* (New York: 1966), also Baur, *Revolution and Tradition in Modern American Art* (Cambridge, Mass.: 1951), p. 44. Most of the literature on Levine is concerned with his painting.

PHILIP EVERGOOD: Lucy R. Lippard, *The Graphic Work of Philip Evergood* (New York: 1966), is the definitive study of his prints and drawings. John I. H. Baur, *Philip Evergood,* and Oliver Larkin, *20 Years of Evergood* (New York: 1946) are helpful as surveys and evaluations of his painting and philosophy. Also, "Philip Evergood Evaluated Pro and Con," *Art Digest,* vol. 14, April 1, 1940; "Evergood's Good and Bad," *Newsweek,* vol. 27, May 13, 1946. "Measuring the Girl Friend for a Strait Jacket," is reproduced from Charlotte Pomerantz, ed., *A Quarter-Century of Un-Americana, 1938–1963* (New York: 1963).

BEN SHAHN

James Thrall Soby, *Ben Shahn: His Graphic Art* (New York: 1957), together with Kneeland McNulty, *The Collected Prints of Ben Shahn,* catalogue of exhibit at the Philadelphia Museum of Art (1957), supply a guide to Shahn's prints, though not to all of his drawings, of course. Also, Selden Rodman, *Portrait of the Artist as an American* (New York: 1951), and James Thrall Soby, *Ben Shahn* (Middlesex, England: 1947). For Shahn's approach to art, and life, see his *The Shape of Content;* Selden Rodman, "Ben Shahn Speaking," *Perspectives USA,* January 1952; "What Is Realism in Art?" *Look,* vol. 16, January 13, 1953; and "Political Cartoons Today," *Art News,* vol. 53, October 1954. Among the periodical literature: Bernarda Bryson, "The Drawings of Ben Shahn," *Image,* no. 2, Autumn 1949; Leo Lionni, "Ben Shahn, His Graphic Work," *Graphis,* vol. II, no. 62, 1955; Edward S. Peck, "Ben Shahn, His 'Personal Statement' in Drawings and Prints," *Impression,* September 1957; and Alfred Werner, "Ben Shahn," *Reconstructionist,* October 3, 1958. Of the exhibit catalogues, especially *Museum of Modern Art Bulletin,* vol. 14, nos. 4–5, Summer 1947, and Downtown Gallery, New York (1955).

LEONARD BASKIN

Brian Doherty, "Leonard Baskin," *Art in America,* Summer 1962; Robert Spence, "The Artist as Counter-Decadent," *College Art Journal,* vol. XXII, Winter 1962–63; "Leonard Baskin—Art for Life's Sake," *American Artist,* vol. 28, November 1964. "Death Without Gods: A Note on Leonard Baskin," chapter in John Canaday, *Embattled Critic, Views on Modern Art* (New York: 1962). Most useful of exhibit catalogues are: Bowdoin College catalogue, Brunswick, Maine (1962), and Worcester (Mass.) Art Museum exhibit of Baskin's sculpture, drawings, and woodcuts (1956). Quotation by John Canaday from Paul A. Bennett, "Leonard Baskin, Graphic Artist," *Publishers' Weekly,* April 5, 1965, p. 73. Baskin quotation on death from O'Doherty article in *Art in America.*

Shahn quotation on nonconformity from *The Shape of Content*, p. 96.

HERBLOCK (Herbert L. Block) cartoons from *The Herblock Book* (Boston: 1952). Other cartoons in *Herblock's Here and Now* (New York: 1955); *Herblock's Special for Today* (New York: 1958); and *Straight Herblock* (New York: 1964). Also, Robert C. Osborn, "Homage to Herblock," *New Republic*, March 12, 1956.

BLACK ARTISTS

The work of Negro artists is discussed, with biographies and many illustrations, in Cedric Dover, *American Negro Art* (New York: 1960); James Porter, *Modern Negro Art* (New York: 1943); *The Evolution of Afro-American Artists: 1800–1950*, an exhibit catalogue sponsored by the City College, New York (1967); a special Afro-American issue of *The Art Gallery*, Irvington, Conn., vol. 11, no. 7, April 1968; and an exhibit catalogue, *Dix Artistes Nègres des États-Unis*, Dakar, Senegal (1966).

Quotation by Chaim Koppelman in personal letter to author.

Artists' opposition to the Vietnam war was expressed in an uneven group exhibit, on the whole unsuccessful, at the New School in 1967. The annotated catalogue, *Protest and Hope*, published by the New School, New York, has an Introduction by Paul Mocsanyi. Steinberg's "Vietnam" was included in this exhibit. For comment on this exhibit, see Hilton Kramer, "Art and Politics," *New York Times*, November 5, 1967, p. D33.

The Negro as subject in American art is discussed, with illustrations, in Alain Locke, *The Negro in Art* (Washington, D.C.: 1940) and two catalogues: *The Portrayal of the Negro in American Painting*, Bowdoin College Museum of Art, Brunswick, Me. (1964), and same title, a condensed version, Forum Gallery, New York (1967). Examples of Charles White's draftsmanship will be found in *Images of Dignity: The Drawings of Charles White* (Los Angeles: 1967).

ANTONIO FRASCONI: Exhibit catalogue, *The Work of Antonio Frasconi, 1952–1963*, Baltimore Museum of Art (1963).

SAUL STEINBERG: Saul Steinberg's drawings have been published in numerous volumes, including *All in Line* (New York: 1945), *The Art of Living* (New York: 1949), *The Passport* (New York: 1954).

XII. *Protest Art in Mexico*

There is no satisfactory history of protest art in Mexico. Of some interest are two histories of caricature: Rafael Carrasco Puente, *La Caricatura en México* (Mexico, D.F.: 1953), and José G. Zuño, *Historia de la Caricatura en México* (Guadalajara: 1961). Representative examples of prints with political or social import will be found in: *Album Taller de Gráfica Popular* [A record of 12 years of collective work] (Mexico, D.F.: 1949); *Estampas de la Revolución Mexicana, 85 Grabados de los Artistas del Taller de Gráfica Popular* (Mexico, D.F.: 1947); Anne Lyon Haight, ed., *Portrait of Latin America as Seen by Her*

Print Makers (New York: 1946); Armin Haab, *Mexican Graphic Art* (Teufen [AR], Switzerland: 1957). Brief sketches of nearly all of the printmakers discussed here will be found in the Haight and Haab volumes and in Virginia Stewart, *45 Contemporary Mexican Artists: A 20th Century Renaissance* (Stanford, Calif.: 1951).

Also useful are: Carl Zigrosser, "Mexican Graphic Art," *Print Collector's Quarterly*, vol. 23, 1936; Jean Charlot, "Mexican Prints," *Metropolitan Museum of Art Bulletin*, vol. VIII, no. 3, 1949; and the following articles in *Artist's Proof*, The Annual of Contemporary Prints, vol. VII (Barre, Vt.: 1967): Erasto Cortés Juarez, "Origins of the Mexican Print," and Charles Herrington, "Modern Mexican Prints" (originally entitled "Twentieth Century Mexican Graphic Art" when it appeared in the *Quarterly Journal of the Library of Congress*).

JOSÉ GUADALUPE POSADA: *Las Obras de José Guadalupe Posada, Grabador Mexicano* (Mexico, D.F.: 1930); *José Guadalupe Posado, Illustrador de la Vida Mexicana* (Mexico: 1963); Hans F. Secker, *José Guadalupe Posada* (Dresden: 1961). Also Katherine Kuh, "Posada of Mexico," *Art Institute of Chicago Bulletin*, vol. 38, 1944; Jean Charlot, "José Guadalupe Posada, Printmaker to the Mexican People," *Magazine of Art*, vol. 38, 1945; a catalogue with Introduction by Fernando Gamboa, "Posada, Printmaker to the Mexican People," *Art Institute of Chicago Bulletin*, vol. 38, 1944.

JOSÉ CLEMENTE OROZCO: Alma Reed, *José Clemente Orozco* (New York: 1932); and MacKinlay Helm, *Man of Fire* (New York: 1953). Also, Laurence Schmeckebier, "Orozco's Graphic Art," *Print Collector's Quarterly*, vol. 21, 1934. Catalogues include Justino Fernandez, *Obras de José Clemente Orozco en la Collecion Corillo Gil* (Mexico: 1949); and Jon H. Hopkins, *Orozco, a Catalogue of His Graphic Work* (Flagstaff, Ariz.: 1967).

DAVID ALFARO SIQUEIROS: Most of the books and literature on Siqueiros are concerned with his painting. Some examples of his graphics, with comment, will be found in *70 Obras Recientes de David Alfaro Siqueiros* (Mexico, D.F.: 1947); *Siqueiros* (Mexico, D.F.: 1951), with comment by Serge Eisenstein; and in Lincoln Kirstein, "Siqueiros, Painter and Revolutionary," *Magazine of Art*, vol. 37, 1944.

ALFREDO ZALCE: Roger L. Crossgrove, "Interview with Alfredo Zalce," ch. in *Artist's Proof, op. cit.*

JOSÉ LUIS CUEVAS: See Toby Joysmith, "What Is Cuevas Trying to Say?", also to be found in *Artist's Proof*. John Canaday has written an appreciation of Cuevas, "Growing Up with José Luis Cuevas," *New York Times*, May 23, 1965.

XIII. *Epilogue: Social Protest in Art Today*

Although the catalogue *Engagierte Kunst: Gesellschaftskritische Grafik Seit Goya*, Neue Galerie–Wolfgang Gurlitt Museum (Linz, Austria: 1966), is valuable mostly for the breadth of its review of protest art since Goya, it also contains a sprinkling of contemporary examples. Unfortunately, it does not give the sources of the prints and draw-

ings. A beautifully illustrated, carefully documented catalogue of "resistance" art is *Arte e Resistanza in Europa,* Museo Civico (Bologna and Torino: 1965), an exhibit held to commemorate the twentieth anniversary of the victory of the Resistance. Inevitably most of the art—passionately antifascist or antiwar —has the limitation of topicality, but some of it is universal and in the modern idiom. *Tendenzen,* from whose pages some of the illustrations in this chapter were taken, is published by Verlag Heino F. von Damnitz, 8022 Grünewald bei München, An den Römerhügeln 6.

Among periodical articles, see Sheldon Williams, "The Return of Involved Art," *Studio,* vol. 173, no. 889, May 1967; Dore Ashton, "Artist as the Conscience of Society," *Arts and Architecture,* vol. 84, June 1967; and Harold Rosenberg, "Art of Bad Conscience," *New Yorker,* December 16, 1967.

Of the vast Picasso literature, the following were most helpful in interpreting Picasso's approach to graphics and, particularly, Guernica.

Bernhard Geiser, *L'Oeuvre Gravé de Picasso* (Paris: 1937); Fernand Moulot, *Picasso Lithographe,* 4 vols. (Monte Carlo: 1949–1964); Georges Bloch, *Pablo Picasso: Catalogue de l'Oeuvre Gravé et Lithographié, 1904–1967* (Berne: 1968). Catalogues: Bibliothèque Nationale, Paris, *Pablo Picasso: L'Oeuvre Gravé* (1955) and *Pablo Picasso: Gravures* (1966); Arts Council of Britain, *Picasso: Fifty Years of Graphic Art* (London: 1956); Los Angeles County Museum of Art: *Picasso: Sixty Years of Graphic Works; Aquatints, Dry Points, Engravings, Etchings, Linoleum Cuts, Lithographs, Woodcuts,* with

Preface by Ebria Feinblatt (Los Angeles: 1966).

Indispensable for study of Guernica is Rudolf Arnheim, *Picasso's Guernica, The Genesis of a Painting* (Berkeley and Los Angeles: 1967); also Juan Larrea, *Guernica: Pablo Picasso,* with Introduction by Alfred H. Barr, Jr. (New York: 1947); John Berger, *The Success and Failure of Picasso* (Middlesex, England: 1965).

Among the commentaries on Guernica: Stephen Spender, "Picasso's Guernica," *New Statesman and Nation,* vol. 16, October 15, 1938; Sir Herbert Read, "Picasso's Guernica," *London Bulletin,* no. 6, October 1938; Ruthven Todd, "Drawings for Guernica," *London Bulletin,* no. 8–9, January–February 1939; (for negative opinion) Vernon Clark, "The Guernica Mural—Picasso and Social Protest," *Science and Society,* vol. 5, Winter 1941; José Lopez-Rey, "Picasso's Guernica," *Critique,* vol. I, no. 2, November 1946; Museum of Modern Art, New York, *Symposium on Guernica,* November 25, 1947.

Pablo Picasso, *Sueño y Mentira de Franco* (Paris: 1937). Also, "Picasso: Sueño y Mentira de Franco," *Graphics,* vol. 1, no. 11/12, October–December, 1945.

Picasso interpretations of bull quoted in Alfred H. Barr, Jr., *Picasso: Fifty Years of His Art* (New York: 1946), pp. 202 and 247. See *ibid.,* pp. 264–265 for summary of criticisms. Arnheim interpretation from his *Picasso's Guernica,* p. 24.

Spender quotation from his article in *New Statesman and Nation,* p. 567.

Picasso, *La Guerre et La Paix,* with commentary by Claude Roy (Paris: 1952).

Index

437